Art of the Deal

Art of the Deal

Contemporary Art in a Global Financial Market

Noah Horowitz

PRINCETON UNIVERSITY PRESS ● PRINCETON AND OXFORD

Published by Princeton University Press,
41 William Street, Princeton, New Jersey 08540
In the United Kingdom:
Princeton University Press,
6 Oxford Street, Woodstock, Oxfordshire OX20 1TW

press.princeton.edu

Library of Congress Cataloging-in-Publication Data
Horowitz, Noah, 1979–
 Art of the deal : contemporary art in a global financial market / Noah Horowitz.
 p. cm.
 Includes bibliographical references and index.
 ISBN 978-0-691-14832-8 (hardcover : alk. paper) 1. Art—Marketing—History—
20th century. 2. Art—Marketing—History—21st century. 3. Art—Economic
aspects—History—20th century. 4. Art—Economic aspects—History—21st century.
5. Art as an investment. I. Title. II. Title: Contemporary art in a global financial
market.
 N8600.H67 2011
 382′.457—dc22 2010021904

British Library Cataloging-in-Publication Data is available

This book has been composed in Sabon with Trade Gothic Display

Printed on acid-free paper. ∞

Printed in the United States of America

10 9 8 7

For Louise

Why should anyone want to buy a Cézanne for $800,000? What's a little Cézanne house in the middle of a landscape? Why should it have value? Because it's a myth. We make myths about politics, we make myths about everything. I have to deal with myths from 10 AM to 6 PM every day. And it becomes harder and harder. We live in an age of such rapid obsolescence.... My responsibility is the myth-making of myth material—which handled properly and imaginatively, is the job of a dealer—and I have to go at it completely. One just can't prudently build up a myth.

—*Leo Castelli, art dealer, 1966*

Contents

Illustrations

..

Figures

Graphs

Tables

Preface

...

How are prices established? What drives fashion and taste? What exactly does money buy?

The first decade of the new millennium witnessed one of the greatest booms in the history of the art market. At its core was the dizzying rise of contemporary art, and as it quickly and confidently asserted itself as the most lucrative sales category, rife speculation about the relationship between art and value took hold.

The year that began by setting further records but would also mark the bursting of the bubble—2008—presented two excellent examples of this landscape. The most notable was Damien Hirst's auction at Sotheby's London, in September, which proved to be the final major triumph of the market's latest ascent; the second, an auction of Chinese contemporary art at Sotheby's Hong Kong, five months earlier.

A gargantuan media spectacle preceded Hirst's two-day sale, intriguingly named Beautiful Inside My Head Forever, and its sheer size and value were astonishing: over two hundred works, all purposely made for the auction, at a presale estimate of $122 to $176 million. Although famous artists occasionally consign their work direct to auction—including Hirst's own Pharmacy Sale at Sotheby's in 2004, which grossed $20 million—none has ever had a stand-alone auction on this scale. By cutting his dealers, Jay Jopling and Larry Gagosian, out of the equation, Hirst mounted a bold attack on the conventions of the art business, declaring that he did not need the support of these powerful brokers. He could go it alone.

This achievement, however impressive, paled in comparison to events that broke out on the very day of the sale itself—Monday, September 15. The global financial markets had been weakening for over a year, and this was when they fell into the abyss. American investment bank Lehman Brothers declared its bankruptcy; Merrill Lynch announced that it would be sold to rival Bank of America; and American International Group, the world's largest insurance provider, announced that it was on the brink of failing (culminating the following day in an $85 billion bailout by the U.S. Federal Reserve). This was a moment of extreme financial turmoil, drawing comparison with the onset of the Great Depression in 1929.

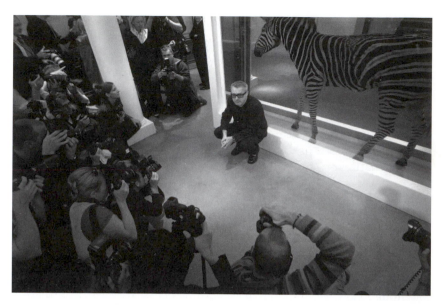

1. Damien Hirst in front of *The Incredible Journey*, 2008, at the Beautiful Inside My Head Forever auction, Sotheby's London, September 2008. (Photo: SHAUN CURRY/AFP/Getty Images)

And yet, seemingly against all odds, the gala evening sale of Hirst's spot paintings, butterfly motifs and animal vitrines realized a staggering $127 million. After the final lot was hammered down on Tuesday's lesser-valued day sale, the two-day total stood at $201 million, with almost a quarter of the lots selling above $1 million and three quarters above their high estimates. The auction house reported that one in three buyers was new to Sotheby's, the majority of these coming from developing markets such as Russia and the Middle East. This strengthened the belief that the globalization of the contemporary art market, already much commented upon, would continue to support price levels despite the financial crisis. The contrast between the tumultuous state of the global economy and the extravagances of the art world could not have been any sharper. This sale, above all other sales, seemed to belie almost any rationale.

Logic nevertheless has a curious way of determining art market events. In Hirst's case, this means prying beyond the incongruity of how his work could sell so strongly amidst the economic turmoil and appreciating Beautiful for what it actually was: the culmination of a painstakingly orchestrated marketing campaign by Hirst and Sotheby's, and a demonstration of the artist's singular adeptness at combining media and financial clout. Most notably, there was no hiding the fact that Hirst's dealers, though cir-

cumvented by the artist and auction house, played a key role in the sale's success, making bids or purchases on more than half the lots in the marquee evening sale and underbidding on the two highest-grossing lots: *The Golden Calf*, which sold for $19 million, and *The Kingdom*, which generated $17.6 million.[1] This bred charges of protectionism and offered a clear indication of how insiders play the market to support prices. Hirst's work had also become a measure of the grandiose pretensions of the contemporary art market, writ large. It embodied the gargantuan ballooning in the size and scale of contemporary art making as well as the unapologetic conflation of art, opulence, and investment. All of these factors were acutely evident in Beautiful, which spared no expenses to underscore the artist's self-importance. Sotheby's converted its Bond Street headquarters into a floor-to-ceiling Hirst spectacle in the week leading up to the auction, giving him a museum-quality solo exhibition and keeping its doors open until midnight on the final weekend to maximize public relations hype and viewing hours; in total, the auction house spent nearly $4 million just to promote the sale.[2]

Though extreme, this treatment was hardly unique and followed on the back of Hirst's exhibition of *For the Love of God*, a platinum-coated human skull adorned with 8,601 diamonds, in a high-security recessed antechamber of Jopling's London gallery, White Cube, in 2007. The circumstances of this sale seamlessly exposed the economic gamesmanship that had become so prevalent in the market: though the skull was originally announced to have sold to a private buyer for £50 million (approximately $100 million at the time), making it one of the single most expensive artworks ever sold and the priciest by a living artist, news soon leaked that it had in fact been purchased by an investment consortium consisting of none other than Hirst, Jopling, and a third, unnamed party who were busy concocting its global exhibition tour. "Art" though it may be, *For the Love of God* was also an overt financial investment that Hirst & Co. would seek to add value to in years to come before selling it off for good.

Our second introductory example concerns another Sotheby's auction, of April 2008: Chinese Contemporary Art III—The Estella Collection. Although this sale netted only a fraction (at $18 million) of Beautiful's record taking, it was a similarly important and highly controversial illustration of some of the strategic ways that economic value was generated in a newly global and diverse art market.

The Estella Collection was assembled by Michael Goedhuis, a New York dealer, beginning in 2004. Its moniker was a marketing concoction drawn from Charles Dickens's *Great Expectations*: "I felt it was a name the Chinese could pronounce," Goedhuis has said. "Although Estella wasn't a pretty character, it's a pretty name."[3] Most of the works Goedhuis

subsequently purchased were sourced from galleries and artists' studios in mainland China, and over the course of three years, some two hundred pieces were brought together under the auspices that they would be part of a major private collection, that the collection would be chronicled in a book of "the highest scholarship," and that some, if not all, of the works would eventually be donated to a museum. The items spanned sculpture, drawing, and painting, the highlight of which was Zhang Xiaogang's oil on canvas, *Bloodline: The Big Family Number 3* (1995), which debuted at the 1995 Venice Biennale. Also included were an array of works in more untraditional media, such as Huang Yong Ping's installation, *Bat Project, I, II, III: Memorandum* (2003), and Wang Jianwei's video, *Spider* (2004). Much of the collection's subject matter reflected upon the social and political tensions of China's transformation from communism to capitalism: the central figure in Zhang's large-scale painting wears a Mao badge. From March to August 2007 the entire body of work was presented in a headline exhibition, entitled Made In China: The Estella Collection, at the Louisiana Museum of Modern Art in Humlebæk, Denmark; a second major exhibition of the collection was presented at the Israel Museum, Jerusalem, from September 2007 to March 2008.

This much is straightforward. The circumstances of the Estella Collection became infinitely more complicated when, during the Louisiana Museum presentation, Sotheby's announced that it would be auctioning the collection the following year. According to the show's curator, Anders Kold, this was a complete surprise and the museum insisted it would never have presented the exhibition had such intentions been declared beforehand: explicit commercial interests—donors leveraging the visibility and provenance of a museum exhibition to add value to their artworks before selling them—certainly raise severe ethical questions for publicly supported institutions like the Louisiana. Even more contentiously, the Sotheby's announcement led to the revelation that Goedhuis was not representing a private collector, as he had alleged, but a consortium of investors, led by Ray Debbane and Sacha Lainovic, wealthy New York businessmen. It also soon became apparent that the Sotheby's auction, to be staged in two parts—the first in Hong Kong in April 2008, and the second in New York later that October—was not on consignment from Goedhuis and his backers, but was to be held in collaboration with William Acquavella, a preeminent New York Impressionist dealer, with whom, it transpired, Sotheby's had actually acquired the entire body of work from the investors in August 2007.

The revelation of these events set off a chain of inflammatory finger-pointing. Artists and dealers who sold work to Goedhuis, often at a deep discount, lambasted him for deception; Britta Erickson, an independent

scholar of Chinese contemporary art who advised on purchases and wrote an essay in *China Onward*, the Louisiana Museum's catalogue of the collection, assailed Goedhuis for misinformation; Goedhuis, himself, feigned innocence, claiming that his backers' decisions were made without his knowledge; and the investment consortium, Acquavella, and Sotheby's were all criticized for flipping the works to turn a profit.

The art market's history may well be littered with similarly opportunistic events, but of particular interest to us is how the circumstances of the Estella Collection reflect what it had become in the new millennium. They are indicative of a global contemporary art economy in which boundaries between collecting and investing are increasingly blurred, throwing the art market's value-added machinery into plain view: a business strategy is identified (in New York); inventory is bought at a trade discount (in China); provenance, visibility, and critical legitimacy are secured through museum exhibitions (in Denmark and Israel); the body of work, now a museum-quality "collection," is sold at a premium (to a New York dealer and a leading international auction house); and this collection is quickly resold at auction (in Hong Kong and New York).[4] Note as well that although most works are conventional two-dimensional pictures, the Estella Collection comprised a number of installations and videos that, as we will see, have only recently gained the market's interest.

• • •

In the pages that follow, I will examine the historical context of these two trajectories. For if Beautiful has won the bulk of popular attention, offering an extreme illustration of the art market's post-2000 excesses and marking the final chapter in this latest speculative bubble as contemporary art sales followed the economy precipitously downward in the wake of the sale, we will see how the calculated entrepreneurialism and international arc of the Estella Collection nonetheless relate to, and seep beyond, the Hirst example—how it is emblematic of what the art world became at the dawn of this century. Where Hirst's success is an exception —a by-product of his distinctive aesthetic and singular acumen at gaming the market—the Estella Collection's unravelling arguably cuts far deeper into the workings of the contemporary art trade. It is evocative of how closely bound investment initiatives have become with the production, distribution and exhibition of art, and it also gives an indication of the ever more expansive types of artworks being sold.

Art of the Deal undertakes a critical account of the art market and how its values (critical, museological, financial) are generated. Specifically, the book will navigate through some lesser-known examples that have not

been considered together in the literature, spanning the rise of art investing and how practices such as video art and what I will call "experiential" art are collected. This text is a testament to the diffuse developments that have lacked cohesion and accountability in the art discourse. By uniting them under a single umbrella, I hope to demonstrate why they must be considered as one and why this is so urgent now.

Acknowledgments

··

Art of the Deal came to life as a Ph.D. dissertation at the Courtauld Institute of Art in London, and I am first and foremost grateful to the Courtauld's academic community for laying the foundations of this book. My many years at the Institute gave me the necessary confidence and determination to pursue my research in the burgeoning realm of contemporary art-meets-economics without ever letting go of the historical bedrock of this nebulous field. In particular, the critical guidance of my advisor, Julian Stallabrass, deeply colored my approach to, and comprehension of, the art market. I am also grateful to my examiners, Alex Alberro and Esther Leslie, for their constructive reading of my thesis and for encouraging me to pursue publication when the present text was still only a distant consideration.

Katy Graddy deserves mention for her assistance in helping direct my early research into art investing during her time at Oxford. Rachel Campbell, likewise, should be singled out for inviting me to present various aspects of my research at her art markets symposiums at Maastricht University, and for her continued warm and collegial support. I have also had the pleasure of befriending James Goodwin and Roman Kräussl, who have provided an informed and opinionated sounding board over the years. Elyn Zimmerman holds a special place in the realization of this book and has proved a constant, and always appreciated, source of guidance. Her late husband, Kirk Varnedoe, passed away before any of these ideas took shape, but his boundless enthusiasm for all things art was influential in shaping my chosen career.

I would like to thank most genuinely the artists, curators, dealers, collectors, and art world professionals whom I interviewed over the course of my research. This ongoing dialogue has proved critical to my understanding of how this economy works, and why; *Art of the Deal* would have been different and all the poorer were it not for these many conversations. Liam Gillick, Isaac Julien, Carey Young, Franzy Lamprecht, and Hajoe Moderegger of eteam and those associated with the Eidar Art Centre in Iceland stand out for their generosity and engaged debate.

Hans Ulrich Obrist's enthusiasm for this research provided a major source of inspiration. I met Hans Ulrich over a "brutally early" coffee in Munich more than seven years ago, and he has since drawn me into his

hurricane world of friends, ideas, and energy for art that I am ever appreciative of. By extension, I wish to thank Julia Peyton-Jones and the entire team of the Serpentine Gallery, where I have had the distinct pleasure of working in a variety of capacities while this book was being written. I came into contact with Daniel Birnbaum and Gunnar Kvaran during my time with the Serpentine, and I cannot thank them both enough for their earnest interest in my writing and professional curiosities, which has gone well beyond the call of duty; I am privileged to call them friends.

Stuart Comer and Pip Laurenson, of Tate, and Chrissie Iles and Henriette Huldisch, of the Whitney Museum, deserve particular recognition for their help in shaping the case study undertaken in the video art chapter. By extension, I am grateful to the galleries, museums, artists, and estates who have granted image rights to illustrate this book, and to all those with whom I have been in contact over the course of my research who have generously supplied the requested facts and figures that populate these pages. This can be a tedious task, but it has not gone unnoticed.

This book is the product of many readings and rereadings, and I am indebted to all who have spent time with it along the way. Jaime Stapleton provided an especially cogent reading of the manuscript in its early stages, as did Franklin Boyd as it neared completion. Andrew Littlejohn and Christophe Spaenjers deserve praise for their detailed commentary on the art fund chapter. Last but not least, I wish to thank Hanne Winarsky, my editor at Princeton University Press, who saw promise in my earliest proposal and who has done a commendable job of shaping the final product. I am also grateful to Terri O'Prey and Anita O'Brien, who helped shepherd the book through production, and the external readers commissioned by the Press who provided a necessary dose of measured insight as I made my final revisions.

My deepest gratitude is to my family, and especially my parents, who believed unequivocally in the relevance of this research and continue to believe in me. Above all, this book is for my wife, Louise, who supported me more throughout this process than can be put into words and whose incredible editing and critical insight helped round it into a coherent whole. We began this journey together as friends and came out the other end as partners-in-crime for life.

Notes on Sources

...

The continued lack of transparency in the international art market makes it especially urgent to be as clear as possible about the data under consideration. Here I spell out some general guidelines about the source material of the facts and figures that are presented in these pages.

Data presented in this book is current as of the end of 2009.

Sales results from specific auctions come directly from the press releases and annual statements of the auction houses in question, unless otherwise noted. The central role of Christie's and Sotheby's, and Phillip's to a lesser extent, in the international contemporary art market dictates that these three auctioneers command the bulk of attention.

All prices for individual artworks sold at auction are from Artnet: http://www.artnet.com. Artnet's price database draws on over five hundred international auction houses and covers approximately four million auction results by over 188,000 artists, ranging from Old Masters to contemporary art; it runs from 1985 to present. The prices quoted by Artnet reflect the actual amount paid by the consumer: the hammer price plus the buyer's premium charged by the auction house (table 1 in chapter 3 presents a historical overview of these rates).

Annual statistics for art sold at auction worldwide, comprising the size of both the overall art market and the contemporary sector, are from Artprice: http://www.artprice.com. Artprice aggregates information from its own extensive international auction price database and provides a clear snapshot of the contemporary art market, which it defines as work made by artists born after 1945 (Artnet, by comparison, does not break out annual sales totals in this manner). One drawback that readers should be aware of, however, is that the data reflected by Artprice covers the hammer price only, not the buyer's premium. The data therefore underestimates the *actual* value of art sold at auction in any given year.

A number of different art market indexes have come into fashion in recent years, and I have elected to use those published by Art Market Research (AMR, http://www.artmarketreport.com) where such reference is made in the body of the text. AMR's indexes, which are based on the average prices of artworks sold at auction, span numerous market sectors and are widely used by art market professionals to measure the general movement of art prices over time. The indexes are available on both a

nominal and an inflation-adjusted basis and can also be formatted to reflect different slices of the market in question (e.g., 100 percent or the central 80 percent). Two caveats, however: first, because AMR's indexes are based on rolling averages, they can appear to lag actual events in the art market; and second, the All Art 100 Index and the Contemporary Art 100 Index that forms the basis of graph 1 actually only consists of painting sales—a hindrance of much research on the art market that is explored at greater length in chapter 3.

Lastly, whereas sales at auction are a matter of public record, prices in the dealer market remain private. Many artists and dealers have nevertheless shared commercially sensitive information with me, and I have attempted to provide extensive footnotes to these sources where applicable. Any error in the presentation of this material is, of course, my own.

Introduction

"I am not really interested in art," explains the founder of a now defunct art investment fund. "It is simply a commodity, which ... produces substantial returns for investors."[1] When I came across this quote online, I had just put down an academic essay characterizing the art business rather differently as "a trade in things that have no price."[2] The inadvertent concurrence of these statements sums up one of the great ironies of the art market. On the one hand, art has little intrinsic economic value (beyond the cost of its materials and the time taken to produce it), sometimes appears purposefully anticommercial, and is often deemed "priceless"; on the other hand, and perhaps as a direct result of these negations, it can generate immense symbolic and commercial dividends. Such apparent contradictions have occupied and bemused art market commentators for generations, but they were thrown into new relief during the latest art bubble as further and increasingly sophisticated art investment initiatives surfaced and as ever greater prices were reached for works with little provenance or art historical acclaim.

This book was originally conceived as a critical account of art investing. When research commenced in 2003, this seemed especially urgent. With prices accelerating after the fallout from the dot-com bubble, speculation was rife about how to make money from art and there was a sharp rise in the number of art investment funds seeking to strategically buy and sell artworks for profit. Yet scholarly literature on the subject was disparate and few had paused to weigh the actual business models of these investment practices or to consider their impact on the ecology of the art market. Discussion of the subject matter from the fields of economics and art was also incompatible. Those in the former camp spoke of investment risks and rewards, and art, when addressed, principally meant painting

and the auction circuit; for the art world, painting comprised but one, typically conservative, tangent of diverse cultural practices, and art investment was usually only approached as evidence of art's debased cooptation by capitalism. The time seemed ripe for a hybrid study of these issues capable of integrating the rhetoric of both disciplines and providing a salient account of art investing, neither upbeat nor disillusioned, to audiences of both areas, and beyond.

That my focus has shifted away from this preliminary formulation is hardly because of a weakening urgency of the matter. Art fund initiatives continue to be undertaken, and intrigue around art investing has accelerated precipitously, spilling over into conferences, books, exhibitions, and widespread coverage across the Internet and mainstream media.[3] More generally, sensational stories about the extraordinary prices recently achieved for contemporary art have been churned out with dizzying force. This has added to the allure of art as a transcendent consumer product, marrying the qualities of luxury goods with promises of high investment returns and unrivaled social prestige.

Three principal factors precipitated a different outlook for this book. The first is practical. Limited information exists on the performance of art funds: the majority, like most hedge funds and private equity funds, are unregulated and do not have public disclosure requirements. Reporting on them is thus fraught with inaccuracies while many, rather than constituting the diversified pools of capital they are commonly perceived to be, are small insider stockpiles of speculative inventory. In addition, very few actually exist beyond preparatory stages, and the field, like many business sectors at the start of the new decade, is facing some trying times due to the lingering effects of the economic crisis and the tapering of demand for unconventional financial products.

The second reason is intrinsic. Art investment funds paint a rather black-and-white picture of the art market. They typically base their business models on a specific and limited product—durable, singular art goods (paintings, overwhelmingly), while practically turning a blind eye to the rest of art production. And their rationale—their fundamental pitch to investors—tends to be based upon a selective reading of how the art market works, drawn from academic studies of art prices at auction. Although this narrow scope is sensible from the perspective of the funds, it offers a highly limited and insular view of art today and hardly provides a sound basis for engaging with many of the equally profound developments also taking place within the contemporary art market. These limitations have been set even further in relief in the wake of the global financial crisis, which has thrown into question the very validity of these funds' assumptions about the "efficiency" of the financial markets and the behavior of art as an alternative asset class.

Leading on from this, the third, and most potent, reason is that contrary to popular belief, art investment funds are not a single, extreme example of art's instrumentality. Although undeniably distinct, they are correlated to other, far more pervasive recent developments, limiting the scope and relevance of an exclusive study. The common denominator is the professionalization of the art industry as a whole, from the escalation of pragmatic career-oriented emphasis in arts education in the 1960s to the flourishing of innovative marketing, financing, and sales strategies by galleries, auction houses, banks, and entrepreneurial art businesses today.[4]

Viewed from this wider lens, it seemed urgent to explore how the recent onset of art funds related to these developments, rather than how they were a historical aversion to the rule; to critically trace their evolution through the arc of contemporaneous shifts within the art economy—and vice-versa. Despite the considerable literature that exists on the history of art markets, the operation of galleries and auction houses, and even the branding of contemporary art, few critical studies have managed to adequately achieve this or to answer some of the most acute questions about the value of art today.[5] Tools inherited from previous decades for making sense of the contemporary art market can look rusty and outdated, and numerous theories have come and gone over the years, annulled by their own overambition to either embrace or shun the new order. This book aims to resolve these shortcomings by providing the first historical account of its kind to shine light on some of the more extreme and novel ways that value is generated in the contemporary art economy. The evolution of art investment funds is considered in conjunction with how a market has arisen for video and experiential art, practices that previously existed on the periphery of the commercial circuit but now reside at its core.

A Historical Perspective

In a bull market, rampant debate about the values of art is unsurprising. For perspective, consider that the last major art bubble of the 1980s, which burst as a result of overexuberant and at times corrupt speculation on painting prices (most egregiously by Japanese investors with Impressionist canvases), inspired a first sustained wave of academic literature on art investment returns.[6] This interest was a result of not only rapid price appreciation but a flooding of new arts institutions and geographies as well as a growing fixation with art celebrities (spiraling outward from the cult of Andy Warhol, who died in 1987). Sotheby's inauguration of its Financial Services Division in 1988 and sales made by the British Rail Pension Fund (BRPF), the first genuine art investment vehicle, at the end of the decade shined further attention on questions of art's economic worth.

But interest in the relationship between art and money far predates this moment. Vasari's *Lives of Artists*, published in the fifteenth century, is one of the earliest and most famous records of the patronage system in Renaissance Italy.[7] Its discussion of the prices and demands of commissions as well as the intense competition among artists to win favor of the papal courts, nobility, and wealthy merchant class has informed research on the subject ever since and leaves little doubt that these issues were as divisive then as now. The origination of public auctions in Holland and Flanders at the dawn of the seventeenth century, spreading to England toward the end of that century, helped evolve the market from an older system of courtly patronage to a more modern supply/demand economy in which members of the predominantly elite social classes vied for distinction through their purchases—and through the public display of bidding itself.[8]

Scores of secondary accounts on the history of the art market have left no shortage of research on who bought what, why, and for how much. This spans the excellent writing on the origins of modern consumer culture in Italy during the Renaissance to the extensive sales records and social histories unearthed in other fascinating research on the seventeenth-century Dutch art trade.[9] Other recent books have shed new light on centuries-old issues by looking at how concepts such as signaling and signposting, drawn from the sphere of game theory, apply to earlier patronage systems: what did artistic commissions signal about their patrons, and how were they used to assert one's stature within the society of the time?[10]

Yet while art's role as a marker of social and economic distinction has been well documented in these historical periods, comprehension of, and interest in, the values of art certainly escalated during the twentieth century. Richard Rush's *Art as an Investment* (1961), one of the first books dedicated exclusively to this subject matter, was a product of the 1950s painting boom and grappled with many of the same questions that have preoccupied later writers.[11] How much longer could these escalating prices, which witnessed some of the first-ever six-figure (dollar) sales of Impressionist paintings, keep apace? Do rising tides lift the value of all works equally, or some more than others? Is investing in art, rather than merely collecting, a viable pursuit? We do not need to reconcile these points to appreciate the cornerstone of Rush's book that it is "doubtful … whether collectors have ever been *unmindful* of the investment value of art."[12]

Rush's text has slipped off the radar of most present-day commentators, owing equally to its discussion of long forgotten names, its outdated methodology (in which the market is cleanly divided into different "schools"), and its usurping by Gerald Reitlinger's *The Economics of*

Taste (published in three volumes between 1961 and 1970) as the quintessential reference point of the period.[13] Yet it still has some notable merits, not least in helping us put the most recent speculative bubble in perspective. Rush's much remarked upon "extraordinary" prices of the 1950s era, for example, offer a sobering wake-up call to commentators nowadays all too eager to herald the utter singularity of the market's recent heights. Consider the then record $770,000 paid in 1959 for Rubens's *Adoration of the Magi*. There is little arguing that this figure pales in comparison to Sotheby's 2004 sale of Picasso's *Garçon à la pipe* for $104.2 million, the first artwork to break the $100 million dollar threshold at auction, let alone the $135 and $140 million sales reportedly brokered behind closed doors in the private market for Klimt's *Portrait of Adele Bloch-Bauer I* and Pollock's *No. 5, 1948*, both in 2006. But adjusted for inflation, Rush's earlier reference point comes to $5.6 million in 2009 dollars. This may no longer be a record-breaking sum, but it is still noteworthy even by today's inflated standards, and especially significant given the context of the time. Whereas the recent flourishing of the art trade has come on the back of an extended period of economic growth and prosperity, and also had the benefit of the 1980s bubble to anchor itself against, the art market at midcentury rose essentially from naught in the postwar years and is all the more impressive because of this.

Similarly, it is worth remembering that global art price levels, commonly believed to have shattered previous records for years on end during the latest boom, actually only drew level with their peak of 1990 in 2007–08. Indexes published by Art Market Research, which are based on the average prices of artworks sold at auction, give a good sense of this: the central 80 percent of the contemporary art market (excluding the top 10 percent and bottom 10 percent) did not eclipse these earlier heights until September 2007, while it took the overall art market even longer—April 2008. Nor should we ignore the fact that three of the top five most expensive artworks ever sold at auction in *real* terms still hail from the 1980s.[14]

A number of important new developments have nevertheless come into focus in the new millennium, and it is worth pointing to some of these to clarify the distinguishing features of our present time.[15] For one, the gap between the top end of the market and everything else has widened, enabling certain artists to enjoy levels of financial success virtually unthinkable in any previous period. Damien Hirst is, again, the ultimate case in point, with his business empire ranking him at number 238 in Britain's 2009 *Sunday Times Rich List*, at an estimated net worth of £235 million.[16] We should be careful not to exaggerate the affluence of today's artists—very few are fortunate enough to sustain themselves through their art, let alone reap windfall returns—but the view from the top is

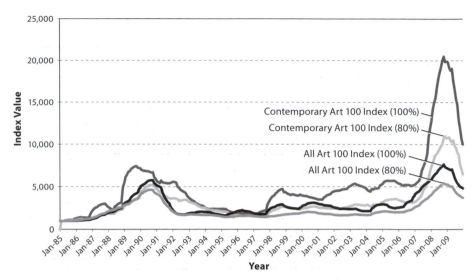

Graph 1. Global Art Price Levels ($, real terms), 1985–2009. Source: Art Market Research.

undoubtedly different from before as certain artists' wealth has come to equal, and even exceed, that of some of the most prominent collectors. For perspective, consider that even before Hirst's Beautiful sale in 2008, his earnings were believed to exceed those of Picasso, Dali, and Warhol combined at the same age (43); even the most successful earlier artists were impoverished by comparison.[17]

Hirst may be one of the most direct beneficiaries of this—leading to him being heralded as the most powerful person in the art world in 2008—but celebrated successes of this kind also have their knock-on effects.[18] One of the most immediate is the sheer rise in the number of artists today, also something unprecedented. This is abetted by increasing coverage of the contemporary art scene in vanity and mainstream media, which has thrust the art lifestyle onto a new level of pop cultural fixation. Indeed, if it were not for the bevy of press on the riches and glamorous habitudes of Hirst and some of his contemporaries, and the varied connections with Hollywood celebritydom that extend from this, it is doubtful that so many would aspire to the profession.

The relationship between art and money, never straightforward historically, has transformed into a new kind of union, at once glamorous, provocative, and banal. During the post-2000 boom, the ever-steeper excesses of the art market ran the gamut from gala beachfront parties in honor of artists, collectors, or institutions, to VIP dinners on art-curated

yachts, to any number of art sales and entertainment functions in exclusive, hard-to-reach places. Such excesses were also evident in the ambitious corporate partnering with art, architecture, and design that progressed from mere sponsorship to the commissioning of exclusive artist-designed consumer products. American artist Richard Prince's £10,000 limited edition *Jamais* handbag for Louis Vuitton in 2008 was only one of many such "imaginative" partnerships. So, while art certainly continued, and perhaps even reinforced, its long history of serving a public good—more art was being seen and discussed by wider audiences than ever previously—there was little doubting which public much of it actually served: an upwardly mobile elite with money to burn.

Though every era inevitably possesses its headline-grabbing prices and household names, and the web of social commentary and competition this yields, there has also never been such an intense and widespread focus on the economics of art as there is today: market information is more exhaustive and accessible, leading people to be more savvy about the benefits of art as a specifically financial asset. We see this concretely in the ballooning of art funds, art financial services firms, and media coverage of the art market's goings-on. Yet these developments have been made possible only through the more widespread and interrelated changes in the global economy at large (at least up to the latest economic meltdown). These include an extended period of corporate profitability and equity market appreciation, dating to the mid-1960s, that has encouraged large-scale investments in the infrastructure of the art market (from galleries and museums to fairs, biennials, and ancillary services); widening levels of income disparity, most acute and disproportionate at the top end of the earnings spectrum, setting the bedrock for new art buyers; the winning out of privatization over public-sector subsidizing, inspiring greater innovation for artists and arts institutions to make ends meet; and lastly, leading on from each of these points, the preeminence of finance, which has yielded new ways of thinking about and conducting business across diverse economic sectors, including, though hardly limited to, art. The net effect is that more money, from more places, has poured into the art market than ever before, inspiring ever more creative ways to put this capital to work.

The much remarked upon rise of both hedge fund collectors and newly rich players from developing markets during the latest boom is a particularly obvious manifestation of these changes. Yet its ultimate unfurling is far more widespread, drawing successively younger and more diverse types of buyers to the mix. This has rung the final death knell of the classical connoisseur and substituted in its place an intoxicating mixture of speculators, fashion seekers, and newly curious aficionados for whom collecting is often but an extension of a broader social and/or financial

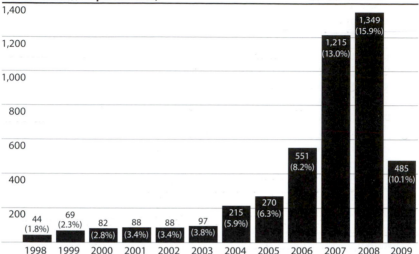

Annual sales ($, millions)
(percentage of overall global fine art
auction turnover in parentheses)

Graph 2. Global Contemporary Art Auction Turnover, 1998–2009. Source:
© Artprice.com.

agenda. A seismic shift in the market's taste has followed in suit. Contemporary art has never been more popular, and there has been a generational shift in the focus of art collecting from objects of an established past to those of a present that is still in formation—the search for the diamond in rough. This has been brewing since at least the middle of the last century with the New York School and Pop artists, and again during the 1980s bubble, but it reached a new level of intensity following the market's subsequent recovery and expansion. In the decade from 1998 to 2008, worldwide sales of contemporary art at auction swelled from just $48 million to over $1.3 billion, representing a more than eightfold rise in the sector's market share, from 1.8 percent to 15.9 percent of the global fine art trade.[19] During this same period, contemporary art would also overtake Impressionist and modern art as the most valuable sales category at the world's leading auction houses, an astonishing feat given the long-standing supremacy of these established categories and the sheer speed of its ascent; whereas just 8 percent of artworks selling above $100,000 were contemporary in 2005, this figure more than doubled, to 19.5 percent, at its peak two years later.[20]

One overriding factor in this shift is the diminishing supply of high-quality older artworks in circulation, which have been steadily absorbed into museum and elite private collections. This is particularly important

20% in 2008

in driving the demand of more established collectors toward contemporary art. A second reason is the immediate rewards of collecting contemporary art: it looks and feels unmistakably like "art" and can enhance one's sense of cultural erudition and fashion wherewithal in a single turn; its meanings and values can be easily shared, communicated, and reinforced (through social engagements and via media outlets); and there is a visceral competitive thrill in acquiring it—in being ahead of the curve and standing to benefit from a newly discovered artist's sudden popularity. In a world in which forms of consumption are increasingly serialized, contemporary art offers an alternative prospect that is anything but. Arguably more so than even architecture, design and haute couture, it is unmistakably unique, thereby reinforcing collectors' individuality, *tout court*. Stratospheric prices of many contemporary artworks further cement this attractiveness, yielding exponentially greater social and financial dividends the higher up the ladder one climbs.

Lastly, contemporary art has become a global phenomenon. This has profoundly shifted the dynamic of the trade since Rush's day. Even if we acknowledge that record prices are always relative, there is no denying that influential buyers and sellers of art have seeped well beyond the conventional Euro-American axis, enabling contemporary art to transgress linguistic and cultural boundaries in a way that few other outlets can: it has become a veritable social glue. This is particularly vital nowadays, for in a globalized world split by social, political, and religious strife, contemporary art is a leveling force offering a tabula rasa relieved of history and anchored to the spirit of progress, innovation, and inclusivity. More types of art are being seen, produced, and collected by more artists and audiences internationally than in any previous period, and the more diverse and pluralistic this work becomes, the more these attributes are reinforced.

Time Frame

Against this backdrop, this book covers the period from 1960 to present, with emphasis on the post-1990 context. This time frame comprises the emergence of Modern Portfolio Theory (MPT, 1952) and its metamorphosis into the Capital Asset Pricing Model (CAPM, 1964) that underpinned the rollout of the first art funds and helped fuel the growth of the financial services industry, drawing new collectors and business initiatives into the frame.[21] British Rail's art investment program was inaugurated in 1974, Citibank launched its Art Advisory Service five years later—the first such initiative for a financial institution of this scale—while the most recent generation of art funds is anchored both to the fundamentals of

presentation. / 1st Art fund 1974 City Bank 1979

portfolio theory and to the residue of these institutional developments. Gerald Reitlinger's aforementioned tome, *The Economics of Taste*, which surveyed the development of the Western art market beginning in the eighteenth century, was published in 1961. More so than Rush's book of the same period, it gave academic credibility to speculative ventures such as BRPF; its sales data also served as the basis for later econometric studies of the art market.[22] And 1973 included two important feats for the auction sector: Sotheby's became the first international art auctioneer to conduct sales in Hong Kong, signaling the importance of the East within what was then a predominantly Western art trade; and Sotheby's sold Robert and Ethel Scull's collection in New York, the first stand-alone auction of contemporary art from a private collection in the United States.[23] If the balance of power in the art market was already recognized to have transferred across the Atlantic from Paris—triggered by the emigration of artists to America during the war years, the concentration of modern art museums in Manhattan, the notoriety of the New York School and Pop artists, and Sotheby's 1964 acquisition of Parke-Bernet, the largest fine art auction house in the United States—these events were momentous insofar as they reiterated these shifting dynamics and validated the profitability of contemporary art.[24] Indeed, Sotheby's has held its Contemporary Art auctions at least twice yearly ever since in both London and New York, with Christie's inaugurating its own such sales in 1974.[25]

The Scull sale, in particular, has come to be regarded as a watershed in the upward trajectory of the contemporary art market. Olav Velthuis, in his important book on the subject, speaks of this auction as highlighting a divide between the "new" art world and its nostalgic past. Dealers in the "old" era were far fewer, had more intimate community bonds, and tended to run their galleries as "small, seemingly nonprofit enterprises"; they were "motivated by love for art," not money. In the aftermath of the Scull sale, a more financially shrewd era in the art market seemingly emerged. Dealers, artists, and collectors became more status and investment conscious, both the scale and ambition of work grew ever larger, and prices were set more aggressively. Whether this break is factually correct, as Velthuis himself points out, is questionable to say the least.[26] But its perceived significance in art market lore is undeniably real and corresponds to a number of other contemporaneous changes that were in the process of manifesting themselves during the 1960s and 1970s.

At a greater level of abstraction, our time frame also corresponds to the birth of the postmodern economy, attributed to the transition from a Fordist to a flexible model of accumulation: top-down bureaucratic managerialism, high levels of state economic intervention, and a manufacturing-centric economy, on one hand, versus a neoliberal ethos of free markets, free trade, and an accentuation of the service-provision industries and

labor market flexibility, on the other. The financial market downturn, the adoption of a fluctuating exchange rate system, the birth of the financial derivatives market, and the termination of the Bretton Woods Agreement (which pegged international gold reserves to the U.S. dollar) during the early 1970s, compounded by the infamous oil crisis and onset of stagflation, demarcated this passage.[27] It is a political-economic system of intense innovation and deregulation that, at least up to the current shakeout from the global credit crisis (which has given the state greater leverage in business through the nationalization of leading financial institutions and the tightening of trade regulations), has remained very much in evidence over the last three decades.

These events had a direct impact on the art market. BRPF's art investments were designed to hedge the inflationary risks of this period; the passage to a more fluid system of international trade was a major step in the construction of a truly global art economy; and this increasingly pervasive free-market ideology led to the diminution of public-sector arts funding and the acceleration of policy-led arts subsidizing. This book will not delve into all of these subjects, but their evolution forms an important backdrop to the deliberations around artistic commodification and art investing that follow.[28]

Postmodernism, more broadly, is also associated with the dematerialization of the art object beginning in the 1960s.[29] This is best encapsulated by the advent of conceptual art, which drew on the avant-garde precedent of artists like Marcel Duchamp and prioritized the contextual and philosophical frameworks of artistic activity to the making of tangible artworks. But dematerialization also spans the emergence of Fluxus, Minimalism, installation art, performance art, body art, video art, and related offshoots that ruptured conventional approaches to art making and spectatorship during this period. As with economic postmodernism, these developments are characterized by a shift toward mobile and networked labor models and an overturning of essentialist principles of authorship and objecthood. They affirmed, once and for all, that art was much more than the painting of pictures or the molding of sculpture—that it was to encompass a great variety of media, practices, and self-critical ideas. Jean-François Lyotard's 1985 exhibition, Les Immatériaux, co-curated with Thierry Chaput and presented at the Centre Georges Pompidou, Paris, offers an excellent crystallization of the link between postmodern theory (of which Lyotard was one of the most famous exponents by the late 1970s) and aesthetic dematerialization.[30]

Dematerialization is a subject of paramount importance to our enquiry because it broadened the economic spectrum of the art marketplace from near exclusive focus on tangible objects to immaterial articles such as content and intellectual property rights.[31] These developments widened

the ambit of tangible objects in circulation, too, as documents and ephemera from temporal events—performances, actions, happenings—gained museological and, eventually, market significance.[32] Far from eradicating the circulation of durable goods, they encouraged their further dissemination and have led to more sophisticated exhibition and sales strategies that I will explore at length.

The post-1990 emphasis derives from several factors. Prior to this period, dematerialized art was marginalized in the market. Dealers' attempts to sell artists' videos had hitherto failed with regularity, and most other activities under the dematerialized art umbrella were posited as either ambivalent or hostile to commercial interests; only limited efforts were made to explore how such output could be sold. Conceptual art, which exceptionally had attracted the interest of private collectors from the outset, still constituted but a minor component of the 1980s art market boom, which was driven predominantly by figurative painting.[33] The market crash at the turn of the 1990s helped reverse this trend by opening a decisive entry point into the commercial gallery circuit for practices that had never gained extensive footing here but emerged as cheaper, viable collectibles as the opportunity cost of presenting them diminished—notably video, experiential and installation art, and practices that have since been popularized under the rubric of "relational aesthetics."[34] Many of the artists associated with these developments are now integral to the contemporary art discourse and market. Three decisive issues that I will examine in this book are how these artists' work enters the market, how this relates to earlier precedents, and what the implications of this are for the contemporary art economy, moving forward.

Globalization

The dawn of the 1990s was framed by the Tiananmen Square protests, the collapse of the Berlin Wall, and the dissolution of the Soviet Union, which saw the neoliberal dogma ushered in by Thatcher and Reagan take on ever more global dimensions. The geopolitical aftermath of this is well known, contributing, among other factors, to the 1992 Maastricht Treaty, which transformed the European Economic Community into the European Union, followed by its subsequent expansion into the former Eastern Bloc; Russia's 1997 accession into the Group of Eight; the launch of the euro in 1999 and its onset as physical currency in 2002; and unprecedented levels of interchange among financial markets internationally, drawing regions such as the Far East, Middle East, Africa, and both Central and South America into ever more dynamic business relationships with North America and Europe. The net impact of these changes remains a subject

of debate, though it is widely heralded as evincing a dramatic shift of power from the United States to actors such as China, India, Russia, the Middle East, and the European Union. Globalization is certain to entertain considerable theoretical and empirical analysis for years to come.[35]

Globalization rhetoric is a clichéd minefield and one should be prudent in deploying it. As Immanuel Wallerstein has demonstrated, far from being unique to the post-1989 context (as is commonly supposed), the course of globalization has been several hundred years in the making.[36] Wallerstein's long-term theorization of the capitalist world-economy has its roots in the crisis of the feudalist system in the mid-fifteenth century that encouraged the major Western European countries to expand beyond established national borders in order to secure continued economic growth. The resulting economic system was more international than previously and far more dynamic than under earlier empires; it was to be articulated through a constantly evolving trade equilibrium across what Wallerstein calls core, peripheral, and semiperipheral countries. The dramatic events of 1989 did not so much push this system into uncharted territory as ask new questions of a U.S. hegemony that had already been in decline since the 1970s oil crises and the failures in Vietnam. The latest financial crisis that struck industrialized nations like the United States first and most overtly has brought this power shift from West to East into even greater focus.[37]

The art market has long possessed international dimensions, especially since the rise to prominence of major American collectors and civic museums in the nineteenth century. The truth, however, is that even if we should be cautious in applying the term globalization to the art economy, basic generalizations are not altogether incorrect. The post–Cold War world order has had a profound impact on the art economy's structure, drawing new artists, collectors, and institutions to the market to an unprecedented extent.[38]

Let us look at some concrete examples. The following highlights are from two recent studies of the international art market by Clare McAndrew: India's art exports surged from €2.6 million in 2000 to €486 million in 2006, with the most rapid increase coming in 2003 when exports jumped up to €508 million, nearly one hundred times the previous year's total. In 2006 China's share of the global market for contemporary art sold at auction (defined as art made after 1970) grew level with Britain (at 20 percent each), with the country possessing the fourth, fifth, and sixth largest auctioneers of contemporary art (China Guardian, Poly International Auction Company, and Shanghai Auction House). In 2007 China became the world's third largest auction market, commanding an 8 percent global share of such sales. And in the five years through to 2006, auctions of Chinese, Indian, and Russian contemporary art displayed

China, Russia, India

Distribution of wealth

some of the sharpest price inflation at 336 percent, 684 percent, and 253 percent growth, respectively.[39] These lofty figures, as McAndrew wisely points out, are in part due to the low base to which they are anchored.[40] They nevertheless underline the growth of prices and volumes in these regions and the new rungs of collectors who are now actively participating in the art market for the first time.

The strength of these regional economies for much of the post-2000 period, coupled with the subsequent acceleration in the number of their high net worth individuals, undergirds this art market ascent. As the art economy continued its rise in 2006, China, India, and Russia had flourishing financial markets and sustained real GDP growth of 10.5, 8.8, and 6.6 percent, respectively—considerably apace of the United States and Britain at 3.3 and 2.7 percent. These gains were translated into robust rates of growth for the high and ultrahigh net worth individuals (people with a net worth in excess of $1 million and $30 million, respectively) in these countries, far in excess of those in Europe and North America.[41] These shifting dynamics are reflected in the art market statistics above and also in anecdotal accounts: "Five years ago buyers who spent more than $500,000 at our auctions came from 36 countries," a spokesman for Sotheby's remarked in 2008. "Last year they came from 58."[42] There are great differences in the wealth distributions across these various countries, and each will feel the impact of the financial crisis in different ways. But it is a fact that the art market is more global than ever previously, and that new collectors and institutions from developing regions will play an important role in the future development of the art economy.

This flowering of wealth and art collecting is inseparable from the global art museum boom, including the inauguration of new institutions, the physical expansion of others, and the opening of satellite branches. Thomas Krens's directorship of the Guggenheim Museum (1988–2008) is emblematic of this tendency and coincides almost precisely with the thawing of the Cold War. Krens's pursuit of these objectives is so visible and thorough that it is today commonplace simply to refer to it as "the Guggenheim effect."[43] For instance, the 1997 launch of the Frank Gehry–designed Guggenheim Museum Bilbao, matched in the same year by the inauguration of the Deutsche Guggenheim Berlin, involved the American institution partnering with the Basque government and Deutsche Bank to loan works from its collection and extend curatorial and administrative services to fill and manage these overseas branches.[44] These undertakings were followed by the 2001 inauguration of the Las Vegas Guggenheim and the 2006 announcement of the Guggenheim Abu Dhabi, again to be built by Gehry, set to open in 2011–12; the institution also manages the Peggy Guggenheim Collection, Venice.[45]

Elsewhere, New York's Museum of Modern Art completed an $865 million renovation in 2004, and London's Tate Modern, which opened to the public in 2000 and became the third most visited museum in the world in 2007—a further indication of the magnetic appeal of contemporary art nowadays—is overseeing a £165 million expansion of its facilities.[46] And in 2007 the Louvre in Paris announced a twenty-year partnership with the city of Abu Dhabi, encompassing a strategic agreement estimated at $1 billion, covering loans, curatorial expertise, exhibitions, acquisitions, and rights to use the institution's name on a new museum (to be built by Jean Nouvel).[47] In fact, this partnership represents only one of five museums planned for a multibillion-dollar tourist development on Saadiyat Island (which will also house the proposed Guggenheim).[48]

Nestling alongside these two trajectories is the equally profound upsurge in commercial galleries with international satellite branches. This phenomenon is among the purest extensions of economic globalization into the art market, enabling galleries to leverage their brand identity, access a widening client base, and provide economies of scale. It may not be entirely new—the global outlets of Marlborough Fine Arts provide an especially good example from the 1970s—but it is certainly more emphatic than ever before. Larry Gagosian's empire of contemporary art galleries—extending from Beverly Hills to Athens, with London, New York, and Rome sandwiched prominently in between (where he operates a total of six spaces)—is the ultimate case in point.[49] Yet others, such as Hauser & Wirth and PaceWildenstein, echo this development and further testify to its far-reaching dynamic.[50] Haunch of Venison, which has galleries in London, Berlin, and New York, was controversially purchased by Christie's in 2007 and offers an even further illustration of the strategic economic function served by these international expansions as well as the centrality of contemporary art to the broader art market—the auction house ostensibly acquiring the gallery both to gain a foothold in the primary sector and to exploit its client base.[51]

These advances are echoed by the swell of private art museums internationally. Advertising magnate Charles Saatchi set the benchmark for this when his eponymous space first opened in London in 1985. However, if a combination of tax incentives (encouraging charitable donations to museums), access to capital, and even restraint once mitigated against these monumental endeavors—or at least restricted them to a more limited, typically posthumous phenomenon—this is hardly so as of late. In the past decade, in lockstep with the global art boom and the flourishing of ever more ambitious individual collections (many contemporary, some not), we have seen a watershed in the rise of private museums and privately funded contemporary art exhibition spaces and foundations. Some

Christies purchases a major galleries to access primary markets & client base

notables and their founders, chronologically, include the Astrup Fearnley Museum of Modern Art (Thomas Fearnley, Heddy and Nils Astrup Foundation, Oslo, 1993); the Rubell Family Collection (Don and Mera Rubell, Miami, 1996); La Colección Jumex (Eugenio Lopez, Mexico City, 2001); the Moore Space (Rosa de la Cruz and Craig Robbins, Miami, 2001); the Neue Gallerie (Ronald Lauder, New York, 2001); Guan Yi Contemporary (Guan Yi, Beijing, 2003); La maison rouge (Antoine de Galbert, Paris, 2004); Palazzo Grassi (Francois Pinault, Venice, 2006); the Pinchuk Art-Centre (Victor Pinchuk, Kiev, 2006); Initial Access: The Frank Cohen Collection (Frank Cohen, Wolverhampton, 2007); the Ullens Center for Contemporary Art (Guy Ullens, Beijing, 2007); the Broad Art Museum (Eli Broad, Los Angeles, 2008); the Devi Art Foundation (Lekha and Anupam Poddar, Gurgaon, India, 2008); the Garage Centre for Contemporary Art (Daria Zhukova, Moscow, 2008); and the Brant Foundation Art Study Center (Peter Brant, Greenwich, 2009). Not one for wanting to be left out, Damien Hirst is also in the process of converting his estate in the English countryside, Toddington Manor, into a museum that will showcase his own art and works from his collection.

These developments mirror the ambitious multicultural contemporary art exhibitions that came into vogue at the tail-end of the 1980s and, in particular, the biennial boom that served as the major critical mouthpiece of art to international audiences during the 1990s. The Centre Pompidou's Magiciens de la Terre (Magicians of the Earth), 1989, is the most famous example of the former tendency and is among the first exhibitions at a major museum to present art of the first and third worlds together in a single show. The exhibition had some major flaws—especially its patronizing use of the word magicians rather than artists in the title—but it set off an important wave of curating around the subjects of globalization and postcolonialism.[52] In terms of the latter tendency, though recurring exhibitions such as biennials are not unique to recent times, the biennial's post–Cold War augmentation is indisputable.[53] Characterized by an unprecedented global inflection and occurring in lockstep with an amplification of contemporary art galleries, museums, journals, websites, prizes, and fairs, biennials' temporal nature and adaptability to transborder flows (of information, goods, services, people) make them well-suited heirs to the flexible managerialism of postmodernism.[54]

Art fairs offer a final illustrative elaboration of the art world's globalization. Where once Art Basel (established 1969) was the principal contemporary art sales event of this sort, notables now include New York's Armory Show ("The International Fair of New Art," 1999, originally set up as the Gramercy International Art Fair in 1994), Art Basel Miami Beach (2002), and London's Frieze Art Fair (2003). Art Cologne (1967), FIAC (Paris, 1974), ARCO (Madrid, 1982), and more recent advents such

as ARTissima (Turin, 1994), Art Forum Berlin (1995), and Paris Photo (1997) exist below this upper echelon. The 2007 inauguration of the DIFC Gulf Art Fair, Dubai (renamed Art Dubai in 2008), and ShContemporary, Shanghai, demonstrates their continued international expansion. The remarkable success of these headline fairs instigated a post-2000 subgenre of satellite fairs composed of mainly younger and lower-profile galleries, which are barred from the main proceedings due to institutional hierarchies and steep entry costs. They seek to profit from the period-specific influx of wealthy collectors, museum officials, critics, enthusiasts, and media during these events.[55] In aggregate, fairs have proved extremely significant in facilitating the ease of galleries' presentation and selling of contemporary art to global audiences and are evocative of the event-driven ethos of the contemporary art world.

Despite the effects of globalization on the art world in recent decades, the emphasis in this book is on developments in the United States and Britain. This reflects the fact that these two countries remain the most important locations for art sales, accounting for upwards of three quarters of global auction turnover in the recent period.[56] New York and London, in particular, are anchors of the art financial services and auction industries, possess large concentrations of museums and contemporary art galleries, host prominent art fairs, are the historical and current headquarters of many art investment funds, and are the cities where the greatest numbers of leading art market players continue to reside and interact.

The decision to focus on these areas is also symptomatic of the schism between globalization and regionalization in the art market.[57] On the one hand, as we have just seen, rising levels of wealth among the international financial elite and the spread of contemporary art museums, biennials, and fairs have made collecting a more distinctly global phenomenon. Yet, on the other hand, there has also been a noted segmenting of art sales into highly specialized, regionally focused trading blocs (Hong Kong as the epicenter of the Chinese trade, Dubai for the Middle East, and so on). While this latter dynamic may change as these developing markets mature, at present New York and London nevertheless remain the primary axes of the international contemporary art trade. This does not belittle the extent of the art market's expansion; it simply acknowledges that if this industry is experiencing an unprecedented level of global growth, the dominant Anglo-American market centers have yet to be unseated.[58]

Art Market Structure

Go Emerging markets

Hong Kong / Dubai

Some background on the structure of the art market and what I mean when I speak of artistic value is essential. I should begin by differentiating

Globalization of contemporary art but yet, central points of sale ncy London

between the art market and the art world: the former refers to the makers, buyers, and sellers of art (artists, dealers, auctioneers, collectors, art financial services firms, etc.); the latter, to the marketplace as well as the expansive web of stakeholders involved in the producing, exhibiting, viewing, and discussing of art (from studio assistants and museum curators to gallery-goers, critics, and art historians). Distinctions are rarely absolute—we often think that museums operate outside the market even though they enter it explicitly through acquisitions and support it implicitly through the exhibiting, and thus validating, of art—but it is nevertheless important to establish an overarching clarification of terms.

It is also instructive to differentiate between the art economy and other asset markets. Strictly speaking, artworks cannot be classified as commodities: perfect substitutes do not exist for most artworks (though they do in principle for reproducible media such as photography, film, and video); artworks do not generate money while in ownership (unlike stocks that pay dividends or property that generates rent); there is no financial derivatives market for art (one cannot sell an artwork "short"); art is highly illiquid and burdened by steep insurance, storage, shipping, and transaction costs (making it a cash-flow negative asset while in holding); and externalities such as the "Three Ds" (death, divorce, and debt) have a comparatively large impact in driving supply to the art market. Like luxury real estate and jewelry, though dissimilar to stocks and bonds, artworks are also what economists call "positional goods": their value is correlated to *relative* desirability (positionality) as predicated upon rarity and the social prestige of ownership. Trades in equity markets, meanwhile, are cleared electronically or through brokers on the floor of an exchange on a real-time basis, virtually 24/7. Despite significant recent improvements in the transparency of art prices online, only auction results are captured here (but not dealer or private sales).[59] Moreover, there remains no centralized clearinghouse for art transactions.

Regarding the art market's composition, artists and collectors are certainly the most numerous yet also the most difficult to quantify. Many of the former are part-timers and most only ever make art as a hobby, while the latter are at once exceptionally diverse (most people of at least moderate means have bought some type of artwork in their life) and impressively concentrated, with not considerably more than a thousand or so major collectors actively vying for premium blue-chip art at any given time. This is reflected in an important recent study in which McAndrew neglects quantifying the size of artists and collectors but notes that the worldwide fine art, decorative art, and antiquities marketplace comprises upwards of seventy-one thousand dealers, of which a core of four thousand account for 75 percent of business and as few as one thousand are responsible for half the market by transaction value; the remainder of

ART: NOT A COMMODITY - cannot be MASS produced → photo - video - film

→ ART → no dividends → no Rent
- no Financial derivatives
- highly illequid
INTRODUCTION • 19

sales are executed by smaller brokers and dealers selling lower-value art.[60] The auction circuit, which accounts for roughly half of the global art trade, is narrower yet and comprises approximately five thousand fine and decorative art auctioneers globally.[61] In the fine art segment, the focus of this book, Sotheby's and Christie's dominate the international auction trade and together accounted for 73 percent of art auction sales by value worldwide in 2008, from just 16 percent of transactions, with the remainder of business conducted by successive tiers of national and local operators.[62]

The art market's ancillary service providers add density to this institutional system. These comprise art lawyers, insurers, shippers and handlers, interior design consultants, collection advisors, agencies that manage resale and image royalties, the private wealth management divisions of banks, art investment funds, and art financial services firms. Corporations, governments, charities, and not-for-profit organizations also play crucial roles in supporting, funding, and presenting art activities. It is estimated that in 2006, the European art market spent €2.5 billion on these ancillary services, which employed over seventy thousand workers, against sales of €19.2 billion.[63]

Artist and writer Martha Rosler proposes two models for conceptualizing the structure of the art market.[64] One involves a pyramid with the most influential players concentrated at the pinnacle, followed by a downward and outward spread of lesser significant actors and institutions. This is useful in depicting the intense competition for a place at the apogee of the art world's elite and is reflected in the fact that only a few main auction houses and several hundred key dealers are responsible for the majority of the market's turnover.[65] It is misleading, however, in giving the impression that upward progression is linear and that there is only one single standard of success. Rosler is aware of these shortcomings and so proposes a second model conceived as a "set of interlocking rings, some close to the center, others further away." This draws on Wallerstein's aforementioned world theory that segments the geopolitical map into core, peripheral, and semiperipheral zones. When applied to the art market, it explains the agglomeration economies of cities like New York and London (characterized by a dense concentration of rings) and the complementary relationship of regions outside of these centers. This is also an important model because it adjusts for overlap in motives. This deemphasises the zero-sum nature of competition attributed to the pyramid model (I win, you lose) and is more consistent with the reality of an art market composed of interlocking circuits of commerce (i.e., that the pinnacle of success and the allocation of resources for contemporary art dealers are not necessarily congruent with those for, say, Old Master painting, nor are they uniform within either of these broad specializations). Despite

- high cost insurance → Storage - Shipping.
→ ART = positional Goods

differences, both models are effective at portraying the art world, correctly, as an industry in which a very small number of actors control a disproportionate level of power in earnings, reputation, and taste-setting parity: "The contemporary art world, like all modern technical/professional discursive fields, is cohesive and (inadvertently) exclusionary. Few people not professionally implicated can meaningfully participate in it."

The definition of art adhered to in this book reflects this hierarchical institutional reading. In the case of a painting, the transition from a completed work to sanctioned Art is not implicit, but dependent upon interaction with the players and institutions denominated above; the more frequent and meaningful these interactions, the better the artwork's provenance and the more credible it becomes. Dealer René Gimpel describes this transition elegantly: "The studio-bound painting is only a chrysalis. The apparently finished painting is now in an embryonic state of becoming. What it becomes depends on how it is consumed but only in consumption does it fulfil its manifest destiny."[66] If demand exists for an artwork, its trajectory toward consumption will begin with its fabrication and progress into a cycle of public presentation, debate, sales, and so forth. The repetition of this cycle, unto interaction with ever higher-order actors, is a key aspect of the value-creation paradigm and explains Rosler's insistence that "the art world is most potently envisioned as a universe of discourse (secured by its economic base)." Failure to inscribe oneself within this discourse or to win the support of its major institutions and collectors marginalizes one to the periphery and restricts the "finished painting's" metamorphosis from becoming high art, proper.[67]

Two major factors, alongside provenance, that affect an artwork's value are its availability and differentiability. Artists need to generate a certain level of supply to create demand—and some even thrive by strategically oversupplying the market for publicity, provenance, and income—but all things being equal, scarcity tends to boost prestige values. In addition, the uniqueness of artworks—that an individual piece may have no perfect substitute—sets them apart from ordinary commodities and enables "monopoly rent" to be charged.[68] This resurfaces prominently in discussions of the contemporary art market that follow and explains the extreme prices artworks may command. As long as at least two collectors wish to acquire a single artwork—the *only* item capable of satisfying their demand—its price may escalate precipitously as they bid against each other.

This boils down to the fact that there are essentially two main variables —one static, the other dynamic—that impact an artwork's price. The former refers to the universe of essentially inalterable features of a work: the name of the artist, the year it was made, whether the work was unique or editioned, as well as its size, weight, shape, color, and content.[69] The lat-

ter, which include its provenance, sales history, and critical reception, changes over time. Despite obvious differences, both can be and are actively manipulated by the producers of art and others with vested interests in its welfare. These actions form the essence of the art of the deal, and it is the task of this book to uncover some of the more extreme ways in which they are put to work.

Value

In addition to how we define art and the market's structure, we must also clarify the role of value. Thus far, I have casually glossed over the rise in contemporary art prices as evidence that art works have discernible *economic* values—that they can be bought and sold for profit (or loss)—as well as noting the *critical* values that works possess—those features that differentiate one piece of art from the next. But artworks also have important *symbolic* values, linked to the social status and prestige of ownership, that distinguish the art economy from other markets. Understanding how these symbolic values function is crucial to appreciating the operation of the art market and this book's main arguments.

Neoclassical economic analyses of the arts, epitomized by those of economist William Grampp, contend that the market is the most efficient arbiter of value (economic and critical) and the optimal device for allocating resources.[70] Grampp argues for the abolition of public-sector arts subsidies altogether, and Velthuis calls him the most outspoken proponent of "Nothing But" theorizations of the art economy, which posit that the art world's structure mirrors that of other economic sectors (that it is *nothing but* an ordinary business system) and that the manners in which art market players interact are essentially meaningless—the law of price, alone, rules.[71]

Suffice it to say, the neoclassical model is hardly popular with those who believe that prices do not fully reflect the range of values—metaphysical, aesthetic, philosophical—that art making connotes. Even more relevant for us is that it does not adequately account for some softer variables that also determine the values and uses of art: the neoclassical perspective is not altogether incorrect, but it must be expanded to account for a full range of factors that motivate participation in the art market. Sociologist Pierre Bourdieu advances this discussion through the integration of what he calls "symbolic capital":

> Alongside the pursuit of "economic" profit, which treats the cultural goods business as a business like any other, … there is also room for the accumulation of symbolic capital. "Symbolic capital" is to be

understood as economic or political capital that is disavowed, misrecognized and thereby recognized, hence legitimate, a "credit" which, under certain conditions, and always in the long run, guarantees "economic" profits.[72]

In other words, while some art market players may see art only as a means of financial enrichment, Bourdieu also accounts for those willing, for the sake of reputation or status-building, to forgo profits for the accrual of long-term symbolic and economic dividends. Unlike stock market investors, then, who we may assume seek financial gain above all else, this implies that the art market more accurately comprises what we might call "socioeconomic maximizers" for whom economic dividends are only one of many motivating factors.[73]

Bourdieu's ideas are not without their problems, and many of the black-and-white polarities advanced in his writing are rooted in an antiquated theorization of the avant-garde that has been ruptured with the onset of postmodernity, especially the lowering of boundaries between high and low culture.[74] The continued valence of his model in light of today's collectors-cum-speculators (as opposed to Bourdieu's envisioned fine art connoisseurs) is certainly questionable in this regard, as is his straightforward equation for how symbolic capital can be churned into economic capital; the art world is seldom as deterministic as he lets on.

Limitations aside, Bourdieu's general theory has many relevant applications. Perhaps its most obvious usage is to distinguish between "commercial" and "genuine" players: high street art dealers who operate as "Nothing But" ordinary businesspeople versus elite dealers who are characterized by a "Hostile Worlds" view of the art market in which capitalist interests are seen as corrosive.[75] This distinction is integral to the discussions that follow as it provides a more nuanced understanding of how investments in the art market are made. At one extreme, we have art investment funds whose raison d'être is to turn a trading profit: they buy and sell art to generate economic capital alone. At the opposite end of the spectrum, we have a wide spectrum of actors who may seek to make money through art but who may also sacrifice short-term capital gains in order to build credibility within the art community: they seek economic and symbolic capital. Between these poles, we find the ranks of trophy hunters and status seekers who pay top dollar, and even willingly overpay, to acquire the social prestige that comes with being recognizable, leading collectors.[76] All of these players are "invested" in the art market, but their mode of operation and objectives can diverge greatly.

A further extension of this corresponds to the division between art dealers' front-room and backroom business—the work they present to the public and that which they sell behind closed doors. This dichotomy

is second nature to many of those who work (at least successfully) in the commercial art trade, yet it remains poorly understood in the literature and mainstream press—most likely as a result of the opaque nature of the art business. In his study of contemporary art galleries in Amsterdam and New York, Velthuis argues that galleries' front-room activity is essentially break-even and associated with symbolic investments in the promotion of living artists' careers; backroom dealings, on the other hand, are more explicitly commercial and are often focused on the more liquid second-ary, or resale, trade. In fact, he finds that secondary market sales comprise roughly 25 to 60 percent these galleries' earnings—often strategically using secondary market sales either to finance the "promotion of more innovative, experimental art" or to "provide a cultural and historic con-text for the artists that the gallery represents on the primary market."[77]

This is extremely relevant for our discussion, and we will see in the ensuing chapters how dealers utilize their promotion of cutting-edge practices like video or experiential art as a loss-leader. Their commitment to this type of art may enhance credibility, but *real* money is made out of public view on sales of more conventional goods (prints, photographs, paintings). Dealers' adeptness at gaming the market in this way is one of the hallmark developments since the 1960s, and we will look at some of the main strategies they have deployed to generate income streams from—and build symbolic credibility around—practices that may other-wise appear resistant to commercialization. Similarly, the escalating eco-nomic significance of contemporary art fairs during this period is due not only to their utility at selling new work to targeted global audiences, but also to their creation of a more liquid secondary market.

A final point to be made about economic value in the art market is that it extends both to ownership of tangible art objects and to the wider set of rights governing the reproduction of artworks as images (copyright) or their use in derivative form (e.g., the generation of other works or mer-chandise based on the original). Intellectual property scholar Jaime Sta-pleton calls this the artwork's "doubled domain" of property and situates the emergence of this distinction in the nineteenth century with the then growing circulation of art images in printed matter. Its relevance has sky-rocketed lately as dematerialized art has entered the market and as art-ists and art institutions present content online.[78] This reorients our focus from, as Stapleton observes, the "object an artist makes" to "what kind(s) of property" are associated with this act of production.[79] In other words, although the sale of durable goods is elemental to the functioning of the art market, it is also imperative for us to understand how claims to such property are managed.[80] The professionalization of the art world that frames our enquiry can be encapsulated in the multiple commercial forms that works like video art have come to encompass: they exist at once as

sets of property rights (governing the circulation of analog or digital content) and as works in embedded form (through their presentation as three-dimensional video sculptures or immersive video installations); they may be freely distributed on the Internet but may also be sold as editioned fine art objects.

The contemporary art market is not unique in distributing products as such, but its high prices and opaque processes make it especially fascinating. Perhaps the most important implication of this is the realization that "the crucial question is not *if* artworks are commodified, but instead *how* commodification takes place."[81] Such a position doubles as a succinct guideline for this book, which grapples with how the contemporary art market works not merely in theory, but in practice.

Outline

Our journey begins in chapter 1 with an investigation of the emergence of video art during the 1960s and the factors that have enabled its market accommodation. I look at the video art economy not as a monolithic identity composed solely of moving-image content, but as an umbrella system encompassing video stills, production photographs, props, and other ancillary goods. The central argument is that the passage of video art into the market is not an autonomous historical process, but emblematic of the professionalization of the contemporary art economy over the past half century, manifest here in the artificial restricting of supply (through limited editioning) and the increasingly strategic selling of related ephemera. In conclusion, I look at the impact that digital video technologies and the circulation of video art on the Internet is having on this landscape.

Chapter 2 examines how an economic infrastructure has arisen for experiential artworks: such pieces, which hark back to the advent of 1960s conceptual art, may comprise installations, performances, events, or all the above and are often *completed* by their audiences. This chapter identifies how a market has been created for such activity and what collectors veritably acquire when purchasing these artworks, drawing upon intellectual property law and Actor-Network-Theory. Emphasis is placed on the Conceptualist precedent and the legalistic accords that governed, and continue to characterize, this type of production. Discussion then widens onto the market mechanisms of diverse contemporary experiential artists beginning in the 1990s as associated with discourse on services-based art and relational aesthetics.[82] The latter portion of this chapter broadens debate even further by drawing a link between these practices and how experiences have come to frame transactions within the global

contemporary art market. The accentuation of an "experience economy" serves as a backdrop for reflections on the lifestyle marketing of contemporary art consumption and the economic function of contemporary art fairs.[83] I consider the implications of these event-driven developments upon the structure of the contemporary art economy, at large, and for the trade in experiential artworks, in particular.

In chapter 3 I shift the locus of debate to art investment funds. Here I assess the onset of these businesses during the 1970s, followed by an up-to-date overview of the structure of this industry. Discussion of finance theory, global investment trends, and the burgeoning field of economic literature about the benefits and risks of art investing is undertaken. Consideration is given to the vision of these funds, to the steep financial and cultural challenges they face and also their relationship to other concurrent developments in the art economy. Crucial points of debate concern their ability to make money in practice and to differentiate themselves from existing players in the market.

The goal of this chapter is twofold: first, to lay the foundations for a sophisticated understanding of the evolution of art investing to date; and second, by its inclusion in this book, to ensure that this history is read through other contemporaneous changes in the art market during the period of discussion. Art funds are often seen as outliers, bearing little resemblance to more conventional dealers and auction houses. This may be true to a degree, but now more than ever it is imperative to view them not as a singular phenomenon but as part and parcel of the significant structural changes that have taken place within the art business in recent years.

To conclude, I look at the impact of the global financial crisis on the contemporary art economy. During the latest bubble a widespread belief circulated that the growth in the market was sustainable. Even at the first signs of the economic meltdown in 2007 and 2008, many maintained that the contemporary art economy was somehow recession-proof—that this time would be "different." Such optimism was put painfully into perspective shortly thereafter as sales dropped and most sectors of the art world experienced major layoffs and closures, along with the tightening of corporate arts sponsorship purses and the scaling back of grants by the trusts and foundations whose money is so vital to the livelihood of artists, curators, scholars, and arts institutions. I return to these developments as they happened and consider what tomorrow's art market might look like. Through such lines of enquiry I seek to come full circle with the value-added paradigm: to fully comprehend the great changes that have recently been wrought on the art market, we must also look ahead to other challenges on the horizon.

..

Video Art

> Artists have frequently viewed their activity as the produc-
> tion of meaning—often disruptive meaning—rather than
> as the production of objects per se. But commodification,
> the fetishization of the corpse of art (and often of the per-
> sona of the artist), eventually outruns all art forms, from
> Dada provocations to medical photography, and in this
> decade it has caught up with video, as video installation—
> a fittingly housebroken museum form for the "electronic
> age."
>
> —Martha Rosler, 1997

In 2002–03 an exhibition of Matthew Barney's *Cremaster Cycle* (1994–
2002) toured the Ludwig Museum, Cologne, and ARC/Musée d'Art
Moderne de la Ville de Paris before culminating at Manhattan's Guggen-
heim Museum. At each venue, the show encompassed the *Cycle*'s five
videos—*Cremaster 4* (1994), followed by numbers *1* (1995), *5* (1997), *2*
(1999), and *3* (2002)—and an abundance of sculptures, photographs, and
ephemera. Central to the project's conceptual vision, the videos and accom-
panying items were installed ensemble, creating an immersive navigable
environment, which some likened to a Wagnerian *Gesamtkunstwerk*—a
"total artwork."[1] In 1999 *New York Times* critic Michael Kimmelman
had famously hailed Barney as "the artist of his generation," and this show
cemented his position as one of the most coveted living artists.[2] After
more than a decade of spiraling renown, the traveling exhibition exposed
the artist to a wider public than ever before: over 300,000 spectators

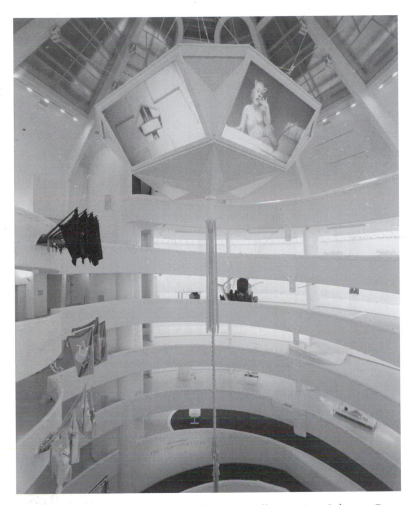

2. Matthew Barney *The Cremaster Cycle*. Installation view, Solomon R. Guggenheim Museum, New York, 2003. (Photo: David Heald. Courtesy Gladstone Gallery, New York, © The Solomon R. Guggenheim Foundation, New York)

visited the show in New York alone, and the Guggenheim brand represented a stamp of institutional approval. Few could deny the density of Barney's output, and the publication of a five-hundred-page exhibition catalogue contextualizing the project's biological lure further laid claim to his art-historical import.[3]

Barney's auction record speaks volumes about this ascent. Although he had gained prominence in the art world by the early 1990s, between

1995 (the year of his first auction sale) and 2001 only 23 of his works were hammered down at auction. But since 2002, in the wake of the *Cremaster Cycle's* trination exhibition tour, over 160 additional works have been sold, nearly 50 of which above $100,000.[4] Barney is today one of the most sought-after contemporary artists, and editions of *Cremaster 2* and *Cremaster 4* are among the most expensive video artworks ever sold, at $571,000 and $387,500, respectively. (See appendix A for a list of the record prices for video art at auction.)

While it is far from unusual for a living artist to enjoy such status, the noteworthy difference in this case is that the moving-image work, installations, photographs, and performances that are synonymous with Barney's practice have until recently been isolated from the art market spotlight. This chapter historicizes this development and examines how economic and symbolic values are generated for video art. The discussion corresponds to this book's overarching thesis on the rise of strategic economical thinking in the art market, from ambivalence over the financial, and even art-historical, relevance of alternative art forms during the 1960s to their increasing institutionalization and key roles within the commercial sector today. Though particular to video art, the arguments in this chapter are intended to reflect similar changes across various reproducible artistic media.

Before I begin, two red herrings should be briefly addressed. First, the marketization of video art is not part of a deterministic metanarrative in which the commercial success of video artists is in any way preordained or following a single, linear path. Instead, this is a phenomenon that evolved sporadically and slowly overcame a number of challenges in order to shape viable economic models that its makers, sellers, and buyers could all accommodate (this remains an ongoing process). Related to this, it is important not to overemphasize the role of the market in shaping video art's evolution. While my focus is with how this economy has taken shape since the 1960s, I do not propose that bottom-line concerns outweigh other fundamental issues relating to the making, curating, exhibiting, and reception of such practices. My main concern is both to contribute to a critical understanding of video art in the broader sense and to set this in play with other key developments in the recent art market.

Second, the term "video art" is misleading. Literally meaning "I see" in Latin, video refers to a mode of production that records images and sound onto magnetic tape, rather than capturing these onto celluloid film and storing them on a reel, as in film technology. Developed in the early 1950s, video was initially visually inferior to the quality of film-based recordings, but continuous improvements in the technology mean that it has become increasingly difficult to visually distinguish between productions. In recent years, digital technology has overtaken both the film reel

and the magnetic tape, converting recorded objects into pixel values that, in turn, are composed of an immaterial, binary digital code. Together with the advanced capabilities of computer editing that have followed in the wake of these techniques, the distinctions between video and film technology have only historical significance.

There is today a very thin and porous line between video art and practices involving film, sound, and slide-projection—even performance. Many artists work seamlessly across these media, and similar guidelines tend to be applied to their conservation. The manners in which these works are sold (usually in limited editions with accompanying ancillary goods) also share much in common, and leading art institutions increasingly refer to all of these practices under the wider term "time-based media art" in order to minimize confusion. This book nevertheless sticks to the term "video art"—not because it disputes the relevance of broader categorizations, but because it serves as a suitable reference to the historical beginnings of the phenomenon, when video was clearly distinguishable from film, and eases discussion of its place in art market discourse, which continuously and pervasively applies this term.

• • •

I commence my narrative by returning to the origins of video art in the 1960s. Early practitioners' objectives and their efforts to supplant and enhance traditional broadcast television are of particular interest. I then assess early sales conventions before evaluating the gradual institutionalization of video art in the 1980s and 1990s, looking in particular at how this was supported by technological improvements, the rise of the Internet, the integration of video art into the core of contemporary artistic practice, and ultimately its widespread acceptance in exhibitions and museum collections.

Against this historical context, we can more adequately assess the resurgent marketization of video art. As we will see, the art market crash of 1990–92 provided a conduit through which alternative practices (including, but not limited to, video) enhanced their institutional footing, gained elevated support from private collectors, and enjoyed increasing relevance within the marketplace more generally. Telltale signs for video art included its strategic parceling into both immaterial and material forms (VHS cassettes and DVD recordings alongside three-dimensional video sculptures and installations); shrinking edition sizes; the proliferation of ancillary collectibles; and its seamless figuration as a lifestyle commodity. I conclude by weighing the consequences of video art's marketization and the opportunities and paradoxes that accompany its expansion across the Internet and into new retail circuits.

Paradox

The emergence of video art must above all be understood as a constellation of a wide range of influences, artistic and otherwise. Chronologies are indelibly linked to the 1965 release of Sony's Portapak, the first consumer video recording device available in the United States. Prior to this, professional moving-image work tended to be shot on 16mm film, with domestic use usually limited to 8mm or Super8 film. Although these provided sufficient image resolution, they were logistically burdensome. Loading film was intricate, accidental exposure risky, and time delays between shooting and film development unavoidable (one week was common). It is easy to imagine the appeal of magnetic video imaging technology with instantaneous feedback.

The Portapak promised just such feasibilities, though the practical benefits of Sony's inaugural offering, the CV-2000, were not robust. Consisting of a small mobile camera and a half-inch black-and-white videotape recorder (VTR), the earliest Portapaks were heavy and could accommodate nothing larger than twenty-minute tapes.[5] They were not cheap either, but at approximately $2,000 when combined with a small monitor and microphone, the unit was a fraction of the cost of prevailing television industry equipment.[6] Incremental modifications led, by the mid-1970s, to Sony releasing the Betamax cartridge and JVC the Video Home System, or VHS. Both formats accommodated half-inch tapes, facilitated up to two hours of recorded content, and could be inserted into cameras and playback apparatuses.

Yet the cultural significance of portable video technologies was a factor of neither affordability, user-friendliness, nor technical sophistication alone, but of the ethos of access and self-determinacy these products embodied. Up to then, televisual tools, like those of the radio industry even earlier, were run by corporations and governments offering prepackaged information in a monodirectional supply. Consumers could acquire the rights to receive content (on television sets) but had marginal ability to modify, let alone create or distribute, it.[7] The "half-inch revolution" changed that.

Video art's chronology, however, is not as linear as this path would suggest. It is important to realize that many of the artistic ideas and interests that the Portapak accommodated had been initiated decades prior to its release. The Italian Futurist Filippo Tommaso Marinetti published his manifesto, "Il teatro futuristo aeroradiotelevisivo," in 1931, promoting the notion of a "total theater" (*teatro totale*) comprised of large television screens—an early pointer. Other pre-1965 examples include Lucio Fontana's "Television Manifesto of the Spatial Movement" from 1952, and Fluxus cofounder Wolf Vostell's intermedia actions and famous television

dé-collage performances, which he began in 1959 together with Nam June Paik.[8] Paik's earliest "manipulated TVs" debuted at Galerie Parnass in Wuppertal, Germany, in 1963.

Paik is often mythologized as having been the first person to purchase a Portapak in America, acquiring one on the day of its release (October 4, 1965) and using it to record Pope Paul VI's motorcade through Manhattan that very afternoon (screening it to friends in the evening). In many accounts of video art, this story is presented as the beginning of a linear cause-effect chronology: video's prehistory (Futurism, Fluxus, performance art, commodity critique) segues into its watershed moment (Sony's Portapak), which once and for all liberates artists from prior constraints and gives birth to a new art form.

Video art's de facto emergence is a lot more complex, and we need to bear a few facts in mind before proceeding with an analysis of its early market history. First, as Martha Rosler points out in her seminal essay "Video: Shedding the Utopian Moment," video's relationship with "corporate TV" and other broadcast mechanisms is trivialized in the above accounts. If we uncritically accept that Paik freed "video from the domination of corporate TV" and allowed it "to go on to other things," we risk overlooking the multiplicity of engagements simultaneously at play and naively conclude that video was always destined to become a formal artistic medium.[9]

Second, to define the crystallization of video art through Paik is to turn a blind eye to the fact that his own "artistic" predisposition was in fact alien to the objectives of many early practitioners. Between the artists who began to use video in the 1960s, including Bruce Nauman, Vito Acconci, Lynda Benglis, Bill Viola, Peter Campus, Les Levine, Ira Schneider, Frank Gillette, and Steina and Woody Vasulka, some tested its technological capabilities of feedback and resolution, some focused on its impact on language, meaning, and mediation, while others simply saw it as a means with which to capture performances or passing interests of the moment. Counterbalancing and complementing this, yet others, including feminists, activists, and collaborative groups such as Rosler herself, Jon Alpert, Top Value Television (TVTV), and Raindance Corporation, were motivated to experiment with video's documentary potential, to expand its broadcast supports, and to assert its political agency.[10] Indeed, those who fell into this latter group did not necessarily see either video technology or their use of it in artistic terms.

Staging Paik as the father of video art moreover risks underestimating the influence of avant-garde film at this early stage on the formation of the practice. Pioneers like Stan Brakhage, Michael Snow, Jack Smith, and Andy Warhol were all working energetically in the 1960s, and their development of underground cinema cannot be cleanly disentangled from

the landmark progress being made with video (and, indeed, Warhol made use of video technology as early as 1965, which he shot on a Norelco camera that was lent to him for promotional purposes). Furthermore, Pop Art reveals a third, and altogether more playful, set of influences within this early evolution that drew inspiration from a mixture of consumerism, psychedelia, and humor and would feed directly into the development of work by video practitioners such as William Wegman.

Yet however intricate and differentiated the emergence of video art is, one thing is certain: conspicuously absent from this sundry heritage is the role of the market. This is far from incidental. Many early video practitioners were either ambivalent or antagonistic to the market's espousal of singularity and objecthood. Process was prioritized to product, collectability dismissed as antiquarian (or, for Marxists, bourgeois), and impermanence championed as a vital condition of the medium.

The crystallization of a new practice or product is often surrounded by a utopian disregard for opulence and an activist rejection of the impurity that monetary concerns bring, and many histories of video art center on just this reaction. But even on this stance we do not find consistency. Marita Sturken disagrees with how "most of the video collectives have been historicized as zany, anti-Establishment groups with mutually supportive and egalitarian structures." In fact, Raindance Corporation was conceived as a "think tank" (its name coined by Gillette as a takeoff on corporate R&D and the RAND Corporation) and began as a profit-making business. And she also points out that documentary troupes such as TVTV "eventually lost [their] impact when confronting the potentially more seductive subject matter of the entertainment industry [in the 1970s]," enticed by the superior production and postproduction facilities of commercial media ventures.[11]

Similarly, while leaning toward Fluxus's championing of nonobjectivity and impermanence, Paik increasingly generated numerous permanent artworks. Pieces such as his *TV Chairs*, *Magnet TVs*, and *Robot TVs* (1965–67) soon fell under the aegis of "video sculpture," a flexible term used to describe works in which the television monitor not only relayed content, but also served as a three-dimensional art object in its own right.[12] So defined, video sculpture indexed television's social functions, especially its integration into domestic household life, and raised phenomenological issues of the physical relationship between spectator and object that were also gaining traction in Conceptual, Minimalist, and installation-based practices during this period. Several such works entered museum and private collections in the 1970s.

There are other incongruities, too. The fact that it is difficult to gain an overview of issues pertaining to the early history of video art's production, distribution, funding, or conceptual orientation is, Sturken argues,

part of the "paradox of video" itself, in which "art" constituted only one trajectory:

> What emerged from this complex set of events was not a medium with a clear set of aesthetic properties and cleanly delineated theoretical concepts. Instead, one sees paradox, the paradox of video's apparent merging of (hence its negation of) certain cultural oppositions—art and technology, television and art, art and issues of social change, collectives and individual artists, the art establishment and content. These paradoxes are at the root of video's problematic relationship to both history and modernism.[13]

Such paradoxes also riddled, and continue to problematize, video's relationship to the market, to which we shall now turn in much more detail.

Early Market History

Early support for video art was typically neither museum- nor gallery-led, but undertaken by not-for-profit foundations, public subsidy, and television stations.

In Britain, broadcast support for artists' video commenced with sporadic BBC2 features in 1970 and a series of shorts (entitled *TV Pieces*) created by David Hall for Scottish TV in 1971.[14] Formal funding appeared in 1972 through the Arts Council Artists Film and Video Sub-Committee.[15] This was complemented by financial support from the British Film Institute beginning in the late 1960s, the inauguration of London Video Arts in 1976, and other institutions such as the Film and Video Umbrella (established 1984) and Channel 4, which started arts programming in earnest in 1985.

In the United States, the Rockefeller Foundation commenced its video funding program in 1965 and quickly evolved into one of the most influential supporters of media art. This was paralleled by support from the New York State Council on the Arts, which commenced its video funding in 1970, and the National Endowment for the Arts (NEA), which initiated its Public Media Program, later the Media Arts Program, in 1971.[16] The Corporation for Public Broadcasting was established in 1967, the Public Broadcasting Service emerged in 1969, and ambitious network ventures were launched as well. Boston's WGBH founded the country's first network-affiliated artist-in-residence program in 1967 (working extensively with Paik from 1970), and experimental television labs at KQED in San Francisco and WNET in New York were also inaugurated during this period.[17]

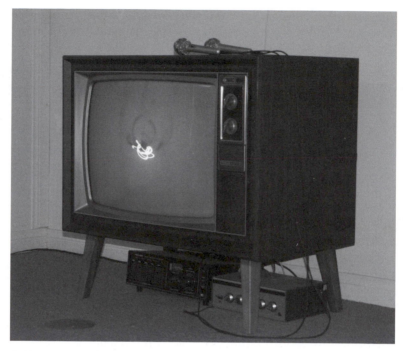

3. Nam June Paik, *Participation TV*, 1963 (pictured version 1969). Color television, two microphones, amplifiers. (Photo: Anne Niemetz. Courtesy David Bermant Foundation, © The Estate of Nam June Paik)

The first widely documented sales of video art in the United States occurred in 1969. New York gallerist Howard Wise brokered a deal for Paik's *Participation TV* (1963) with American collector David Bermant; and Nicholas Wilder, a Los Angeles gallerist, placed a compilation of Nauman's single-channel videos, dating from the late 1960s, with a private European collector.[18] But early sales of video work were modest, and neither Nauman nor Paik had a broad foundation of collectors for this aspect of their production.[19] In fact, Wise, who had represented kinetic and electronically based artists since the late 1950s and whose 1969 exhibition TV as a Creative Medium is hailed as the first landmark show of video art in the United States, closed his gallery in 1971, frustrated by the bleak financial prospects of such practices and by the inherent limitations of producing and exhibiting them in the commercial gallery context.[20] Wise subsequently founded the not-for-profit media facility Electronic Arts Intermix (EAI) during the same year. EAI added editing and postproduction facilities in 1972 and its Artist Video Distribution Service a year later; it remains one of largest video art archives in existence today.[21]

4. Bruce Nauman, *Stamping in the Studio*, 1968. Video still. (Courtesy Sperone Westwater, New York, © 2011 Bruce Nauman / Artists Rights Society [ARS], New York)

Another noteworthy effort to extend video into the market was the founding of Castelli-Sonnabend Videotapes and Films (CSVF) in 1972 by gallerists Leo Castelli, Nauman's dealer, and Ileana Sonnabend. Directed by Joyce Nereaux and Patricia Brundage, CSVF aimed to become the distribution arm of this joint venture. Its model was to offer videotapes and films both for rental and for sale, and its first inventory catalogue of 1974 listed works by thirty-one artists, including Acconci, Nauman, Benglis, John Baldessari, Joan Jonas, and Richard Serra. Video and film rentals were priced from $15 to $150 and sales from $40 to $1,000, with most at the lower end of these two ranges. Notably, CSVF sold the bulk of this material in unlimited quantities, with only a small selection of the videos (but not films) offered in limited editions of twenty at $1,000 each. Acconci's video, *Home Movies* (1973), could be rented for $50 and bought, in edition, for $1,000, and Serra's film, *Color Aid* (1970–71), could be rented for $75 and purchased for $350.[22]

Although these prices appear modest in comparison to the six-figure sums that video art has recently begun to command, they were not altogether insignificant given the technological limitations of the time and the fact that the tapes were uneditioned. Furthermore, the $1,000 limited

editions translate to approximately $4,000 today. This puts them on par with entry-level pricing for such work now, yet with the caveat that editions currently sell in far smaller quantities—usually in series of five or six. Given that there was no precedent for selling this type of work and that the art world was still coming to terms with video art's critical relevance, it is perhaps unsurprising that CSVF struggled to generate demand for this material and that the venture was ultimately abandoned in 1985.[23]

Gerry Schum occupies a pivotal role in video art's early dissemination in Europe. Schum had studied film and television in Berlin and Munich and worked interchangeably as a film-maker, curator, and gallerist. In 1967 he produced the 16mm short, *Schaustücke—Ereignisse*, and two other documentaries, 6. *Kunst-Biennale San Marino* and *Konsumkunst—Kunstkonsum*, which were distributed on Sender Freies Berlin (SFB), a public radio and television service. The following year Schum approached this broadcast station to realize his "Fernsehgalerie Berlin" (Berlin Television Gallery).

The Television Gallery was similar in spirit to American television network ventures, but Schum's focus was on art distribution, not research and development. It also had a political agenda: broadcasts were intended to address a "mass public" and to "destroy" the "traditional triangle of studio, gallery and collector."[24] On 28 March 1969 the Gallery presented its first televisual exhibition on SFB with *Land Art*, a 35-minute survey of work by Marinus Boezem, Walter De Maria, Jan Dibbets, Michael Heizer, Barry Flanagan, Richard Long, Dennis Oppenheim, and Robert Smithson. The video was acclaimed for bringing together a young and relatively oblique grouping of artists and has subsequently been credited with formalizing the term "land art" as a marker of the extragallery tendencies that were then gaining notoriety. The second, and last, televisual exhibition, *Identifications*, was aired on 30 November 1970.

Schum's enterprise took a sharp and contradictory reversal at this juncture. Following *Identifications*, a sequel to *Land Art* that presented the work of twenty artists in short back-to-back segments, networks relinquished their support for his program and he began to sell work through the very commercial channels he had formerly resisted. To do so, he took extracts of *Identifications* by Joseph Beuys, Gino de Dominicis, Gilbert & George, Mario Merz, Ulrich Rückriem, and Reiner Ruthenbeck and produced editions in 16mm and video formats, accompanied by signed certificates of authenticity. Beuys' *Filz-TV* thus sold in a limited edition of six for DM 9,800 (approximately $3,700 at the time), and all pieces associated with *Identifications* were available in unlimited editions at DM 1,500 and could be rented for DM 300. Shortly thereafter, a standard of approximately DM 1,000 was established for museum purchases of unlimited editions, with no lending rights.[25]

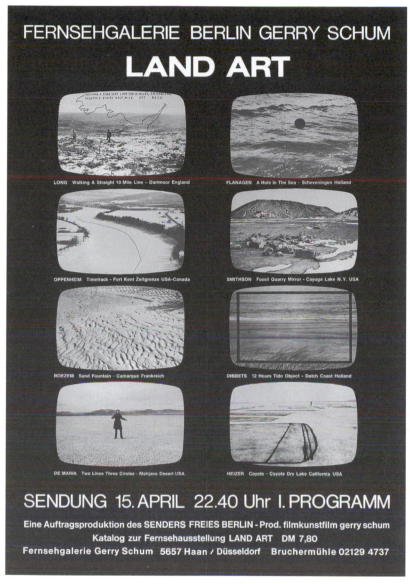

5. Poster announcing the transmission of the television exhibition *Land Art* by Fernsehgalerie Gerry Schum, 1969. (© Ursula Wevers, Cologne)

By the end of 1970 Schum abandoned film altogether, and over the course of 1971 he and his collaborator, Ursula Wevers, produced videos by Dibbets, Rückriem, Baldessari, Daniel Buren, and Lawrence Weiner. Most significantly, he founded the Videogalerie Schum in Düsseldorf that October, the first commercial gallery dedicated exclusively to video art. The venture was heralded within the art community and included in the Venice Biennale and Documenta V, both in 1972. Despite such recognition, Schum resolved in November to close the gallery by year's end due to poor sales, and just a few months after this, in March 1973, he tragically took his own life.[26]

A number of personal factors contributed to this suicide and it would be inappropriate to speculate on the extent to which they were financially motivated. Nevertheless, retrospective accounts by Schum's former friends and colleagues indicate that money was certainly a factor, and in particular that he was growing increasingly frustrated with high production costs and limited sales outlets.[27] Such difficulties corresponded to those of CSVF in the United States and of other European galleries during this period as well. Art/Tapes/22, Maria Gloria Bicocchi's Florentine gallery that opened in 1972 and staunchly promoted video editions, closed in 1977; Ingrid Oppenheim's gallery/video-film production studio, which opened in Cologne in 1973, followed by a branch in Brussels that same year, shut in 1980.[28]

The sporadic evolution of museum video art collections reflects many of the challenges that were also present in the commercial sector at this time. Here, however, the critical questions concerned what video art collections would constitute and how they were to be constructed.[29] One basic issue was how to administer video purchases—as with moving-image work like film, or as object-based practices like painting or sculpture? Others included how to address video's oppositional thrust and its constitution as an information-based art. For instance, because of technological limitations, video projection was not widely feasible in the early period, and its presentation long remained tied to the television monitor. This proved a constant grievance—the invariable fact that video exhibitions in museums were bound to a formalist genealogy of passive spectatorship evoked, as Rosler has put it, a "distinctly modernist concern with the 'essentials of the medium.' "[30]

The Everson Museum, Syracuse, which in 1971 established the first museum department dedicated to video art, offers an illustrative case in point. Its then curator, David Ross, argued that because video, "like much conceptual performance work, is essentially uncollectible, its patrons must focus on the sponsorship of inquisitive rather than acquisitive activity."[31] The Everson evolved into one of the country's leading centers for video programming during Ross's tenure of 1971–74 and staged impor-

tant solo shows of Paik (1972) and Gillette (1973), among others. Yet however uncollectable Ross found video art, the Everson nevertheless began acquiring it during his employment, as did the Long Beach Museum of Art (LBMA), where Ross next worked, in 1974.[32] Elsewhere, the Neuer Berliner Kunstverein inaugurated the first institutional video collection in 1972, London's Tate Gallery commenced its video art acquisitions in 1972 as well, and MoMA, New York, did so in 1975.

Despite these noteworthy advances, the complexity of issues surrounding video collecting, not to mention the conservatism of many museum officials, meant that most institutions shied from collecting video at all during this period and adhered instead to more flexible, and temporary, video exhibition programs.[33] This enabled them to sporadically evaluate the field, but also to shelter themselves from protracted engagement with a medium whose art-historical import and conservation standards remained unclear.

• • •

A major factor contributing to these initial commercial difficulties was video art's technical, contrived status. Many artists were drawn to video not because of its formal, aesthetic capabilities, but because it enabled them to capture and experiment with live events and performance. This mediation role took some getting used to for collectors and institutions biased toward more conventional means of expression, and particularly so as the transmission was typically far from perfect: even if artists produced high-quality color tapes, these gains were usually lost on collectors due to the poor resolution of television sets at the time. In addition, early editing limitations were crudely visible and further hampered the aesthetic attractiveness of the new medium. Unlike film, which can be physically cut and pasted by hand, video editing is executed electronically by assembling image sequences from one, or several, sources onto the tape of a second machine. But the half-inch equipment available to artists was not designed to accommodate the necessary synchronization for so doing, meaning that the desired alignment of frame was a matter of accident, not acumen.[34] Costs were also prohibitive: even modest increases in editing capacity on Portapaks corresponded to orders of magnitude in terms of price.

Degradation presented yet another challenge. Every time a videotape is played, magnetic heads on a playback machine rotate across the tape's surface, scuffing it and physically diminishing resolution quality—as also occurs when tapes are copied. Furthermore, the magnetism of tapes is sensitive to temperature and humidity: incidental exposure to excessive heat or moisture demagnetisezs and destroys them. Conservators estimate that VHS tapes have shelf lives of approximately one decade.[35]

It quickly became evident that machine obsolescence and divergent technological standards further compounded these issues. Industry competition catering simultaneously to professional and retail demands meant that these features were consistently parlayed off one another and that a diversity of video playback supports flourished.[36] This necessitated judicious planning on behalf of collectors to stockpile video playback devices and their accompanying audio/visual apparatuses to mitigate against obsolescence risk, yet this was typically a process of trial and error rather than a priori strategizing.[37]

All of these factors underscore the most salient economic issue—that video content is both intangible and reproducible and therefore at odds with the market's cherishing of unique, durable art goods. While tangible material entered transactions as videotapes and playback equipment, these possessed no intrinsic economic value per se outside of their utility in presenting the underlying magnetic content (information). One strategy to combat this was for artists to sign videotapes so as to legitimize them. But while this offered authenticity, it contradicted the fundamental fact that the information these tapes stored was the real locus of value.

Further complicating matters was the absence of generally accepted standards for regulating the circulation of videos in the commercial market as dealers had not yet adopted the limited editioning policies that were in place for sculpture, prints, and other art multiples. Until a suitable economic model was developed to deal with this, collector demand and the prices paid for video works remained low and museums only tepidly purchased them. The rising prevalence of video sculpture and video installation in the 1980s, the artificial restriction of these formats to limited editions, and improvements in recording, playback, and preservation standards ultimately enabled just such a market to form and for prestige values to be associated with it.

Institutionalization

The 1980s

The 1980s marked a number of important developments for video art that helped to further establish its place in the art world and set the stage for its integration in the market. First and most notably, growing numbers of artists and institutions were taking an active interest in the technology. The Whitney's 1982 Paik retrospective was evocative of this, constituting the first solo show of its kind for a video artist at a major museum. This was followed by a series of major international exhibitions on Bill Viola, including his 1985 show at the Moderna Museet in Stock-

holm and culminating in his 1987 MoMA retrospective. And several important group exhibitions helped to further strengthen the impact of the new medium, including Luminous Image (1984) at Amsterdam's Stedelijk Museum and Video Sculpture in Retrospect and Today: 1963–1989 (1989) at Cologne's Dumont Kunsthalle.

Noninstitutional events also contributed to the consolidation of the practice. The launch of MTV in 1981 is particularly important. Most significant was that its immediate and wide-reaching success testified to the power of video imagery and the cult of the music/art celebrity, factors that offer a preliminary glimpse of video art's eventual transformation into a lifestyle commodity by the 1990s.[38] Video lounges in nightclubs also arose in the early 1980s, marking an expansion of earlier underground screening spaces and soon becoming fertile breeding grounds for the development of scratch video and video sampling.[39] Video art festivals, moreover, sprawled widely across this decade. In the United States, the Fourth Annual United States Film and Video Festival (Park City, Utah) expanded to include video for the first time in 1982, while the National Video Festival (Washington, DC) showcased video installations by Ed Emshwiller, Shigeko Kubota, and Viola that same year. Several such initiatives were inaugurated across Europe, culminating at decade's end with the launch of Video Positive: The UK's International Festival of Electronic Arts in Liverpool in 1989.[40]

By this time, video artists were also benefiting from the upsurge in electronic arts more generally and used similar venues to present and discuss the aesthetic possibilities of these new media. One of these was Ars Electronica in Linz, Austria, which was founded in 1979 and instituted its prestigious Prix Ars Electronica in 1987.[41] These assimilations were short-lived, however, and toward the end of the decade video art moved decisively toward the art world, whereas the more overtly technologically orientated practitioners of electronic art remained on the margins.[42]

The main technological advance of the decade for video artists was the laser disc (LD). Released in 1978, this was an improvement from earlier protocols burdened by content degradation and comparatively poor user interoperability. Compared with VHS tapes, LDs offered greater picture resolution, stored both analog and digital content, reduced physical stresses incurred during playback (because of optical scanning by lasers), and handled multiple audio tracks (an advantage for installations that mandated sophisticated audio/visual coordination). Conservator Paul Messier has correspondingly observed that this helped make LDs the most popular video-disc format for professional use during the 1980s, and artists like Viola, Dara Birnbaum, and Gary Hill were quick to adopt the technology.[43]

Video art nevertheless remained in a precarious financial situation.[44] The main reason for this was that it often necessitated spatial dimensions

and viewing conditions (darkness, circuitry) that were neither available nor suitable to the majority of institutions and private collectors. Most had yet to be convinced of its art-historical importance, and lingering doubts about the reliability of the new video technology did not help. In addition, sales contracts lacked the necessary complexity to provide the market with a much-needed peace of mind about how to install, conserve, and manage rights to such work.[45]

One collector who did venture into video art at this time was Count Giuseppe Panza, a prominent client of Castelli's who had built up an impressive collection of postwar art since the 1950s. Yet his video purchases were restricted to a small selection of works by Nauman and Douglas Davis and were inferior in number in comparison to the rest of collection, which comprised upwards of seventy artists and some 2,500 works.[46] During the 1980s many commercial galleries actually abandoned support for video while others lessened its emphasis in their exhibition programs. On the eve of Paik's 1982 retrospective, Castelli captured the prevailing mood of the decade by exclaiming that "Commercially, video art has turned out to be almost totally unprofitable."[47]

Profitable or not, artists continued to experiment with the technology and new advances were made, especially in installation-based work, which was gaining wider critical and institutional recognition.[48] The spatial installation of video components in which materials such as televisions and projection screens are juxtaposed in relation to one another as well as to a total system (the artwork) was in use virtually as soon as artists took to the technology. As artist Francesc Torres notes, precedents include the multimedia installations of the Russian avant-garde and the Dadaists in the early twentieth century, which "provided an existing structure into which video was able to expand (and by so doing, help define)."[49] However, video installations had, up to this moment, been prominent mainly in network-sponsored artist-in-residency programs. They were illiquid goods that had failed to attract any noteworthy interest from the commercial market and were often put down as a "noncommodity" art and an exclusively institutional phenomenon.[50]

One reason for the change in the perception of video installations in the 1980s was borne of their funding structure. Video art continued to draw its main financial support from not-for-profit institutions, governmental organizations, and network television stations, and successful grant-seeking applicants were often pressured to pursue advances in technological research and development in line with these boards' demands. For Sturken, this was manifest in the NYSCA's desire "to veer away from financing community-based, information-oriented works to funding 'video art' by the mid-1970s," and the Rockefeller Foundation's "decision to explore artists' television and to fund postproduction centres."[51] This led

to a fundamental shift in the economics of video production whereby funding bodies with vested interests of their own increasingly supported practitioners from whom they stood to materially benefit. Though some artists resisted or were ambivalent to this trend, many played along, if only, as Rosler reckons, out of a case of "production envy."[52] And as the growth of video practitioners relative to funders increased during the 1980s, a further streamlining of content was increasingly apparent: controversial or difficult material was increasingly phased out and the attraction of new, larger audiences for this work became a priority.[53]

A second, and less deterministic, explanation for the rise of video installations concerns the broader critical/theoretical context of art making during this period. This relates to artists' fundamental attraction to video as an alternative to more conventional object-based practices, providing the opportunity to create a work that unfolds in both time and space (hence, video's subsequent heralding as a time-based medium). This opened new avenues for innovation and experimentation and closely corresponded to other challenges against objecthood and authorship being mounted by conceptual, minimal, postminimal, and performance art dating from the 1960s. Together, these fell broadly under the umbrella of an emergent postmodern, and occasionally dematerialized, artistic practice critical of inherited conventions and eager to expand the field of how art could be made, communicated, and experienced. The particular interest in video installation was borne of artists' earnest desire to advance these terms and to test the boundaries of sculpture itself.

As installation, video could be more easily exhibited, and ultimately collected, as *art*. Or, as Vito Acconci presciently observed in 1984, "Video installation places placelessness ... it is an attempt to stop time.... Video installation returns the TV set to the domain of furniture; the TV set, in the gallery/museum, is surrounded by the sculptural apparatus of the installation."[54] If museums had theretofore only sparsely engaged with single-channel videos, the sculptural and more distinctly exhibition-friendly qualities of video installations made them comparatively more attractive to promote. Indeed, installations promise a spectacle, the experience of having to be there, unrivaled by single-channel content displayed on a monitor or broadcast on television. And because each installation is unique, they gain a prestige quotient similar to paintings that enable monopoly prices to be applied to them.

The 1990s

The 1990s were characterized by a "completely changed concept of video as a work of art."[55] This transition was propelled by technological

improvements, which made video more accessible to a far greater numbers of artists, and also by the more hospitable reception that video art was getting in museums and galleries. The practice transitioned from a somewhat marginalized artistic discipline to a core feature of an increasingly pluralistic contemporary artistic practice. This helped lead to a much-discussed rhetorical shift during the decade from use of the somewhat marginalized term "video artist" to the broader catch-all, "artist working in video," which reflected the fact that fewer artists were working exclusively in video any longer; it had become an accepted and integral mode of expression alongside many others.

1991 was the darkest moment in the art market crash, putting to bed the speculative bubble of the previous decade synonymous with bold neo-Expressionist painting and the overexuberant buying and selling of Impressionist art. Scores of arts businesses downsized, restructured, or closed.[56] In retrospect, one upside to this was that the narrow aesthetic foundations supporting the 1980s art market now gave way to a more experimental ethos. Galleries increasingly began exhibiting video largely because, according to Barbara London, associate curator in MoMA's Department of Film and Video, "they had nothing to lose"; sales had dried up and the opportunity cost of showing video and other alternative practices diminished.[57]

Prominent first-generation video practitioners, including Viola, Birnbaum, and Hill, entered the commercial circuit in the early years of the decade, each enjoying their first-ever solo commercial gallery exhibitions between 1991 and 1993.[58] Video art was also beginning to feature prominently in the work of a younger generation of artists (Matthew Barney is one example), and in the exhibitions of up-and-coming dealers like David Zwirner. Zwirner included video in his inaugural exhibition of 1993, and he closed out his first year with "Sampler": Southern California Video Collection 1970—1993, comprising thirty-five single-channel videos selected by influential Los Angeles artist Paul McCarthy.[59] In total, twenty-six of Zwirner's forty-four exhibitions during the 1990s possessed a video component, while ten were exclusively devoted to the practice.[60]

The photography market, in particular, was quick to respond to the new economic environment, and this had a direct impact on video. Photographs had begun to make their way into museum collections only during the 1970s, having long been sidelined due to issues of reproducibility and discord over their constitution as fine art.[61] The centrality of photography to then prominent Conceptualist practices and improvements in color film processing, however, amplified the scope of artistic and academic engagements with the medium and, in turn, its museological appeal.[62] Auction houses began holding regular photography sales by the mid-1970s, and economist Jeffrey Pompe has found that between 1980

and 1992 photography prices grew at a real annual rate of just over 30 percent.[63]

However, it was only during the 1990s that the values of photographs began to mirror more established practices. Photographers Richard Prince, Andreas Gursky, and Thomas Struth are emblematic of this transition. Their first sales at auction from 1989 to the mid-1990s fetched four- and modest five-digits sums. As the size of their works increased significantly, taking on the proportions of academic painting and thereby reinforcing their status as unique, collectible objects rather than reproducible prints, prices skyrocketed. The effect of this became acutely apparent the following decade. Gursky's $600,000 sale of *Paris, Montparnasse* (1994, 187 × 357 cm) in 2001, the same year as his solo exhibition at MoMA, was then the highest-ever price for a contemporary photographic work, and records have since followed in quick succession. Prince's *Untitled (Cowboy)* (2001–02, 254 × 169 cm), auctioned by Sotheby's for $3.4 million in 2007, is the most expensive photograph sold at auction; closely behind is Gursky's *99 cent II, Diptych* (2001, 206 × 341 cm) at $3.3 million, also sold by Sotheby's in 2007. In total, nearly 2,000 photographs and prints by these three artists have sold at auction, 16 in excess of $1 million and more than 250 above $100,000, significant sums by almost any measure in the art market.[64] That the most expensive of these have almost unilaterally been sold in headline contemporary art auctions, rather than photography-only sales, further cements the medium's "high art" status.

The more widely exhibited and valuable photographs were in the 1990s, the brighter video art's own prospects became. Intrinsic similarities between the mediums—both involving the recording of light—helped this development along. One moving, the other still, they are aesthetically comparable and can be laced together. For example, a flourishing market for video stills and production photographs related to videos developed during the 1990s, providing an important additional revenue stream for such artists. This crucially meant that money could be generated from both the original video artwork and derivative, two-dimensional objects. Gradually this inspired the selling of ever-greater and more diverse kinds of ephemera, often sold in multiples. Lastly, the two practices were also beginning to share a number of nonintrinsic similarities: these included ever-larger physical dimensions (paralleling the shift from single-channel video to video installation), increasingly aestheticized presentational formats, and, as we shall see, artificially limited supply (through editioning).

As is already clear from the discussion above, video increasingly acquired a hybrid nature. The crossover with photography was one manifestation—another concerned the waning differentiation between video and film. Technological improvements in video projection meant that artists by the mid-1990s could mirror the quality and sophistication of film

screenings, and this led to a prolific expansion of immersive video instal-
lations. A younger generation of practitioners began to use this in a way
that mirrored a formerly isolated cinematic aesthetic. Douglas Gordon's
24 Hour Psycho (1993), a painstaking slowdown of Alfred Hitchcock's
classic film, was one such example, as Scream and Scream Again, a 1996
exhibition including work by Gordon, Tony Oursler, Isaac Julien, and
Marijke van Warmerdam at the Museum of Modern Art, Oxford, was
one of the first shows to frame this trend. This development has since
become doctrine in critical writing and exhibition making on the subject,
cumulatively actualizing what Scream curator Chrissie Iles anticipated as
an "unprecedented crossover between the languages of video and film."[65]

Video's hybridization is further established by the fact that many of its
practitioners began entering the art world from other disciplines. Doug
Aitken, for example, was an established music video director and has
continued this work alongside his technically accomplished and visually
slick video installations and photographs. And Isaac Julien was a founding
member of Sankofa Film and Video Collective in the 1980s and gained
cult acclaim with works such as *Looking For Langston* (1989) and *Young
Soul Rebels* (1991). Julien acknowledges that his shift from making
feature-length films to video installations, commencing with *Trussed*
(1996), the two-screen piece that debuted in Scream, derives from a com-
bination of the new technical capabilities of video and the wider range of
opportunities then being afforded for exhibiting and selling this type of
work in galleries and museums. His comments are especially enlightening:

> By the mid-1990s, it was pretty obvious that making experimental
> films became quite difficult as there was no place to show such work.
> But more than that I think it was a question of value because there was
> no value being afforded those artistic experiments and innovations.
> They were being completed degraded and eroded.... Privatization and
> corporatization made it suicidal to conceive of making new image
> work. Plus, the innovation for moving-image work was not in [the
> experimental film] arena any more. The artists had taken the camera,
> it was in the art world that you saw more interesting work.[66]

A further factor that facilitated this transition was the introduction of
DVDs and subsequent phasing out of LDs. Scratching LDs was a risk,
poor production standards meant that some discs decomposed prema-
turely, and, unlike VHS, users could not directly record onto them (this
was limited to professional editing studios). LD players were also expen-
sive, and the technology never gained a strong retail following in either
the United States or Europe. Because LDs could carry analog content,
purists preferred them to the all-digital DVDs, but the point is now moot:
adoption of the DVD format by Hollywood film studios by the late 1990s

precipitated the withdrawal of LDs from retail distribution, and thus from long-standing relevance within the art world.[67]

If LDs were attractive to artists and institutions by enhancing the technical and conservation capabilities of video art, widespread convergence of digital standards on DVDs revolutionized the ease and expediency of exhibiting and distributing this type of work, and of lowering associated costs and expertise.[68] The physical compactness of DVDs and their ever-greater high-definition (HD) capabilities compounded their appeal; more significantly, they were relatively cheap and easy to produce, ship, and insure. This meant that artists and galleries could replace lost or broken exhibition copies at minimal cost and time, making the discs themselves essentially disposable.[69]

Two conferences, "How Durable Is Video Art?" and "Playback 1996," organized sequentially in 1995 and 1996, are regarded as watershed moments in the conservation of video art. Facilitating dialogue among leading video artists, curators, conservators, and technicians, and motioning the need for further resources to be directed toward such research, these conferences had a direct impact on video collecting.[70] Indeed, their engagement with hitherto underappreciated aspects of video conservation proved decisive in museums' warming attitude toward video art acquisitions.

Lastly, we cannot underestimate the rise of the Internet, which completely quashed the attraction of artists to the immediacy, self-determinacy, and distributional reach of video as a technological medium. David Ross was acutely aware of the implications of this seminal development already in 1995: "The astonishingly rapid rise of the World Wide Web as a site for the interaction of artists and audiences has literally changed the ground-rules governing the relationships between artists, audiences and the mediating institutions (like art museums) in such a profound fashion, that the advances of video art already begin to look rather minor in comparison."[71] The adverse effect of this was to intensify the art-historical relevance of video practice. For having been outmoded by the Internet as the utopian medium of the moment, video's earlier challenge to the "hegemony of the art museum ... and its institutions" could now be seen as but a precious antecedent to more recent and far more expansive developments taking place online. This has since served to enhance the museological and economic value of video art and has raised the ownership stakes of moving-image content distributed online.

Museum Collections

One of the most striking illustrations of the advances made by video art during the 1990s is its extension into the permanent collections of leading

international museums. This phenomenon is not wholly distinct to this period. As we have seen, some major institutions like MoMA commenced their video art acquisitions during the early- to mid-1970s, and a great many others also began exhibiting it at around this time.[72] The differences between these two periods are nonetheless profound and are crucial to highlight as a backdrop to video art's ultimate marketization.

The construction of film and video collections at Tate in London and at New York's Whitney Museum of American Art provides an excellent basis for demonstrating the evolution of museum interactions with the practice on both sides of the Atlantic.[73] Tate is one of three museums making up the New Art Trust (which also includes MoMA and the San Francisco Museum of Modern Art), established by collectors Pamela and Richard Kramlich in 1997 to further the presentation and preservation of time-based media works, and it also houses the only museum conservation department worldwide dedicated exclusively to time-based media arts. The Whitney possesses the largest international collection of film and video installations from the 1960s and 1970s.[74]

Tate purchased its first three video works in 1972, all by the British artist-duo Gilbert & George: *A Portrait of the Artists as Young Men* (1970), *In the Bush* (1972), and *Gordon's Makes Us Drunk* (1972). Each tape was originally commissioned by Schum and consisted of a half-inch black-and-white video recording in an edition of 25, ranging between seven and sixteen minutes long; all were accompanied by signed certificates of authenticity.

The acquisitions testify to Schum's pivotal role in consecrating video art's institutional status. Yet Tate's commitment to acquiring editioned single-channel video was short-lived. The museum purchased Dan Graham's film projection *Two Correlated Rotations* (1970–72) the following year, but this was its final such acquisition for more than a decade. The next video purchase was in 1984—Susan Hiller's installation *Belshazzar's Feast, the Writing on Your Wall* (1983–84)—however, this was the sole video or film that entered the permanent collection in the 1980s. By the 1990s the situation began to turn dramatically: from 1993 to 1996 the museum acquired 12 film and video works, followed by 48 between 1997 and 2000. An annual high was reached in 2008, with 42 works acquired, and by the end of the decade the museum's film and video collection had grown to a total of 234 artworks (see appendix B2).

It is no coincidence that this rise in film and video acquisitions mirrors the 1996 appointment of Pip Laurenson as sculpture conservator for electronic media. Prior to this, time-based media were managed by the sculpture conservation department. A significant development in Tate's conservation infrastructure occurred in 1996: an independent team was formed to deal with the more sophisticated aspects of caretaking for "elec-

6. Gilbert & George, *Gordon's Makes Us Drunk*, 1972. Video, 12 minutes. (Courtesy White Cube, © Gilbert & George)

tronic media." In 2005 this group was renamed Time-Based Media Conservation (TBMC) and gained full autonomy as one of seven distinct conservation sections within Tate—and the only one of its kind internationally. Before purchasing new works, TBMC writes a preacquisition condition report that covers costs at acquisition (relating to archiving and display equipment) and flags presentation issues. They collaborate with a copyright officer from the acquisitions team to detail relevant legal issues, and the conservators record interviews with the artists about installation and technological parameters—"good policy," as Laurenson has it.[75]

Coinciding with these developments, Tate took conscientious steps to ensure that it had ample conservation and curatorial capabilities. In 2001 Gregor Muir was appointed Kramlich curator with a focus on media art, and at his departure in 2005, Stuart Comer took over as film curator.

Tate's film and video acquisitions accelerated on the back of these developments, and in 2004 Time Zones, the museum's first exhibition dedicated exclusively to film and video art, was staged. As Laurenson observes, however, "it is important to understand that Tate has mainly focused on video installations, not single-channel works." The aforementioned pieces by Gilbert & George represent some of the only such holdings in the museum's permanent collection. Furthermore, it only possesses *one* work from the 1960s—*Neagu's Boxes* (1969), by Paul Neagu—seventeen from the 1970s, and eight from the 1980s; fully 82 percent of the items in its film and video collection date from 1990 to the present. Laurenson's matter-of-fact detailing of this is telling:

> Curatorially, Tate made some unusual decisions in that it didn't have a media arts department and so has always collected within the mainstream of its broader activities. Acquisition criteria simply states that a

potential purchase represents important art for that period ... but we have never objectively tried to do a history of media arts; time-based media works, in a way, thus gain parity with others in the collection. I think this is an important strategy because it avoids some of the marginalizaton of media arts collections and enables the allocation of resources for conservation. The obvious disadvantage, however, is that Tate has significant gaps in its collection—especially artists' film and video from the 1960s and 1970s—which are beginning to be addressed retrospectively.[76]

Comer notes that the institution has recently begun undertaking research in Eastern Europe and Latin America to enhance the representation of film and video work from these regions and cites recent collaborations with the British Film Institute as evidence of steps being undertaking to reconcile these gaps.[77]

Although its engagement with film and video collecting did not occur until the early 1980s, the acquisitions made by the Whitney follow a similar trajectory as at Tate.[78] Paik's *V-yramid* (1982), an installation, was the first video artwork it purchased, in 1982, followed by only two other such pieces during the 1980s, Mary Lucier's *Ohio at Giverny* (1983) and Paik's *Magnet TV* (1965), which entered the collection in 1983 and 1986, respectively. The Whitney's next video acquisition was Buky Schwartz's *Yellow Triangle* (1979) in 1992. The following year David Ross was appointed museum director, and under his leadership the institution acquired a further 27 film and video artworks during the 1990s (Ross departed in 1998 for SFMoMA). The situation turned precipitously in the new millennium: in 2000, 27 such pieces entered the museum's permanent holdings, and between 2001 and 2006, 93 acquisitions were made. The last three years of the decade continued this trend, with 28 works obtained in 2007, 23 in 2008, and an annual high of 37 in 2009. By the end of the decade, the Whitney's collection of film and video art totaled 239 items (see appendix B3).

Similar to Tate, the Whitney's pursuit of moving-image work first required an administrative development within the institution. This came in 1997 with the hiring of film and video expert Chrissie Iles, formerly head of exhibitions at Modern Art Oxford, as curator of contemporary art. In 1998 a film and video acquisition committee was established to help administer purchases in this area; the vast majority of the Whitney's film and video acquisitions come after this juncture.

The Whitney differs from Tate in that, as a comparatively smaller institution, it does not have an electronic media conservator. Conservation is overseen in concert among the curatorial team, an audiovisual coordinator, internal conservators, and, if necessary, outside consultants.[79] Its

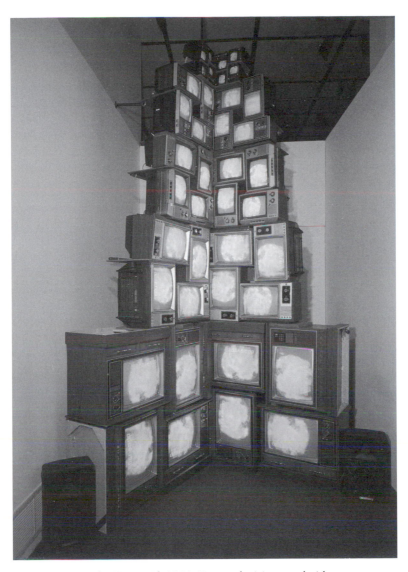

7. Nam June Paik, *V-yramid*, 1982. Forty televisions and videotape, 186 3/4 × 85 × 74 in. (474.35 × 215.9 × 187.96 cm.). Whitney Museum of American Art, New York; Purchase, with funds from the Lemberg Foundation, Inc., in honor of Samuel Lemberg 82.11. (Photo: Geoffrey Clements, © The Estate of Nam June Paik)

collection is also distinguished by its comparatively larger body of early film and video installations, of uneditioned single-channel videos, as well as its focus on American practitioners. Additionally, the Whitney is committed to presenting 16mm film in its intended state rather than transferred to video, and it has amassed a large number of 16mm projectors and loopers to achieve this—"a unique situation for a museum," according to Iles.[80] Just under half of the Whitney's holdings date from the 1960s and 1970s, including more than thirty works from the Castelli-Sonnabend Film and Video archive that the museum is reconstituting as part of a special collection.[81] Iles and Henriette Huldisch, who joined the museum as assistant curator in 2000, describe the institution's ambitions as follows:

> The Whitney Museum's collecting policy is committed to the acquisition of work produced in an art-world context and by avant-garde or Experimental filmmakers, including both established and younger, emerging artists. This practice places us in an unusual position as an art museum, navigating two historically separate areas, and deliberately crossing traditional boundaries between film and art history. Our approach reflects an acknowledgement of the under-recognized relationships among different media in artists' practice, and between artists and filmmakers.[82]

Whereas Tate is seeking to enhance its international scope, the Whitney has chosen to broaden its representation of early film and video art.

Two trends are eminently apparent from this comparison. First, acquisitions of video art are very recent: it was not until the mid-1990s, and especially in the new millennium, that collecting truly accelerated. Second, acquisitions have tended to center on installations. These two biases are evident in the collections of many other major contemporary art institutions as well, and they underscore how museum purchases of video art are a highly particular phenomenon.

For Iles and Huldisch, this is simply "illustrative of a general institutional lassitude toward collecting moving-image art."[83] Yet it also reinforces the divide between the two principal trajectories in video art's evolution—one information-based, the other spatial. On one hand, we have single-channel content that can just as easily be broadcast on television—or disseminated on the Internet—and has long proved difficult for museums to integrate into their core exhibition programs. And on the other, we have that wide spectrum of installation-based practices that are very much a product of, and response to, the gallery setting—not to mention the history of sculpture and site-specific art. If this bias can be accounted for in museums' duty to serve as custodians of work that they are uniquely qualified to present, conserve, and contextualize, it also alludes to how

video's marketization would not come via the early efforts of those like CSVF and Schum to sell single-channel work that had a slippery relationship to the art market, but through installation and other more distinctly spatial variants of video, aided by the more sophisticated limited editioning practices that flourished only in the post-1990 context.

Marketization

Video art's extension into the market since the 1990s has been robust. For if its reproducibility and intangibility present commercial barriers, its malleable structure more than makes up for these. Or it can, anyhow, if it is thoughtfully packaged and cleverly sold.

Such considerations consumed cultural theorist Fredric Jameson in his analysis of video art in 1991. "What is out of the question," he contends, "is to look at a single 'video work' all by itself; in that sense, one would want to say there are no video masterpieces, there can never be a video canon, and even an auteur theory of video (where signatures are still evidently present) becomes very problematical indeed."[84] Rather, Jameson theorized video as the "artform par excellence of late capitalism" in which "the older language of the 'work'—the work of art, the masterwork—has everywhere, largely been displaced by the rather different language of the 'text,' of texts and textuality." Video art, which prioritized content to objecthood and constant revision to finitude, was the perfect embodiment of postmodernism: no masterpieces, only "interesting" texts.

Though provoking, Jameson's arguments are also problematic, as in the market artificially limited supply sanctifies the uniqueness of a video work and reinforces authorship; literal reliance on the signature is supplanted by the sales contract.[85] To be fair, when these comments were published, it would have been difficult to predict the extent of video art's economic ascent. The irony is that the beginning of video art's extension into the commercial sector dates from the very year that *Postmodernism* hit the press.

Yet even two decades on from these remarks, video's relevance to the art economy remains poorly understood. The majority of contemporary art collectors continue to shy from the medium, ambivalent about its aesthetics: it may now be acceptable to appreciate video art in an exhibition, but it is altogether different to purchase such work for one's home. The logistics of acquiring video art can also make collectors uncomfortable: compared to conventional art objects, it is not always evident just *what* one is buying. Basic technological challenges, from obtaining the correct display equipment to the threat of content degradation, continue to make collecting video more complex than simply hanging a painting

on a wall, not to mention the fact that such a work is not always and implicitly "on." And because video art is relatively new to the commercial circuit, its resale prospects are not entirely clear. Art market economists continue to focus almost exclusively on painting in their analyses of art's investment value, as a number of important recent books on the art economy, such as those by Don Thompson and Clare McAndrew, have ignored video art altogether.[86]

This is not without reason. Very few video artists have enjoyed significant commercial and institutional success in their lifetime, and indeed even successful artists and dealers who work with video tend to characterize it as a break-even enterprise. While ever more sophisticated methods for editioning video content and selling ancillary goods (photographs, props) have certainly made it more commercially viable, real money, following Olav Velthuis's front room/backroom distinction, continues to this day to be generated from other aspects of these artists' output—or, in the case of dealers, through sales of work by other artists in the primary and secondary markets. Indeed, many of the most well-known artists working in video—including Nauman, Barney, and Gordon—work extensively, and far more profitably, in other media. Few galleries, meanwhile, promote video art exclusively, but integrate it into a multidisciplinary contemporary art program that sustains a manageable balance between exhibitions of "difficult" work (such as video) and safer shows (often of paintings or drawings).[87] Video art may therefore have entered the commercial gallery context but bottom-line concerns restrict its reach as demand remains limited; more conventional media, by extension, continue to prove far easier to sell.

The relatively small size and newness of the market for video art at auction also contributes to the weak understanding of its economics. Its presence at auction, for example, dates only from 1988 with Christie's $60,000 sale of Paik's *Family of Robot: High Tech Child* (1987), comprising thirteen television monitors on a wooden base. Values have increased since this point, culminating in a record price of $712,000 in 2006 for Bill Viola's *Eternal Return* (2000), a grouping of flat-panel plasma screens, which was hammered down at Phillips de Pury & Company, New York. Even so, video art maintains a second-class status at auction, where sales are hardly more than 1 percent of annual contemporary art turnover (by value) and where the top prices achieved by popular video artists like Viola, Paik, and Barney pale in comparison to the record sums realized in other segments of this market.[88] Video art, for example, has yet to cross the $1 million barrier whereas in 2008 alone, sixty-five works by Damien Hirst sold above this threshold.[89] The medium is typically omitted from the headline evening auctions, and none of the major auctioneers employs a devoted video art specialist.

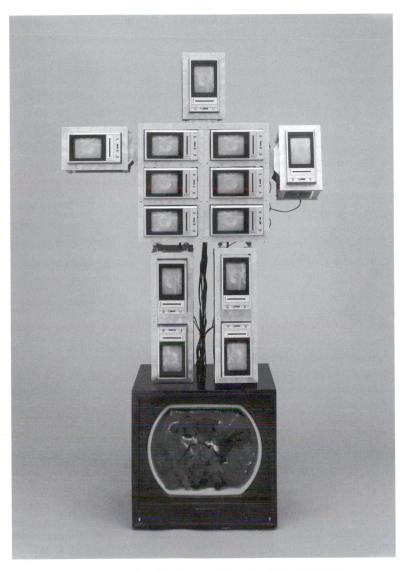

8. Nam June Paik, *Family of Robot: High Tech Child*, 1987. Thirteen color televisions in aluminum frame on 1950s RCA cabinet with paint and video, 79 1/2 × 44 1/2 × 26 in. Collection of the Akron Museum of Art, purchased with funds from Mr. and Mrs. Irving Sands and the Museum Acquisition Fund. (© The Estate of Nam June Paik)

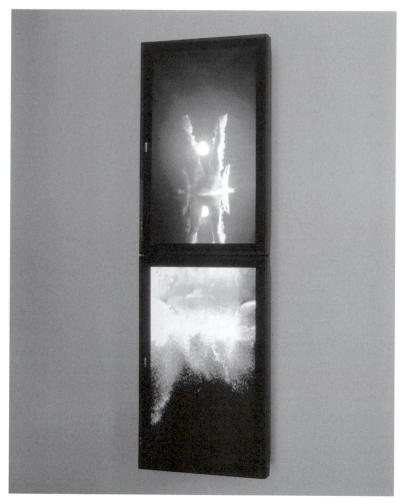

9. Bill Viola, *Eternal Return*, 2000. 81 × 25 1/8 × 6 1/8 in. (207.65 ×
63.82 × 15.56 cm.). Video/sound installation; two channels of color video
on two plasma displays mounted vertically, one over the other, on wall
with two speakers. (Photo: Mike Bruce)

It is nevertheless imprudent to dismiss video art's economic value. For
if we accept Pierre Bourdieu's premise that players in the art market seek
a combination of *symbolic* and *economic* capital, then video art is a sig-
nificant asset indeed. "Video art is such an intrinsic part of contempo-
rary art practice now that any investor should keep his eye on it," under-
lines Gregor Muir, now director of London's Hauser & Wirth Gallery.

"There has been a massive increase in the number of video works being made since the 1990s and though it's yet to be determined how video art will sit in the market, it will surely be part of it, with the secondary market growing.'[90] Muir's comments are especially relevant in the light of video art's escalating prominence in elite museum and private collections: the "success of video's failure," to reorient a remark made by Ross in 1995, concerns its presence in many of the most symbolically significant contexts.[91]

Above and beyond the museum collections already discussed, major collectors like French luxury goods mogul and former owner of Phillips de Pury & Company, Bernard Arnault, are among the most avid video buyers, while others like Pamela and Richard Kramlich and Jean-Conrad and Isabelle Lemaître have gained notoriety for their considerable focus on moving-image work. This now lofty status is clearly reflected in the German survey *Kunstkompass*, one of the oldest and most respected numerical rankings of contemporary artists, published annually by the magazine *Capital*.[92] The barometer rates artists based on a combination of their exhibition records, inclusion in museum collections, and sales prices, among other variables, and in recent years several artists regularly working in video have appeared in the top 20. Included in 2007 were Matthew Barney, at number 20, preceded by Pipilotti Rist (19), Douglas Gordon (15), Bill Viola (14), William Kentridge (10), Mike Kelley (8), Rosemarie Trockel (4), and Bruce Nauman (2). For comparison, the 2009 list had Bruce Nauman at number 1, followed by Fischli & Weiss (11), Kentridge (14), Gordon (15), Dan Graham (16), Pierre Huyghe (17), and Mike Kelley (20). This indication of prestige far exceeds the relatively small size of the video art market itself.

Sales Contracts and Ancillary Goods

Let us look a little closer at the ways in which video art enters the contemporary art market. Video art transactions resemble those of the mainstream media industry in which buyers compete not for possession of tangible goods (as in commodities markets), but for rights to own, distribute, and brand content. In film and music, this involves selling source material in return for public broadcast rights; selling DVDs, CDs, and MP3s for private consumption; securing advertising deals; and marketing ancillary merchandise like posters, clothing, or toys.[93] Parallels exist with other industries as well, and it is widely acknowledged that artists and galleries often use installations (video or otherwise) as loss-leaders, not unlike the fashion business, which undertakes similarly loss-making but ultimately brand-elevating exercises.[94]

10. Christian Jankowski, *16mm Mystery*, 2004. 35mm film. DVD master copy, DVD viewing copy. Certificate and installation instructions. 5 min. Edition 5 II. (Courtesy Klosterfelde, Berlin, and Lisson Gallery, London)

The video art market that began to take its form in the early 1990s is distinguished from its earlier manifestation of the 1960s and 1970s by the sophisticated management of both moving-image content and ancillary goods.[95] This is in part technologically driven, in part due to growing familiarity with the capabilities of video art, and also a product of significant advances in the legal support structure of this market—most notably how an intellectual property regime is drawn upon to legitimize the practice's museological relevance and enhance the prestige value of ownership.

Christian Jankowski's *The Hunt* (1992), a seventy-one-second single-channel video, provides a good example of the new market. The work is sold as a two-tiered collectable: for €400 collectors can buy a VHS edition of two hundred for private consumption (to be screened on a television monitor); or for €10,000 they may purchase a DVD edition of six sold as an "exhibition version" (to be projected). While the content is identical, the VHS version represents a terminal sale in which the collector is not safeguarded from the inevitable degradation of content and is only allowed to present the artwork privately. The premium paid to acquire the higher-resolution DVD marks a long-term engagement with the artist and gallery to conserve and update the work as necessary and enables collectors to loan the work for public presentation. Elite collectors have thus been targeted by limiting supply, by enhancing image resolution, and by accommodating more sophisticated institutional preservation requisites; others benefit from their ability to attain a lower-grade version of the work at a cheaper price. Furthermore, five video stills, each in an edition of ten, are also sold in relation to this production. Jankowski's career

16mm Mystery

Certificate of Authenticity

Christian Jankowski
16mm Mystery, 2004
Film installation
TRT: 5minutes
1 x 35mm Film
1 x Digital Betacam (NTSC)
1 x DVD (NTSC)

Edition # ——————

This certifies that this film is an authentic edi-
tioned artwork by Christian Jankowski. Limited
duplication rights are extended to the purchase.
Subsequent copies may not be distributed under
any circumstances. This work may not be exhib-
ited publicly or distributed on internet without
prior consent of the artist and or his representing
agents:
Klosterfelde, Berlin and Lisson Gallery, London

11. Christian Jankowski, *16mm Mystery* certificate of authenticity, 2004.
(Courtesy Klosterfelde, Berlin, and Lisson Gallery, London)

has bloomed since the mid-1990s, and according to the Lisson Gallery, which represents him in Britain, both video versions have sold well and the stills have sold out.[96]

Barney's *Cremaster Cycle* occupies a unique position within this history. This piece, unrolled in a series of chapters between 1994 and 2002, is the quintessential multidisciplinary contemporary artwork, spanning performance, sculpture, photography, drawing, video, orchestral composition, and a great number of art-historical, cult, and hermetic reference points. This proliferation of forms coincides with Barney's desired conflation of time- and object-based media: "For me it is critical that all of these forms come together as one piece. The films, the sculpture, the photographs, the books.... I tend to think non-hierarchically in the way that the different aspects of the *Cremaster* project are symbiotic."[97]

The breadth of saleable goods linked to his production stems from this symbiosis and is the project's most significant economic issue. The much-heralded videos, for instance, are only one aspect of the overall production that comprises over 150 objects spanning flags, prosthetic limbs, and Vaseline-encased production stills, sold either independently or together as installations.[98] When editioned, these account for the nearly one thousand items that compose the *Cremaster Cycle*, of which 70 percent are photographs.[99]

Even more telling is how the content is parceled into bundles of material and immaterial properties, enabling the *Cremaster Cycle* to exist in the market in two states at once. For instance, the digital video footage that constitutes the source matter for each of the five *Cremaster* projects has also been transferred to 35mm film.[100] This facilitates the projection of these works both in museums and movie theaters. This aspect of the *Cremaster Cycle* therefore mirrors that of the commercial film industry and constitutes one of the project's economic circuits. But a second, and arguably more important, circuit also persists: the *Cremaster* videos are sold to collectors in limited editions of ten as LDs and DVDs, encased in vitrines with accompanying props. Value is therefore strategically added to video content through the bifurcation of moving-image material as both 35mm film available for commercial rent and limited editioned art goods that can be exhibited both as sculpture (as vitrines) and as video art (by playing the LDs or DVDs).[101]

This entrepreneurialism was evident from the project's outset. Seed funding for the first film, *Cremaster 4*, was secured through sales of a promotional photograph of Barney against a tartan backdrop as the Loughton Candidate. James Lingwood, codirector of London's Artangel, which coproduced the inaugural project, notes that the picture was taken in a New York studio during the earliest stages of filming; it was sold by Gladstone Gallery in an edition of thirty. At this juncture, the economic

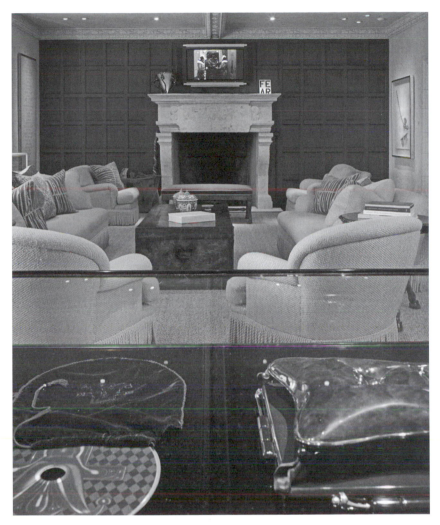

12. Matthew Barney's *Cremaster 5* above the fireplace in the living room of Richard and Pamela Kramlich. Laser disc presentation in foreground vitrine. (Photo: Ethan Kaplan/The New York Times/Redux)

structure of the project was unclear.[102] The gallery knew the work would ultimately be editioned though not precisely how, nor was it apparent who would fund its eventual exhibition and screening costs. The problem was solved first by raising money through sales of this photographic edition and second through an agreement with luxury goods multinational Cartier to cover outstanding expenses. Artangel was allowed to premiere

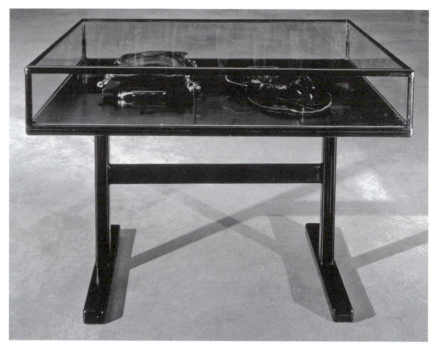

13. Matthew Barney, *Cremaster 5*, 1997. 35mm print, laser disc, polyester, acrylic, velvet, sterling silver, 36 × 48 × 37 in. (Courtesy Gladstone Gallery, New York, © Matthew Barney)

Cremaster 4 in British cinemas while Cartier obtained the rights to present a *Cremaster 4* exhibition in France in 1995, to screen the film in French cinemas, and to "secure some works [from Gladstone] at an advantageous price."[103]

A much overlooked dimension of the *Cremaster Cycle* is that all but one of its productions (*Cremaster 1*) comprised similar large-scale editions. *Cremaster 2* included two photographic editions of forty, *Cremaster 3* included one photogravure in an edition of forty and two photographic editions of fifty, and *Cremaster 5* included one photographic edition of thirty; five etchings in an edition of forty were also sold at the close of the project. Tellingly, the photographic editions of both *Cremasters 3* and *5* were produced in the year prior to completion of the videos, the only objects associated with each of these works to have been fabricated as such. This underscores the strategic roles these editions played in securing income up front and highlights the extent to which *Cremaster*'s business strategy was correlated with the buoyancy of the contemporary photography market during this period. These factors were to become especially

crucial as production values rose over the course of production, from approximately $120,000 for *Cremaster 4*, in 1994, and to more than $4 million for *Cremaster 3*, in 2002.[104]

Barney is candid about these methods. He cites Nauman's editioned sculptures and Robert Smithson's site/nonsite vocabulary as decisive influences for his own economic model. Thus while he insists that his use of production stills possesses a conceptual legitimacy in terms of developing aspects and slowing down the moving-image nature of the *Cremaster* narrative—of accentuating a link between how "discrete objects, photography and secondary forms are brought back from the site (the film) into the art institution"—he has no illusions about the important role these goods have in financing the project. He openly acknowledges that the photographs are "much more profitable" than other aspects of the *Cycle* and that they have been used to generate money up front. Comparison is given to a commercial cinema model where concepts have to be presold before filming commences, though Barney admits that it "does feel a little perverse to sell something that doesn't exist if you continue to think of the artwork as a sculpture."[105]

Artists have for centuries bolstered the economic and prestige value of their work through limited editioning. Notable precedents include Albrecht Dürer's woodcuts and engravings of the early sixteenth century and Auguste Rodin's sculpture multiples from the late nineteenth century.[106] The difference with artists like Barney is a fundamental lack of clarity concerning where the relevant "artistic" values reside: In the videos? Or in their physical manifestation as sculpture, photography, and ephemera? Judging from his emphasis on symbiosis, Barney may argue that all components be weighted with equal values. The danger is that against the gravitas of his moving-image work, sales of ancillary products can appear slight.

If Barney's economic success is exemplary, it is hardly unique. Numerous artists working in film and video command five- and six-figure prices for their work and complement such output with the sale of photographic editions and ephemera, often derived from or related to moving-image content. The mechanics of this are a practical resolution to monetizing the value of content that may otherwise be difficult to sell, and it has more in common with ordinary business enterprise than many artists and gallerists might be willing to admit. Shirin Neshat, who like Barney is represented by New York gallerist Barbara Gladstone, is one example. Neshat's *Rapture* (1999) is sold as a two-screen 16mm film installation in an edition of six, alongside twelve photographs in editions of ten. Tellingly, *all* of the nearly 350 works by Neshat sold at auction through 2009 have been photographs, many of which have links to her films and videos.[107]

London-based Isaac Julien and his gallerist Victoria Miro offer another relevant example. Julien's *Paradise Omeros* (2002) was produced on a £160,000 budget.[108] It was marketed as a three-screen version in an edition of four for £50,000 and as a single-screen version in an edition of ten at £10,000; fourteen photographs, comprising a mixture of triptychs, diptychs, and single works (all in editions of four), were also sold in prices between £8,000 and £20,000.[109] Assuming an average cost of £14,000 per photograph, the seventy items produced for *Paradise Omeros* generate an aggregate list price of £1,084,000, or nearly seven times the project's cost.[110] The rationale is classic venture capital: upfront financial risks are taken on by artist and dealer, and a sales strategy is implemented to net back costs, and ideally to turn a profit.

Julien's *True North* (2004), a fourteen-minute 16mm film (digitally transferred to DVD), is sold as a three-screen version in an edition of six at £60,000; as a two-screen version also in an edition of six at £50,000; and as a single-screen version in an edition of ten at £12,500. This is accompanied by a set of production photographs comprising four photographic triptychs at £12,000, nine single photographs at £6,000, and eight lightboxes priced between £15,000 and £25,000, each in editions of six. *True North* thus yields 148 saleable items at a combined list price of £2,357,000 against a production budget of roughly £336,000, also about seven times cost.[111]

The buying audiences for these works reflect the aforementioned stratification of collectors: three of the three-screen works have been allocated to museums, one to a semipublic foundation, and two to private collectors; two of the two-screen works have gone to museums, one to a private foundation, and one to a private collector; all ten single-channel works have sold to private collectors; and the photographs have been evenly divided between private and institutional parties. Breaking down the market for *True North* as such illustrates its strategic economic nature.[112]

Julien's prerogative is illuminating. He eloquently contends that the scaling up and scaling down of such pieces is a "version of versioning," something that filmmakers have been grappling with for decades. In his case, this is undertaken to distinguish output, to sanctify artistic production:

> For me, versioning or editioning is a way of valorizing a practice or medium that had been devalorized for so long.... There is an ethical aspect to it.... It's not to do with the market as such, but with the idea of placing value on a work, a way of establishing a certain autonomy within a framework.... I don't think the gallery is telling me to edition as such, but it grows out of a multiplicity of interests spanning filmmaking, photography, and installation—a willingness to differentiate.

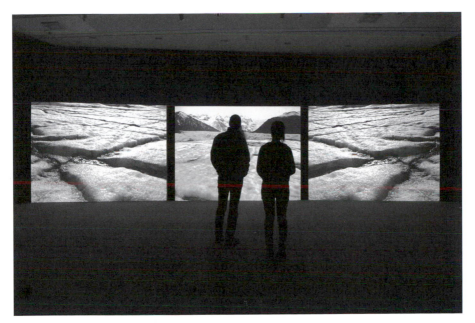

14. Isaac Julien, *True North*, 2004. Installation view. Triple screen projection, 16mm black/white and color film as DVD transfer, sound, 14'20". (Courtesy Isaac Julien and Bildmuseet Umeå, Sweden)

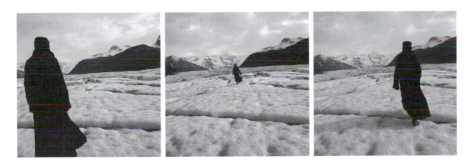

15. Isaac Julien, *True North Series*, 2004. Triptych of digital prints on Epson Premium Glossy, 100 × 100 cm. each. (Courtesy Isaac Julien and Victoria Miro Gallery, London)

But the process is hardly haphazard, and its financial underpinnings are palpable. Julien acknowledges that the two-screen version of *True North*, for instance, is a "sponsor's edition" strategically fabricated to recompense the project's financiers.[113]

More recently, at his April 2006 exhibition at Metro Pictures, New York, Julien exhibited, for the first time, a portfolio of photographs originally produced in conjunction with his 1989 film, *Looking for Langston*; eight months later, in December 2006, his *True North* lightbox series debuted at Art Basel Miami Beach. "It's not like I'm making the photographs cynically so they can be part of an ancillary aspect of the films," insists Julien. "Of course, I can't dismiss this entirely either—that could be one spin of it. But, ultimately, it's more complex than this because they still have to work conceptually and aesthetically. I'm really declaring my interest in photography."[114] This may be true, but when set within the broader context of artists who have developed a similar economy for their film and video work, it is imperative to acknowledge the considerable extent to which these interests serve a crucial, even outright, financial function.

Packaging, Display, and Private Collections

It is imperative to consider how artists and galleries have come to package video content in order to understand video art's marketization. The Lisson Gallery, which represents a number of artists working in video, including Jankowski, Oursler, Dan Graham, Rodney Graham, and Jane and Louise Wilson, accompanies many of their film and video sales with "presentation" or "collector" boxes. This initiative commenced in 2000 and is undertaken in conjunction with Book Works, a not-for-profit publisher that began issuing video boxes for artists such as Yinka Shonibare in the late 1990s. The Lisson boxes cost approximately £200 to manufacture and offer collectors an attractive option for displaying their moving-image work. These typically contain one or multiple DVDs, a Digital Betacam submaster cassette, a certificate of authenticity, and installation instructions. The Lisson has furnished these to accompany work by nearly twenty of its artists, and they are becoming increasingly commonplace in the trade at large: Julien also produces such boxes, as does Zarina Bhimji, another successful artist working in video.[115]

These developments are not limited to the literal packaging of this content: the production of immersive installations and increasingly high-definition film and video work is also significant. All of these qualities are acutely evident in Barney's *Cremaster Series*, of which the final two works (*Cremaster 2* and 3) were shot on HD video, and in Julien's multiscreen

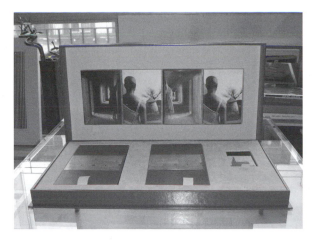

16. Isaac Julien, *Fântome Créole*, 2005. Collector's box, 4 × DVDr, 2 × digital beta camera with stereo sound, 1 × DA88 with 5.1 surround sound. (Courtesy Isaac Julien)

audio/visual installations like *True North*, whose three-screen projection measures twelve by four meters and is shot with striking resolution against a picturesque tundra landscape. Viola, Neshat, Aitken, Gordon, Yang Fudong, and the Wilsons are among the most prominent further examples.

Three significant points must be raised in relation to this. The most critical from an institutional perspective is how the technical complexity and costs of these works have encouraged museums to begin coacquiring them. For instance, Viola's five-screen installation, *Five Angels for the Millennium* (2001), was jointly purchased by Tate, the Whitney, and the Pompidou in 2003.[116] Another important example is *Cremaster 2*, coacquired by SFMoMA and the Walker Art Center, Minneapolis, in May 2000.[117] These intricate acquisition/loan programs may be indicative of a genre of relationships set to burgeon as the prices to buy and the expenses to preserve such work increase. If so, they could have an important impact on editioning and pricing policies (will the dilution of one edition across three parties encourage dealers to charge more for it?), not to mention more basic issues such as how artists approach the fabrication of such work.

A second point concerns how advanced technological capabilities have enabled the presentation of video art to flourish in both institutional and private contexts. This has encouraged video art's migration beyond "black box" gallery display and offers expansive possibilities for artists to exhibit and sell their work. Aitken's *Sleepwalkers* (2007), projected nightly

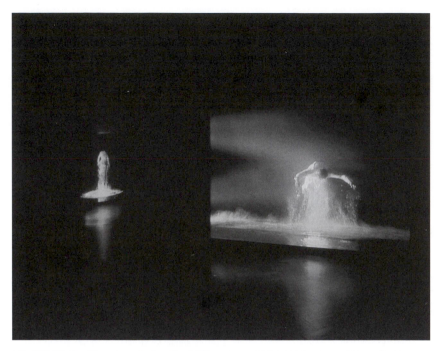

17. Bill Viola, *Five Angels for the Millennium*, 2001. Video/sound installation:
i. Departing Angel; ii. Birth Angel; iii. Fire Angel; iv. Ascending Angel; v. Cre-
ation Angel. Five channels of color video projection on walls in large, dark
room; stereo sound for each projection. Projected image size: 7 ft. 10 1/2 in. ×
10 ft. 6 in. (2.4 × 3.2 m.) each; room dimensions variable. Performers: Josh
Coxx (panels i–iv), Andrew Tritz (panel v). (Photo: Mike Bruce)

for three weeks onto eight different surfaces of MoMA's exterior in 2007,
offers an excellent case in point, and the artist is making a new version
of the piece for the opening of the Miami Art Museum in 2011 (to which
one of *Sleepwalkers'* six editions has been donated).[118] Elsewhere, Michal
Rovner collaborated with luxury goods multinational Chanel in 2005 to
produce a work consisting of 200,000 computer-controlled LCD panels
on the facade of the company's Hong Kong boutique. This transformation
of walls into screens indicates new types of partnerships between art, ar-
chitecture, design, and commerce that are likely to proliferate moving for-
ward. It also indicates the instrumental role that technology-based arts in
particular play in enabling cultural and corporate institutions to engage
ever-wider audiences (through public presentations of art-as-advertising).

These features are not lost on private collectors. In the case of Norman
and Norah Stone, Aitken adapted his five-screen projection, *Electric Earth*

18. Doug Aitken, *Sleepwalkers*, 2007. Six-channel video installation, dimensions variable. Installation view at the Museum of Modern Art, New York. (Courtesy 303 Gallery, New York)

(1999), which originally occupied 1,200 square feet of exhibition space, into a single-screen version that now resides in the couple's one-car garage-cum-installation space.[119] A 2007 article in the *New York Times Style Magazine* highlighted how other collectors have accommodated video projections in their private residences too.[120]

The video art collection of Pamela and Richard Kramlich, which formed the basis of two of the most important exhibitions on the subject to date and has led the couple to be regarded as the preeminent video collectors in the United States, offers one of the single best illustrations of the video economy's evolution.[121] Their collection began in the late 1980s as the practice was maturing and beginning to gain relevance in major museum exhibitions, but before its institutional explosion of the mid-1990s. Their first purchase was Peter Fischli and David Weiss's single-channel video *The Way Things Go* (1985–87). Birnbaum's *Tiananmen Square: Break-In Transmission* (1989–90) was their first video installation, bought in 1992 and subsequently installed in the stairwell of their home.[122] This time frame, not to mention the rise in museum purchases of video art at this moment, illustrates how the first significant wave of video art buying occurred only once its museological significance was becoming more apparent and its technology more manageable. The Kramlich

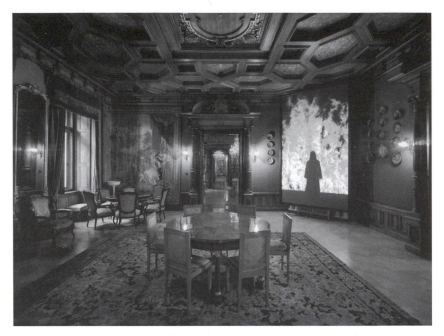

19. Bill Viola, *Fire Woman*, 2005. Installation view in the private residence of Princess Gloria von Thurn und Taxis. (Photo: Dwight Eschliman)

collection is also extremely well balanced, with "millions" having been spent on two hundred single-channel works, sixty installations, and one hundred related photographs, paintings, and other objects, spanning historical pieces from the 1960s to new works from the present day.[123] This is important because it demonstrates the range and diversity of work that is now entering the market, notably a combination of single-channel, installation, and object-based derivative work. The Kramlich's aforementioned founding of the New Art Trust in 1997 to support research and scholarship in the field has also spawned the partnership between MoMA, SFMoMA, and Tate, which currently leads the field in developing innovative ways of collecting and presenting video art.[124]

French video art collector Jean-Conrad Lemaître argues that the shift to digital video summoned by DVDs in the 1990s was foundational to his desire to start acquiring it. Thus while Lemaître and his wife began collecting art in 1983, they made their first video art purchase in 1996 and have since focused exclusively on the practice.[125] Their entire moving-image collection is on DVD with the exception of two 16mm films, *Gellért* (1998) and *Green Ray* (2001), by Tacita Dean.[126]

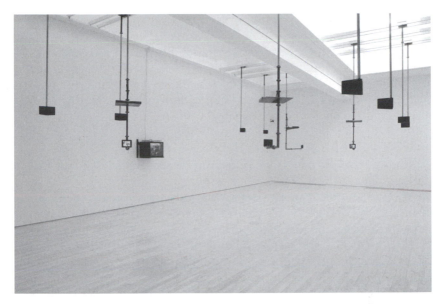

20. Dara Birnbaum, *Tiananmen Square Break-In Transmission*, 1992. Five-channel color video, one screen, four LCD monitors, four stereo channels. Installation at Stedelijk Museum voor Actuele Kunst (S.M.A.K.), Gent. (Courtesy Marian Goodman Gallery, New York)

In general, the most substantial extension of video art into private collections occurs in the form of LCD monitors and HD plasma screens. One therefore witnesses artists returning to monitors, though not as clunky props but as slick display devices. The ambitious manipulation of video content on such screens is central to the work of Paul Pfeiffer—whose presentation of *Fragment of a Crucifixion (After Francis Bacon)* (1999) and *Pure Products Go Crazy* (1998) at the 2000 Whitney Biennial preceded his receipt of the prestigious $100,000 Bucksbaum Award that same year—and they have been readily appropriated as aesthetic supports by other video artists such as the Wilsons, and for much computer-generated art as well, including that of Julian Opie and Michael Bell-Smith.[127] Barney's *Cremaster 5* is thus presented on a flat-screen monitor above the Kramlich's fireplace, with the accompanying vitrine at the opposite end of their living room.

Growing use of wall-mounted plasma flat-screen televisions links up the third point concerning how present-day video art has come to occupy a reserve of sanctity and contemplation formerly dominated by painting. This reinforces comparisons between the video art and photography

markets insofar as the large-scale dimensions and high-resolution finishes that have become characteristic of the latter have raised innumerable comparisons to the painterly tradition as well. Viola was referred to as simply "the Rembrandt of video" in a Christie's catalogue accompanying the sale of his 2001 video triptych, *Witness*, in 2005. This ensemble of three horizontal LCD flat panels was hammered down for $320,000, making it the sixth most expensive piece of video art ever sold at auction. (Another version of the work would go on to sell for $601,000 at Sotheby's in 2007, the third highest ever such price.)

This underscores collectors' gravitation toward video content that is unmistakably "artistic," encompassing portraiture and other subject matter with deep museological heritage. Marty St. James and Anne Wilson's 1990 video portraits *The Actress*, *The Swimmer*, and *The Singer*, encased in picture frames and hung on walls, were the London National Portrait Gallery's first video commissions and the earliest such works to enter the institution's permanent collection. Similarly, Julien's *Vagabondia* (2000), a double DVD rear projection shot in London's Sir John Soane's Museum, is the artist's only work represented in Tate's film and video collection. One sees this as well in pieces like Viola's *Nantes Triptych* (1992) and *The Greeting* (1995), loaded with biblical and art-historical allegories, and in Robert Wilson's recent video portraits of celebrities like Brad Pitt.[128] Wilson's productions last between thirty seconds and twenty minutes and capture subjects as if frozen still; they are shot both in horizontal format for viewing on television or movie screens and in vertical orientation for HD plasma flat-screen monitors and are sold for $150,000 in editions of three.[129]

Lifestyle

A final signal of video's vitality within the contemporary art market is the new contexts that have emerged to facilitate its exhibition and sale. The Gallery at Sketch in London, founded in 2002, promotes itself as the city's only gallery devoted exclusively to video art. It is a 250 square meter space with videos "creating a continuous strip of projection 360-degrees around the perimeter."[130] The Gallery at Sketch is a not-for-profit organization and does not sell the videos on display; admission is free.

But though it is not a commercial operation, it is not exactly uncommercial either. The Gallery is located in a hybrid dining room-cum-art space inside an exclusive eating and drinking establishment that encompasses a tea room, two bars, and two dining rooms. Video screenings are organized to coincide with the demands of this larger business, and the Gallery, situated in the main dining room, usually presents two or more

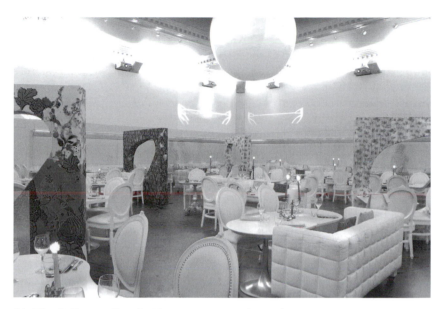

21. The Gallery at Sketch. (Courtesy Network London PR)

programs simultaneously. One is the daytime program, open to the public from 10 AM to 5 PM, Tuesday through Saturday; the other is the evening program, admission to which is limited to restaurant and bar patrons. In the latter, former assistant curator Marisa Futernick points out that content is developed as a suitable backdrop for dining (audio is usually muted) and is thus differentiated from the more "challenging" work projected by day.[131] Artists such as Julien, Fudong, Candice Breitz, and Oleg Kulik have been recipients of daytime exhibitions; evening projects have tended to comprise graphic design, computer animation, and video shorts.

This clever packaging of video content evidences a long-brewing but decisive shift in the reception and perceived utility of video practice. First, it underscores the dramatically different host venues for video then and now, substituting its once amateurish and radical qualities with its new role as a trendy lifestyle accessory. Sketch may not sell video art, but it certainly leverages its promotion of it to create a distinctive niche within the high-end entertainment market—a "constantly changing space with video art, food, people and music." Second, and more important, these motives indicate the blurry divide between not-for-profit and commercial art market circuits. Julien's 2003 exhibition at Sketch, for example, ran in conjunction with his solo show at the Victoria Miro Gallery across town, enabling Sketch to fortify its credibility as a leading venue for contemporary art, and Miro to benefit from the augmented visibility of her artist at

the same time she was selling works from his exhibition. Each profited symbolically and economically from the show.

A different iteration of this is illustrated in the Orange Lounge, a gallery space in the South Coast Plaza mall in California, launched in July 2004 as an off-site digital and video art branch of the state's Orange County Museum of Art.[132] The interpenetration of art, technology, and commerce is equally unmistakable here. In fact, Orange Lounge is but OCMA's latest initiative at South Coast Plaza, overhauling a "knick-knack sale space" that had formerly served as a museum shop. Like the Gallery at Sketch, it is an unambiguously trendy space in which viewers are encouraged to recline on lounge chairs while taking in wall-mounted flat-screen artworks.[133] The implication is that video's reception is increasingly packaged as a model of passive consumption, a leisure activity to be enjoyed in a momentary respite from shopping.

These developments are not altogether novel as video art's museological turn at the close of the 1970s was qualified by similarly passive gestures—the monitor on pedestal display as dangerously reverential. But only recently have they filtered into the sales regimen, as evident in LOOP Barcelona and DiVA (Digital and Video Art Fair), two notable video art fairs.[134] LOOP, inaugurated in 2003, occurs once annually in its namesake city; DiVA, renamed since its initial incarnation as Moving Images (also held for the first time in 2003), has since 2005 hosted events in various international locations several times per year. Both are fitted with robust VIP programs and have tended to occur in hotels in which participating galleries exhibit work out of individual rooms or suites.[135]

Paramount to this model is, again, the notion that video content be consumed as a leisure good, bound within a broader model of socializing: "the collector can sit on the bed and watch the videos as if he were at home!" praises Jean-Conrad Lemaître, official spokesman of LOOP 2006. In the next chapter I will discuss the experiential emphasis of art fairs more thoroughly. Here it suffices to consider how DiVA and LOOP draw on lifestyle marketing techniques to sell and broaden the collector base for this type of work. Paradoxically, if the history of video art's marketization serves as a good proxy, these video-only fairs may also be short-lived as they risk marginalizing video art as but a faddish commercial subcategory of contemporary art at large.

Implications

One of the most pressing issues for the video art market today concerns clarifying its financial and legalistic terms and establishing "best-practice" conventions. This is crucial because as different versions of works come

into circulation, the questions of what one owns or how such pieces are to be presented intensify. In 2005, for example, Tate Modern took liberties in projecting Julien's *Encore (Paradise Omeros: Redux)* (2003) without consulting the artist. At issue was that this piece, presented to Tate trustees as a purchase for the Library Display Collection in September 2004, was only intended for monitor display. *Encore*, in fact, is another version of the aforementioned *Paradise Omeros*; it was made for inclusion in an eleven-disc collector set sold by the New Museum of Contemporary Art, New York.[136] Julien confronted Tate on the matter and the misunderstanding was ultimately resolved.[137] Nevertheless, this illustrates the logistical complications surrounding content ownership and suggests that even well-intentioned parties may not perfectly comprehend all aspects of how a work may be presented.

Anri Sala's *Intervista (Find the Words)* (1998) offers an exceptional example of the legal challenges video art presents to collectors. *Intervista* is a twenty-six-minute video projection that was originally distributed by Idéale Audience International. It first gained acclaim in film festivals and achieved art world recognition via its inclusion in successive exhibitions at the Moderna Museet, Stockholm, and ARC/Musée d'Art Moderne de la Ville de Paris (MAMVP), in 1999–2000. After these shows, Sala gained representation with the Chantal Crousel Gallery, Paris, and MAMVP set about, in 2001, to acquire the work.[138]

In undertaking its due diligence, the museum discovered that *Intervista*'s limited editioning was misleading. Although the institution was aware that the piece existed as a version of six installations, it did not realize until this juncture that Idéale Audience and Crousel were also planning to release *Intervista* as a single-channel work for private use, in a proposed VHS edition of 220. Nor did it know that another VHS version had already been distributed in the United States. These discoveries spurred a negotiation between museum, gallery, and production company over sales terms. At stake was *Intervista*'s diminished singularity, reinforced by the disparity in price the museum would be paying for the installation versus that spent by owners of the single-channel VHS edition. In the end, the museum won out, with a final contract annulling the proposed Crousel-Idéale Audience single-channel edition.[139]

The *Intervista* sale occupies a significant position in video's marketization for at least two reasons. First, it demonstrates how museums continue to prioritize the collecting of unique, or at least strictly editioned, art goods. *Intervista*'s assumption into MAMVP's permanent collection was to be as a site-specific exercise with the museum attempting to restrict, insofar as possible, the circulation of this work (as a single-channel retail version) in the market. A second offshoot concerns why it was ever deemed apposite for the piece to exist in multiple formats. Is an "installation"

version dictating that the work is "not authorized [for] presentation on a TV monitor" truly necessary when a valid single-channel format already existed? This is a challenging question. For Sala, the installation ensured that the piece would exist in its "purest state" in perpetuity: the experience of viewing it as a projection in a self-contained environment was deemed elemental to the artistic conception of the piece itself.[140] The existence of VHS monitor-based variations was therefore supplemental and served principally to increase the work's visibility, yet it was not a perfect substitute. Even so, the suspicion lingers that this is but a half-baked justification for the work's "artness" and its subsequent validation in a museum context—*Intervista*'s emergence as a video installation grounding it as high art against its otherwise more humble manifestation as an avant-garde video.

MAMVP curator François Michaud is candid about the contradictory distribution formats this work embodies and suggests that *Intervista*'s transference from cinema to fine art is symptomatic of present-day economic protocol: "Like other hybrid objects within the arena of contemporary art, Anri Sala's video had no a priori character or, at the very least, this was merely a function of the economics of its own distribution.... Only market conditions, at a given moment, determined its forms."[141] We will return, in the next chapter, to the idea that an artwork such as *Intervista* lacks an "a priori character." This idea is relevant here insofar as it illustrates how such a moving-image work may be adjusted to target particular contexts and collectors. It also recalls Velthuis's argument that artists may negotiate two or more economic circuits simultaneously—here, the interstice between avant-garde cinema and contemporary art galleries and museums—and that resolutions may be both sensible and contradictory.

The *Encore*-Tate and *Intervista*-MAMVP affairs are only two of many plausible variations on this theme, and they illustrate the need for best-practice conventions to solidify for the video art market. Curator Hans Ulrich Obrist explains:

> One problem [with video] can be a lack of clarity vis-à-vis the relevant terms of debate. I'm fine with editioning and I think most curators and collectors understand the reasons for subdividing the marketplace in this fashion. What seems to be at issue, though, is a generally accepted awareness of how videos are to be exhibited, screened, and cycled throughout the art economy in practice. There's still too much haziness here.... We've got to be more transparent.[142]

This is sensible and reinforces claims that video conservators have been stressing for years: open dialogue is key if time-based media preservation is to mature. That the market should seek similar goals seems only natu-

ral if video collecting is to thrive in the long run.[143] While unlikely to eradicate contradictions in how such artworks filter through the art economy, it should help raise awareness of how these procedures unfold and clarify collectors' responsibilities.

Yet uncertainties remain. As video art migrates into collectors' homes with increasing haste, long-standing issues gain renewed importance. A fundamental, if strikingly basic, problem is how to determine when a work should be switched on or off.[144] Or, more fundamentally, what does such a work consist of when not in use? Such questions indicate that some of the main opportunities and challenges of video art collecting amount to basic considerations about our relationship to objects and to our inhabited environments: we may now be able to unobtrusively mount plasma monitors on our walls, yet this hardly means that we want artists' videos emanating from them in endless loops.

There are other challenges, too. Some collectors may reproduce and circulate copies of their own editions. Though there are disincentives against doing so—it can be illegal and it also dilutes the scarcity value of the "limited" artwork—such transgressions may be inevitable. Knock-offs of *Cremaster 3* caused an uproar in 2003 when they surfaced in a string of eBay auctions. Websites like UbuWeb and YouTube have also become popular, publicly accessible stockpiles of contemporary as well as historical video art, and enthusiasts have developed a knack at locating and sharing coveted single-channel works.[145] Artist Chris Hughes, for example, has acquired some 1,500 bootleg videos ranging from Acconci to Barney. He meets his sources on the art fair circuit, or they approach him through his website where his inventory is listed. "Video art specifically arose out of a desire to create an immediately accessible, infinitely reproducible art form," Hughes explains. "The viral quality of video is essential to the nature of its artistic use."[146]

Critique

The crystallization of video's marketization is contentious. The aggrandizement of video installation in art institutions is especially controversial, and critics deride its proliferation as a retrograde symptom of the international museum boom—a crafty means to fill increasingly cavernous art spaces.[147] This is difficult to dispute and it is certainly true that the popularity of video art since the 1990s owes a great deal to the forces of globalization. The low costs of shipping and insuring DVDs from one exhibition to another, for example, compare favorably to the more expensive and time-consuming process of distributing paintings or sculpture by freight. In addition, although allusions may be made to cinema, video

installations remain differentiated from mainstream theater conventions. Julian Stallabrass has termed this a "battle over spectacular display"— "how to persuade an audience to travel to a museum or other site rather than watch television, go to the movies, a gig or a football match, or shopping."[148]

The high prices commanded by some video artworks are another of the most prevalent sources of critique. "Ironically for a medium that always intended to be a way of avoiding the elitism of the gallery system, the process of charging huge numbers for limited editions and showing huge installations in cathedral-like settings has given it a credibility," argues Rosler.[149] Such features are indeed exemplary of how artificial constraints are imposed to sanctify content and generate demand, as well as of the great changes wrought in how video art has been produced and exhibited since the 1960s. Above all else, they testify to the parity video-based practices have achieved in the art world and to the considerable symbolic and economic capital now bound up with them.

But is there more to this? Marc Spiegler, writer and codirector of Art Basel, has ventured that the lofty prices commanded by contemporary artworks at large are correlated with equally large production costs: the latter are simply a function of the former.[150] The budget spike in the eight years between *Cremaster 4*, at $120,000, and *Cremaster 3*, at $4 million, would certainly seem to reflect the expensive nature of producing increasingly ambitious work.

In actuality, this line of thought merely scratches the surface. By far the most expensive sector of the market—painting—incurs relatively minor production costs. And although there may be a tendency in video art for input costs to inflate, this is hardly true of all artists' work. The escalating technological capabilities and diminishing prices of consumer electronics— from HD camcorders to computers, editing software, and so on—offer an especially good counterpoint as to why this is even more so today. Further, though prices may be correlated with production costs, Velthuis's research suggests that Spiegler's line of thought is true only to a degree. Dealers are unlikely to charge widely divergent prices in the primary market for two video works by the same artist that share similar attributes but have diverging production costs: this would imply that differences in quality exist. Lastly, causality may run in the reverse: ability to charge high prices encourages artists and dealers to invest in increasingly expensive and ambitious projects, not vice-versa.[151]

This leads to a second node of critique regarding limited editioning policies and sales of ancillary products. Rudolf Frieling, SFMoMA's curator of media arts, presumably has both in mind when he posits that the *Cremaster Cycle* is exemplary of "marketable exploitation."[152] This is echoed by the artist Pierre Huyghe, who reckons that, "For videos, edi-

tions are fake. When Rodin could only cast three sculptures of a nude before the mold lost its sharpness, it made sense. But all my works are on my hard drive, in ones and zeros."[153]

One of the most strident counterpoints to this situation was realized in 1999 when the collective R(tm)ark issued *Untitled #29.95: A Video about Video*, which repackaged clips of editioned video art into a fifteen-minute production sold at the "reasonable cost of $29.95." "In short," one critic observed, "*Untitled #29.95* puts its makers' theory into practice: if video is by nature a medium meant to be mechanically reproduced and widely distributed, then one must necessarily seize control of the medium by sabotaging the market for high-priced limited edition videos with low-cost, endlessly reproducible bootlegs."[154]

One major problem, however, is that a suitable economic resolution that maintains the integrity of an artwork and facilitates sales is seldom clear-cut. Huyghe, for example, still sells his work in artificially limited quantities. A second issue is that R(tm)ark's proposed low-cost, endlessly reproducible model fails to engage the fact that market prices, especially for installations, do not simply reflect single-period transactions but long-term engagements to preserve the work in question. In the end, such editioning and pricing policies are really just the logical outcome of the art market's financial structure: big-ticket sales of artificially limited goods to well-endowed institutions and private collectors represent a pragmatic resolution to the economics of video art.

At the extreme, the processes of video art's marketization are seen to have bankrupted the practice and encouraged a migration of creative interests toward the Internet. Stallabrass weighs some of these factors in his book on Internet art, while this debate has been stirring since the mid-1990s on discussion platforms like Nettime, and in writings by net theorists like Geert Lovink.[155] In a 2004 article, Rosler raises Lovink's now famous claim that "the revolution will be webcast" to summarize these developments: "Activists and hacktivists have stepped into the space vacated by video, whose expansively utopian and activist potential has been depoliticized, as 'video art,' much like photography before it, was removed from wide public address by its incarceration in museum mausoleums and collectors' cabinets."[156] She has elsewhere argued that a percentage of video art sales be repatriated to conservation institutions, and she is adamant that her own videos are not sold as editioned art goods, but are to be publicly accessible at not-for-profit bodies like EAI.[157]

Rosler's moral high ground echoes her position as a leading voice of the critical Left and needs to be seen in this context to be fully appreciated (as Stallabrass, likewise, writes from a Marxist perspective). Indeed, her idealistic, even nostalgic, antimarket stance is central to her own practice but hardly needs to be taken as a viable working model for makers of

video art on a whole: one would be hard-pressed to disagree with her desire to make videos widely accessible in public institutions or online; however, this need not be antithetical to selling work in the private sector. For most artists, the reality is far from black and white.

Despite these qualifications, it is nevertheless possible to take Rosler's standpoint as symptomatic of a rift punctuating the contemporary art market between those who sell their work and others who, whether by choice or consequence, do not. This is a far-reaching debate and touches on diverse activist and interventionist practices, as well as more general questions about the commodification of art.[158] Such issues have been thrown into even further relief in recent years with the opening of the Internet as an unparalleled cost-effective mechanism for presenting and distributing video content. We will return to this issue below, but its centrality to this debate cannot be understated. At least in the video context, we could be more precise and locate this division as part and parcel of the forces contributing to the practice's marketization, with editioning, ancillary production, and lifestyle marketing comprising three of the most prominent sources of spite. Tensions about swelling budgets thus shift the terms of debate from how market values are added to video art back to very basic issues about why such expensive undertakings are deemed worthwhile and what this says about the state of our current market system from a historical perspective.

The Digital Market

If these tensions appear familiar, it is because they have been polarized over the past decade into heated cultural debate on the status and future direction of today's music and film industries. With the advent of decentralized file-sharing communities like Napster and portable electronic music devices like the iPod, consumers streamed to the Internet and inaugurated an unprecedented wave of uploading and downloading of digital music content. This wreaked havoc for traditional content suppliers, and Napster, launched in 1999, was closed in 2002 on grounds of copyright infringement. But legal peer-to-peer (p2p) music file-sharing platforms such as LimeWire have since been erected, in addition to fee-based services like iTunes. Although there is inconclusive data as to whether these developments have encouraged consumers to buy more music, they have had a profound impact on *how* music is consumed: online and often for free from p2p networks.[159] In the film industry, the rapidity with which DVDs are released to the consumer market, combined with the eagerness of consumers to capture accessibility benefits of downloading films from

the Internet, has placed added competitive pressures on movie theater operators and led to tremendous price competition for DVDs.[160]

The net impact of these developments remains to be tabulated. Nevertheless, the business models of traditional music and film content owners are now in flux. As in the art sphere, the questions are similar: How to keep audiences coming (to the cinemas, music stores or museums) when they could just as easily buy or access material online at home? How to control the proprietary flow of information, and ensure that authors and owners are paid, when technological advances have so greatly empowered the influence of users? But if these industries' struggles are contemporaneous, solutions are not necessarily congruent. All will have to confront the reality of decentralized user networks and online file-sharing communities. In the music industry, this will likely result in studios forging close partnerships with p2p distribution platforms and perhaps with user-based networks directly (which musicians have begun utilizing to sell recordings to net-linked consumers).[161] The movie business may be comparatively more insulated from these changes because its content is not as well suited to byte-size flows: one has to download a ninety-minute movie versus a three-minute song. Therefore, law scholar Yochai Benkler concludes that digital distribution is unlikely to eradicate the willingness of audiences to continue paying for the experience of cinema-going; it simply affects, and potentially makes far more diverse, the manners in which this content is consumed at home.[162]

But the video art market is different. One response to this changing media landscape is defeatist: rather than competing with these new infrastructures, the practices of artists and art institutions may turn inward and embark upon more intensive engagements with film and video as historically defined. Iles and Huldisch are candid about the implications of this for museum collections: "In the face of rapidly advancing digital technology, the end of video and film as we know them is a certainty.... Museums are likely to find themselves becoming custodians of otherwise outmoded types of media and technology, which survive in the art world but not on the mass market and are dependent on institutions to care for and conserve them for posterity." These remarks echo those of Ross about how the Internet has made video art an apposite museological good. Saliently, this reading also accounts for recent works like Tacita Dean's *Noir et Blanc* (2006) and Rodney Graham's *Torqued Chandelier Release* (2005) that incorporate arcane cinematic equipment into projection installations. One should of course be careful not to conflate such filmic pieces with video art proper: they involve an alternative mode of production and conjure different semiotic and conceptual structures through their emphasis on the phenomenological relationship between spectator, projector,

and screen, and film-making's industrial past. Nevertheless, they certainly mark an affront to the flat-screen HD digital presentational formats currently in vogue and, like much recent moving-image output, are hardly unmarketable; economically speaking, they just occupy an alternative mode of product differentiation within this landscape.

In other instances, the art world confronts the digital distribution of video content head-on. 3″ ("Three Minutes"), a 2004 exhibition at the Schirn Kunsthalle, commissioned ten artists to produce three-minute digital videos. The works were then screened on-site and made available for downloading on the museum's website for the duration of the show.

Philippe Parreno, who contributed *The Power Station* to 3″, has also innovated with alternative distribution models in solo exhibitions of his own. His 2005 show at New York's Friedrich Petzel Gallery consisted exclusively of gifting DVD copies of his eleven-minute work, *The Boy from Mars* (2003), to audiences. Yet these were not intended for permanent viewing: through a process of oxidation, content on the discs would be destroyed forty-eight hours after the discs were removed from their plastic packaging. According to the artist, these decisions enabled him to sidestep the inevitable pressures of having to create a site-specific environment in which to screen his art and to make use of a technology that was still undergoing research and development within the movie industry: "I thought it best just to give the piece away and let the audience make use of it as they wish."[163]

Parreno's maneuver is a clever. By circumventing the "black box," he subtly draws attention to the ritualized contextual parameters delimiting contemporary video art display. The artificiality of these circumstances deeply concerns him, and much of his practice is bent upon tweaking the minutia of institutional protocol—of utilizing the exhibition as a "medium" in its own right. His 1998 founding of the production company Anna Sanders Films, in collaboration with Huyghe and Dominique Gonzalez-Foerster, further demonstrates his interest in disseminating moving-image content outside of the museum/gallery context. With *The Boy from Mars*, however, the adverse is equally applicable: Parreno's self-destructive offering can also be construed as gimmicky, and by failing to furnish gallery-goers with a long-term collectable, he reinforces the disparity in access between his legitimate collectors and his merely interested public. Hence the fact that *The Boy from Mars* was ultimately marketed as a set of four limited-edition HD videos (transferred from 35mm film), five editioned neon signs (one of which was displayed on the exterior of the Petzel Gallery during Parreno's exhibition), and a unique bookshelf designed by Parreno to display the DVD give-aways.

In 2006 Parreno made headlines with *Zidane: A 21st Century Portrait*, a ninety-minute film he codirected with Douglas Gordon. The feature,

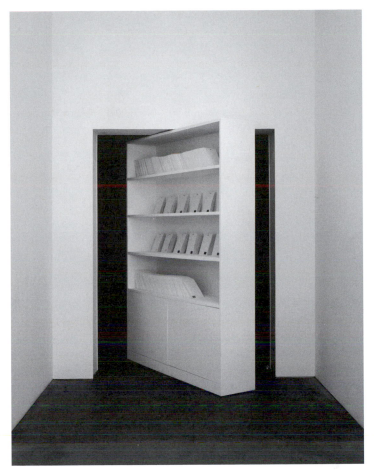

22. Philippe Parreno, *The Boy from Mars*, 2005. Wooden bookcase, rixson hinge, DVDs, 95 × 70 × 15 in. (241.3 × 177.8 × 38.1 cm), PP 05/006. (Courtesy the artist and Friedrich Petzel Gallery, New York)

which closely follows the French footballing legend in a game between Real Madrid and Villareal, premiered that May at the Cannes Film Festival, debuted to art audiences the following month at Art Basel, and has since screened in cinemas internationally; a DVD version was released in January 2007. This work is evocative of many themes discussed in this chapter: the artists are transparent about its substantiation as portraiture, and the accompanying soundtrack by Mogwai and the seventeen cameras used to record Zidane attest to its highly polished and labor-intensive

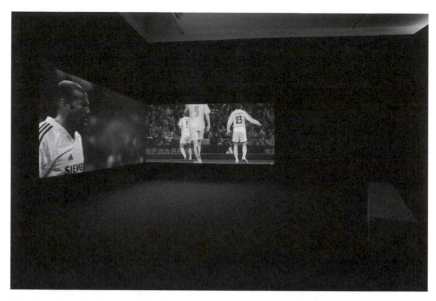

23. Douglas Gordon and Philippe Parreno, *Zidane: A 21st Century Portrait*, 2006. Collection Fondazione Sandretto Re Rebaudengo. Produced by Anna Lena Films and Palomar Pictures

audio/visual aspect.[164] It also occupies a unique position within the historical trajectory of video art, being one of the first, and arguably the highest-profile, project to be realized first in cinemas and next in art institutions.[165] On the latter, *Zidane* has been reformatted as a projected video installation in an edition of seventeen: one side of a screen captures the entirety of the feature-length movie; the other, the real-time feed of the whole game from one of the seventeen cameras used during the filming. Its list price is $200,000 per edition, and it has been purchased by a number of major museums, including the Guggenheim.[166]

None of this is surprising with regard to the scope of video art's marketization. Yet as artistic productions segue into industries formerly thought distinct, renewed urgency about the paradoxical aspects of the art economy arises: once one has viewed the feature-length version of *Zidane*, how necessary is it to do likewise in a slightly modified form within a museum? Those with vested interests in presenting such content in art institutions tend to argue that there is a clear distinction in terms of the *quality* of the experience on offer.[167] This may be true, but it is also hard to ignore economic issues such as how the art market draws on spectacular display to differentiate itself from mainstream entertainment in-

dustries at the very moment that logistical barriers between these sectors diminish.

It is instructive to come full circle with Barney. *Cremaster 3* was the sole film in the *Cycle* to be distributed to a retail market, released on DVD as *The Order* in 2003, at $35 per copy. However the disc's content is not the three-plus-hour production alluded to on its jacket, but rather a thirty-minute interactive teaser of the film's final sequence in the Guggenheim's interior. Audiences can thus watch the entirety of the half-hour clip or plug in and out of the disc's menu to peruse unedited footage and watch individual characters perform in real time; Barney likens this to a video game.[168] Although one may trust that the inclusion of the Guggenheim and artist-protagonist Richard Serra within this work are for reasons beyond their own marketability, it is difficult to ignore how this may have affected decisions as *Cremaster 3* was reformatted for popular release: allusions to a famed museum and art-historical personality constituted ready entry points with which a wider public could engage, and tactically navigate, an otherwise hermetic and theoretically loaded project. The DVD may therefore succeed as an additional "version of versioning," yet it can also be construed as but a tangential publicity stunt for the project's de facto collectors; like Parreno's *The Boy from Mars*, Barney's otherwise sincere desires for his film to reach larger audiences are mitigated by his failure to deliver the real thing.[169]

These affairs reflect the fundamental disparity between the art market and the commercial music and film industries. Where the latter may be adjusting distribution platforms to account for the increasingly decentralized nature of audio/video supply, they have the advantage of mass infrastructure and demand. As long as they maintain equity in the operations that regulate the flow of this material, theirs is ultimately a numbers game in which a potentially smaller stake in a larger pie is offset by the lower costs and higher profit margins of doing business in a digital media landscape.

But even as these logistics infiltrate the cultural sector, it is unlikely that the art market's value chain will be fundamentally overturned; video art's marketization has never been a question of content ownership in exclusivity. Rather, as this chapter has argued, video art's economic prospects have only been realized in part through the trade of screening and distribution rights. A more substantial matter is how these concerns have been integrated into traditional exhibition display (as sculpture and installation, and more recently as wall-mounted "video painting"), and how increasingly valuable ancillary products have been issued and content both stratified and asestheticized to enhance demand in the wider art market. Video versioning may proliferate and p2p interfaces may add further

vitality to the art trade's economic circuits, but it is likely to be some time, if ever, before these displace the sanctity and experiential immediacy of museological display—or the practice's more recent appropriation into "lifestyle"-centric enterprise.

In conclusion, it is fascinating to note just how underacknowledged, even misunderstood, this aspect of video art's evolution is. Michael Rush's closing comments in his recent book on the subject provide an excellent illustration:

> The task of Video art (as with all of art) will be to challenge the narrative presuppositions and demands of commercial filmmaking, thus creating an alternative Filmic art, digitally based, but conceptually innovative and not commercially driven. The fact that commercial interests will envelop the innovations (as has been the case in the history of Video art) will only enhance the need for artists to keep exploring beyond the boundaries of the marketplace.[170]

One would be hard-pressed to disagree with Rush's premise—that commercial pressures underscore the need for artists to undertake ever-more "innovative" engagements with moving-image content. Yet the reality, as we have seen, is that artists' ability to do so is difficult to uncouple from economic dependencies. Indeed, the very consecration of "video art" is linked to the practice's museological relevance and, in turn, the ability of its makers and sellers to accommodate to what remain highly conventional exhibiting and collecting standards. The popularity of YouTube and similar online video platforms, though still limited by questions of quality (videos are often pixilated and with poor sound), present new opportunities and challenges for the future development of such standards.

Perhaps a more decisive challenge moving forward, then, involves not only exploring the terrain beyond the market, but working toward a better critical understanding of its conventions and engaging them more thoroughly and innovatively. This will assist in the development of best-practice conventions so crucial to video art's integration in the commercial sector. With resolve, it will also raise the visibility of the artificial constraints and sales strategies that have, with ever-greater effect, been employed in the name of high art so that a more sophisticated and long-overdue reconciliation between truly significant video artworks and their merely derivative collectables can at last take place. The current transitioning of the art market from a period of exuberance toward a more fragile economic state may just prove to be a turning point in this weeding out process—separating the truly pioneering video artworks from others that are merely trendy or easily collectible. Only time will tell, but it would be a welcome development, enabling the next chapter in video art's market history to be written as its first moment captured here is put to rest.

..

Experiential Art

> We always had the historical choice of either lying
> through or living through our contradictions. Now
> through the genius of the bourgeoisie, we have a chance
> to market them.
>
> —Carl Andre, 1976

> The much-maligned "art scene" of the present day is per-
> fectly harmless and even pleasant, if you don't judge it in
> terms of false expectations. It has nothing to do with those
> traditional values that we hold high (or that hold us high).
> It has virtually nothing whatever to do with art. That's why
> the "art scene" is neither base, cynical, nor mindless: it is a
> scene of brief blossoming and busy growth, just one varia-
> tion on the never-ending round of social game-playing that
> satisfies our need for communication, alongside such others
> as sport, fashion, stamp-collecting and cat-breeding. Art
> takes shape in spite of it all, rarely and always unexpect-
> edly; art is never feasible.
>
> —Gerhard Richter, 1990

Rirkrit Tiravanija's breakthrough exhibition at New York's Paula Allen
Gallery in 1990, *untitled 1990 (pad thai)*, consisted of the artist staging
a free Thai dinner at the opening reception. This meal was Tiravanija's
only contribution to the show. All that remained on view for the duration
of the exhibition were the traces of this event—free-standing gas burners,

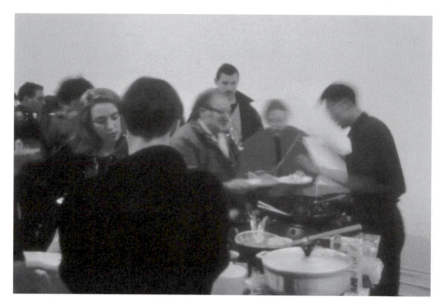

24. Rirkrit Tiravanija, *untitled 1990 (pad thai)*, 1990. Installation view, Paula Allen Gallery, New York. (Courtesy the artist and Gavin Brown's Enterprise, New York)

table scraps, soiled cutlery, and empty beer cans. Against the backdrop of the turn-of-the-decade art market recession, *untitled 1990 (pad thai)* served the literal function of bringing members of a then reeling New York art world together, catalyzed by the gift of free food. This has been interpreted as a thoughtful reworking of Fluxus performance and Beuysian "social sculpture," and it certainly marked a decisive shift from the self-important style of painting characteristic of the previous decade to the more modest and playful interventions that rose to prominence in the 1990s.[1]

Tiravanija's work has been exhibited and written about widely in the years since, and in 2004 he was awarded the Guggenheim Museum's prestigious Hugo Boss Prize. He is recognized for encouraging and manipulating modes of sociability in art contexts: food, music, and film screenings are typical devices around which his artworks form. But pinning down the artist's aesthetic remains a subject of discord. Critic Jerry Saltz labels him a "Potlatch-Conceptualist"; French theorist and curator Nicolas Bourriaud argues that he "explore[s] the socio-professional aspect of conviviality"; his dealer, Gavin Brown, maintains that his is an art of melancholia.[2]

Tiravanija himself refers to his work as an ongoing game.[3] In *untitled 1992 (free)*, he relocated the entirety of 303 Gallery's back office to its

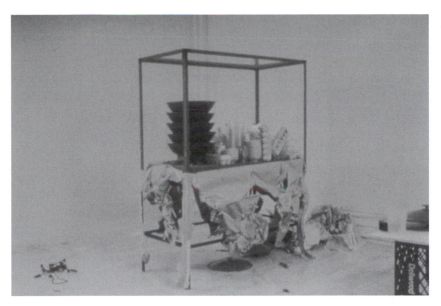

25. Rirkrit Tiravanija, *untitled 1990 (pad thai)*, 1990. Installation view, Paula Allen Gallery, New York. (Courtesy the artist and Gavin Brown's Enterprise, New York)

main exhibition space. For the show's duration, business was conducted in full public view, while Tiravanija erected an impromptu kitchen and served food to visitors at the rear, in the gallery's traditional inner sanctum. His sole contribution to the 1995 Johannesburg Biennial was to organize a soccer match for the show's participants. "As he explained," writes one critic, "he hoped to achieve through the game what he thought was the primary purpose of bringing artists from all over the world to Johannesburg. A soccer game, a meal, a concert, or a rest area thus become the framework for a communal experience and a social exchange."[4]

Other projects signal the extensive deployment of this logic. *Untitled 1999 (tomorrow can shut up and go away)* at Gavin Brown's Enterprise in New York and *untitled 2002 (he promised)* at the Vienna Secession have witnessed the artist constructing inhabitable wood and chrome structures whose configurations are based on his former residence in New York and the Schindler House in Los Angeles, respectively. Because *untitled 1999* was open 24/7, some people took the opportunity to temporarily inhabit the space. The Vienna exhibition was not accessible to the public around the clock, but it incorporated sound studios, DJ booths, massage chairs, and lectures in a densely programmed itinerary. Since the late 1990s, much of Tiravanija's attention has been focused on The

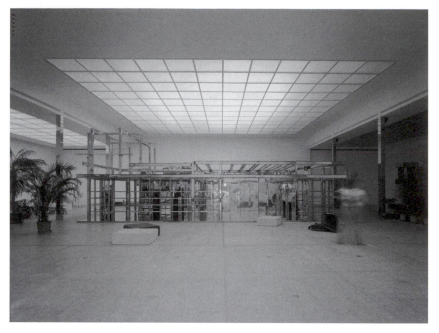

26. Rirkrit Tiravanija, *untitled 2002 (he promised)*, 2002. Installation view, Vienna Secession. (Courtesy the artist and Gavin Brown's Enterprise, New York)

Land, a rice field on the periphery of Chiang Mai, Thailand, dedicated to "cultivat[ing] a place of and for social engagement."[5] The project was initiated by the artist and Kamin Lerdchaiprasert in 1998 and focuses on aspects of self-sustainable development with "certain intentions towards community, towards discussions and towards experimentation in other fields of thoughts"; work on the site is undertaken in collaboration with farmers and students from the local community and artists and architects, internationally.[6]

Tiravanija's work itself is not the focus of this chapter. He has been introduced here as exemplary of contemporary artists whose emphasis on experience and social interaction has prompted a new type of transaction in the art market. Such artists include Pierre Huyghe, Philippe Parreno, and Tino Sehgal, whose work will be discussed below. But it also extends to many others, including Carsten Höller, Jeremy Deller, and Emily Jacir, who are omitted from our account.[7] Despite extensive writing on the work of these artists, there is as yet no definitive economic analysis of their practices. The present chapter seeks to address some of the many questions that have followed in the wake of experiential art-

27. Rirkrit Tiravanija, *untitled 2002 (he promised)*, 2002. Chrome and stainless steel. Approx. 116 × 472 × 236 in. (294.6 × 1198.9 × 599.4 cm.). Solomon R. Guggenheim Museum, New York. Purchased with funds contributed by the International Director's Council and Executive Committee members: Ruth Baum, Edythe Broad, Elaine Terner Cooper, Dimitris Daskalopoulos, Harry David, Gail May Engelberg, Shirley Fiterman, Nicki Harris, Dakis Joannou, Linda Macklowe, Peter Norton, Tonino Petra, Elizabeth Richebourg Rea, Mortimer D. A. Sackler, Simonetta Seragnoli, David Teiger, Ginny Williams, and Eliot K. Wolk, and Sustaining members: Tiqui Atencio, Linda Fischbach, Beatrice Habermann, Miryam Knutson, and Cargill and Donna MacMillan; with additional funds contributed by American Express, 2004. 2004.124 (Courtesy the artist and Gavin Brown's Enterprise, New York)

works and in particular looks at how these are sold and the extent to which the global art world has become experientialized.

The premise of this study is similar to that of the video art enquiry: to explain what collectors acquire when purchasing experiential artworks; to explore how such works are sold; and to survey the challenges in this process. As in chapter 1, discussion will be linked to precedents of the 1960s and 1970s, notably conceptual art. But it will move beyond this, too, by looking not only at the marketability of these works but at the importance of other intangible features to the structure of the recent art economy.

I commence with an examination of conceptual art's emergence in the 1960s and a summary of how it strengthened the relevance of intellectual property law in art and shifted power relations within the marketplace. We will then be in a solid position to evaluate the legacy of these innovations, a discussion that will be carried out in tandem with a review of the more recent discourse around services-based art and, in particular, Nicolas Bourriaud's influential book, *Relational Aesthetics*.[8] This discussion, in turn, enables a narrower look at how intellectual property rights are applied today. As we will see, collectors of both conceptual and experiential art do not buy tangible goods or intangible services and experiences per se, but rights to a system or network that often involves a combination of these elements. This is an extremely important concept and distinguishes such transactions from more conventional means of acquiring static objects (such as paintings), and we will look at a number of examples to demonstrate how it works.

The latter portion of this chapter further contextualizes these developments. The integration of experiences into business frameworks and the upsurge of lifestyle commerce, I argue, have boosted art tourism, reinvigorated experience-oriented art practices, and set the stage for the rise of contemporary art fairs, the apex of the art experience economy. I conclude by discussing the role of fairs in the global art economy, especially their adeptness at both interconnecting art world players and providing a liquid sales platform. We will also see how they present new opportunities and challenges for selling experiential artworks and establish an important model for the development of the art economy moving forward.

Definitions

The definition of experiential maintains that it is "of or pertaining to experience or observation; based on or derived from experience."[9] My usage of the term refers to artworks that depend, in part or in full, on an exchange between artist and audience. This exchange may constitute the totality of the work: spectators are provided with guidelines for engagement —via objects or scenarios—and frameworks for *experience-as-art* are set in motion. Or it may be only one of many aspects of the artwork, which could also involve books, contracts, documentary devices, or objects and systems like paintings, photographs, or installations.

The concept is not straightforward. Not all experiential works demand a literal artist–audience engagement and many artists actively resist the term, arguing that it neglects more salient aspects of their work while wrongly pinning attention on the experiences it produces and on mis-

understood notions of interactivity.[10] An additional problem is that when applied to art, experiential is pervasive and therefore redundant: all engagements with art constitute experiences of a certain sort—for example, the experience of standing before a painting or sculpture. Experiential will nevertheless be applied in this chapter as a rhetorical compromise that enables us to anchor current art discourse to alternative applications of the term in conceptual art and forms of artistic service-provision.

As indicated by its etymology, conceptual art refers to practices that prioritize an artwork's idea or the variables encircling its production or reception to the fabrication of tangible objects. Conceptualism is thus an art about the system of art making, from how a work is conceived to factors such as criticism and the audiences, contexts, and institutions that bring it into being. Art historian Alexander Alberro refers to this as the "deprivileging" of art and aligns Conceptualism with a Marxist critique of consumer society that resonated with much 1960s political activism and avant-gardism.[11] Here it shares a commonality with the origins of video art whose promises of reproducibility and mass distribution attracted artists for similar reasons. But like the multiplicity of factors surrounding video art's emergence during the same period, Conceptualism is also a hybrid phenomenon with diverse and occasionally contradictory paths.[12] In their famous and controversial article of 1968, Lucy Lippard and John Chandler equated Conceptualism with the dematerialization of the art object, although few, then or now, accept this reductive analysis outright: conceptual art certainly deemphasizes materiality, yet this hardly precludes a work's existence in tangible form.[13] Nor, as Lippard later conceded, was it any more capable than its "less ephemeral counterparts" to elude the "general commercialization" of the art market, a common misperception of Conceptualism's supposed promise.[14]

Selling Conceptual Art

Conceptual art is a familiar and expansive territory, and only some of its most significant economic aspects will be considered here: how it broadened the horizons of artistic production/reception; and how it employed contracts and documentation to establish its own market.

Like certain avant-garde predecessors, conceptual art aspired, albeit on varied levels of conviction, to breach the principles of artistic "genius" canonized by nineteenth-century romanticism and institutionalized by the modern art museum.[15] This often resulted in artists' efforts to expose context, to shift authorial roles, and to investigate new means of disseminating their art. Lawrence Weiner's tripartite "Statement of Intent" (1969) is worth restating:

1. The artist may construct the piece
2. The piece may be fabricated
3. The piece need not be built

Each being equal and consistent with the intent of the artist the de-cision as to condition rests with the receiver upon the condition of receivership.[16]

The presentation of much conceptual art is highly variable as a work's material manifestation may be subject to the actions taken by its receiv-ers. Four of the eight pieces that Weiner contributed to the exhibition January 5–31, 1969, at Seth Siegelaub's gallery in New York consisted only of titles in the show's catalogue, their realization being left entirely to the receiver.[17] A degree of the artist's authorial autonomy is thus ceded to parties—be they curators, collectors, or audiences—who engage with the work and ultimately determine whether or not it takes material form.[18]

French conceptualist Yves Klein's contribution to this narrative is ex-emplary. In *Transfer of a Zone of Immaterial Pictorial Sensibility* (1959–62), Klein offered collectors the opportunity to purchase an "immaterial zone" in exchange for payment in gold, half of which the artist would disperse into the Seine. The exchange, conducted in front of a curator or critic, at least two witnesses, and the collector, was photographically doc-umented and the collector received a certificate of authenticity confirm-ing the amount of gold that had been "transferred" (the weight of which corresponding to the size of the immaterial zone being purchased). The caveat, however, was that to actually own this immaterial experience—the *real* artwork—the collector was required to burn the certificate. The ritualistic experience of engagement—with Klein and with the concept of nothingness—is thus postured as the ultimate object of ownership. Art historian Benjamin Buchloh has spoken of Klein's legacy in language imbued with contemporary marketing rhetoric: "The dubious distinction of having claimed a natural phenomenon … as private property, a brand name, and of legalizing this preposterous pretense by a signature or by the quest for a patent, is Yves Klein's."[19]

Seth Siegelaub is the paradigmatic example of how Conceptualism ad-vanced these "preposterous pretenses." Heralded as the preeminent dealer of the first generation of American conceptual artists, including Weiner, Carl Andre, Robert Barry, Douglas Huebler, Joseph Kosuth, and Sol Le-Witt, among others, he linked up artistic production with then novel ideas of marketing and advertising and added value to these practices through the issuance of sales contracts. Siegelaub only actually operated a tradi-tional gallery between April 1964 and June 1966, during which time he mounted a series of happenings and environments in an office where he also sold Oriental rugs. Ironically, his most significant contribution came

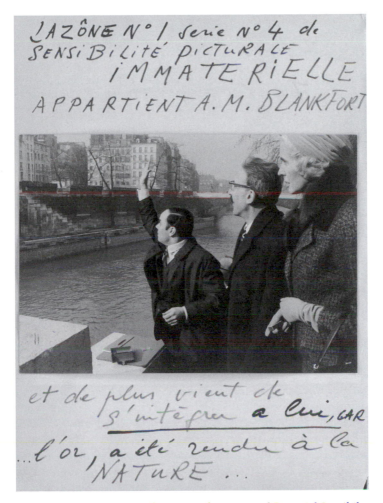

28. Yves Klein, *Transfer of a Zone of Immaterial Pictorial Sensibility*, Pont-au-Double, Paris, 10 February 1962. *From left*: Yves Klein, Mr. and Mrs. Michael Blankfort. (© Yves Klein, ADAGP, Paris)

when he closed this space and relocated his gallery to an uptown apartment. This move was practical—Siegelaub had been struggling to pay rent on the larger commercial property due to poor sales—and it also summoned a seminal realization: since Conceptualism's overriding characteristic was the information it conveyed, why not eradicate the gap between the work's material form and its mode of dissemination?

Robert Barry's *Inert Gas Series* (1969), a work that released inert (invisible) gases into California's Mohave Desert, is a quintessential example

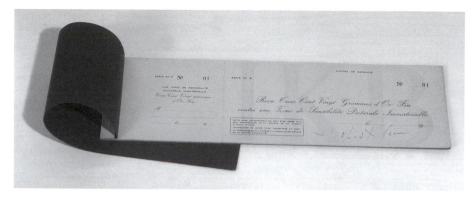

29. Yves Klein, *Transfer of a Zone of Immaterial Pictorial Sensibility*. Receipt booklet, series no. 5, 1959. (© Yves Klein, ADAGP, Paris)

of how Siegelaub and his artists tested the limits of marketability. Although widely publicized by Siegelaub as a poster, the work was never exhibited: the poster only provided a textual description of the piece, the address it listed was a post-office box, and the telephone number directed callers to a prerecorded message, again describing the work. All that materially remains of the experience are photographs Barry shot on-site and an audio recording, neither of which was exhibited. "The exhibition," underscores Alberro, "was accessible to the public solely in the form of advertising, as a pure sign."[20]

Douglas Huebler's *Variable Piece #44, Global, March 1 1971* offers a different example. Issued as an edition of one hundred, each piece constituted a grid on paper of three rows with ten empty boxes. For one decade, commencing in 1980, its owner was to place a photograph of himself or herself in the middle box and to amass a photograph of the owner of the edition number above and below hers or his in the adjoining box on top or bottom; each collector's edition was thus differentiated from the next based upon choices made and the extent to which the system was pursued. As art historian Mark Godfrey has observed, this work "played with the psychology of collecting" even though it "predated the era of editioned artist's photographs." "The piece required a form of social interaction the collecting system did its best to occlude, and ironically insured that the final work, after ten years, was unique."[21]

Because Conceptualism challenged many conventional principles of art making and collecting, sales contracts were issued to clarify the terms of engagement. These followed the example set by Klein and artists like Piero Manzoni and Robert Morris, and they had the dual function of legitimizing the artwork and enumerating ownership rights.[22] Due to the fact

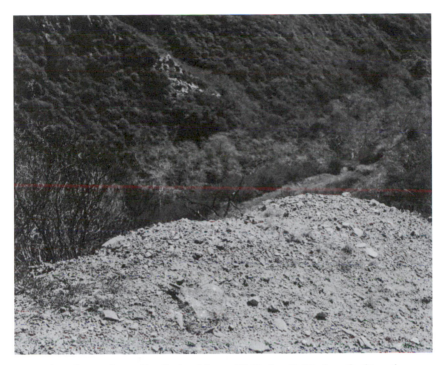

30. Robert Barry, *Inert Gas Series: Neon*, 1969, detail. Black and white photograph, 8 × 10 in. Collection of the Art Institute of Chicago. (Courtesy the artist and Yvon Lambert Paris, New York, © Robert Barry)

that such a large quotient of conceptual art existed solely as an idea or statement—pending the action of an as yet unknown receiver—these contracts and other forms of documentation became pseudo art objects in their own right as they were often the primary means of exhibiting such work in galleries. Barry's *Inert Gas Series*, to take one example, may not have been exhibited at the time, but versions of it have since been sold as framed collectibles with original photographs and statements of intent.

This process, and its embedded contradictions, was the subject of Buchloh's important retrospective analysis of Conceptualism in 1990 that concluded that no matter how radically opposed Conceptualists may have been to the art market and its institutions, such contracts merely affirmed their relevance to both.[23] This "aesthetic of administration," he argues, ruptured the "profoundly Utopian (and now unimaginably naïve) claims" associated with Lippard's earlier contentions that "Art intended as pure experience doesn't exist until someone experiences it, defying ownership, reproduction, and sameness"; such experiences were fungible from the outset.[24]

31. Robert Barry, *Inert Gas Series: Neon*, 1969. Two photos, each 8 × 10 in.; one text: 11 × 8 1/2 in.; 20 1/2 × 40 in. (52.1 × 101.6 cm.) frame. Collection of the Art Institute of Chicago. (Courtesy the artist and Yvon Lambert Paris, New York, © Robert Barry)

The most famous art contract to come out of this period was the "The Artists' Reserved Rights Transfer and Sale Agreement," drafted in 1971 by Siegelaub and lawyer Robert Projansky. It grew out of Siegelaub's involvement in the Art Worker's Coalition and sought to enhance artists' rights over the circulation of their work by entitling them to a percentage of resale profits; it was freely distributed to hundreds of Siegelaub's friends and colleagues and was printed in *Studio International* in April 1971.[25] "As a practical solution," Siegelaub has remarked, "the contract did not question the limits of capitalism and its private property; it just shifted the balance of power in favor of the artist over some aspects of a work of art once it was sold.... [I]t was just proposing a simple way that the artist could have more control over his or her artwork once it left their studio."[26]

Despite its ambition, the Projansky Contract, as it is known today, floundered within only a few years. One problem was that of enforcement: no infrastructure was ever established to collect the royalty. Alberro highlights two additional challenges: first, because sales had to be declared, it threatened the discretion of dealer sales; and second, it was feared that infringements upon collectors' rights to use and sell work might deter them from buying such art.[27]

Ironically, the Projansky Contract's failure to gain traction proved just how successful Siegelaub et al. had been in selling artistic experiences. Lim-

itations on resale rights had become unattractive precisely because of Conceptualism's marketability:

> For the Agreement's precise limitations served to confine even work that existed only as abstract idea or, alternately, only as widely dispersed documentation within its capital relations, and thus inserted conceptual art into the art market as a pure commodity or bill of sale. The aura absent from conceptual art was thereby reintroduced in the auratization of the signature. If conceptual art attacked the privileged nature of art and made the experience of art collecting more practicable than ever before, Siegelaub's contract ensured that one facet of the new art would not be so readily accessible—namely, the experience of ownership.[28]

Having achieved this and upon playing such a vital role in Conceptualism's formulation, Siegelaub left the art world in 1971 and never exhibited again.

Relational Aesthetics

Although there has been no shortage of attempts to explain the economics of conceptual art, it is worth recalling Kosuth's remark on Dan Flavin, an artist whose iconic neon tube structures bridge Conceptualism, Minimalism, and process-art: "When someone 'buys' a Flavin he isn't buying a light show, for if he was he could just go to a hardware store and get the goods for considerably less. He isn't 'buying' anything. He is subsidizing Flavin's activity as an artist."[29] This may well be the case, and Kosuth's commentary highlights how collectors of such work do not merely acquire precious art objects, in the more conventional sense (Flavin famously made use of ordinary, mass-produced materials). But collectors *are* "buying" something, and in Flavin we can identify a constant that runs throughout this chapter: one acquires the rights to a system of objects (or relationships) and a long-term obligation to maintain the work to the artists' specifications. Indeed, Flavin was among the first generation of artists to issue detailed terms of sale with their work, which in his case specified how and under what conditions fluorescent tubes could be replaced, not just to prevent a work's quality from diminishing (as with a mal-conserved sculpture), but to save it from failing to function altogether (with the expiration of its tubes).[30]

Artist and writer Andrea Fraser has observed how the market for such work reconstituted collectors as "altruistic" patrons, thus cementing a link between 1960s avant-gardism and "art's premarket past." She excerpts Huebler to clarify her point: "Anyone could produce a [Carl] Andre

or a Flavin. At the same time, I believe that the collector is someone who enters into a conspiracy with the artist that is beyond the issue of accessibility, an agreement that the sensibility is an important one. This agreement may be really what the owner had that is original."[31] This line of thinking corresponds to the essence of conceptual art contracts and suggests that

> the return of the patron their work implied had less to do with the disappearance of objects with specifically artistic value than with the emergence of a specific relation: the "conspiracy" Huebler describes in his statement and inscribes in his contractual works.... [S]uch value depends on the symbolic conditions of an artistic position: on the degree to which a work's underlying principles are recognized as unique, legitimate, and historically relevant.[32]

This observation is of paramount importance and enables us to equate the market for conceptual art, and related offshoots, with more conventional practices like painting. For while there may be obvious differences between these art forms, all fundamentally rely on a system of belief for economic values to accrue. As discussed in the definition of art in the introduction, it is not enough for a work simply to exist; the market must recognize it as "unique, legitimate, and historically relevant," and this is as true for painting as for the type of work summoned by artists like Flavin. The key, then, is to achieve this institutional validation; differences in price are primarily a function of the coming together of certain variables, from how easily the work can be exhibited, transported, and insured, to its critical merit as well as its provenance and backers.

The continuity between the symbolic conditions flagged by Fraser in the 1960s and those in the new millennium are remarkable. When questioned about what collectors acquire in purchasing his art, Liam Gillick, an artist pivotal to the relational aesthetics debate, echoes Kosuth in suggesting that "The best collectors are those who ultimately buy '*time*.'"[33] This is a privileged position and presumably accrues only to somebody whose value is recognized. However Gillick's remarks are logical and correspond to his own practice, which includes the fabrication of tangible art goods—sculptures, installations, prints—alongside writing, lecturing, teaching, curating, and consulting. For the artist, these engagements are all of equivalent significance. Yet because the marketplace tends to prioritize the former *goods* to the latter *services*, the acquisition of his "time" can therefore be interpreted as an unrestricted subsidy toward his pursuit of these varied activities.

These networked interactions form the basis of Nicolas Bourriaud's *Relational Aesthetics*, published in French in 1998 and translated to English in 2002, which elaborates a theoretical framework around contem-

porary artists such as Tiravanija, Gillick, Pierre Huyghe, and Philippe Parreno. Many of these artists came in contact with each other in France, where Bourriaud was based as a curator, during the early- to mid-1990s, but the writings have broad appeal. In *Postproduction*, 2002, Bourriaud addresses many of the same artists and draws attention to appropriation, sampling, deejaying, and hacking.[34] Ambitiously projected, transdisciplinary in scope, and by and about renowned figures in the art world, the two texts have generated a stifling amount of commentary. "Not since the early years of Postmodernism's theoretical reign," surmised one commentator in 2004, "has the art community been so intimidated, enthralled or annoyed by a theory than it is today by Nicolas Bourriaud's writing on relational aesthetics and postproduction."[35]

Bourriaud hails the "collapse" of the "falsely aristocratic" conception of art as a finite and concrete gesture: "The contemporary [art]work ... is henceforth presented as a period of time to be lived through, like an opening to unlimited discussion. The city has ushered in and spread the hands-on experience."[36] He is drawn to the idea that art represents a "social interstice," adapted from Marx to designate relationships that exist outside the capitalist sphere. He then extends this as the basis for his vision of the contemporary art exhibition that "creates free areas, and time spans whose rhythm contests with those structuring everyday life, and it encourages an inter-human commerce that differs from the 'communication zones' that are imposed upon us."[37] Relational aesthetics is slotted within this framework as a generalized post-1990 artistic current that breaches the suffocating cultural dystopia feared by early postmodernists and suggests the plausibility of a revitalized artistic field in which actions, schematics, and *experiences* are favored over finished products. Occupying temporary exhibition sites, such artists establish a rubric in which the form an artwork takes "only assumes its texture (and only acquires a real existence) when it introduces human relations."[38]

Once activated by an audience, Tiravanija's meals become quasi performances: an artist sparks the possibility of interaction and contemplation, and the relationships that develop around such engagements serve as pivotal aesthetic dynamics of the artworks themselves. Bourriaud's vision of this type of practice is formidable: "The possibility of a *relational* art (an art taking as its theoretical horizon the realm of human interactions and its social context rather than the assertion of an independent and private symbolic space), points to a radical upheaval of the aesthetic, cultural and political goals introduced by modern art."[39]

Bourriaud's provocative account is useful in identifying some of the distinguishing features of contemporary experiential, or relational, art, but it is not free of problems. His critics have been especially vociferous, with attacks centering on his dubious democratic claims, his championing of

art in situ, and the periodization of his arguments.[40] For instance, while correctly arguing that "the constitution of convivial relations has been an historical constant since the 1960s," Bourriaud presents a superficially simple account of earlier precedents and likewise fails to come to grips with their consequences for today's artists. By suggesting that Conceptualism liberated artists of the 1990s from being concerned with the "definition" and "broadening" of art's boundaries, he clearly overstates the issue.[41] He not only turns a blind eye to those contemporary practices that continue to take art's institutional structures as modes of departure but more fundamentally fails to demonstrate how relational art's newfound "capacities of resistance within the overall social arena" are enacted. The "micro-utopias" that Bourriaud so highly applauds are at times difficult to parcel from the *power-to-the-individual* hype characteristic of the 1990s dot-com economy, to which we shall return in more detail below. And it seems fair to ask more generally whether interhuman relationships are truly "aesthetic," and irrespective of this, if the artists under consideration actually have that much in common.

Yet, if Bourriaud's writing may be at fault for its lack of art-historical reflection, it is still germane because it has crystallized an important umbrella-set of contemporary art activities. It also forms an accessible bridge to other more critical accounts of recent service-based and poststudio art. Fraser's extensive writing and work around project-based art offers a good alternative example, as does art historian Miwon Kwon's discussions of site-specific art and globalization.[42] Kwon presents an ambitious thesis about how changes in the production and presentation of art today have diminished the importance of what artists *make* relative to what they *provide*: "It is now the performative aspect of an artist's characteristic mode of operation (even when working in collaboration) that is repeated and circulated as a new art commodity, with the artist him/herself functioning as the primary vehicle for its verification, repetition, and circulation."[43]

The economic parameters of the artworks discussed by Bourriaud, Kwon, and others share close ties with intellectual property law. The latter's application to the art market enables rights to cover not only the trade in tangible goods but the broader system of production and reception associated with an artist's creative labor. In the next section we will draw on Actor-Network-Theory to grasp these economic parameters more clearly and, ultimately, to propose *what* collectors of experiential art actually obtain. As one may infer from the earlier analysis of the video art market, despite all the rhetoric about dematerialization, many of these artists still generate a substantial body of tangible, unique, and/or editioned goods.

Actor-Network-Theory

Actor-Network-Theory (ANT) is linked with Pierre Bourdieu's sociological writings and, in particular, to research by Bruno Latour, philosopher of science, who has been preoccupied with the subject since the early 1980s; Michel Callon and John Law, colleagues of Latour's at the Centre de Sociologie de l'Innovation, Paris, have also been influential in its formation.[44] ANT derives from an analysis of science and technology and first and foremost proposes that knowledge is a social product, encompassing material forms, skills, and actions rather than the end result of "privileged scientific method."[45] In a familiar example, one's ability to drive a car is predicated not only on how the car accelerates, brakes, and steers, but the driver's technical skill, past driving experience, the weather, other cars, and the manufacturing processes of the car itself. In the ANT framework, such variables are known as "actants"; cumulatively, they create the driving network.

Critics of ANT believe it trivializes the distinction between man, concept, and machine. Such distinctions, according to the theory, are not externally imposed but are the product of specific characteristics the actants, human and otherwise, acquire in creating the network. This is consistent with the theory's rejection of an essentialist analytical methodology, focusing more on how relationships are constituted to form *something*, rather than taking that something for granted. From its origins in techno-scientific jargon, ANT has been applied to a variety of disciplines, from poststructuralism to health care and anthropology.[46]

Legal scholar Jaime Stapleton discusses ANT's relevance to art by looking at the link between intellectual property law and the dematerialization of the art object. Stapleton's account is modestly different from that presented here as he does not address conceptual art per se, but the legacy of Conceptualist predecessors like Marcel Duchamp and contemporaneous movements like Minimalism. His argument is nevertheless relevant, and he underscores that all these avant-garde activities, like Conceptualism itself, fall "easily within the scope" of copyright law. Stapleton thus contends that the main achievement of Minimalism, famous for restricting aesthetic choices and for generating serialized industrial forms, "was not to critique copyright but to shift the location of copyright away from the 'revealed object,' the exhibitionary object, and place it in its documentation" —to "imply that the 'full' work always lay somewhere beyond the *material* realm." He then draws on this to demonstrate how it helped shift the hierarchy of production from a conventional basis in which the artist is solely responsible for making a work to one in which authorship falls unto a "broader network of social relations," encompassing "'human actors'—

artists, viewers, critics, historians—and 'non-human actors'—the object, the gallery, the catalogue, the review—and 'temporal factors'—the conditions of the particular moment in which the event of the 'composition' occurs."[47]

The most important economic aspect of this is that, despite appearances to the contrary, authorship remains firmly in place. Artists may no longer be involved in all aspects of a work's manifestation, but they are authors nevertheless and possess all the legal and financial privileges that come with this. Or, to paraphrase Minimalist Robert Morris, "it was not that the artist became 'unimportant,' just less 'self-important.'"[48] The only difference under this new regime is that there would be almost no conditions governing the form a finished work might take, and an ANT framework could be applied to just about any artwork. We therefore find that contrary to what one may infer from the externalization of the processes of artistic production epitomized by Minimalism (and by extension, Conceptualism)—*desubjectivization* as a challenge to the "capitalist character of aesthetic relationships" and *networks* as an anticommodification avant-gardist strategy—ANT has led to ever more sophisticated management of intellectual property rights and abetted individuals' ability to lay an economic claim to the properties that flow from their creative labor.[49]

The foundations of this are not unique to the recent period and actually have their roots in late nineteenth-century applications of copyright, mainly in the publishing industry where authors sought to control the flow of derivative elements stemming from a complete work.[50] Yet its legal underpinnings reached new heights with the economic dematerialization of the 1980s, ultimately constituting the backbone of the knowledge economy that remains a dominant force today.[51] This is a crucial distinction because it enables us to situate ANT in relation to legalistic doctrine in other economic sectors, and therefore to appreciate how managerial conventions elsewhere inform how such rights are governed in the art market, too.

Although ANT is an especially relevant framework for addressing dematerialized artworks, it also holds general appeal. Any piece of art is the residue of certain actant networks and the transference of works, such as the relocation of an altarpiece from a medieval chapel to a museum, has long been a source of ethical and logistical debate. As contemporary art's market values have ascended, one also witnesses an intensification of questioning around what collectors actually own. Some recent high-profile cases include Damien Hirst agreeing to fix, or entirely remake, works that involved the preservation of dead animals in glass vitrines. For traditionalists, this borders on heresy: wherewith the value of the original creative act if artist and collector agree to remake an artwork at

the merest sign of wear (in this case the decomposition of preserved sharks)? ANT and intellectual property law suggest that economically and legalistically, these types of questions are misguided because they shift the register of what such collectors acquire, from unique tangible goods to systems of rights, expectations, and obligations governing how these goods are to be presented and conserved—a further parallel with the Flavin discussion above.

To extend the most famous such example in recent years, one could argue that when hedge fund billionaire Steven Cohen bought Hirst's *The Physical Impossibility of Death in the Mind of Someone Living* (1991) for a reported $8 million in 2006 and paid the artist a one-off fee to re-create the piece with a new shark, he did not really purchase a static sculpture (the original shark-in-tank), but the intellectual property that gave birth to that sculpture as a legitimate Hirst artwork and which would allow Cohen to present it as such and to renew it as necessary.[52] It was quite a shrewd transaction, too, for not only had Cohen acquired arguably the artist's earliest major work, but he also leveraged its restoration to strike a deal with the Metropolitan Museum of Art to place the "new" shark on display for three years, from 2007 to 2010. Should Cohen ever choose to resell the work, the added provenance and visibility secured through this loan could presumably prove to be highly lucrative and well exceed the restoration costs he incurred. This arrangement, alongside Fraser's "avant-garde contract" or what Huebler earlier labeled the "conspiracy" between collector and artist, can ultimately be understood as relationships that ANT makes evident and helps regulate through applications of intellectual property law.[53] Collectors do not just acquire fixed art objects, but systems conceived and consecrated by artists that they subsequently own the rights to.

Actor-Network-Theory in Practice

An instructive empirical application of ANT is advanced by art historian Vivian van Saaze, who assesses how Huyghe and Parreno's *No Ghost Just a Shell* (1999–2003) was conceived, exhibited, and ultimately purchased by the Van Abbemuseum, Eindhoven.[54] In this work, the artists bought the rights to a manga character, Annlee, from a Japanese film development agency and distributed her image to thirteen artists and collaborators who then created a series of individual artworks in various media based upon her. These works were exhibited in over twenty-five international institutions over the course of three years before culminating in a group show at the Van Abbemuseum in 2003, at which point the project entered the institution's permanent collection.[55]

32. Philippe Parreno, *Anywhere Out of the World*, 2000. 3D animation movie transferred onto DVD, sound Dolby Digital Surround, blue carpet, poster. Four minutes. Edition of four. (Courtesy the artist and Friedrich Petzel Gallery, New York)

But what did the museum purchase? Van Saaze stresses that one cannot approach this question by assuming that *No Ghost* had an a priori identity. Instead, Huyghe and Parreno instigated a conceptual framework for a series of engagements. The project must therefore be seen as a dynamic system allowing a range of activities to occur, rather than a preordained set of objects to be produced. For instance, the Van Abbemuseum exhibition represented a new part of the work by grouping all aspects of its production together. And acquiring *No Ghost* triggered a further set of complexities: first, works had to be purchased from the artists and their respective galleries; second, it was decided that a book about the project would be published (this book, too, was conceived as an "artwork"); and third, a new piece by Huyghe and Parreno was to be created.[56] This latter factor resulted from the Van Abbemuseum's realization that some of the artists' video editions—*Two Minutes Out of Time* (2000), *One Million Kingdoms* (2001), and *Anywhere Out of The World*

(2000), the first two by Huyghe, the latter by Parreno—had already been sold out. *Travelling Pod* (2003) was their resolution, consisting of a robot the artists manufactured with the electronics company, Phillips, which would roam gallery floors and project their earlier videos on walls; together, these would constitute a new "unique" work. The Van Abbemuseum's challenge lay in identifying not what it had bought, but what it *was buying.*[57]

Huyghe takes up a different inflection of these tendencies when working alone. *Streamside Day Follies* (2003), like *No Ghost*, also involved the coordination of activities inside and outside a gallery, and the adaptation of a work to multiple contexts. This piece consisted of a community celebration coordinated by the artist in a new residential development (Streamside Knolls) in upstate New York; the filming of this event; the screening of the film at New York's Dia Center; and the artist's collaboration with architect François Roche to build a community center in Streamside Knolls. *Streamside Day Follies* debuted as an exhibition at Dia in October 2003 where the twenty-six-minute film was presented in a specially designed environment with four moving walls and documentary sketches. It then migrated to Marian Goodman's Paris gallery in 2004 where it was projected in a room (now without moving walls) that included a green carpeted floor, a tree, and a graphite wall drawing of a community center by Huyghe and Roche (the building itself remains a work in progress); guests were served cake. The piece is sold in an edition of six as a digital video projection and can be installed in one of two ways: in the configuration with moving walls as at Dia; or as a sequence of two rooms (one with the projection, another with the wall drawing and a tree) as at the Marian Goodman exhibition.

Huyghe is aware of the difficulties such work faces once an initial presentation ends. He speaks of this as a perennial problem, which he seeks to address by "building the context" of an artwork, by which he means taking an active role in developing the "procedures, expectations, conditions of reception and relevant financial parameters" embodied by a project's manifestation.[58] He is cognizant that he makes not only tangible artworks, but systems of objects and ideas. Or, to reinstate the above terms, he establishes actor-networks to which his collectors acquire property rights.

These considerations also surface with Tiravanija. In 1995 Anton Kern, a New York gallerist, organized a dinner by the artist in his apartment. Or rather this was to be the enactment of *untitled 1991 (tom ka soup)*, purchased by Kern for approximately $3,000 and first exhibited at the Jack Tilton Gallery, New York, in 1991. The dinner, staged in Kern's Manhattan loft, was conceived as an intimate get-together for a dozen friends—

33. Rirkrit Tiravanija, *untitled 1991 (tom ka soup)*, 1991. (Courtesy the artist and Gavin Brown's Enterprise, New York)

including Bourriaud and Gillick—familiar with Tiravanija's work. It consisted of a Thai soup and drinks, while Kern retained the cooking appliances and unused ingredients, which have since been stored in a cardboard box in his home. Consistent with the artist's wish, no photographs or videos were taken during this dinner and thus no documents remain to chronicle it. Nor did Kern receive a written contract elaborating the work's parameters; these were conveyed to him verbally.

If Tiravanija deviates from earlier Conceptualists by prohibiting these documentary tools, then what is actually being purchased? Bourriaud raises this question, but his response is ambiguous: "What has one bought when one owns a work by Tiravanija other than a relationship with the world rendered concrete by an object, which, per se, defines the relations one has towards this relationship: a relationship to a relationship?"[59] Kern's explanation is more succinct: "What I have acquired is an idea more or less, a sentiment and communal memory for all involved." He also mentions that he remains interested in talking about this dinner because he knows that "Rirkrit would be happy about the fact that dialogue pertaining to this event was still ongoing."[60]

Yet this is only part of the equation. Tangible objects such as food supplies and cooking equipment accompany this transaction as well, in addition to the terms conveyed by Tiravanija that dictate how these goods are to be utilized and how they may later circulate in the art economy. Holding with ANT, one can therefore identify both tangible and intangible properties (the objects within this system, and the rights governing how this system functions) that enable *untitled 1991 (tom ka soup)* to be seen as a set of property rights and not merely the immaterial niceties articulated by Kern; Tiravanija is firmly the author of this work, its realization is just dependent upon the actions of the actants within its network. An exclusive experience, memory, and timeless discussion may thus be at the core of Kern's acquisition, but so also is a noteworthy quotient of both symbolic and economic capital related to the system in question. Indeed, the very relevance of Kern's purchase to discussions about the economics of this type of art indicates that it was incisive, and it seems reasonable to assume that he could reap multiples of his initial outlay should he ever wish to resell it: later editioned cooking-themed collectibles by Tiravanija have sold for more than $30,000 at auction, and *untitled (tom ka soup)* is both unique and among the artist's earliest such works—possibly implying an even further premium.[61] This is the key difference between purchasing an experiential artwork and merely partaking in it, be it a dinner or otherwise.

Another illustrative case in point involves *untitled 1993 (1271)*, Tiravanija's contribution to the Aperto section of the 1993 Venice Biennale. Here, the artist navigated a canoe-turned-gondola through Venice's canals, out of which he served Cup-O-Noodles to passersby. The work references 1271, the year Marco Polo returned from the Orient and introduced pasta to Italy; Tiravanija's reweaving of this narrative through the gift of a mass-produced commercial export constitutes, as Janet Kraynak has observed, "a foil to enact the disputes over history: who determines it, who has the right to own it, and how knowledge of it is transmitted."[62] After debuting in Venice, it was acquired by Andy Stillpass, an American private collector, who inaugurated its purchase with a Cup-O-Noodles celebration hosted by Tiravanija at his home. The canoe now hangs from a tree in Stillpass's backyard.

One may interpret this interchange as a crass appropriation of an artwork's intended signification—as if, in acquiring the canoe and collaborating with Tiravanija to host a house party, Stillpass stripped the Venetian precedent to its core elements but did away with the historical context and public engagement that made the original work noteworthy. Yet while this reading is not altogether incorrect, it is hardly novel either: the transference of site-specific artworks is always problematic insofar as

34. Rirkrit Tiravanija, *untitled 1993 (1271)*, 1993. Aluminum canoe, two aluminum pots, two camping burners, three tables, six chairs, cup-o-noodles. Dimensions variable. Installation view, home of Andy Stillpass, Ohio. (Courtesy the artist and Gavin Brown's Enterprise, New York)

it entails a shifting of context. Indeed, any time a sculpture is moved, a performance reenacted, a painting rehung or an exhibition reinstalled, the artworks and events take on new meanings. The benefit of ANT is that it helps to downplay an essentialist reading of Tiravanija's original act and implies that future presentations of this work, however different, remain relevant. Put differently, ANT enables us to account for inevitable shifts in context and to contend that far from perverting the foundational circumstances of the artwork, acquisitions like Stillpass's purchase of *untitled 1993 (1271)* are but the logical outcome of an artwork's migration through the marketplace. Thus Tiravanija's canoe can take on one meaning in Italy, another in Stillpass's backyard in Ohio, and perhaps another if it is to be reinstalled in an exhibition elsewhere; the duty of criticism is to weigh the relative merit of these occurrences.

Extensions

In recent years, there has been a noteworthy proliferation of the ways in which experiential artworks have been bought and sold. Here we will look at how some contemporary artists unmentioned in *Relational Aesthetics*

35. Andrea Fraser, *Untitled*, 2003. DVD, RT: sixty minutes. (Courtesy the artist and Friedrich Petzel Gallery, New York)

have sold their work in order to strengthen the correspondence between the focus of Bourriaud's writing and the experiential underpinnings of the contemporary art market writ large.

Andrea Fraser's *Untitled* (2003) offers an abrasive take on the marketing of artistic services. In this work, the artist, with the support of her New York dealer, Friedrich Petzel, commissioned a collector to have sex with her in a hotel room. The encounter was documented by a stationary video camera, the content of which Fraser utilized as the basis for an installation involving a silent, unedited, sixty-minute video of the event displayed on a small monitor. *Untitled* was produced as an edition of five, with one copy going to the collector-turned-participant and the other four being offered for sale by Petzel (two of which have been purchased by European institutions). It is sold with numerous restrictions: the buyer does not have the right to make video stills or distribute any representations of it; the buyer does not have the right to make, broadcast, or webcast excerpts; the buyer does not have the right to loan it without the artist's or gallery's consent; and Fraser is to be consulted before it is shown publicly. "It was about taking the economic exchange of buying and selling art and turning into a very personal, human exchange," Fraser explains. "It had to be based on trust."[63]

TERMS OF SALE

Andrea Fraser
Untitled
2003
DVD
rt: 60 minutes
Edition of 5
AF 03/001

- The artist retains the copyright of the aforementioned work and images thereof.

- The work cannot be broadcast or webcast by the purchaser in any form, in its entirely or in excerpt.

- No video stills or video excerpts can be produced from the work by the purchaser. Three video stills provided with the work may be reproduced by the purchaser for the purpose of representing the purchaser's collection only; they are not to be distributed by the purchaser for publication under any other circumstances.

- The work cannot be projected. The installation specifications require that it be shown on a monitor no larger than 30" that is not directly visible from available seating.

- The work may be exhibited in the facilities of the purchaser, or in the context of an exhibition organized by or representing the collection of the purchaser, with prior consent of the artist or Friedrich Petzel Gallery. The purchaser cannot loan the work to other individuals or institutions for exhibition. All exhibition requests must be referred to the artist or Friedrich Petzel Gallery.

- Any publication or didactic material related to the work must be approved by the artist.

_____ _____
Friedrich Petzel Gallery Purchaser

36. Andrea Fraser, *Untitled*, 2003. Terms of sale. (Courtesy the artist and Friedrich Petzel Gallery, New York)

The piece treads precipitously between sensationalism and institutional critique. Some writers sarcastically derided its constitution as "interactive art" while others questioned the relevance of Fraser's act as veritably "transgressive."[64] Whatever one's take, *Untitled* clearly exceeds the collector's physical encounter with Fraser and also encompasses the documentation of this interchange as an object (installation), a recording (video), an image (video still), and a topic of debate. The piece is thus simultaneously a literal and metaphorical engagement with the idea of selling art *as prostitution* and "objectification," and a resuscitation of Conceptualist interest in aligning modes of production, reception, and distribution.[65]

A different iteration of this play on interactivity is evident in the work of Tino Sehgal. The artist, championed as having been trained in dance and economics, produces performances-cum-installations that substitute objects for choreographed people and often play with art world conventions. *This Is Good* consists entirely of a museum guard standing upright, bouncing from leg to leg, stopping, and then declaring, "This Is Good, Tino Sehgal, 2001. Courtesy the artist," drawing attention to artwork credit lines.[66] *This Objective of That Object* (2004) consists of five actors who swarm audience members upon entering the exhibition space. It is carefully staged: move and they move with you; respond to their statements and they will retort in a staccato of theoretical snippets; fail to engage in their "discussion" and they fall to the ground, terminating the piece—but only until the next spectator enters and the process is renewed. Sehgal does not circulate press releases with his work, there are no opening parties, and documentation is forbidden. Yet his art can be, and is, collected, and what one acquires is the right to enact such a work according to Sehgal's script. Like our earlier example by Yves Klein, Sehgal conveys the work's terms orally to the collector in the presence of a notary and often a curator or conservator. Should the work be resold, the owner is instructed to do likewise, and on and on. The artwork is thus performed and its mode of circulation is a performance. Not unlike the children's game of telephone, a work's materialization is dependent upon how clearly the terms of its production are conveyed and how accurately these instructions are then deployed.

Sehgal renews a literal preoccupation with Conceptualism's dematerialization: "While most artworks in being objects mirror what has been the historically prevalent mode of economic production, the transformation of material, these works propose the transformation of actions as a way of obtaining a product or an art work."[67] Yet despite his earnest efforts, one senses, with those like Huebler and Weiner in mind, history repeating itself. The problem is that this crafty neoconceptual gambit risks becoming a dead-end, a slick mode of product differentiation that in

fact replicates and reifies to a higher degree the material objects against which his art is pitted. One critic's perspective is especially scathing:

> The oral contract is, near as I can tell, the only added-value in Sehgal's process.... In the case of Sehgal, the oral contract clause is nothing other than a gimmick which deflects attention from the main issues.... What he is selling [collectors] is a certain status, like country club membership. His hyperbolic claim that his activity "has nothing to do with the model of production on which our civilization is based" is either a joke or an index of his ignorance of the body of work on cultural and social (re)production in areas as diverse as history, anthropology, and sociology. His collectively corporeal, non-immaterial, institution-bound events are, at any rate, indifferentiable from what, in 2006, goes under the name "theater-production."[68]

Far from being delinked from earlier administrative preoccupations, the selling of certain contemporary experiential artworks remains firmly entangled therein.

This gamesmanship is even more acute in the late Jason Rhoades's *Black Pussy* series, comprising his Black Pussy ... and the Pagan Idol Workshop, 2005, an immersive exhibition-cum-mock flea market in London's Hauser & Wirth Gallery, and a series of events entitled *Black Pussy Soirée Cabaret Macramé* at the artist's Los Angeles studio from January to July 2006. In the former, exhibition visitors were required to navigate a clustered environment of neon signs, dream catchers, and thrift store curios; the latter involved ten invitation-only "soirées" structured as "hybrids of performance, Happening, dinner party and art opening" and premised upon "high levels of guest participation."[69] While Rhoades's galleries flaunt *Black Pussy*'s blatant commercialism as illustrative of the artist's "conceptual vigor"—evident in the creation of a coffee table book and soundtrack from the Los Angeles events—they are considerably less transparent about how this work has actually been marketed. In fact, the entire Hauser & Wirth environment consisted of 360 sculptures, which were sold individually.[70] And in a final act, the Los Angeles studio was reconstituted as a solo exhibition at New York's David Zwirner Gallery from November 2007 to January 2008 and ultimately sold as a single installation. This dual *coming-together* (as environment/event) and *merchandising* (as sculpture/installation) is exemplary of the financially shrewd decomposition of contemporary experiential art, and of how event-driven spectacle and the aura of an artist-cum-maverick impresario are enlisted to imprint high art values. With the passing of time, they may also come to be seen as exemplary of the glut that has characterized the contemporary art market during the post-2000 bubble.

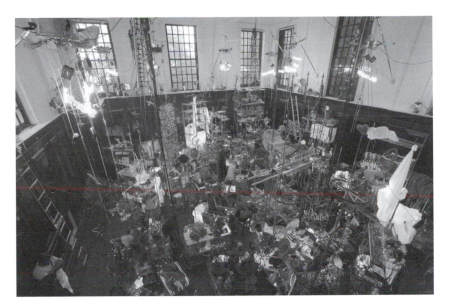

37. Jason Rhoades, *The Black Pussy ... and the Pagan Idol Workshop*, 2005. Installation view, Hauser & Wirth, London. (Courtesy the Estate of Jason Rhoades and Hauser & Wirth)

Hajoe Moderegger and Franzy Lamprecht's *International Airport Montello* (2006) offers an excellent alternative example of how these types of works enter the market and literalizes the idea that art may be sold as a touristic event. In January 2004 Moderegger and Lamprecht, who go by the name of eteam, purchased a ten-acre tract of land near Montello, Nevada, on eBay. Montello is a sparsely populated frontier town located in the northwestern part of the state, and the land acquired was identifiable only with the assistance of a Global Positioning System. The two struggled with the accessibility of the plot and, more fundamentally, with the project's financing (they are not represented by a commercial gallery, thereby posing an extra challenge).

In spring 2005 eteam secured a grant from Art in General, a not-for-profit New York gallery, and in conjunction with capital allocated to them through a 2006–07 NYSCA Individual Artist Grant, Finishing Funds from the Experimental TV Center, and the opportunity to stay and work in the area through the residency program of the Center for Land Use Interpretation, they embarked upon the construction of a fictitious international airport. Ultimately, the artists decided to organize an event in which a chartered plane would depart from New York and disembark in

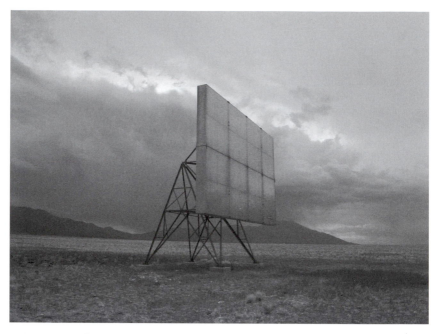

38. eteam, *Reflector*, 2007. C-Print, 20 × 30 in. (Courtesy the artists)

Montello for half of a day before continuing onward to Las Vegas. The project was conceived as an interactive performance in which all "passengers" had a role to play: Sofia Hernández of AIG was a stewardess, Montello residents managed an impromptu airport bar and café, while Moderegger and Lamprecht were airport representatives who surveyed the activities with video cameras. Such an undertaking corresponds to other projects by eteam that abstract and reorient commonplace activities, and it constituted an obvious play on the peripatetic nature of the increasingly global, contemporary art world.

Depositing these participants in Montello on a chartered flight was costly, exceeding the $6,000 budget of AIG's grant. For eteam, however, this financial challenge proved to be among the most interesting aspects of the project: "How do you sell something," reflects Moderegger, "which is not the destination?"[71] The solution evolved out of adjustment and compromise. Moderegger and Lamprecht, in consultation with representatives of AIG, decided to structure the event as a three-day getaway in which the Montello layover was but a single element of a "cultural tour" through Nevada. eteam, however, would be present only in Montello; the rest of the excursion was led by an AIG constituency and included two journalists, alongside a half dozen collectors who paid $5,000 each for

the experience plus a photograph taken by eteam on the site. This photographic edition (of ten) was subsequently sold at AIG for $2,500, while Moderegger and Lamprecht have since produced a three-screen installation and single-channel video from recordings of the event.

Hernández has remarked upon the project thus: "I want to see the *International Airport Montello* in relation to land art in the area, not in the context of relational aesthetics."[72] Yet even if one chooses to do so, the flexible model of financing and exhibiting undertaken by Moderegger and Lamprecht is reminiscent of relational aesthetics artists. As with some of our earlier examples, the piece is less about what is physically produced, *pace* Kwon, than the services provided. Lamprecht's thoughts are exemplary:

> The project is based on belief. It's a collaborative belief system, maybe like the stock market. Everyone assumes, and gets reassured by the others, who assume as well, that the others assume.... Because it is often just the moment of a collaborative belief and effort that manifests the appearance of the work and transforms the possibility into a reality, *International Airport Montello* continues our investigations in how to create remembrance of those moments.[73]

And when sold, it is this belief in the relevance of eteam's avant-gardist event-cum-holiday that adds value to one's experiences and the residual editioned photographs.

• • •

Mindful of these examples and the analysis above of Tiravanija via Conceptualism, the overriding feature of such sales is the fundamental hybridity they encompass. The product under consideration may be an event; it may consist of an interpersonal experience; it might take the form of a contract, verbal agreement, even a libretto; it may be a book, prop, photograph, drawing, speech, video, or film; it may be at once an installation and a sculpture; and it is likely to be a permutation of some, or many, aspects of the above. Bourriaud enthusiastically acknowledges this flexibility as a defining feature of relational aesthetics, yet his attempts to distinguish it from conceptual precedents are overstated: "Relational art, which is well removed from the administrative rationality that underpins it (the form of the notarised contract, ubiquitous in the sixties' art), tends to draw inspiration more from the flexible processes governing ordinary life."[74]

But just how "well removed" is relational art from Conceptualism's "administrative rationality"? One might reinstate Alberro's perspective on the Projansky Contract to contend that any distancing is but a testament to the continued market success of Siegelaub et al.: today's "experiential"

artists may operate at an arm's length from administrative criterion only insofar as these guidelines are taken for granted by themselves and by the marketplace. Stallabrass has addressed these dynamics thus:

> Art in the 1990s has sometimes been thought of as a synthesis between grandiose and spectacular 1980s art with the techniques and some of the concerns of conceptual art. The result was to splice linguistic and conceptual play with visually impressive objects.... Perhaps this synthesis is the result of a negative dialectic, which has forced on art not a realisation but rather a taming of Conceptualism's radical critique, in a false accommodation with what it most despised.[75]

To be fair, Stallabrass is not explicitly referring to *Relational Aesthetics*. The specific example he raises is *Seven Ends of the World* (2003), an installation in which Tobias Rehberger—an artist unmentioned by Bourriaud—has filled a room with clusters of glass balloons in what is described as "both a technically accomplished, spectacular and appealing object, and the manifestation of an idea."[76] But neither is he omitting such tendencies from this account, as the synopsis above is intended to serve as an engulfing generalization, and he proceeds, a few paragraphs later, to discuss *Relational Aesthetics* protagonists such as Maurizio Cattelan and Gabriel Orozco to refine his argument.

The previous section's discussion further strengthens historical links to the marketing of conceptual art. What we shall consider here is how the current generation of experiential artists' insistence upon *use*, as exemplified with Tiravanija, has a contentious relation with the actuality of how their output circulates within the art economy, especially the continued exhibition of detritus and props from performances. I have already discussed the contentious aspects of Stillpass's purchase of *untitled 1993 (1271),* but it should be stressed that despite even the best intentions of private collectors and institutions, practical circumstances may curtail the modes of engagement upon which Tiravanija's practice thrives: cooking or loud music may simply not be feasible due to museum regulations, and the artist may not be able to attend his events in person. The 2002 presentation of Kern's *untitled 1991 (tom ka soup)* at the San Francisco Art Institute offers an excellent example of the former (a meal was prepared in the gallery's cafeteria to inaugurate the exhibition opening, but detritus was then placidly installed for the duration of the show), while the 2004 exhibition of *untitled 1991 (musselslessum)* at the Los Angeles Museum of Contemporary Art exemplifies the latter (neither Tiravanija nor his assistants could attend the show, so a meal was prepared in curator Michael Darling's home before the opening and the remnants were statically displayed during the exhibition).[77]

Untitled 1996 (lunch box), sold by 1301PE, Tiravanija's gallery in Los Angeles, offers an even more extreme example of these issues. An edition of 108, this $800 work consists of a stainless steel tin from Bangkok, a four-course Thai meal, a stamped and numbered Thai menu, and a Thai newspaper from the date of purchase. The piece requires collectors to ring 1301PE with the name of a local Thai restaurant which, within three days, will home-deliver a meal and associated objects (mailed to them from the gallery). As 1301PE's director, Brian Butler, explains, these props are not intended to be collected as relics, but as devices to be employed on the day the meal is delivered and thereafter; he even suggests that if brought to auction, the value of an unused Tiravanija prop should be no higher than its initial purchase price.[78] These comments, of course, simply reiterate those consistently made by Tiravanija: "Basically I started to make things so that people would have to use them, which means if you want to buy something then you have to use it.... It's not meant to be put out with other sculpture or like another relic and looked at, but you have to use it."[79] However, while this optimistically shifts focus from acquiring a "lasting object of status and taste, to an ongoing process," it remains unclear how frequently collectors will actually "use" (and reuse) such artworks.[80] Stillpass's canoe hangs in his backyard and Kern's artefacts remained in storage for nearly a decade before they were reexhibited at SFAI. Tiravanija and Butler's urgency for the work to be put into constant use may thus result in a debilitating sense of being unfulfilled if this clause is not met. In the end, this underscores what a piece like *untitled 1996 (lunch box)* actually is—a limited edition artwork that does little more than index hallmark elements of the artist's practice (Thai culture, food).[81] It is a collectible. No more. No less.

Nancy Spector detailed just how precarious this interchange has become when addressing the Guggenheim Museum's acquisition of Tiravanija's *untitled 2002 (he promised)* and the problems that arose with American Express, the corporation that helped support the purchase of this work. Specifically, Spector recounted how party planners hired by American Express turned what was supposed to be a downtown art event in October 2004, at which a new credit card would be launched, into a posh, if not crass, public relations function without honoring their portion of the deal—to secure the needed permits for the museum to mount a subsequent four-day presentation of the work in accordance with the artist's specifications.[82] It was not until the Guggenheim pointed out a potential breach of contract that the company coordinated the necessary permits for the public film screenings and a twenty-four-hour concert finale that Tiravanija mandated under the original terms of agreement.

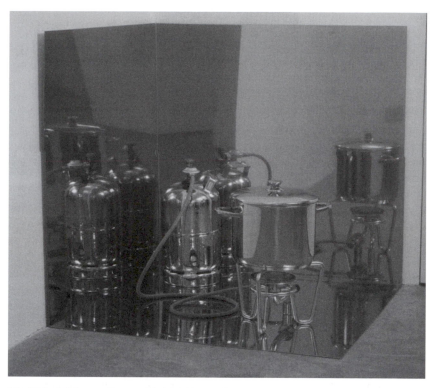

39. Rirkrit Tiravanija, *untitled 2003 (cooking corner)*, 2003. (Courtesy the artist and Gavin Brown's Enterprise, New York)

This is evocative because it underscores the pros and cons of ANT's applicability to the art economy. On the one hand, this framework is useful in enabling us to understand an artwork like *untitled 2002* not as an autonomous object—merely a chrome replica of the Schindler House— but as a complex network in which a physical structure is used as a platform for film screenings, concerts, meals, and other activities that may change over time. But on the other hand, this very open-endedness means that such works may fail to be fully realized: in Spector's anecdote, were the weekend activities not coordinated, the Guggenheim would merely have inaugurated a piece of architecture, but not a legitimate Tiravanija "artwork."

All contracts are open to abuse, of course. But as the actant networks of such artworks grow, making them inherently more complex, they may be particularly susceptible to misuse. Their parameters may not be familiar to the parties involved in their presentation (versus the display conventions for more traditional artworks), especially in cases when obligations

are not expressed in writing (as is the case with Tiravanija, and Sehgal, who purposefully do not issue written sales agreements with their art). This is one actuality that makers, buyers, and exhibitors of experiential artworks must take note of as such pieces migrate through the art economy. I return to this problem at the end of this chapter; here it serves as a useful segue to extend our debate onto a discussion of how experiences today constitute increasingly decisive filters for transactions in the broader contemporary art world.

Lifestyle

Up until now, discussion has been limited to how the market for experiential art operates. However apposite, such an analysis is nevertheless subject to a literal reading of the art experience economy premised upon how certain types of practices are bought and sold. But what if the terms of the debate are broadened? What I would like to suggest is that an equally significant aspect of this debate concerns how art-related experiences have come to constitute increasingly important frameworks for collectors' engagements within the contemporary art market at large.

It is imperative to clarify the terms of debate. First, artistic value creation has for centuries been inseparable from art's social function—as a status symbol and as a means of communication and group identification. Insofar as these factors are determined by the contexts in which art is seen, discussed, and traded, social experiences have long been elemental to defining art's financial worth. What has changed is the explicitness with which art's lifestyle attributes are marketed by art businesses: the contemporary art experience, epitomized by an upwardly mobile set of globe-trotting actors and activities, has become a veritable commodity in and of itself.

Adam Lindemann's popular book, *Collecting Contemporary* offers an exemplary illustration of this development.[83] Lindemann is a collector. This is crucial, and a rare occurrence historically, because it suggests that his "insider" knowledge sets him at a relative advantage to the distanced scholar. The book, however, is less about *what* Lindemann knows than *who*, as its contents comprise edited transcripts of his conversations with prominent art world actors, encapsulating much of today's art world writ large. Appendices include an interview with Sam Keller, then director of Art Basel; a four-page section entitled "A Year in Art Collecting" that presents an annual calendar punctuated with dates and descriptions of important art auctions, fairs, and biennials; and a "Partial Glossary of Terms You Need to Know" that offers a roughshod summation of art-historical and trade argot.

The impression, consistent with the book's claim to help one "navigate the art market like a pro," is that collecting can be telescoped into a tidy sequence of gala sales events, "heavyweight" exhibitions, and apposite name dropping. Perhaps it is so. Lindemann terminates his brief introduction to the book with a section entitled "the social life/the art scene": "There is no doubt that a large part of the Contemporary Art world is the art scene, and this is mostly a good thing. The number of people showing up at auction previews and art fairs grows and grows. Most of them have money but buy nothing. Why? ... The Contemporary Art world is fast becoming a major social event, and people are there to see and be seen, as much as to look at and perhaps to buy art."[84] One does not merely purchase artworks but consumes the art lifestyle.

This social experience, if ever-present within the art market, has come to constitute an increasingly lucrative business commodity. Concurrent with the rise of global high net worth wealth since the 1990s, for example, a number of leading financial institutions opened, or expanded, art advisory departments of their own, a phenomenon we will look at more extensively in the next chapter. Services include tax and estate planning, purchasing advice and facilitation, curatorial and conservation assistance, art loans, and social perks such as VIP invitations to the types of events mentioned by Lindemann. Ideally, this represents a sophisticated model for managing clients' art and financial assets under one umbrella, with the value-added benefit of providing privileged *access* to leading galleries, artists, and art functions.

Access is critical to understanding the art experience economy. Consider Fine Art Wealth Management (FAWM), a London-based firm launched in 2004 by Randall Willette, former executive director and head of art banking for UBS Wealth Management. In addition to the aforementioned services, the firm also caters to clients' lifestyle needs. A subsection of FAWM's website is simply titled "Events & Lifestyle Services":

> A new breed of collector is filling the seats at Sotheby's and Christie's. This new collector wants to be part of the art world, meet the artists and hang out at their parties.
>
> Today's private clients are seeking "lifestyle" services as well as "wealth services." To grow, private banks will have to adapt their service offering to this new client, for whom wealth is no longer defined as net worth.... The traditional collector is giving way to those who want an environment enhanced by a variety of art objects and the social status that goes with it.[85]

Redoubling the affirmative nature of these propositions—that art consumption enhances one's lifestyle and is about not only buying artworks, but meeting artists and hanging out at their parties—FAWM supplements

its lifestyle address with a flowchart compiled by consultants CapGemini/
Ernst & Young, entitled "The Lifestyle Needs of Private Clients." It reads
like an opportunistic lesson in social climbing and civic idealism: (1) "Ex-
perience life changing financial events" (an IPO, stock options, inheri-
tance, etc.); (2) "Enjoy success and establish new social structure" ("buy
yachts and planes," *build an art collection*, "meet and develop rela-
tionships at new social levels"); (3) "Take care of family and loved ones";
(4) "Give back to the community."[86] More so than even Lindemann's
book, it intones that one's assumption into a respectable art world posi-
tion, as a collector or philanthropist, can be achieved with a measured
blend of social acumen and managerial box-checking.

This raises the question, of course, as to whether there is a "new" col-
lecting class for contemporary art, or whether its appearance, as postu-
lated by Willette, is merely a fleeting product of the most recent art bubble.
Because FAWM has a vested interest in perpetuating this notion—new
collectors are obvious target clients—one should be wary of the firm's
promotion of this claim. Furthermore, while the art world's globalization
has certainly made collecting more international, we have already observed
in the introduction that the United States and Europe remain the domi-
nant art market centers.

But despite these limitations, we have equally seen how significant lev-
els of new money have entered the contemporary art market in the new
millennium and how conventional forms of connoisseurship have declined
in the inverse.[87] This fueled the speculative run-up of prices and helped
make the art economy more diverse and pluralistic, ultimately enabling
experiential practices to flourish. For while the notion of purchasing in-
tellectual property rights may be obscure to relatively older and more
traditional collectors, it is increasingly harmonious to a younger genera-
tion that has come of age in the knowledge economy. Such collectors,
characterized by their mobile cosmopolitanism and ravenous pursuit of
new trends, also generated a surplus of demand for art-related experiences,
in general. In the next section, I examine the basis of this art experience
economy before concluding by looking at some of the various ways it is
currently being manifest.

The Experience Economy

It is instructive to return to Bourriaud to evaluate these issues. Despite the
rush of art critics and historians to expose the flaws of his theories, *Rela-
tional Aesthetics* remains an exemplary point of departure for economic
analysis of the contemporary art market precisely because of its correspon-
dence to trends in business management. In *The Experience Economy*,

Joseph Pine and James Gilmore argue that experiences have emerged as a fourth distinct economic offering, differentiated from commodities, goods, and services. Their argument parallels the economic dimension of Tiravanija's art and Bourriaud's theses: "While commodities are fungible, goods tangible and services immaterial, experiences are *memorable*. Buyers of experiences ... value being engaged by what the company reveals over a duration of time." This is summarized in the following formula: (1) Extract Commodities; (2) Make Goods; (3) Deliver Services; (4) Stage Experiences.[88]

Coffee chain Starbucks and themed restaurants like the Rainforest Café and Planet Hollywood that rose to prominence during the 1990s are obvious illustrations of Pine and Gilmore's concept (forging "eatertainment" experiences). Others include the toy store FAO Schwartz and Niketown, "which draw customers through fun activities and promotional events (sometimes called 'shoppertainment' or 'entertailing')."[89] Yet the experience economy comprises broader shifts in branding and marketing, too. In manufacturing, it is used to explain the change in emphasis from how goods perform to how consumers feel while using them. Thus Infiniti, the luxury division of Nissan, has trademarked the phrase "Total Ownership Experience" to underscore the comprehensive experience of purchasing, driving, servicing, and owning a car. Or consider the following statement by Gary Bonnie of Hillenbrand Industries, a company that offers memorabilia capability for funeral ceremonies: "What we sell is the *lifescaping* experience of gathering with others, rummaging through old photographs and other mementos, and recalling fond memories. The collage just happens to be the outcome; the true value is experienced in going through the process we've helped script."[90]

Such reflections share an emphasis on process and experience as the locus of value evident in much post-1960s art. They exceed this as well, having discovered a parallel function in the marketing rhetoric of today's art service providers such as banks, advisors, and consultants who, following FAWM, promise not merely to manage collections, but to integrate collectors into the art lifestyle. Reverberations of these themes permeate many of today's business industries, including the lifestyle and financial services sectors, and retailing, which has witnessed the rise of "mass customization." Pine and Gilmore contend that between 1959 and 1996, employment in experiential industries grew at nearly twice the rate of the service sector as a whole; companies that stage experiences benefited from price increases well in excess of inflation.[91]

One problem is that Pine and Gilmore, like Bourriaud, struggle to defend the periodization of their thesis: though experiential marketing circa 1990 is arguably more comprehensive and strategic than ever, the concept certainly predates this moment, and even the onset of postmodernity.

The rise of department stores such as Harrods and Galleries Lafayette at the dawn of the twentieth century, for example, was premised upon similar experience staging—an engulfing architectural space combined with the myth that anything could be purchased. Nor is it altogether clear whether customers demand experiences per se, or if they are just briefly smitten by some such businesses: twice bankrupt Planet Hollywood, which has closed scores of international branches over the past decade, and the initial fiasco of London's Millennium Dome suggest that merely staging experiences does not ensure long-term success. In actuality, Pine and Gilmore's strongest claim concerns more than offering consumers prepackaged experiences; it is about crafting *individualized* experiences and dynamic services of personal relevance.[92]

A number of recent books have picked up on and extended this point. Paul Nunes and Brian Johnson's *Mass Affluence* demonstrates how changing demographics have led businesses to tailor their marketing and product offerings to new types of consumers. They present the following statistics to illustrate the rise of "moneyed masses": the top 1 percent of earners has seen its share of income explode, from less than 10 percent of total income in the United States in 1979 to 18 percent by 1997 and 21 percent by 2000; in 1970, 3.7 percent of Americans made more than $100,000 per annum (in today's dollars), whereas 13.8 percent did so in 2001.[93] This has eradicated what in midcentury was termed the "mass market": the wealth distribution curve has become bulkier at the lower end and both fatter and longer at the upper end, all at the expense of the stereotypical middle class. Such statistics reflect similar developments in the growth of the HNW space, but rather than concentrate on buying patterns of the ultrawealthy who account for the bulk of art collecting, Nunes and Johnson focus on the expansion of "affordable luxury" markets (Gucci shoes versus private planes) and new ownership patterns such as leasing.

This latter observation is a departure point of Jeremy Rifkin's *The Age of Access* in which he remarks upon intangible assets, the downfall of private property, and a "weightless economy" to identify an economic shift from ownership to access.[94] Rifkin offers an expansive account situated in the onset of the 1970s postmodern economy. "The *sharing* of economic activity is the defining feature of a network-based economy," he writes, while adding that the market for tangible goods is reaching satiation, being substituted by the public's embrace of commodities that promise only ephemeral utility.[95] Partial ownership structures associated with cars, executive jets and holiday time-shares are some of the examples he utilizes to illustrate the types of financial products and services available to today's consumers. In aggregate, they substantiate an economy in which "experiences" of every variety are rendered marketable.[96]

C. K. Prahalad and Venkat Ramaswamy's *The Future of Competition* assesses how the Internet is changing the nature of interaction between firm and consumer. Diverging from Pine and Gilmore's argument, which investigates how experiences can be staged by companies to add financial value to their offerings, this book focuses on new opportunities for cycling value between firm and customer. The authors associate this with the rise of "consumer-to-business-to-consumer" (C2B2C) patterns of economic activity in which the "new value creation space" is identified as "a competitive space centered on *personalized co-creation experiences* developed through purposeful interactions between the consumer and a network of companies and consumer communities."[97] This is a more networked view of business similar to that postulated by ANT: the goods, services, and experiences under consideration do not possess essentialist identities but are in the constant process of formation. One upshot is that it carries potentially radically different implications from that advanced by Pine and Gilmore regarding who is controlling the experience.[98] This divergence can be explained by the Internet's growth in the intervening years between these publications and increasingly sophisticated comprehension of its economic opportunities.

One of the most interesting subplots of this experiential landscape is how artistic avant-gardism itself has influenced business management. Again, this trajectory is not unique: oppositional practice and radical cultural symbols have long been appropriated into mainstream functionality. Yet its contemporary manifestation is unparalleled, ushering in a moment in which entrepreneurialism has become tantamount to thinking outside the box, as so-called fashion hunters scour cultural developments in search of marketable trends, products, and content.[99]

The most comprehensive account of these developments is Luc Boltanski and Eve Chiapello's *The New Spirit of Capitalism.* Boltanski, a sociologist, and Chiapello, a business school instructor, combine disciplines to divulge their painstaking analysis of changes in business management guidebooks between the 1960s and 1990s, which they use to develop a theoretical account of capitalism situated in Max Weber's earlier discussions of the subject. They analyze three historical stages in the spirit of capitalism. The first, advanced at the end of the nineteenth century, is structured upon the ideal of the bourgeois entrepreneur who employed a "vulgar utilitarianism ... to justify the sacrifices required by the market in pursuit of progress"; this is the "heroic" speculator, the "conquistador." The second emerged between the 1930s and 1960s and represented a shift in emphasis toward the organization: this constituted itself in the birth of the managerial class who replaced the singular "captain of industry" and instilled security through long-term planning and economizing rationalism; civic functions were elaborated through solidarity between

firm and state in pursuit of "social justice." The third took hold at the turn of the 1990s and remains the dominant ideology today. It rejects hierarchy altogether, focuses "obsessive attention" on flexibility and adaptability to change, and is premised upon the ideal of a "networked," global firm in which workers are organized in small, mobile, and multitask teams capable of quick and efficient mobilization. Whereas in the 1960s care was taken to make bureaucracies more flexible, Boltanski and Chiapello observe that "the [business management] literature refrained from challenging basic principles": the 1990s, by contrast, were characterized by a "subversion of hierarchical principles" referred to as the "big bang."[100] If Pine and Gilmore's thesis draws intuitively upon avant-gardist strategies such as the deprioritization of tangible goods to immaterial experiences, top-down product offerings to collaborative processes, Boltanski and Chiapello offer a comprehensive empirical account of how these strategies have been incorporated into managerial tactics and how they have evolved even more robustly than discussed in *The Experience Economy*.

"Cool capitalists" like Bill Gates and Ben and Jerry are figureheads of the new spirit of capitalism; "casual Fridays" and pool tables abutting work cubicles are tentacles through which its logic permeates the workforce's psyche. "So rhizomatic has management literature become," contends one review of this book, "that Boltanski and Chiapello almost suggest, in mischievous mood, that [Gilles] Deleuze and his followers could be taken for management gurus rather than anti-establishment philosophers."[101] But this is precisely the point, having been anticipated by Frankfurt School philosophers like Theodor Adorno and postmodern theorists like Fredric Jameson skeptical of the interpenetration of work and leisure, and the coopting of cultural, even anti-establishment, production into capitalist enterprise.[102]

Tim Griffin addressed some of these tendencies and the prevailing need to stimulate critical conversation on the subject in his inaugural column as editor-in-chief of *Artforum* in 2003:

> Information-based industries knowingly re-purpose the art-historical lessons of dematerialized objects. ("You see coffee," reads one recent Sprint ad featuring the image of a single steaming cup. "We see data.") Even something so intangible as emotion is today fully acknowledged in the business pages as a source of value, with products designed to transform living into lifestyle as part of the "experience economy." (Consider "blue" become the more leisurely "Bondi Blue," named after an Australian beach, in iMac coloration).[103]

In an important article of 2005, Matthew Jesse Jackson compares Spencer Johnson's *New York Times* personal finance best-seller, *Who Moved My Cheese?*, to the Palais de Tokyo's curatorship under Bourriaud

and Jerôme Sans. Commerce, entertainment, and art viewing here casually "flow" from one to the next, "with the three activities admixed in intoxicating ways"; this specific example is but a microcosm of developments in the newly global contemporary art world, and it indicates how experiential protocols surface here with force.[104]

Laboratories, Museums, Biennials

Several post-1990 developments reinforce the link between experience economy rhetoric and the experiential underpinnings of today's art world. Three of these pertain to shifts within the museum industry and account for the growth of on-site artistic creation, the upsurge of multinational museum partnerships and branches, and the increasing number of biennials in the global exhibition landscape; another concerns the boom in contemporary art fairs.[105]

Jackson's Palais de Tokyo reflections correspond to the increasingly popular tendency of contemporary art institutions to pitch themselves as sites of artistic production. This is a crucial distinction: versus a museum's traditional function to amass and display works from its collection, this trend thrives on the constant commissioning of new work and the internalizing of this process into how audiences experience their time in galleries. Again, this is not new. Conceptual art exhibitions such as Harald Szeeman's seminal show, When Attitudes Become Form, 1969, popularized the commission-centric approach to presenting art. The difference between then and now is that this focus has become the modus operandi of a growing number of art institutions. "While the exhibition site constituted a medium in and of itself for the Conceptualists," urges Bourriaud, "it has today become a place of production like any other."[106]

This tendency is epitomized by the Palais de Tokyo, where, between 2001 and 2005, Bourriaud and Sans advanced their model of a progressive art institution as a "site of contemporary creation." Their codirectorship involved adjusting the institution's hours of operation (now from noon to midnight); dismissing "white cube" display in favor of exposed industrial walls and concrete floors; and integrating a large theater into the main exhibition space. Only sparse physical barriers distinguish this space from the adjoining restaurant, shop, and café. *What Do You Expect from an Art Institution in the 21st Century?*, published by the Palais de Tokyo on the occasion of its launch, compiled hundreds of responses to this question from leading curators, artists, writers, designers, and architects: the prevailing sentiment is one of utter flexibility and open-endedness—the ability to "dream," as Sans and Marc Sanchez write, "of institutions that

are different: venue-laboratories, places of adventure, open to all questions, contradictions, risks."[107]

Bourriaud and Sans's activities coincided with those of other European noncollecting institutions such as the Kunstverein Munich, under the curatorship of Maria Lind from 2001 to 2004, and BALTIC Centre for Contemporary Art, Gateshead, an "art factory" founded in 2002.[108] Lind's "Sputnik" program saw the institution appoint cultural advisers (artists, curators, critics) who were tasked with three-year consulting relationships. Collaborations could result in the production of exhibitions or symposia, but just as well in creating new ways for the Kunstverein to engage with its public: Gillick created a new display space and furniture to present the institution's archive to visitors; Apolonija Susteric overhauled the entrance foyer, inviting "visitors to talk together or simply relax"; Carey Young revamped the Kunstverein's advertising material.[109] BALTIC's architectural layout was conceived as a vertical stack of artist studios, galleries, and cinemas as well as a shop, café, and top-floor restaurant, all of which opened onto an unobstructed view of the converted ex–flour mill's interior space.[110] In theory at least, visitors could freely peer into the studios of visiting artists-in-residence as they circulated throughout the building, thus furnishing a dynamic exhibition experience supplemented by the ability see works *being made*.[111]

Although these changes in exhibition programming and museum design are significant signposts of a shifting articulation of the audience experience, they are modest by comparison to mainstream institutional expansions of the same period. This trend, the second of the factors under consideration, has been widely documented. It is important to mention it briefly here because it exemplifies the event-driven conflation of museum management and cultural tourism: it is a vision of "destination art" in which the act of *seeing* art is complemented, even eclipsed, by the touristic experience of *being there*. The rationale is familiar: through the implementation of signature architecture, an art institution's expansion—by either renovating an existing exhibition space or creating a new building—can enhance the museum's brand and drive regional economic development. Fraser has quoted former Guggenheim director Krens on the contemporary museum's insatiable need for expansion: "growth is almost a total law.... Either you grow and you change or you die."[112] And both she and art historian Hal Foster have written on the vicious circle of "spectacularization" in art and its institutions: "Big art demands big spaces. Big spaces demand big art. Big, spectacular art and architecture draw big audiences"; the logic perpetuates ad nauseum.[113]

The growing number of museum expansions and international partnerships is also correlated with the 1990s biennial boom. Salient aspects

of these developments are well accounted for in the literature and were raised in the introduction. Here, it suffices to underscore that a neoliberal ethos similar to that of the museum expansions is largely accountable. Biennials represent potentially substantial sources of revenue from tourism, advertising, and art sponsorship to the benefit of their host localities, and to associated artists and curators as well. They are thus especially attractive to emerging economies and regions where contemporary art institutions are otherwise sparse. Importantly, they share with the aforementioned institutions an emphasis on commission-based work and an administrative flexibility that enables new artistic trends, typically orchestrated by rotating curatorial teams, to be presented. At best, this generates progressive cross-cultural dialogue such as in Okwui Enwezor's Documenta XI, 2002, which was structured as a sequence of five "Platforms" spanning two years: the first four represented an international series of conferences and lectures on globalization; the fifth constituted the art exhibition in Kassel, Germany. At worst, however, some biennials may struggle to shake suspicions that they are much more than exercises in cultural branding.

There is an interesting relationship at play here between the spectacularization of museum spaces and biennials, on one hand, and the emergence of experiential exhibition structures and art-making tactics, on the other. The latter, which range from Tiravanija's dinners to Sehgal's performances to the Palais de Tokyo's program, are certainly spurred in conscientious response to the former: bold production and exhibition methods are substituted with alternative models of engagement that place comparatively less emphasis on the presentation of tangible artworks. But there are at least two problems with this. First, these methods are not entirely new: the great loan exhibitions of the nineteenth century foreshadowed an experiential model based on the staging of epic singular events rather than the presentation of static collections.[114] And second, the "alternative" paradigm has lost much of its oppositional thrust as artists like Tiravanija and Sehgal have increased in renown and as art institutions across the board have adopted the experiential ethos.

Many of these tensions were apparent in the Sixth Caribbean Biennial, 10–17 November 1999, organized by artist Maurizio Cattelan and curator Jens Hoffman on the island of St. Kitts. Its roster included ten of the most visible contemporary artists (including Tiravanija), it counted major art institutions as sponsors, and it prompted the publication of a hardcover book.[115] Yet despite these symbols of credibility, the project was an insiders' hoax: no artworks were exhibited, nor, notwithstanding cryptic magazine advertisements (published in *Frieze*, *Artforum*, and *Flash Art* in November 1999), was any "public" invited to attend. Rather, its protagonists, in addition to a small group of invited journalists, photographers,

and friends, congregated at the Golden Lemon beachside resort and partook in a collective ruse—"sharing meals, sun, and baths; erasing any trace of art and elevating conversation to a virtuoso exercise."[116]

One can question whether the project's mode of refusal (of outsiders, of presentable content) was progressive or just lazy—even elitist. In actuality, it was probably a mixture of all those things, and certainly an illustration of its organizers' shrewd public relations acumen. For our purposes, the single most significant aspect of the Sixth Caribbean Biennial is how it testifies to the politically compromised status of art and exhibition making at the very moment of the art world's globalization. Indeed, the curators' decision to locate their faux exhibition on a holiday destination island offers a cynical vision of the biennial's dead-end elaboration as *nothing but* cultural tourism. Art historians Katy Siegel and Paul Mattick would appear to concur. The cover of *Art Works: Money*, their 2004 book on contemporary artists' "fascination with money," includes a photograph of Tiravanija, Orozco, Pipilotti Rist, and Olafur Eliasson dancing on the beach during this biennial.[117] The authors do not discuss why they selected this image, but its use certainly seems ironic and its logic, apparent: the *lifestyle* of some leading actors within today's art world has become inseparable from deeper reflections about art and commerce generally. Such a photograph, then, functions as a stand-in for the extent to which the art market has become irrevocably conflated with tourism, experiential offerings, luxury consumption—and partying (all of which are ostensibly endorsed by the artists themselves).

Art Fairs

The clearest illustration of this theme is the contemporary art fair, which has witnessed a prolific post-2000 expansion. This, too, is well documented, but it is relevant to ask why such events, though decades-old mainstays in the art world calendar, have suddenly become so popular.[118] The simple answer is that they offer a logical, market-friendly resolution to surging international interest in contemporary art by presenting large quantities of work for sale in a short, concentrated time frame and by serving as a good networking platform.

Art Basel, the most esteemed of such events, is an excellent example: amassing some three hundred blue-chip galleries for a four-day event every June, there are literally tens of thousands of artworks on offer.[119] Prices commence in the hundreds and proceed into the millions, thereby catering to market newcomers and seasoned veterans, alike. But Art Basel's success, epitomized by its extension into Miami Beach in 2002 (delayed one year due to 9/11), is more accurately due to calculated entrepreneurialism.

Under the directorship of Sam Keller from 2000 to 2006, it shifted from a respected if somewhat conservative operation to a dynamic intermingling of big business and new money with all the trappings of progressive exhibition management. Art Unlimited, inaugurated in 2000, is a popular section of the fair that showcases projects such as large-scale installations and multimedia art that cannot be displayed in the convention center's booths; its selection is governed by a gallery committee and two curator-advisors. Art Statements was initiated by Keller to accommodate galleries' solo exhibitions of artists, and the fair also coordinates a dense program of conversations among leading artists, curators, critics, architects, and collectors.

Most other newcomers have replicated this model, sometimes to numbing effect. London's 2009 Frieze Art Fair comprised 165 galleries from over thirty countries; Frieze Projects; Frieze Talks; Frieze Film; Frieze Music; Frieze Education; Sculpture Park; a Frame section for young galleries to present solo artist exhibitions; and the Cartier Award, a grant for non-UK artists to produce work for the fair.[120] Frieze's significance is such that most of the city's art institutions now coordinate their major autumn openings, sales, fundraisers, and social events to coincide with the fair.

At least for the moment, the contemporary art fair is the pinnacle of the post-1990 institutional trends denominated above, combining a focus on artistic production, curatorial innovation, and programming largesse with the clever salesmanship of galleries and auctioneers. Indeed, many of the protagonists are identical from one circuit to the next, an observation perfectly in synch with Frieze, itself an extension of the eponymous monthly art journal launched in 1991. This slippage is the logical outgrowth of the contemporary art world's transdisciplinary surge that melds artists, curators, critics, and dealers in a free-form interplay of context generation and value creation. And as public arts subsidies diminish and museums take years to put exhibitions together, fairs offer rapid gratification for the presentation and selling of art.[121] Contemporary art fairs are especially privileged in this respect because unlike other such events, they do not apply a rigorous vetting policy, and attribution risk related to looted or black-market goods is comparatively low (e.g., Nazi war loot).[122]

Yet these developments are not without drawbacks. One rejoinder is the inverse relationship between the growing number, and frequency, of fairs and the quality of work: "The absolute number of good works available is the same," reckons Harald Falckenberg, a prominent German collector, "but the percentage of good works in the booths has absolutely dropped. There's a lot of material for 'art buyers,' but not what I'd call 'real collectors.'"[123] Participation for galleries is also expensive—costs of rental, travel, and administration can press into six figures for a headline

40. Galerie Eva Presenhuber's stand at the 2009 Frieze Art Fair, featuring Ugo Rondinone, *A Day Like This Made of Nothing and Nothing Else*, 2009. (Photo: Linda Nylind. Courtesy Frieze)

41. Visitors at the 2009 Frieze Art Fair. (Photo: Linda Nylind. Courtesy Frieze)

booth—and pressure is therefore immense to generate sales. This, in turn, accelerates and ups the ante of exhibition programming insofar as galleries increasingly treat fairs like any other show. One unnamed dealer at Art Basel Miami Beach in 2006 ambitiously remarked that "The gallery exhibition—as a publicity mechanism for artists—is obsolete."[124]

This sentiment may be extreme, but fairs have certainly had an irrefutable impact on galleries' revenue streams: for some, fair sales constitute half, if not the majority, of annual earnings; one-third of annual turnover is common.[125] Blurring of the primary and secondary markets is part and parcel of this shift as dealers are forced to draw into the single space of the booth activities that might ordinarily be parceled between their front- and backroom business (e.g., the selling of new work and the reselling of old). "Beyond that," observed *New Yorker* columnist Peter Schjeldahl in 2006, "nonparticipation may be suicidal, risking losses not only of revenue but of artists whose loyalty depends on how gamely they are promoted." Schjeldahl quoted one dealer as saying that "The art world is so event-driven these days that if you don't take part in the major fairs you almost don't exist in the public mind."[126]

Frieze's particular bridging of art business and art writing has subjected the fair to criticism from skeptics who question the ethics of such practice, not unlike the airing of similar allegations in the financial services industry vis-à-vis conflicts of interest in investment research and investment banking: What prevents *Frieze* (the magazine) from running a feature story on an artist or work that features prominently in Frieze (the fair)? Who can ensure the absence of bribe-taking? Amanda Sharp and Matthew Slotover, Frieze Art Fair's cofounders, insist that these risks are nonexistent, but the conflicts of interest between criticism and commerce are difficult to ignore.[127] Perhaps it is best to accept Frieze (magazine and fair) as symptomatic of the contemporary art world's converging economic circuits and of escalating competition among arts institutions to validate such work.

Jack Bankowsky, critic and former editor-in-chief of *Artforum*, addressed these tensions and the emergence of "Art Fair Art" in an important article on the subject.[128] He begins by describing two pieces: Tiravanija's act of "noncompliance" at the 2005 edition of Art Basel in which he fortified Neugerriemschneider's booth with an insurmountable brick wall inscribed with "NE TRAVAILLEZ JAMAIS," the famous rally cry of 1960s Parisian activism (the booth remained empty for the duration of the fair); and Cattelan's Wrong Gallery coup at the 2004 Frieze Art Fair, which involved hiring a model to sit in a chair in a white cube to answer questions about a piece of feces placed next to her feet. Other examples flow freely: Anthony Burdin's locked-down bunker-turned-recording studio at Michele Maccarone's 2004 Frieze booth; Sehgal's *This Is Right*, involving children-turned-Conceptual Art salespeople/pranksters at Frieze's 2003 inauguration; and Piotr Uklanski's graffitied call-to-arms, "BOLTANKSI/POLANSKI/UKLANSKI," at Gavin Brown's Enterprise, also at Frieze in 2003. These cases, Bankowsky admits, tend toward the "sensational over the substantial," but the art fair as a functional context for art making,

information gathering, product differentiation, and "attention-grabbing" has surely arrived. His thesis is rooted in impresarios like Andy Warhol, Yves Klein, and Salvador Dáli, and models of engagement associated with Conceptualism and its offshoots (he highlights institutional critique), to forge an artistic genre at ease with the intermingling of art and commerce that plays the "PR game ... like a hand of cards."[129]

Even more significant than the genesis of Art Fair Art is the art fair's aggressive surge into new markets, its churning out of ever more emerging content, and its pursuit of new money. The inauguration of Art Basel Miami Beach (ABMB) is exemplary of this, catalyzed with the intentions of securing a comparatively higher emphasis on young galleries and others outside of the traditional transatlantic axis (specifically its promotion as a launching pad into Latin America). But one should not be misled: of 275 galleries at the 2009 edition, only 13 percent were located outside of Europe and North America, twenty (or 7 percent) of which were from Central and South America.[130] This may be natural inasmuch as Art Basel is a European institution with strong historical links to this region's art institutions. In practice, it suggests that at least in the early phases of such expansions—including those into Dubai, Shanghai, and elsewhere—cross-cultural dialogue is tempered by the desire of predominantly Western dealers to win business from collectors in these developing economies and to attain a presence in these regions that may be beneficial to the gallery's future prospects.

Thus far, Miami Beach has proven to be an amicable host. As with other nonauction dealings, sales can only be estimated: Art Basel does not receive a percentage of revenues, nor does it ask galleries to declare them. Even so, it is reported that at least until the market slowdown of 2008, sales turnover had escalated with each successive event, and other measures suggest the model is indeed working: since its inception in 2002, attendance grew from 30,000 to a high of 43,000 in 2007, and satellite fairs expanded from a couple at inception to more than twenty by 2009; 99 percent of galleries reapply for booths year after year (what fair officials note is the "ultimate performance indicator"); attendance at the event has become compulsory for influential players in the museum and auction community; and in 2006, as the bubble neared its peak, NetJets, which offers shared ownership of private jets, booked 216 flights to Miami, second only to the Oscars, up 44 percent from 2004.[131] As Keller concedes, it is an "ideal place for people to come to from all over the world.... There are some wonderful hotels and good restaurants, and it is hot there in December." One may even suggest that contemporary art fairs constitute near perfect embodiments of the experience economy's penetration into the cultural sector. Not only do they adjoin buyers and sellers of contemporary art goods and services, but they streamline the

contemporary art experience into a tightly packaged event—*a lifestyle*— for the international business and social elite.

None has done this more spectacularly than ABMB, where it has become a perfunctory journalistic task to evaluate not only the fair, but the "scene." After all, celebrity gossip sells, and these gatherings are anything but short of Hollywood glam and financial bling. Guy Trebay's review of the 2006 edition of ABMB charted a hypothetical "social marathon" of "V.V.V.I.P.'s," comprising breakfast with Steven Cohen, lunch with gallerist Larry Gagosian, a peek at a Yoko Ono installation in a hotel lobby, and a dinner hosted by Michael Douglas and Catherine Zeta-Jones.[132] Karl Schweizer, head of art banking at UBS, which brings thousands of clients annually to the fair and is its main sponsor, reiterates this point, observing that fairs have indeed become desirable lifestyle perks for affluent individuals and a means of "leveraging social acceptance" within the global art world.[133]

These features gained a new level of literalness in 2007 with the inauguration of SeaFair's *Grand Luxe*, a $30 million megayacht-cum-mobile art fair.[134] The purpose-built yacht can accommodate up to twenty-eight galleries, who rent space for $40,000 to $120,000 per month, and anchors at affluent ports along the eastern seaboard, from hedge fund capital Greenwich, Connecticut, to Miami Beach, in conjunction with ABMB. Unlike other fairs, admission to browse the galleries' offerings is strictly by invitation only: SeaFair's founder, David Lester, unironically calls it a "Mark Twain riverboat for sexy people."[135] Replete with private dining and event spaces, the *Grand Luxe* marks the full-scale extension of the experience economy into the gap between fine art and the high life.

Keeping in line with such lifestyle developments, artforum.com, the website operated by the namesake journal, has since 2004 headlined a section entitled "Scene and Herd," an online diary of international art goings-on.[136] Its contents read like a gossipy blend of who's who tempered with judicious, albeit highly subjective, journalism; it constitutes at least one art monthly's proactive response to blogging. Brian Sholis, artforum.com's former managing editor, observes that it is an attempt to create an "informal sociology of the contemporary art world."[137] Typical source material includes coverage of conferences, fund-raisers, dinners, performances, and openings of important exhibitions, biennials, and, of course, art fairs. And like Trebay's "social marathon," stories typically meander through a deluge of personal encounters, often lingering on the intricacies of socializing. David Velasco had this to report from Miami:

> The line for the Visionaire party recalled Disney World—or a slaughterhouse—with the wait divided into several stations, a meager attempt to minimize crowd anxiety.... Once you passed the barricades,

the party wasn't so bad, with free cocktails, Petrossian caviar, and complimentary bottles of Imperia vodka. But it wasn't so great, either —as artist Walead Beshty noted earlier, Miami is all "short conversations with people you like and long conversations with people you don't," and this party was a case in point. Someone remarked that Visionaire functions are heading wearily in the direction of Spago. A friend introduced me to Simon, one of several half-naked models hired to roam around the party. Eyeing his glabrous chest, I asked his age. "Sixteen," he said. Tacky? Probably. Just when I feared that the party was getting a bit "too Miami," I spotted Isaac Julien on the deck.[138]

By casually blurring one such innuendo with the next, any such writing risks a degree of vulgarity, especially when coupled with candid photographs of the protagonists under consideration. More blatant was "The Art Universe" mapped in *Vanity Fair*'s December 2006 "Art Issue," strategically released to coincide with ABMB: dealer Larry Gagosian is pitted at the "Center of the Universe" and is encircled by scores of the most visible art world actors.[139] The mystique of art, money, and celebrity that this type of journalism perpetuates is hardly new. Yet this and other recent incursions into the art world's lifestyle cult are more expansive than ever before, and their narrow portrayal of contemporary art events and actors risks further cementing long-standing hierarchies of value in art.

Art fairs, like the art market in general, are hardly democratic: gallery inclusion is determined by committee, participation and attendance costs are steep, and *access*—to the prefair vernissages, to the deluge of dinners and parties, to the "best" works themselves—is meticulously tiered. Even so, fairs appear to be indicative of how the art world may be organized in years to come. Like other advanced market-making systems, they are exemplary at streamlining transactions and providing salient information by showing the maximum number of works to the largest and most relevant of international audiences in the shortest amount of time. The budding social scene that accompanies them can thus be seen as a logical corollary to the influx of buyers and sellers to the trade, and to the respective amplification of goods and services on offer. Transaction risk cannot be eradicated, but the more people one knows and trusts, the better informed one's judgments become, and the higher one's probability of buying a quality work at a fair price.

More cynical interpretations, however, are also feasible. Rather than necessarily improving one's chances of selecting "winners," this incestuous socializing may also encourage herdlike behavior in which collectors' tastes converge on a comparatively small subselection of artists. This brings to mind the stardom phenomenon in economics (which posits that the star artists are not necessarily the "best" but have just achieved a criti-

cal mass of popularity), and it reinforces the linear managerialism of Lindemann and FAWM, not to mention the clichéd celebrity focus of the aforementioned journalism.[140] It also corresponds to other critiques of art fairs that regard them not as the symptom but the cause of rampant speculation in the marketplace, and fear that they are evocative of contemporary art's imminent instrumentalization—in the construction of identities, as an invaluable commercial product, as tool for regional development, and as an easily digested leisure activity.[141] Some artists will inevitably profit in the long term from these conditions, but the risk is that a market correction may preemptively damage the careers of those whose prices have been artificially inflated, while others may fall into and out of fashion as their instrumental utility shifts.

The uniqueness of the present generation of international contemporary art fairs is how they have pushed these ever-present dynamics to new extremes. Indeed, their churning of experiential catchwords into veritable commodities has made attendance at these events relevant not only for art world insiders, as previously, but for new rungs of collectors and affluent novelty seekers eager to join the game. It is a one-stop shopping gambit that is fully sensible to the peripatetic social and economic elite, and it has succeeded precisely in fostering the myth that one has to be present at these events and their accompanying functions to be relevant. This explains why there are an increasing number of those within the art world who consume the art lifestyle but do not (yet) collect: they may be honing their knowledge of the marketplace to inform future transactions, while many others may just be appropriating its social graces. Perhaps only well after the bursting of the latest bubble will it be possible to see if this business model persists, but one thing is for certain: all are complicit in perpetuating its experiential framework.

In Context

What becomes of the art experience economy, following easing of contemporary art sales since late 2008, remains to be seen. I will return to some of these issues in the conclusion, but here it is important to stress that even as the art economy enters its transitional phase—from its recent excesses to what may be a more modest landscape—it is difficult to imagine the complete eradication of the event-driven, top-to-bottom "social marathons" that have become characteristic of its operation. Indeed, in an increasingly global art world, the institutional changes observed in the latter half of this chapter have become elemental to presenting art, generating information, and interconnecting the art world's actors. The building of new, ever more spectacular museums may thus be temporarily put

on hold and attendance at fairs may diminish in the near to medium term, but history has a curious way of repeating itself and there is little reason to believe that these dynamics will be fully outmoded as the art market continues its global trajectory.

Earlier yet, innovations around conceptual art set the stage for the operational logic of this system by broadening the scope of artistic production and reinventing how audiences experience art and how this type of output was to be administered. Such developments have expanded the art market's lexicon and bolstered the feasibility of collecting any number of artistic goods, services, and experiences; what at first may have appeared antithetical to market accommodation has, via intellectual property law, become perfectly harmonious with it. Moreover, we have observed how some of the leading rationales for selling experiential art as an event or dematerialized belief system parallel the experientialization of the contemporary art world, writ large.

As this trajectory continues to infiltrate emerging regions, it will likely bring important capital inflows into the mainstream art world and enable novel types of engagements and innovation. But it might also make these engagements increasingly streamlined and shallow. On one extreme, this corresponds to the aforementioned insular landscape of neatly packaged artistic content (i.e., that which can be easily displayed in a fair booth); on the other, as Bankowsky suggests, it tends toward a battle of which artist, gallery, or museum screams the loudest. In the end, both are opposite sides of the same coin and strengthen comparisons between the art world's globalization and trends in economic globalization, premised upon the cost-efficient and fluid transborder migration of goods, services, experiences, and capital and the ability to endlessly differentiate one's product.

It is also useful to reflect upon the burgeoning market for experiential art itself. Artists' use of intellectual property law, for instance, broadens the scope of the marketplace's offerings and enables those whose practices formerly fell beyond the scope of the commercial sector to generate income from their pursuits. This is fundamentally good as it adds dynamism to the art economy and affords comparisons with other domains of intellectual property law and with ongoing cultural debate about copyright and content ownership online. This crystallizes market developments that have been decades in the making and may constitute the bedrock for even more progressive developments in the art economy to come.

At the level of artistic practice, however, the fact that the market can accommodate increasingly diverse offerings is not intrinsically beneficial. When placed under a more critical light, many of the artistic innovations discussed in this chapter can appear as dead-end demonstrations of ultimately simple legal and economic concepts. Or, as critic Dave Hickey has sarcastically remarked of other recent variations of art fair art, questions

of quality aside, many such gestures are little more than the "most easily explained works of art on planet Earth."[142] I touched on this in my discussion of Tino Sehgal—insofar as the mere fact that his work is salable can almost seem to justify its existence—but it is wide reaching. Do we really need to have a dinner, get-together, or event construed, and ultimately collected and exhibited, as art? And if so, where do we draw the line? And what price this privilege?

Such questions, of course, are as old as the avant-garde, which has had a precarious relationship with the market since its emergence over a century ago. Yet, the truth is that while experiential practices may offer a vital counterposition to more conventional modes of production, their justification as art can also appear flimsy, even under the best circumstances. This feeling is only amplified as ever greater numbers of artists take up such "alternative" positions, perpetuating an anything-goes mentality that on one hand can be labeled as progressive, but emptied of context and PR hype can just as easily leave audiences feeling that they are simply being taken for a ride. We need neither endorse nor critique these operations here, but it is of utmost importance to demystify their pretensions and appreciate the significant role that the market plays in shaping them.

Then there is the problematic relationship between some artists' insistence upon the functionality of their output and the hesitancy of collectors to put these items to use; some may prefer to exhibit them statically as relics, while institutional regulations may curtail their intended utility altogether. One resolution, embraced by some at the extreme, is to do away with the term "art" altogether in such instances. Though potentially attractive, this would discredit the fundamental role that the market and its institutions play in validating, and ultimately financing, such pursuits. In the end, the two sides are inextricably linked. Perhaps what can then be said with most conviction is that should the art world's experiential conventions diminish, possibly with the sobering up of the market after years of speculative growth, collectors' willingness to pay for gimmicky relics and art experience may waver and make many of this chapter's cases in point exemplary of a bygone era of speculative exuberance.

• • •

"With me, it is always about a structure for people to use," says Tiravanija. "I don't want to tell people how to use it. But I think there must be something in art that gets you to that point of there being a different reality, of having another kind of experience."[143] This vision permeates the artist's work and binds together many of the artistic practices discussed in this chapter. But as we have also observed, experiential artworks

are perhaps disproportionately susceptible to misappropriation. As with the video art economy, it is therefore imperative that best-practice conventions become more clearly articulated for such forms of production. This will assist conservation efforts and help maintain the continued art-historical relevance of these works, ultimately establishing firmer administrative foundations for the perpetuation of related undertakings to come. The gravity of this can be gauged by considering that, lacking such advances, the exhaustive competitive pressures associated with the art world's event-driven model may overwhelm even well-intentioned actions on both sides of the production equation, leading artists, collectors, and institutions to engage in transactions that none of them fully comprehends. Which is to say, despite experiential artists' best intentions to the contrary, the open usages their structures are principled upon may fuel "another kind of experience" altogether—that of being appropriated as a prop for somebody else's party.

..

Art Investment Funds

Let us begin by comparing two quotes, the first by art historian Leo Steinberg in 1968, the second by Bruce Taub, chief executive officer and founder of Fernwood Art Investments, in 2004:

> Avant-garde art, lately Americanized, is for the first time associated with big money. And this because its occult aims and uncertain future have been successfully translated into homely terms. For far-out modernism, we can now read "speculative growth stock"; for apparent quality, "market attractiveness"; and for an adverse change of taste, "technical obsolescence." A feat of language to absolve a change of attitude. Art is not, after all, what we thought it was; in the broadest sense it is hard cash. The whole of art, its growing tip included, is assimilated to familiar values. Another decade, and we shall have mutual funds based on securities in the form of pictures held in bank vaults.[1]

> We are the first independent firm to develop a comprehensive suite of art-focused investment research, advice, financial products and services for sophisticated investors and collectors. Our work generates new ways to participate in the art market and, in the process, brings significant new capital to the art economy. In short, Fernwood is employing rigorous portfolio management techniques traditionally applied to equities, bonds and commodities, in combination with academic and art trade expertise, to derive investable art insight.... The difference between art collecting and art investing *is* Fernwood.[2]

Read in succession, these passages have that uncanny feeling of fate being sealed. Writing as the new order of the 1960s contemporary art market

was still taking shape, Steinberg foresees the ultimate instrumentalization of art as *nothing but* a financial asset, and Taub, writing at the dawn of the twenty-first century, confirms his fears. Conceived as a sophisticated art finance business offering both art investment platforms and related market services, Fernwood certainly was no mere mutual fund.

Steinberg's remarks form part of the historian's seminal writings on the shifting terrain of modern art, and they could not provide a better historical framework for our own enquiry into the proliferation of art investing.[3] Taub's comments, on the other hand, spell out Fernwood's grand vision and are representative of the current art fund industry—of just how far into the throws of "big money" art has gone.[4]

Fernwood was founded in 2003 by Taub, formerly of Merrill Lynch, on the conviction that art constitutes a viable alternative financial asset class that can be exploited through strategic trading. To achieve this vision, it set out to raise $150 million to be invested in two primary art funds: a Sector Allocation Fund that was to be diversified across eight genre categories (spanning Old Masters to Emerging Masters); and a higher-risk Opportunity Fund established to capture "more immediate opportunities within the broader art economy for financial returns."[5] Split between offices in New York and Boston, the firm hired twenty industry professionals, from auctioneers and dealers to economists and art critics, to achieve these ends.

Fernwood was not alone. One year earlier, the Fine Art Fund (FAF) had been inaugurated in London by ex-Christie's veterans Philip Hoffman and Lord Gowrie, with an even more ambitious investment target of $350 million. And scores of other art investment funds and syndicates had either just been set up or were on the horizon, such as the China Fund (by Julian Thompson and Jason Tse, both formerly of Sotheby's), ArtVest (by Daniella Luxembourg, former cohead of Phillips de Pury & Luxembourg), and Aurora Fine Art Investments (by Russian billionaire Viktor Vekselberg). With its finger hot on the pulse, Dutch bank ABN-AMRO in 2004 announced its intention to inaugurate a fund of its own as well as an art investment "fund of funds," which would make investments across this burgeoning landscape.[6] (Appendix C provides an overview of these funds.)

Not even a decade on, this field has already taken a different shape. ABN-AMRO's multiple ventures never progressed beyond the planning stage, Fernwood was dissolved in 2006, and many other upstarts that once lit the landscape have since faded from view.[7] Even FAF, the largest fund currently in existence with $89 million under management spread across four different investment vehicles, has raised less than a third of its original target and is close-lipped about its overall performance.[8] The industry, like any business sector in its early phase of development, is a work in progress, and it is critical for us in the context of this book to

cautiously adjudge its evolution: it could go on to thrive in the years to come, but the outcome of its particular marriage of art and finance remains difficult to foretell.

What is certain is that while the art fund industry is apt to transform for the foreseeable future, the rise of art investing—as an idea and business practice—offers one of the clearest illustrations of how the market has changed since Steinberg's day. For it is not only emblematic of the enterprising new ways in which contemporary art is sold and experienced, as examined in the preceding chapters, nor of how the art economy as a whole has embraced globalization; it is modern global finance embodied.

Few topics in the art market have been as energetically discussed yet as poorly understood as investing. This is largely due to its controversial nature. For many artists, as well as much of the art world, the practice is seen to bankrupt art of all meaning and metaphysical value; it is a further and severe encroachment of capitalism into the cultural sector. Dealers tend to share this opinion and also see art funds as a competitive threat. The funds themselves are under no illusions that they are trying to profit through art but see their activity as opening the benefits of participation in the art market to wider numbers of people than ever before (who can now buy and sell shares of a fund) as well as bringing a much-needed boost of liquidity and transparency to a market otherwise synonymous with its opacity and lack of regulation. These latter objectives, however, tend to get muddled between stark fundamental opposition to art investing and the art world's inability, or palpable disinterest, to understand funds' financial jargon. Resistance is also apparent in the broader financial community, which struggles to understand the art market and to accept art as a viable asset class. From both sides, art funds tend to be seen as "outsiders," distanced by a linguistic and cultural gap.

Many commentators have been quick to designate the growth of art funds as evidence of a new dynamic in the trade, though few have paused sufficiently to address how these businesses are run and what their effects actually are on the structure of the art market; most discussion is highly speculative in character. This is evident both in casual banter and also in some more serious literature, such as Louisa Buck and Judith Greer's *Owning Art* (2006), which presents dazzling contemporary art sales figures during the post-2000 boom period to conclude that "these huge profits have meant that art is increasingly viewed as an alternative asset class."[9] Such viewpoints are not incorrect—the promise of vast riches may certainly encourage some to invest in art—but they miss the crux of what is fundamentally unique about our current moment: the extent to which the vogue in art investing has been driven by the coming together of the worlds of art and finance. Art investing, as we will see, is not novel, and

past market booms have borne their share of speculators-cum-investors, but never before has there been such an emphatic spillover from finance to art about how to achieve this.

I should clarify that there is a fine line between being attracted to art's investment prospects—the halcyon vision, so prevalent of late, that prices will continuously ascend—and buying art solely for this purpose. Even now, as classic forms of connoisseurship are on the wane, the promise of making money tends only to be one of many factors motivating collectors' purchases. Similarly, the prestige buying that swelled contemporary art prices in the new millennium as new collectors, from hedge fund titans to Russian oligarchs to Middle Eastern royalty, turned to the field to mark their distinction (social, cultural, political) must be kept separate from investment in art for financial returns alone. Prestige buying is extraordinarily important to contemporary art's globalization and its constitution as a status symbol par excellence, but it will not be addressed in much detail here. Several writers have published widely on the topic and, as I shall attempt to justify below, it is arguably not as singular to our current moment as the art investment turn.[10]

Our final case study looks at the phenomenon of art investing through the consolidation of the art fund industry, the purest manifestation of art's conscription to the world of "big money" and "familiar values" projected by Steinberg. It describes what these businesses do, the context out of which they have arisen, and the opportunities and challenges they face. While our two preceding chapters focused on some of the key recent developments in the coming together of art making and economics, the present is a more explicitly financial undertaking; "art" itself can often seem missing from the equation, being reduced by investors to a purely instrumental function. Furthermore, whereas my analyses of video and experiential art mainly looked at the primary market, the secondary market wins the bulk of attention here. Art funds tend to operate in the resale sector, where values are more established and works can be traded more seamlessly and discreetly. With few exceptions, my earlier emphasis on contemporary art takes a backseat to these funds' search for investment opportunities across the broader art economy.

I begin with an introduction to the logic of art investing and to the structure and operation of art funds. Next, I return to the origins of art investing in the early twentieth century and examine how the field has changed from then to now. I look at some historical precedents to the current practice as well as the body of economic literature that endorses it and how growing sophistication within the global financial marketplace has catalyzed interest in its benefits. I then open onto a comparative analysis with the hedge fund and private equity industry to set art funds in context. We will see that although art may possess a theoretical invest-

ment utility, overcoming conflicts of interest, managing investment risks, and achieving real returns are difficult. These issues are overlaid with more general reflections on the impact that the changes in the art market observed in the earlier case studies may have on art investing and whether the rise of these speculative practices might, ironically, threaten the prestige values that make art so coveted in the first instance.

A definitive assessment of this terrain cannot occur until one is able to track the performance history of today's current generation of art funds. This may not be possible for another decade, perhaps longer. Nevertheless, it is now an opportune moment to begin coming to terms with their implications and, in the context of this book, to develop a more sophisticated understanding of their broader relevance within the present-day art economy.

Overview

The premise of art investing is fairly intuitive: to buy cheap and resell at a premium while minimizing the onerous transaction, shipping, storage, and insurance costs that make art an expensive asset to hold. Two widely held assumptions undergird this basic objective: first, that art as an asset class is weakly or noncorrelated to the international equities markets (e.g., that art prices essentially move independently of other more conventional assets like stocks and bonds);[11] and second, that the art market is highly inefficient, riddled by opaque prices, low levels of liquidity, and large informational asymmetries. These points are germane for if art funds' buy low–sell high principle is self-evident enough, what distinguishes them from other market speculators is their ability to strategically unlock art's supposed noncorrelation benefits and to profit from the market's inefficiencies. Their premise, then, is to concentrate a critical mass of art and financial expertise under a single umbrella to make this a realizable goal.

We can appreciate the tenets of this strategy through comparison with the recent economic climate. Following a period of extended growth, the global financial market nosedived beginning in autumn 2007 owing to the residual fallout from the housing crisis and the systemic drying up of the credit markets (the "credit crunch"). This drove the world's main stock indices into 50 percent declines and caused scores of leading financial institutions to either crumble or restructure.[12] To the extent that the prices of art are uncorrelated to these developments, one would expect art funds that bought shrewdly in the period leading up to this crisis to be well prepared to weather these conditions. At best, the logic goes, art prices may rise as investors transfer their money into cash and unleveraged real

assets such as art and commodities like gold and silver. At worst, art should hold its value better than conventional assets such as stocks and bonds, especially in an inflationary environment where irreplaceable hard assets tend to outperform the broader market: company shares might become worthless, but a Canaletto, as FAF's cofounder and CEO Philip Hoffman underscores, "will never fall to zero."[13] In addition, irrespective of the art economy's globalization, it remains a fragmented and hybrid market, meaning that price discrepancies that beset one sector may not be apparent elsewhere: values in the United States and Britain may depreciate, but the same may not occur in India or South America and savvy, well-structured art funds should be able to take advantage of these differences. And lastly, an economic downturn may actually provide an attractive opportunity for savvy investors to stockpile artworks at depressed prices.

Art funds also compare attractively to galleries in several respects. For one, they are capable of having lower cost-bases and overhead: they save on real estate by not having to pay for large exhibition spaces. Second, their concentration of financial and art market expertise across numerous market sectors should, if organized efficiently, exceed the competencies of most galleries, which are often more specialized.[14] Third, the large capital base sought by art funds gives them a purchasing power that eclipses that of gallerists, who tend to be poorly financed due to high operational costs and the continuous reinvesting of business profits. Hoffman emphasizes this point: most galleries and private dealers are severely cash strapped, with only a very small minority having above $10 million of investable assets, and hardly more than a handful in excess of $100 million.[15] (By contrast, we should recall that at inception Fernwood and FAF sought to raise $150 and $350 million, respectively.) Finally, and owing in part to these capital limitations, most dealers tend to turn over their assets rapidly: they attempt to buy at a deep discount and resell as quickly as possible (ideally purchasing, or holding on consignment, only with a particular client in mind). However, because funds have longer investment horizons of up to a decade, they can undertake potentially more advantageous "buy and hold" investment strategies. This insulates them from short-term fluctuations in the market, allows them to offset steep transaction costs (which can be amortized over a number of years), and also broadens their buying universe beyond the scope accessible to most dealers, especially for works that are either riskier or selling at a only modest discount (both of which the fund can buy and set aside for a number of years in the hope that the market will turn in their favor). Art funds are thus capable of delivering significant liquidity to the marketplace. This feature, coupled with their proposed ability to identify and invest in op-

portunities quicker and more fluidly than competitors, underscores their promising strategic position.

Today's art funds are set up essentially like private equity or hedge funds, a major departure from earlier initiatives, which tended to be run as syndicates or private partnerships and hardly offered the same range of structured investment solutions. They aim to securitize the buying and selling of art by giving accredited individual and institutional investors exposure to the art market through shares in a fund.[16] Most are structured as five- to ten-year closed-end investment vehicles, meaning that, unlike the more liquid market for stocks or mutual funds, investors are able to purchase shares only until a certain point at which the fund is "closed."[17] Their capital is then "locked up" with the fund and shareholders can redeem their equity only at preallocated intervals (e.g., quarterly or annually) or at the end of the fund's term as it is drawn down. Investors typically contribute a minimum of between $100,000 and $250,000 to the venture, for which they pay a "2 and 20" fee: the fund's management company deducts 2 percent of committed capital per year to cover overhead and operational costs and also takes a 20 percent performance fee on earnings, usually above a hurdle rate of between 6 and 8 percent.[18]

Also like private equity and hedge funds, while most art funds operate out of offices in the United States, Britain, and continental Europe, they tend to be registered in offshore domiciles such as the Cayman Islands, Channel Islands, British Virgin Islands, Bermuda, and Luxembourg. These investor-friendly jurisdictions have low levels of regulation and attractive tax regimes that enable such funds to optimize their investment returns. Americans, for example, are required to pay a steep 28 percent capital gains tax on art and collectibles (versus 15 percent on real estate and securities), yet a BVI-registered art fund is more efficient for investors because there are no capital gains taxes here at all; the difference can then either be reinvested in further art purchases or distributed as a dividend to shareholders.

Art funds' capital and investment return targets can vary greatly based upon their objectives, management structure, and financing. Some funds, like Fernwood and FAF, aim to raise hundreds of millions of dollars, whereas many fall into a more moderate $15 to $50 million range. Performance objectives can vary, too, though most funds seek returns of 10 to 15 percent per annum net of fees.[19] Once the money is raised, or at least once enough money is secured to begin investing on an initial tranche of capital before the fund is closed, the fund starts to purchase artworks. For a ten-year fund, investments generally will be made in years one to four, with divestments occurring in years three to ten. Some funds may try to grow their capital base in the early period by buying and reselling

rapidly and reinvesting proceeds into further purchases; after a certain mandated point, generally around year three or four, the fund will no longer be able to make purchases but will hold inventory until an optimal sales opportunity is identified.

Art funds' cash flows need not be limited to their core investment business. They may monetize the value of art in their inventory by renting it to investors in the fund or by loaning it to exhibitions.[20] Investors with FAF, for example, can borrow works owned by the fund at a cost of 1.25 percent of their appraised value. And exhibition loans, especially to prominent museums, can be a smart way for funds to actively manage their asset base: storage and insurance costs are reduced (which would typically be covered by the exhibiting institution) and provenance is added to the artwork (which should theoretically boost its resale price). In addition, funds may leverage their art market expertise by consulting for private collectors or financial institutions. Hence alongside its four investment vehicles, FAF has an art advisory relationship with BSI Bank in Switzerland and Banco Santander in America through its wholly owned subsidiary, Fine Art Investment & Research Limited, Inc.

Most funds apply a multitiered management structure. At the apex is a senior management team or investment committee comprised of the funds' founders, chief investment officer, and other reputable advisors. This group, often with strong auction house and finance backgrounds, dictates the funds' scope and vision, raises capital, assists in the due diligence process, and is the chief mouthpiece to investors, the media, and the art and financial communities. Trading is usually executed by a well-placed team of external art buyers. These tend to be practicing gallerists, private dealers, and ex-auction house specialists; they are experts in the field, have extensive client contacts, and are able to identify, source, and trade artworks with the funds' financial backing (optimally with a resultant trade discount). Unlike senior management and administrative support teams, the art buyers tend not to be on the firms' monthly payroll. Instead, they usually receive commissions for placing work with the fund as well as carried interest in the funds' performance. Art advisors may also intermediate between the buyers and management; these are often either critics, academics, or retired art market specialists used to provide objective oversight on trading decisions.

Fernwood's proposed eight-step investment strategy was exemplary of this: (1) determine overall allocation; (2) assess liquidity and cash deployment; (3) employ investment analysis expertise; (4) identify and source potential opportunities; (5) perform due diligence and negotiation; (6) determine portfolio suitability; (7) execute transactions; and (8) continually reassess cash and exposure. The goal, in other words, was to apply "seamless and ongoing" active management to optimize investment returns.

Art funds typically deploy three main investment strategies. The first is a "diversified" strategy in which investments are made across multiple geographical markets and market sectors—from Old Master and Impressionist painting to contemporary art. Another is a vertically integrated "region-specific" strategy—for example, a Chinese art fund composed of porcelain and antiquities as well as work by living artists. And a third is an "opportunistic" strategy that seeks to profit through distressed sales and informational asymmetries arising in the wider art market (e.g., buying at a significant discount from the inheritor of an estate who may want to quickly convert their art to cash). Most funds are based on one of these three general strategies or some hybrid thereof.

A good representative example is provided by the Fine Art Fund I, FAF's first investment vehicle, launched in 2003. FAF I was conceived as a diversified fund specializing in five market sectors (optimal allocations in parentheses): Old Masters (25–30 percent), Impressionist (30 percent), Modern (20 percent), Contemporary I (1960–85, 15–20 percent), and Contemporary II (1985–2010, 0–5 percent). Its art buyers are leading experts in each respective sector whose tasks are to introduce work to the fund, oversee its purchase, and, often, its resale.[21] Once a promising item is identified, an art advisor vets the proposal and puts forward a recommendation to FAF's management, led by Philip Hoffman, which in turn undertakes due diligence of its own. Its works vary in price—beginning in the mid–five figures to several million dollars—but no single item costs more than 15 percent of the fund's committed capital, and any purchase greater than 7 percent of its commitments requires approval by the Fund Board. Investors allocate no less than $250,000 to the fund and are charged a 2 percent management fee and a 20 percent performance fee after a 6 percent hurdle. The fund has a ten-year duration, with the option of two additional one-year extensions, and returns cash to investors from the end of year four onward (once it is no longer buying works). Its sophisticated structure and ambitious business strategy make it exemplary of how far art investing has come in recent years and give us a platform to critically engage with both the history and future trajectory of the practice.[22]

Origins

Interest in art investing may be escalating, but it is hardly new. Art historian David Solkin has discussed the emergence of paintings as objects of "widespread capital investment" in eighteenth-century England and Peter Watson, in his excellent book on the formation of the modern art market, has cited Baron Friedrich von Grimm, also in the eighteenth century, as

advocating that "purchasing paintings for resale was an excellent way to invest one's money."[23] Preeminent Cubist dealer Daniel-Henry Kahnweiler stretches the history of art market speculation further yet, pointing out that the Marquis de Coulanges, in the seventeenth century, said that "paintings are as valuable as gold bars."[24] Yet despite these roots, the figure of the art investor as we know it today had not truly emerged even by the late nineteenth century as bourgeois-entrepreneurial capitalists laid the bedrock of the modern art market: investments were still principally made to enhance social prestige, not to reap explicit financial reward.[25]

The most famous early example of a business conceived to invest in art is the Peau de l'Ours (Bearskin) art club, established by financier André Level in Paris in 1904. It consisted of thirteen partners, including Level, who each contributed 250 francs annually to a pooled trust, which was used to invest in modern artworks. It has been described, presumably unbeknownst to Steinberg, as the "first mutual fund in modern art."[26] In total, Peau de l'Ours purchased approximately one hundred items over a ten-year period. The entire collection was then auctioned at Hôtel Drouot, Paris, on 2 March 1914, generating sales of 100,000 francs, or nearly four times the original outlay. Picasso's *Saltimbanques* (1905) was the most expensive item, selling for 12,500 francs against an original purchase price of 1,000 francs in 1908. Yet despite this apparent success, the onset of the First World War, followed by the Great Depression and eventually the Second World War, meant that this precedent failed to gain headway; the next wave of art investment activity would not emerge until the 1970s.[27]

The concept of art-as-investment has evolved significantly over the past century. During the first half of the 1900s, few commentators emphasized the correlation between the art and financial markets or noted art's potential attractiveness as a financial hedge—key criteria nowadays. Reporting instead focused on how rising prices heralded art's investment potential.[28] There is a suggestive distribution in these writings, too: prior to 1970, journalism on art investment is concentrated in the early to mid-1930s and again during the 1960s.[29] This is consistent with the publication of Rush's aforementioned *Art as an Investment* in 1961 as well as the increasing focus on the subject in the popular media. Germany's *Der Spiegel* allocated the cover of a 1966 issue to the debate (with the headline reading "Art as Investment"), and German business magazine *Capital* launched its heralded *Kunstkompass* artist-ranking guide in 1970.[30] One explanation is that the aftershocks of the Great Depression and transition into the New Deal era mobilized discourse in the former period, while the inflationary lag from the mid-1950s, the stock market crash of 1962 and the eventual recovery of the art market during the 1960s drove the latter. This substantiates the aforementioned point that

art's intrinsic value makes it especially attractive during periods of high inflation as well as the notion that interest in art can rise during periods of financial and political turmoil: art as a reserve of unassailable meaning in difficult times.[31]

The watershed study of historical art prices is Gerald Reitlinger's *The Economics of Taste*, published in three volumes between 1961 and 1970.[32] His data set of some 5,900 painting and objets d'art sales from 1700 to 1961 added a formerly unprecedented level of quantitative rigor to the literature and his assertions were unambiguous: "By the middle of the 1950s, after two world wars, a world financial depression, and a world wave of currency inflation, 'art as an investment' had lost any stigma that it might once have possessed."[33] Mere euphoria over sales prices had thus been replaced with a judicious blend of quantitative and qualitative judgment; "art as an investment" was correlated with art's utility as an inflationary hedge.

Reitlinger's conclusions begat a more sophisticated approach to the subject of art investing that led, in the current period, to the grafting of modern finance theory onto the art market. This will be discussed below. Here it is revealing to observe that the earliest institutional art investment funds were inaugurated only shortly after Reitlinger's study and occasionally made explicit reference to his research. The British Rail Pension Fund (BRPF) is the shining case in point, but there are other examples, too. In 1970 Baron Leon Lambert founded Artemis in Luxembourg, while the following year Ephraim Ilin incorporated Modarco (Modern Art Collection, S.A.) in Panama on $5 million and $3 million investments, respectively. The two were inaugurated as pure trading concerns—Artemis even likened itself to an "Art Investment Banking Firm"—a strategy that suited both visionaries—Lambert, a banker; Ilin, an industrialist.[34] Within its first year, however, Artemis lapsed from fund into a publicly traded dealership and continued to operate as such until its eventual closure in 2006; Modarco's investments began losing money in 1974–75 and the company merged with fine art dealer Knoedler in 1977.[35] During this period, other similar ventures either went public and floundered shortly thereafter (e.g., the Sovereign-American Arts Corporation, founded in 1968 and listed on the National Stock Exchange in 1970), withdrew applications from the U.S. Securities and Exchange Commission before they ever reached this stage (e.g., the Art Fund, founded in 1969, and Collectors Funding), or remained discreet private ventures (e.g., the John Adams Fund, Inc. which invested in Impressionist and post-Impressionist art).[36]

In fact, none of these businesses would survive in their original form by the end of the 1970s. In 1985 the *New York Times* simply reported that "The mutual fund approach to art, a hot idea during the art boom of the 1970s, has no survivors."[37] This testifies to the weak historical track record

of art investment funds and must not be forgotten as the practice undergoes its renaissance.

British Rail Pension Fund

BRPF is the only major art fund to survive the 1970s. One key difference between this fund and its contemporaries was that it was not just a product of the then buoyant art economy but was launched as an innovative way to hedge the double-digit inflation triggered by the OPEC-led oil crisis of 1973, which significantly weakened the equity and commercial property markets and the value of the British pound.[38] Business objectives were long term (spanning twenty-five years), and the rationale was that if precious metals were regarded as financial safeguards, why not art?

Fund director and visionary Christopher Lewin cited Reitlinger and concluded that most categories of art had proved sound long-term investments and that between 1920 and 1970, only returns to tapestries and arms and armor had failed to match inflation: "The risk element is not as great as you might think. Demand will increase, supply won't … we could be international in buying goods without any problems of foreign exchange regulations.… I had very good reason to suppose that works of art would be an excellent hedge."[39] Lewin thus recommended the annual expenditure of up to 6 percent of BRPF's annual cash flow on art (around £3 million per year), and between 1974 and 1980 BRPF invested across diverse market sectors (painting, sculpture, books, furniture, bronzes, jewelry), ultimately allocating £40 million to some 2,400 items.[40] Moreover, by directing no more than one-third of its funds to Old Master paintings and drawings and by limiting Impressionist exposure to 10 percent, the directors felt well suited for long-run gains. BRPF stopped purchasing art at the turn of the decade once its collections were sufficiently diverse and inflation had cooled.[41]

The fund began divesting its art portfolio in June 1987. This decision was prompted by several factors: first, the strong art market at the time provided a good climate for optimizing investment returns; second, more suitable investment avenues had become available by this point than when the art investment strategy was first implemented in the 1970s (i.e., index linked bonds); and third, there was a growing awareness of art's high maintenance costs and the difficulty of continuously and accurately valuing such a broad collection.[42] Ironically, although these sales meant that British Rail would be disregarding its long-run strategy, they also proved to be the most profitable.

Through 1988 the fund had offloaded about a thousand items for approximately three times their initial cost.[43] More notably, when the fund

liquidated a collection of its Impressionist paintings in April 1989, it collected £34.9 million, against an initial £3.4 million outlay, for an impressive 21.3 percent annualized investment return. Chinese porcelain sales in May and December 1989 were also profitable, netting £10.5 million against a £1.6 million purchase price, for a 15.4 percent cash rate of return.[44] But other investments appreciated at inferior rates. Primitive art and furniture were notorious laggards, while an otherwise "fine group" of Old Masters sold in July 1996 translated into a real loss of 0.4 percent per annum.[45] The cumulative performance of BRPF's art portfolio, through the final liquidation of its assets in 2000, reflects these weaker results and lies at an overall cash IRR of 11.3 percent, or 4 percent per annum in real terms after allowing for inflation.[46]

BRPF is typically enlisted as a successful precedent, especially by art fund enthusiasts. The ultimate objective of its art investment strategy was to beat inflation, which it achieved through the careful purchase and sale of certain core artworks. Yet its results were not unilaterally encouraging. First, though its returns to art outpaced inflation, they underperformed those of the major stock markets over the investment period.[47] Second, BRPF was fortunate to offload its Impressionist paintings during an unprecedented boom in this sector, and it therefore benefited from circumstances that new funds cannot be expected to replicate. Third, because trading decisions had to pass approval from an art subcommittee, time delays were at times unavoidable and liquidity issues proved burdensome: attractive buying opportunities were forgone due to administrative impediments. Additionally, despite a strategic agreement with Sotheby's, the auction house served principally as collection advisor and offered only minimal reductions in the buyer's premiums and seller's commissions. Transaction costs were consequently substantial—approximately 5 to 7 percent to buy and sell—and considerably diminished the fund's bottom line. It has been alleged that the auction house sold poor-quality works to BRPF, "especially those it owned or on which it had provided an advance or a guarantee," a detrimental conflict of interest that will resurface in the discussion below.[48] The cost of insurance was also significant. While BRPF understood the importance of lending to private collections and museums to boost provenance and divert these premiums (applied to the borrower), many of its holdings remained in storage throughout the venture; they were either too fragile to loan or mandated special display conditions that made such loans infeasible.[49] BRPF thus bore the full price of insuring such goods, which in conjunction with the aforementioned factors diminished the fund's investment returns.

Post-BRPF art investment ventures have struggled even more. At the peak of the 1980s bubble, Chase Manhattan Bank solicited $300 million of investments from pension funds for a closed-end art fund but failed to

raise the necessary capital and shelved the venture before it ever got off the ground.[50] And between 1989 and 1991, Banque Nationale de Paris (BNP) allocated $22 million toward the creation of two art funds of its own. Hundreds of investors participated, but when the works were auctioned in 1998 and 1999, the fund absorbed losses of more than $8 million. Not only did BNP invest at the top of the market, but its duration was too short and executives have since lamented the "rigidity" of its operational structure, a claim that echoes a shortcoming of BRPF.[51] English outfit Taylor Jardine, established in 1998, offers a different example. Aspiring to buy and lease paintings to corporations, the venture purchased over 1,900 works and optimistically projected returns at 10–15 percent per annum. The firm was liquidated in 2003, claiming losses of £6.4 million, after it was unable to loan more than three hundred items. Britain's Department of Trade and Industry shut down a similar scheme, Barrington Fleming Art Society, in March 2001.[52]

In Theory

Interest in art funds abounds despite this unremarkable history. One reason is due to the market's extraordinary strength for much of the post-2000 period—rising prices bolstering the impression that art is a lucrative financial asset. Yet the most significant factors are the heightened theoretical credibility of art investing, the growth of the alternative investment industry, and the range of structured solutions now offered by art funds.

Today's art funds, unlike their predecessors, draw upon a barrage of recent economic literature to convey the merits of art as an alternative asset class. Fernwood, for example, hired Ph.D. economist Robert Gough as its chief economist and published an array of financially sophisticated marketing materials, replete with whizzy charts, graphs, and academic citations. Since 2004 FAF has both sponsored and participated in seminars under the title "Art: An Alternative Asset Class."[53] These sessions have incorporated notable art and financial market professionals such as Daniella Luxembourg of ArtVest, Citibank's Mary Hoeveler, and economists Michael Moses and Rachel Campbell and aspire to demonstrate the benefits of investing in art.

The inclusion of Moses, former professor at the Stern School of Business, New York University, and Campbell, associate professor of finance at University of Maastricht, is exemplary of this new paradigm.[54] In "Art as Investment and the Underperformance of Masterpieces," published in 2002, Moses and Jianping Mei found that between 1875 and 2000 the average annual *returns* realized by art goods were between those of equities and bonds (less than the former, greater than the latter) and possessed

lower *volatility* and *correlation* with these assets than previously esti-mated.[55] Their conclusion is that art can be a beneficial component of a financial portfolio. Campbell, writing in "Art as an Alternative Asset Class (2005), upholds this thesis and argues that over the longer term, and especially during extreme market movements, art can yield "signifi-cant benefits" to investors.[56]

Let us look closer at this terminology to understand exactly what is being argued. The concept of an expected return corresponds to the *aver-age return* an asset produces for its owner. In the case of a coin toss where the owner will receive either $1 (heads) or $3 (tails) every time a coin is flipped, the *average expected return* is $2 even though the owner will never receive this sum on any throw: the *actual return* (either $1 or $3) always varies from the *expected return* ($2) by a factor of one, and the probability of either scenario is 50 percent. As this game is played, the owner expects to earn $2 per toss in the long run but must realize that actual returns may deviate from this figure in the shorter term. One mil-lion coin tosses will generate an average income proximate to $2 per throw, but ten tosses may produce an average far closer to $1 or $3: a string of heads or tails will have a significantly greater impact on this smaller sample. An asset's expected returns and the investment horizon necessary to achieve these are elemental to finance theory and feature prominently in economic literature on art trading.

Investors also need to be aware of the probability of achieving the aver-age return at any moment. This is called an asset's risk, or *volatility*: by how much do *real* returns fluctuate around the average? Economists de-scribe these properties in "variances" or "standard deviations" that refer to the range within which a given outcome is expected to occur a certain percentage of the time.[57] Provided a normal distribution, or bell curve, in which returns coalesce around an average and tail off equally in both directions—such as in the coin-flipping game—there is a 67 percent prob-ability that returns fall within one standard deviation and a 95 percent probability that returns fall within two standard deviations. Therefore, the higher the standard deviation, the greater volatility and investment risk.

This can be a confusing concept, so it helps to use Mei and Moses's calculations for clarification. In a subset of their study, they observe that between 1900 and 1986, art returned 5.2 percent per annum with a vola-tility (standard deviation) of 37.2 percent, while the S&P 500 stock index generated an average of 5.7 percent per annum with a volatility of 20.7 percent.[58] Thus, art returned between –34.2 and 42.9 percent per annum roughly two-thirds of the time, while it returned between –70.2 and 80.6 percent per annum about 95 percent of the time.[59] Conversely, stocks returned between –15.0 and 26.4 percent, and –35.7 and 47.1 percent, within the same one- and two-standard-deviation parameters. With a

higher average annual return (5.7 versus 5.2 percent) and lower standard deviation (20.7 versus 37.2 percent), one may begin to comprehend the relative investment risks and benefits between art and equities: art appears to have a lower mean return and is more volatile.

In isolation, such characteristics do not legitimize art investment as it is assumed that rational investors will choose the least return variance for a given level of mean return: art, being more volatile and less lucrative (on average) than stocks, would therefore appear to be an inferior asset.[60] The reality is more complex, as illustrated by Modern Portfolio Theory (MPT), a profit-maximizing model for the combination of assets. Advanced by economist Harry Markowitz in 1952, MPT postulates that if the average return, variance, and covariance for individual assets within an investment basket can be quantified, an "efficient portfolio" can be created to optimize an investor's returns.[61] Key here is covariance, or the relationship of assets to one another and to a market bundle (an equity index, for example).[62] As Markowitz's judgments passed through a series of revisions and ultimately helped spawn the Capital Asset Pricing Model (CAPM), a theory concerning equilibrium asset pricing, it became accepted that in the construction of an investment portfolio, the variance of an individual asset's return is trivial; what matters is the relationship between the return of an individual asset and the return of all assets taken together (called the "market basket"). So, whereas prior to Markowitz it was generally assumed that aggressive investors should purchase more volatile assets than conservative investors, portfolio theory advocated a more complex process of asset diversification in which investment risk is spread across assets with different correlations to the market basket.

Fernwood exemplified the crystallization of this logic. In its marketing material, it urged art investments to "fall under the same broad strategic financial umbrella as other invested assets," utilizing an efficient frontier analysis to demonstrate the hypothetical advantages of so doing.[63] Over the twenty-five-year period ending 31 December 2003, Fernwood calculated that the statistically optimal portfolio consisting of 35 percent equities, 45 percent bonds, and 20 percent art not only generated superior performance to ten-year bonds (11.0 versus 9.9 percent, respectively), but also endured a risk level of only 7.7 percent, the lowest risk among all assets classes (equities, bonds, gold, and art) in the model. By comparison, a portfolio consisting of either 100 percent equities or bonds would have a less optimal risk-return profile. Echoing the lessons both of CAPM and some notable recent economists, Fernwood concluded: "Art's remarkably low and even negative correlations to other asset classes play a key factor in the model's outcome. A portfolio's efficiency can be significantly improved by allocating some exposure to fine arts."

The crux of Mei and Moses's findings therefore does not reside in art's risk-return metrics—nor, as is the common misperception, in the absolute price appreciation of artworks—but in the correlation between the price movements of these assets and those of other financial instruments: a rational investor may choose to hold art if it is believed that art prices move weakly, or inversely, to other investments in their financial portfolio. While this viewpoint may have long substantiated an intuitive case for art investing, Mei and Moses's study of 4,896 price pairs (repeat painting sales at auction) over one hundred years was among the first, and certainly the most influential, to quantitatively endorse it. These findings have since been reinforced by Campbell, who argues that not only do the U.S. and U.K. art markets have negative and low correlations with equity markets, respectively, they are less volatile than these markets as well.

It cannot be emphasized strongly enough how important it has been for these economists to lucidly translate the theoretical benefits of art investing into intelligible economic jargon. This had the watershed ability to open the art market to a world of modern, global finance from which it had long been distinct: on paper at least, art could now be championed as a dynamic "alternative" asset class. This transfixion with art's investment benefits is evident in the talismanic coverage of Mei and Moses's research in the mainstream media and Moses's numerous appearances on news networks and in conferences and discussion panels elaborating his cause.[64]

Demand

The recent growth of art fund activity is not propelled by theoretical arguments, alone, but also by developments in the art and financial services industries. One catalyst extends from the rise of the art advisory profession. Citibank's Art Advisory Service, cofounded in 1979 by Patrick Cooney (hired by Fernwood) and Jeffrey Deitch (who went on to become a prominent New York gallerist and in 2010 took over as director of the Museum of Contemporary Art, Los Angeles), may have inaugurated this field at the institutional level, but many have followed suit.[65] Since the 1990s Chase Manhattan, Coutts, Credit Suisse, Deutsche Bank, Bank of America, and UBS have all launched similar business units in an attempt to win and retain the business of financially elite art collectors, and ABN-AMRO's aforementioned art fund was to be predated by an art investment advisory service of its own.[66] Meanwhile, if the advent of Sotheby's Financial Services in 1988 marked the auction industry's willingness to furnish similar offerings, scores of specialist firms such as the

Art Capital Group, Art Finance Partners, Emigrant Bank Fine Art Finance, and Fine Art Wealth Management (FAWM) have since crowded this niche offering anything from loans against art to varied art lifestyle services.

There is a fine line, however, between art investment advice and the type of art-focused services offered by these institutions. "We don't advise our clients to invest in art," insists Francesca Guglielmino, former director of the Citibank service, "but wealthy people have art and so we have a unit for them."[67] Nevertheless, art market journalist Georgina Adam observes that "while most of the art advisory services anxiously deny that they ever advise clients to 'invest' in art, in fact they provide a great deal of information about different aspects of the market."[68] Citibank's offerings thus include an Art Advisory Service that provides clients with condition, authenticity, provenance, pricing, and market insight for acquisitions and sales; an Art Management Service that creates a photographic database of clients' collections and oversees the shipping, installing, conserving, and insuring of their art (with industry rates); and an Art Finance Service that facilitates loans, with clients' art held as collateral. The key point is that while most of these institutions do not counsel clients on art investing—FAWM being one obvious exception—their packaging of increasingly sophisticated art collection and financing services actually shares a lot of common ground with the offerings of today's art funds.[69]

Funds like FAF and Fernwood, for example, were set up to provide dynamic art financing and collection management services as well. At FAF, these include guidance on customers' personal collections, due diligence on artworks outside of the fund's own investment universe, short-term rental arrangements, loans, art financing, restoration, and coinvestment opportunities. And the fund is also the chief art advisor to the private wealth clients of BSI Bank and Banco Santander. Fernwood was poised to furnish a similar bundle of offerings—encompassing "Quantitative Econometric Research and Analysis," "Market Intelligence Gathering," "Collective Behaviour Analysis," and "Economic Analysis and Forecasting"—alongside its art investment portfolios. If managed efficiently, these would have rivaled, and possibly exceeded, the competencies of other leading art finance businesses.

These aims dovetailed with the liberalization of the art trade aspired to by Taub:

> The securitization (perhaps a better term would be "democratization") of previously illiquid investment categories is a steady, ongoing trend that has gained momentum with the spread of global capitalism, to the benefit of increasingly wider groups of investors. These benefits are typically enjoyed first by a small, privileged group of insiders, then by a wider group of sophisticated investors, and finally become retail in-

vestment opportunities available to all. Equities and bonds made this journey over the last century, and funds-of-funds are now making more non-traditional investment categories (such as hedge funds and private equity investing) accessible to individuals with smaller and smaller amounts of capital to invest. I believe that art is heading down the same road, to the eventual benefit of all investors.[70]

Rising wealth levels among the world's financial elite and their accelerating demand for alternative assets and lifestyle amenities created a receptive backdrop for just such a transition. This reflects what economists call positive income elasticity of demand: the wealthier people become, their demand for luxury goods (or "nonessentials") such as art rises more than proportional to their income increase.[71] And in recent years there has been both an extraordinary concentration of wealth in the pockets of accredited high- and ultrahigh net worth individuals and a more sophisticated understanding of how they spend their money on "passion investments."[72] Fernwood's founding vision of 2004 explicitly cited the importance of the growing HNW demographic to their business prospects, and it also plays a key role in the focus of virtually all current art funds.[73]

CapGemini and Merrill Lynch's *World Wealth Report* substantiates this upward trend: at year-end 2007 HNW wealth totaled $40.7 trillion, and it is believed that this figure will reach $59.1 trillion by 2012.[74] In this same study, art ranks only slightly behind luxury collectibles (private jets, yachts, and high-end cars) in HNW's investments of passion and is considered relatively insulated from the adverse affects of the tumultuous global economy.[75] I will address this supposition more critically in the conclusion, but it is most important in the present context to understand the central role of art in the expenditures of this growing universe of financially elite investors.

The increase of alternative asset investments held by HNWs also alludes to the prospects of art funds.[76] By 2005, for example, alternatives comprised 20 percent of HNWs investment portfolios, up from just 3 percent in 2000.[77] This surging popularity was epitomized by the wondrous growth of the hedge fund industry. Like art funds, these investment vehicles are not new: the first hedge fund was founded in 1949 by Alfred Winslow Jones, who introduced the then groundbreaking concept of hedging investment bets.[78] Through strategic trading (often short selling), and extensive borrowing (leverage), hedge funds attempt to exploit market mispricings that other, more traditional investment vehicles, such as mutual funds, cannot logistically, or legally, pursue.[79] Economists William Goetzmann and Stephen Ross describe this as follows: "[Hedge funds] pursue strategies that can be termed 'arbitrage in expectations,' or

expectational arbitrage. That is, they seek to provide a positive expected return on capital with a minimal exposure to systematic sources of risk by 'hedging away' exposure to traditional asset classes typically held in the investment portfolio."[80]

Exceptional results were achieved through this strategy, especially early on. From 1962 to 1966 Jones outperformed the top mutual funds by more than 85 percent, net of fees. A 1968 U.S. Securities and Exchange Commission survey reported the existence of 140 such funds, a figure that has grown tremendously ever since. Although it is difficult to quantify the growth of this industry (hedge funds are not legally obliged to disclose assets under management [AUM] or earnings), it is estimated that 1,000–2,000 existed by 1990, representing approximately $38 billion in invested assets. By 2003 this had escalated to 8,000 funds and $800 billion in assets; and by 2008 it was estimated that there were 11,700 hedge funds with $1.7 trillion AUM (numbers that have since tailed off in the wake of the global economic crisis).[81]

Art funds have not only benefited from rising interest in hedge funds. The popularity of other alternative investment vehicles, such as real estate investment trusts (REITs) and private equity funds, is also critical, and many art funds envision themselves as hybrids of these businesses.

This is deliberated in a 2004 case study on Fernwood published by the Harvard Business School (HBS). The study quotes Todd Millay, senior consultant to Fernwood, as describing art as being "on the same journey that real estate took over the last few decades."[82] REITs date from the late nineteenth century, but they did not take their current form until the passage of the Real Estate Investment Trust Act in 1960. With this legislation, these trusts, which enable investors to purchase shares in a pooled group of properties, were exempted from corporate income taxes if they adhered to criteria such as establishing lower minimum investment levels. Following the passing of the 1986 Tax Reform Act (allowing REITs to manage their properties directly, without third-party oversight), the opening of REITs to pension funds in 1993, and the 1999 REIT Modernization Act (permitting them to provide specialized management services to tenants), there were nearly 150 publicly traded REITs managing $200 billion in the United States by the end of 2009.[83] Like REITs, art funds give investors exposure to a bundle of assets for a lower capital outlay than otherwise possible.

Private equity funds, which purchase stakes in private companies in hopes of reselling them at higher values, offer a notable point of comparison as well. "The private equity model," observes the HBS study, "[is] similar to Fernwood's in that the end goal of both models [is] 'asset appreciation.' Private equity investment style [is] not based on portfolio management; instead it focused on singular transactions and eventual re-

payment to investors after a specified amount of time (usually 10 years)."[84] This explains why art funds are keen to loan works to enhance provenance and reduce insurance costs. But similarities do not end here: FAF's ten-year closed-end limited partnership is indebted to private equity funds' characteristic decade-long lifecycle as well, as the aforementioned "2 and 20" fee structure resembles that of both private equity and hedge funds. And similar to other alternative investment vehicles, the marketing jargon of today's art funds heavily underscores its managers' past track records, as many are also run out of the major financial centers like New York and London but registered in investor-friendly jurisdictions such as the Bahamas and British Virgin Islands.

Hedge Funds

Art funds can be put into further context by exploring some comparisons with the hedge fund industry. Despite the assets amassed by hedge funds and their extensive media coverage, their overall size is actually less than 1 percent of total financial assets, globally—measured by the combined market capitalization of stocks, bonds, and bank savings. Even upon accounting for leverage, they still do not control more than 3 percent of the world's financial assets.[85]

The field of art investing constitutes a similar relative position: considerable media coverage has been complemented by only a marginal financial impact on the art economy. Recent estimates indicate that the global art market, comprising both auction and private sales, amounts to approximately $50 billion versus projected AUM of $350 and $150 million for FAF and Fernwood, respectively.[86] Over the expected ten-year life cycle of these funds, this equals $700 million and $300 million in total turnover (buying and selling), or an average of $100 million annually ($70 million for FAF, $30 million for Fernwood). Assuming there are ten additional funds with AUM of approximately two-thirds that of Fernwood (at $100 million each, or $20 million in annual turnover—recall that FAF and Fernwood are reported to be the *largest* such businesses), this would constitute an additional annual turnover of roughly $200 million. The annual turnover of art funds thus approximates $300 million ($100 from FAF and Fernwood, $200 from the remainder of the industry), or merely 0.6 percent of the value of the $50 billion international art market in 2009. Furthermore, projecting that the global art market grows at the rate of inflation (3 percent) while the turnover of such art funds increases at an aggressive 15 percent per annum (thus assuming that fund returns meet the top end of their investment guidance), even a decade hence (2018), the market share of these vehicles equates to just 1.6 percent.

These figures are admittedly misleading. Because of the high volume and rapid turnover of their holdings relative to traditional "real money" investors, hedge funds actually constitute a much larger degree of trading volume than their market share suggests. They can account for a majority of trading on certain assets, and their high levels of leverage (which were known to exceed ratios of 30 to 1 during the bull market) can have a huge impact on financial institutions globally, as became acutely evident during the credit crisis.[87] Art funds may display similar characteristics. Because they are mostly managed out of New York and London, their presence in these markets may be disproportionate compared to the global trade; ditto their presence in Western postwar art, which is a strong component of many such funds. Additionally, and most notably, the actual size of the art fund universe is far smaller than suggested above: Fernwood no longer exists, FAF raised less than a third of the $350 million it originally sought, and only a small handful of additional funds were in existence by the end of 2009 (see appendix C).

There are also a number of caveats to hypothetical investment returns. Because hedge funds are exempt from SEC registration, reporting, and regulation, performance is difficult to quantify. In fact, those who report performance tend to possess the best track records: the most successful funds publicize returns while those that perform poorly, or fail, proceed undocumented. This is known as "survivorship bias" and may overestimate returns of a hedge fund index by as much as 2 to 3 percent. "Backfill bias" is also prevalent and can inflate performance statistics as well.[88] Furthermore, astonishing track records of a small number of funds may produce misleading statistics on average returns.[89] In summary, if and when one is able to quantify the art fund industry's performance, these factors will figure prominently, and one suspects that the success of a few such businesses may overshadow the industry's more humble aggregate profile.

In addition, the etymology of alternative investing is slippery. Where "alternative" once referred to assets on the fringe of the investment frontier, it has come to constitute a linguistic catchall for increasingly transparent and liquid ones. A corollary question is thus: as such investment devices become mainstream, do their perceived economic benefits increase, remain constant, or diminish?

Evidence suggests that returns across the alternative investment frontier are lessening. One consequence of the hedge fund industry's growth since the 1990s, for example, is the confluence of rising liquidity and diminishing returns. Such are the characteristics of an economic cycle, and where alternative once meant high risk, high return, the most popular hedging strategies now possess correspondingly weaker investment prospects. From 1998 to 2004 the ability of hedge funds to profit from two of the most basic mispricing opportunities in the equity markets deteriorated

substantially.[90] Goetzmann and Ross have also discovered an overall drop in hedge fund profitability, from returning 13 percent annually between 1989 and 1994, down to 8 percent annually between 1994 and 2000.[91]

It remains to be seen whether similar dynamics will unfold in the art fund universe. Yet it seems reasonable to assume that the profound increase in the availability of art information over the past decade—hugely abetted by online sales price databases—has reduced available arbitrage opportunities. This is an especially curious phenomenon, for on the one hand this development has enabled increasingly sophisticated arguments about the financial benefits of art investing to take shape; and yet on the other hand, the very availability of such information may restrict funds' investment prospects (the more people know, the smaller asymmetries in the market will become). If financial returns diminish as the industry expands, then a crucial issue for funds moving forward will not only concern how well they sell the art investing vision but how capable they will be at demonstrating to investors that this is no mere passing fad.

Lastly, similarities to hedge funds suggest that art funds may also have a high burnout rate and, even more fundamentally, that they may suffer from a severe lack of funding in the near to medium term as investors shift into more conservative investment strategies in the face of the global financial crisis. Under ordinary circumstances, Goetzmann and Ross calculate an annual hedge fund failure rate as high as 20 percent, and the investment research firm Sanford C. Bernstein & Company estimates that 40 percent of such vehicles cease to exist after five years.[92] The credit crisis has exacerbated this, and since 2008 the industry has been ravaged by a combination of poor investment returns, escalating redemptions, and greater levels of regulatory scrutiny, which have caused many funds to close and a great many others to dramatically scale back their operations. It is estimated that in 2008, the size of the industry halved to approximately $1 trillion under management, a finding in synch with hedge fund magnate George Soros's remarks before Congress in November 2008 that the industry would shrink by half to three quarters from its peak of nearly $2 trillion; Barclays Capital has subsequently said that 70–80 percent of hedge funds will shut.[93] This has severe implications for art investing as a drain on capital to these funds will make it extremely challenging for art funds to secure the necessary level funding they require to get off the ground.

Challenges

Notable economic studies may endorse art investing, but this has not always been the case.[94] Princeton economist William Baumol's seminal

paper of 1986, "Unnatural Value: Or, Art Investment as Floating Crap Game," offers an excellent point of comparison. Although this was not the first article of its kind—earlier and oft-referenced art investment analyses include those of Robert Anderson (1974) and John Picard Stein (1973, 1977)[95]—its ingenuity, coupled with the time of its publication during the 1980s art market boom, helped to elevate interest in art's financial prospects. "Unnatural Value" does not compute correlations between art and the financial markets, but its survey of 640 repeat painting sales from 1652 to 1961 offers sound perspective nevertheless. Having achieved a real annual return of merely 0.55 percent per annum over this period, Baumol concludes that the probability of a acquiring a "good" art investment is akin to a gambling crap shoot: "In comparison with government securities, [such returns] imposed an opportunity *loss* upon the hold of the painting of close to two percentage points per year." Furthermore, because art price movements appear to be random—Baumol equates this to the 'random walk' metaphor of the stock market—he challenges the ability of investors to profit "with any degree of reliability."[96] This is an obvious affront to the art fund business model.

Goetzmann's research on historical art investment returns also dampens the allure of art as an asset class. Over the period 1716–1986, he finds that real art returns of 2.0 percent per decade outpaced those to stocks (0.2 percent) but were less than those of bonds (3.1 percent) and considerably more volatile than both of these assets (56.5 percent volatility for art versus 19.6 and 9.3 percent volatility for stocks and bonds, respectively).[97] This high volatility, in conjunction with art's "strong positive correlation" to other assets, suggests that "it is unlikely that art was a superior investment" over this period: art is a "poor vehicle for the purposes of diversification."[98]

Goetzmann is likewise critical of the repeat sales regression (RSR) methodology widely utilized to quantify historical art returns (the Mei/Moses Index is based on a RSR, as is Goetzmann's own 1993 article, among many others). The RSR identifies the investment returns of an asset sold more than once and is attractive for use in the art market because it identifies how particular works appreciate (or depreciate) over time. It is nevertheless subject to numerous limitations. First, by only accounting for resales, the RSR is limited to a small subset of the art trade and is a poor instrument for establishing financial returns over short investment periods (unless the number of resales is sufficiently large). Second, it presents a strong upward bias as decisions by an owner to sell may be conditional upon whether the perceived value of the artwork has increased. Third, the RSR requires homogeneity by assuming that damage and/or deterioration of an artwork has not occurred. And lastly, it fails to capture price

fluctuations of artworks not broadly in demand, or others that have been removed from circulation.[99]

There are alternatives to the RSR, the most popular of which is the hedonic regression.[100] This model accounts for the heterogeneity of assets and measures the performance of a grouping of unique goods based upon shared characteristics. In the process of its development, it has benefited real estate and consumer product research and, more recently, the art market: because artworks possess identifiable variables (the artist's name, date of execution, dimensions, signature, medium, etc.), the hedonic regression is a useful step in accounting for product differentiation within a price index. This methodology reconciles some of the RSR's limitations by accounting for heterogeneity and by incorporating a larger sample set.

Yet despite its rising popularity, it is not flawless. The hedonic index is unable to account for the impact of damaged goods and it assumes that the given variables explain all inherent price movements. This becomes problematic, for example, if an artwork's constitutive elements are not easily attributable or if such characteristics change over time (e.g., through deterioration). This is why the hedonic regression is usually implemented to chart the financial returns to paintings and prints, whose characteristics tend to be the most standardized.[101]

These hindrances are evident in the lack of consensus as to what the financial returns to art actually are. Art market economist David Kusin simply observes that an "'all art index' is meaningless."[102] When applied to identical data sets, the RSR and hedonic regressions may also produce different rate of return estimates.[103] Moreover, because much of the literature does not account for the impact of unsold lots at auction or for transaction costs, art investment risks and returns may in practice be different from what these studies indicate.[104]

A further limitation of this research is that it only concerns sales at auction, a sector that accounts for roughly half of the global art marketplace: the financial ramifications of dealer and private party sales remain largely unaccounted for in the literature.[105] This is not fundamentally problematic—much economic analysis is derived of sample data sets—but because of the dealer market's opacity, it is difficult to quantitatively account for price characteristics of artworks here or for correlations between this and the auction sphere.

This shortcoming is compounded by the fact that art in the vast majority of these studies (including those by Baumol, Goetzmann, Mei and Moses, and Campbell) actually entails only paintings and is often drawn from a small subset of the market as a whole.[106] For example, while Mei and Moses's research has been key to expounding the benefits of art as an asset class and, consequently, to the recent growth of art investing, it

is also controversial: their data set only looks at repeat sales of paintings at Christie's and Sotheby's in New York. Leaving aside these economists' importance to the literature, this is an undeniably thin and highly selective slice of the international art market. We are given no sense of the investment characteristics of nonpainterly artworks, and there appears to be a strong upward bias in their conclusions as they evaluate the price levels of artworks only at the peak of the market (in other words, they neglect the enormous universe of art that never makes it to the two main U.S. salesrooms or only sells once at auction).[107]

Moses's subsequent retirement from NYU and his founding, in 2007, of Beautiful Asset Advisors, which gives fee-paying subscribers access to proprietary art market research, raises further questions about such biases.[108] The fact that the Mei/Moses Index is now a trademarked business (The Mei Moses™ Fine Art Index) may color its founders' position: Mei and Moses now have a clear vested interest to sell their product and investment services. Similarly, moral hazards may arise when academic economists appear on panels about art investing sponsored by art funds and art financial services firms eager to promote the legitimacy of art as an asset class. At the very least, critical remarks on the subject are apt to be kept to a minimum. Perhaps most fundamentally, then, while it is important to recognize the significance of this ever-expanding body of literature to our understanding of international art markets, it is equally imperative to keep it in perspective. Such research has certainly added color to the risks and returns of investing in art, but it is at best a theoretical guideline that continues to be burdened by its selective scope.

Another important question we must ask in relation to this is how this literature relates to the actual operation of art funds in practice? This is not easy to resolve given the discreet nature of these businesses. Nevertheless, it is unlikely that the risk/return parameters of private market investments made in distressed deals and other off-market opportunities will mirror those of the literature. Though perhaps profitable, such transactions are also apt to be riskier than an auction "market basket," and they may possess different correlations to other assets than implied. The portfolio diversification benefits of art investing suggested by the literature also have little bearing for art fund investors unless these vehicles can actually reproduce index returns. However, there is as yet no tradable art sales index for funds to invest in, while the lack of a derivatives market for art goods means that these vehicles cannot "hedge" their investments in any true sense: art funds can acquire works in the belief they will rise in value, but they cannot hold a contrarian view of the market by selling art short and betting that the price of work by a particular artist, or sector of the market, will decline.[109] This implies that art funds may be riskier than they would like investors to believe.

FAF's precedent also suggests that it may be difficult for funds to realize their proposed investment strategy. For example, FAF I was originally meant to attain a model portfolio consisting of 15–20 percent of art produced between 1960 and 1985 (Contemporary II) and just 0–5 percent of art produced from 1985 to present (Contemporary I). Yet as the fund has evolved, so has its model portfolio, with the two categories expanding to between 30 and 40 percent and 5 and 10 percent, respectively. It is therefore possible that fully *half* of the investments in this fund could be allocated to contemporary art.

This is clearly due to the buoyancy of the contemporary sector since 2000 and reflects FAF's ambition to cash in on these ballooning values. But it may also serve a logistical function that such funds do not publicly declare. Because art investing is a relatively new phenomenon, sophisticated investors are unlikely to accept the concept of art as an asset class or fund managers' past track records outright: they want to see a history of returns. In response to this, funds must rapidly turn over assets in their early stage in order to embellish their credentials and demonstrate that they are indeed making sound investments. This is to be expected insofar as such trading falls within the parameters of a fund's stated portfolio allocation. Yet the reality is that because the contemporary sector has grown so robustly and been so lucrative relative to other parts of the market since 2000, many funds, as suggested by the distribution of FAF's own holdings, may not be holding steadfast to their claimed objectives. "Sector diversification" may thus prove to be a catchy, but erroneous, byword as these funds are drawn into a vicious cycle of having to quickly generate returns in order to raise capital, ultimately exposing their portfolio to greater risk than anticipated—especially if they are caught holding large portions of contemporary art purchased at the peak of the market in 2007 and first half of 2008.

This not only applies to FAF. Prior to its closure, Fernwood was the lead sponsor of the New Art Dealers Alliance (NADA) Art Fair in December 2005, held in conjunction with Art Basel Miami Beach. This arrangement was synonymous with the firm's desire to remain "on the cutting edge of art market trends and developments," and it also fulfilled a shrewd business objective: to advance the firm's marketing campaign and to create a potentially lucrative networking platform in order to give the fund preferred access to desired contemporary works from the dealers, collectors, and artists at the fair.

These observations do not diminish the potentially lucrative investment prospects of art funds. If they raise sufficient capital from investors, their large capital reserves and extensive market knowledge could certainly enable them to exploit informational and regional asymmetries arising in the marketplace. Yet the high levels of risk they may take on to

do so underscore a fundamental schism between the theoretical promise of art investing as an academic subject of debate and how art funds actually operate in practice.

Inefficiencies

The art market's inefficiencies compound the difficulties of capturing index returns and profiting from opportunistic trading strategies. Some of the key issues are low liquidity, opaque market information, high transaction costs, and limited arbitrage opportunities.[110] The implications of these for art funds will first be examined economically and then, in the following section, sociologically.

Liquidity is arguably the most prominent of these inefficiencies and concerns how quickly an asset can be sold without disturbing prices. Art is generally seen as illiquid because there is a limited market infrastructure for facilitating sales: artworks may be in high demand but they cannot be seamlessly sold, unlike other assets like stocks, which can be traded essentially with the push of a button. Auctions offer an extreme illustration of this (where three- to six-month lapses between consignments and sales are typical), but private market transactions are time-consuming and labor intensive, and there is an ever-present fissure between these two circuits that clouds market information: auction prices are transparent but dealer prices are not.[111] In addition, many works trade infrequently and others are constantly being removed from circulation as they are purchased by, or donated to, museums—what has been called the "museum factor."[112] Because of these issues, art funds must be selective in composing their portfolios: while art's low liquidity and the lack of price transparency may present attractive investment opportunities (e.g., differences in value that funds can exploit), they also could be detrimental should funds misread market information and end up holding works no longer in high demand or should they need to divest their portfolios quickly and unexpectedly (e.g., with a sudden rush of redemptions from investors).

The economy's weak pricing system, which lacks a single generally accepted valuation methodology, is another inefficiency.[113] For example, art investors cannot simply determine the value of an artwork by calculating the discounted value of its future cash flows, as is commonplace in the equity and real estate markets. Furthermore, art is a cash flow negative asset: unlike stocks and property, art does not pay financial dividends or generate rent to owners, but it does impose storage, handling, shipping, and insurance costs.[114] Such costs underscore both a fundamental risk of investing in the art market and its speculative nature. One can make an educated bet that the price of an artwork may rise in the future, but cal-

culating such gains is hardly a perfect science and the costs involved in taking a position in this market can prove detrimental.

It is also important to account for the potential difficulty art funds may have in turning over their investments within their proposed five- to ten-year time frames. In a 2005 report, Barclays Capital observed that art may indeed be beneficial within a "diversified" portfolio, but stressed that "to be sure of making real returns over inflation, [one] need[s] to hold it for over 35 years"—or more than three times the duration of most current funds.[115] Mei and Moses elaborate: "Art may be appropriate for long-term investment *only* so that the transaction costs can be spread over many years."[116] Furthermore, while the costs to transacting in other capital markets are homogenous and relatively low—especially with the advent of e-trading—those in the art market are comparatively exorbitant: buyers' premiums have increased steadily at auction since the early 1990s and can account for upwards of 10–20 percent per transaction (versus an approximate range of 1 percent, or less, with stocks) (table 1 shows the escalation of these fees at auction).[117] This further amplifies the investment risks enumerated above.

Because such transaction costs are neither uniform nor transparent, they are omitted in most economic literature, meaning that the aforementioned studies of historical art investment returns are inflated.[118] It is therefore of utmost importance for funds to reduce these fees. Fernwood was certainly aware of this and noted that, "because of [their] buying power, [they] are able to purchase fine art at substantially lower transactions costs," similar to trading discounts given to powerful institutional investors in other financial markets. The extreme disparity in the cost of transacting at auction versus in the equity markets suggests that to *meaningfully* diminish such fees, firms must trade actively in the dealer or private markets. So doing, however, may not be easy, as discussed in the next section.

We should also acknowledge the limits to arbitrage that burden art investment returns. The aforementioned absence of a financial derivatives market for artworks and the fact that that there are no perfect substitutes for unique artworks offer obvious examples of this as they inhibit the ability of arbitrageurs such as art funds to correct market mispricings. Moreover, even when pricing inefficiencies are identified, the risks and costs attributed to investing may outweigh the benefits. Economists Bruno Frey and Reiner Eichenberger explain: "Art market speculators may correctly forecast rising demand for top paintings, but it is nearly impossible for them to foresee whether export and other restrictions arbitrarily imposed by government in response to fickle public pressure leads to a dramatic fall in price. More generally, the dependence of art prices on political and administrative interventions hinders successful arbitrage."[119]

TABLE 1
Buyer's Premium at Christie's and Sotheby's, 1975–2009

Date	House	Buyer's Premium
September 1975	Christie's	10% inclusive
September 1975	Sotheby's	10% inclusive
January 1993	Sotheby's	15% on the first $50,000 10% thereafter
March 1993	Christie's	15% on the first $50,000 10% thereafter
February 2000	Christie's	17.5% on the first $75,000 10% thereafter
March 2000	Christie's	17.5% on the first $80,000 10% thereafter
March 2000	Sotheby's	20% on the first $15,000 15% between $15,00 and $100,000 10% thereafter
April 2002	Christie's	19.5% on the first $100,000 10% thereafter
April 2002	Sotheby's	19.5% on the first $100,000 10% thereafter
January 2003	Sotheby's	20% on the first $100,000 12% thereafter
March 2003	Christie's	19.5% on the first $100,000 12% thereafter
January 2005	Christie's	20% on the first $100,000 12% thereafter
January 2005	Sotheby's	20% on the first $200,000 12% thereafter
January 2007	Sotheby's	12% on the first $500,000 20% thereafter
February 2007	Christie's	12% on the first $500,000 20% thereafter
September 2007	Christie's	25% on the first $20,000 20% between $20,000 and $500,000 12% thereafter

TABLE 1 *cont.*

Date	House	Buyer's Premium
September 2007	Sotheby's	25% on the first $20,000 20% between $20,000 and $500,000 12% thereafter
June 2008	Christie's	25% on the first $50,000 20% between $50,000 and $1,000,000 12% thereafter
June 2008	Sotheby's	25% on the first $50,000 20% between $50,000 and $1,000,000 12% thereafter

Source: Christie's, Sotheby's Press.

Note: Prior to 1975, the major auctioneers only charged commissions to sellers (ranging from approximately 12 percent to 30 percent). With the introduction of the buyer's premium in 1975, originally only applied by Christie's and Sotheby's to sales in Europe, the seller's commission was reduced to approximately 2 percent to 10 percent. The buyer's premium was introduced in the United States when Christie's opened its first auction house in New York in May 1977; Sotheby's (then Sotheby Parke Bernet) began charging the premium in New York in January 1979.

The field of behavioral finance raises similar challenges to the applicability of the Efficient Markets Hypothesis (EMH), a central feature of Portfolio Theory.[120] EMH is based upon three assumptions: (1) investors are rational and value securities rationally; (2) to the extent that investors are irrational, their trades are random and cancel each other out; and (3) to the extent that investors are irrational in similar ways, their actions are met by rational arbitrageurs who eliminate their influence on prices. In contradistinction to this, behavioral finance argues that investors' irrationality and logistical impediments within the actual structure of financial markets have more profound impacts on prices than otherwise assumed.

This line of thought has come into vogue in the wake of the global economic crisis (which has revealed the frailty of assumptions about the workings of modern finance), and the art economy offers some instructive extensions of it. When applied to the art trade, for example, behavioral finance suggests that opportunistic trading strategies may be curtailed in practice because investors cannot sell short overvalued artworks or execute risk-free hedged bets. In addition, the whims of fashion and taste may undermine even the best art investment forecasts as, unlike under EMH, art market actors may not deviate from rationality randomly, but

in the same herdlike way: pricing anomalies may therefore last longer and be more extreme than otherwise supposed.[121]

Social Barriers

Art investment funds, of course, view these inefficiencies optimistically. Leveraging their quantitative and qualitative expertise, alongside their sizable purchasing power, they argue that such conditions bear rich speculative opportunities.[122] Today's art investment pioneers, like their hedge fund counterparts, are thus staking their claims on the prospects of the efficient/inefficient rift.

But current art funds are not the first to highlight the economic benefits of this market's inefficiency. In 1991 economist Richard Coffman argued that this attribute of the art economy, which stems from pervasive asymmetric information, implied that "investors have a reasonable chance of making above normal returns."[123] Asymmetric information may benefit the seller who knows more about the good than the buyer (i.e., provenance or condition) and thus knowingly withholds such information when transacting, or it privileges the informed buyer who makes undervalued acquisitions and resells at a premium.[124]

This latter scenario is precisely that championed by art funds. "Everyone who has tried this before has either been too financially focused, and didn't understand the art," reckons Taub, "or too art focused—without understanding the financials."[125] The delicate balance reconciled across analytical investment metrics, art-historical knowledge, and "insider" savvy is strategically intended to help these funds profit from such informational deficiencies. Nevertheless, bargains may be limited at auction due to exorbitant fees, a point Coffman emphasizes.[126] To truly reap the financial rewards of asymmetric information and market inefficiency, art investors must transact outside the auction sector and in the private markets instead.

Olav Velthuis's research on the contemporary art economy suggests that this objective will be challenging for funds to achieve. Drawing on empirical data—interviews with contemporary art dealers in Amsterdam and New York—and the field of economic sociology, he argues that free-market transacting is restricted in the art economy due to deeply embedded cultural conventions.[127] The foundations of Velthuis's argument are not unique—revisionist accounts of other financial markets have been similarly articulated—nor does he discuss art funds. But his approach to the art economy is fresh and yields some important ways of reconciling our analysis of art investing (itself exemplary of free-trade ideology) as

well as our broader enquiry into the relationship between art and global finance.[128]

The single most penetrating concept he deploys is what sociologist Viviana Zelizer calls "circuits of commerce." Velthuis elaborates:

> Rather than being solely motivated by utility maximization, members of ... circuits may be inspired by concerns of status, care, love, pride or power. In daily economic life, they not only need to collect information and make decisions on its basis, they also need to make sense of the behavior of the partners they engage in trade relationships with. This behavior may not be universally rational, but it does make sense within the circuits that economic actors inhabit.[129]

The applicability of this statement to the art market is considerable. In a system where artist-dealer-collector relations are highly personal, even familial, economic decisions are actively restrained by social dynamics.[130] Because of this, the *art world circuit* (where profit is but one factor in a more elaborate cultural system: economic plus cultural capital) can be seen to distinguish itself from art funds' *financial circuit* (where profit rules: economic capital alone). Hostility between the two can be understood as a battle over conflicting "utility maximizing" objectives.

The presence of multiple, and potentially conflicting, socioeconomic circuits greatly expands our understanding of art investing as a merely abstract financial exercise: the will to sustain long-term artist-collector relationships on behalf of dealers (of one circuit) implies that purely speculative parties (of another) may be barred from otherwise lucrative trading opportunities. To illustrate this, Velthuis discusses the inefficacy of art investors to capitalise on auction/dealer pricing discrepancies. In December 1999 an exhibition of Andreas Gursky's photographs in a commercial New York gallery sold out for prices of $50,000 per item. Only two weeks before, an earlier photograph of his (*Prada I*, 1995) was hammered down at Christie's New York for $173,000, well above its $40,000—$60,000 presale estimate and despite the fact that it was of the same edition size and dimensions of the later works.[131] Velthuis observes that Gursky is one of many coveted artists whose auction prices may exceed those commanded at galleries, implying that art market price dispersion is systematic —possibly even strategic.[132]

For speculators, these irregularities indicate hypothetical arbitrage opportunities: one could theoretically buy low from a gallery and sell high at auction. But the feasibility of executing such trades is restricted because gallerists and auctioneers do not adhere to the same maxims when selling artworks. The latter seek to achieve the highest price that the market will bear at any given point in time, while the former strive to establish a fair

price that they can sustain (with steady increases) in the long run. Or, to borrow more formal economic terminology, dealers "do not let prices clear the market by selling works to the highest bidder."[133] Instead, they rely on what Velthuis calls "alternative rationing mechanisms" to enhance their ability to set the market price and to control the direction, and pace, of supply: "In their attempt to limit the possibility of future resale and investment potential of an artwork, dealers restrict rather than enhance the liquidity of artworks: they construct moral and even semilegal boundaries between the auction and avant-garde circuit to prevent arbitrage from taking place."[134]

These preventative measures are hardly altruistic and it can be largely out of self-interest that dealers attempt to safeguard their artists from speculative forces—which, in the case of a sudden flooding of works to market, may unduly signal an artist's weakness and deteriorate his or her prices.[135] One way of achieving this is by "placing" works with trusted collectors and stipulating a first right of refusal should the collector wish to resell the artwork. Although many gentleman's agreements are verbal, some are specifically written into sales contracts. Whatever the case, they are certainly effective at limiting speculation: "collectors do not engage in arbitrage since they know that it will harm their future relationship with a dealer." Velthuis highlights a scathing remark from one of his dealer interviewees: "If there is a Luc Tuymans on the secondary market, that is here, not at the auction houses. Because the collector does the right thing, he gives it to us, so that we feel good about him buying other works, even by this artist. If he would put it at auction, we would never sell to him again, we punish him."[136] Indeed, collector blacklists circulate within the dealer community.[137]

This antispeculative vehemence is sound business sense. In fact, dealers' suppression of the economic—that they will not adjust to "parasitic" auction prices for a quick profit—may ultimately strengthen their financial prospects: collectors continue to do business with them because they trust their prices, and so the quality of their inventory.[138] Dealers' aversion to the auction circuit is linked not only to its perceived price volatility but also to their distaste for its short-term priorities: whereas dealers are indebted to sustaining an artist's entire career, auction houses principally seek rapid and profitable turnover. The downside of this is not merely sentimental: as goods leave the dealers' inventory and extend beyond the network of collectors who comply with the first right of refusal, their control over supply diminishes—and with it, their monopolistic price control mechanism. (No wonder they commonly repurchase their own artists' work at auction, which enables them to set a public market price and to enhance their control over supply.)

When analyzing the art trade's financial dimensions, we should also acknowledge the diverse manifestations, and equally diverse *meanings*, of gift-giving and moral obligation. Velthuis states: "My findings suggest that the structure of the art market is supported by more than just the monetary influx of collectors buying art for hedonistic purposes. Instead, the market relies on a dense fabric of mutual gifts and favors: dealers subsidize artists, artists donate works to dealers, collectors occasionally buy works to support an artist or a gallery, or enact the role of the dealer's moral and financial banker."[139] Or, as Zelizer elsewhere argues, "gifting" may be as "pragmatic, calculating, and obligatory as market transfers."[140] The true price of collecting thus appears to be more complex than neoclassical economic analysis indicates: social obligations must additionally be accounted for when projecting hypothetical art returns.

We should, of course, be careful not to overstate the case. The high levels of speculation evident in the contemporary sector during the latest boom, especially the unprecedented volume of contemporary art being sold at auction, suggest that the preventative boundaries and social obligations highlighted by Velthuis also have their limits. If a collector's bid is high enough, in practice we find that many dealers will ignore these codes and sell an artist's work nevertheless. Yet despite obvious, and even widespread, exceptions to the rule, preexisting social ties and loyalty are clearly elemental to the dealer market's vitality and suggest that, unlike the implicit liberal ideology of economic theory, "the art market is far from a democratic institution."[141] And this implies that art funds' investment objectives may be intrinsically flawed: because their vindication of art as an asset class is based so strongly upon free-trade economic theory, they may have underestimated the behavioral aversion of the market—especially the dealers-cum-buyers who are integral to their success—toward such unabated speculation. Their success, then, clearly resides in their ability to get the market to play by their rules.

• • •

This line of thought helps explain why art dealers are commonly regarded as the best art investors. The caveat here is that their "investments" are composed of both symbolic *and* economic capital, as theorized by Bourdieu: dealers are ultimately *socioeconomic maximizers*, cultivating the value of their capital stock and their own symbolic reputations—the two interpenetrate one another—for long-term gain.

One upshot is that an implied premium may be charged in the dealer market should art funds wish to transact independent of the field's prevailing social conventions. This could be reconciled as the premium to

trade speculatively. In practice, it implies that art funds may have to offer their dealer-buyers more generous financial arrangements than these dealers' preferred clients in order to receive the best works. Dealers could thus potentially "punish" art funds by making the *real* costs of doing business with them exceed the theorized gains. In other words, art funds might become victims of their own success. The costs associated with transforming the art market's embedded relationships into fluid, high turnover business ties may nullify the respective trading profits realized in so doing.

An additional hindrance for art investors is that failure to be inscribed within the dealer hierarchy means that their potential trading universe may be preemptively restricted. If this occurs, art funds may be forced to trade in goods with sizable secondary markets and may be ostracized from other potentially lucrative avenues. For example, even if dealers and gallerists are willing to trade with art funds in the secondary market, they may hesitate to do so in the primary market where they have the most incentives to protect their artists' career paths. It is, of course, in the interest of funds to promote and advance the careers of the artists whose work they hold by loaning to exhibitions and marketing their work—key to their value-added active management strategy. Yet because they have a fiduciary duty to investors to sell at the maximum price, rather than to place work with trusted collectors and institutions, they may inevitably aggravate these same dealers and gallerists when they "dump" work back onto the market. This means that art funds may have only limited access to the market sector where investment rewards, and risks, are arguably the greatest.

It is important to note, in this respect, that most art funds—unlike hedge funds and private equity funds—do not have exclusive relationships with their traders. Instead, they tend to buy and sell through dealers who are also active in the market independent of the fund. They then attempt to align the interests of these hired hands by offering them financial incentives to place work with the fund. FAF, for instance, offers its art buyers an undisclosed annual consultancy fee, a finders' fee ranging from 2 to 10 percent and a portion of the carried interest at the end of the fund's life.[142] However, while there are advantages in maintaining non-exclusive trading relationships (dealers who are already active in the market may have the best access to quality work and the deepest client networks, not to mention that certain parties may not wish to knowingly trade with an art fund), it is unclear whether or not such incentives will ensure them of prioritizing funds over other avenues.[143]

Three factors bode in favor of the dealer/"art buyer" remaining faithful to the fund. One is that the dealer believes that the above incentives are more lucrative than short-term independent trading upside; a second is that the dealer does not want to bear the transaction risk alone; and a

third is that the dealer does not have the capital to trade without the fund's financial backing. Unless the dealer's consultancy fee is significantly large, or unless the dealer stands to sufficiently profit from the fund's overall performance, the first point is dubious. Suppose that a dealer who acts as a buyer for a fund identifies a work for sale at $100,000 that she knows she can resell to one of his clients for $200,000. In this case, it is difficult to believe that the dealer would give this work to the fund. If traded independently, she could net $100,000, which even after steep transaction, administrative, insurance, storage, and shipping costs of 15 percent would still earn him about $85,000. On the other hand, if the work were sold through the fund and the dealer received a precost 10 percent commission, she would only, at best, receive $10,000 plus a percentage of carried interest associated with this work at the end of the fund's life. In reality, a dealer would only presumably choose not to execute such a transaction alone if the fund's fees and incentive structures were large enough (an unlikely event), or if she was not actually certain about his ability to resell this work at twice cost.

This accounts for the second point above and reiterates why art funds are risky enterprises: one expects that rational dealers-cum-buyers would save the best opportunities for themselves and allocate only weaker and riskier assets to the fund. We have seen this before in BRPF's advisory relationship with Sotheby's, which was reported to have passed along low investment grade assets to the fund. A main factor preventing this conflict of interest nowadays is that dealers tend to purchase work at a deep discount that they can turnover rapidly, whereas funds' longer-term buy-and-hold strategy enables them to acquire inventory with less obvious immediate returns. To the extent that this is so, the type of work dealers buy for themselves and source to the fund need not be the same. Yet because art funds need to generate returns in order to raise capital during the early stages of their development (especially as they seek to tap the instiutional market where investable assets and compliance hurdles are at their greatest), in actuality they may be competing for the same deeply discounted work as their dealers/buyers. This is a severe conflict of interest that is yet to be overcome by the present generation of art funds.

The last point is certainly the one that funds emphasize the most. This coincides with Taub's aforementioned desire to bring capital and liquidity to the art marketplace and explains why Hoffman is adamant that art funds are strategically positioned better than dealers: in theory, art funds should have access to more money, quicker and with less strings attached than their competitors. Certainly the biggest current issue in relation to this point is art funds' ability to actually raise sufficient capital and put their superior purchasing power to work; we will look at this more thoroughly in the next, concluding section. But irrespective of this, the lack of

investable assets in the dealer community does not preclude dealers/buyers from either receiving bank loans to finance such transactions or partnering with another party to execute these deals. Funds do have speed and low administrative hurdles in their favor: the majority of financial services institutions do not lend against art, while a credit advance may be time-consuming and costly even at institutions that do (there are also likely to be upward limitations on how much banks are willing to loan against collateralized art); and it may be laborious for a dealer to find another nonfund party to partner with. In the end, however, conflicts of interest prevail and it is unclear whether incentive structures and rapid access to capital would ever consummate an entirely efficient financial relationship between practicing dealers and art funds.[144]

Art Funds Today

Less than a year after ABN-AMRO launched its art investment advisory service in 2004 and attempted to inaugurate a fund of funds, it deserted both enterprises. Company spokeswoman Carolein Pors claimed that "the available art funds were not sufficient to put together a fund of funds." Meanwhile, of the twenty art funds on which ABN-AMRO performed due diligence, they offered their clients only *two* (FAF and the China Fund) as third-party investment vehicles: "While a host of funds are currently jostling to find investors," it was reported in 2005, "few are succeeding. Most have scaled back their initial optimistic targets and only one [FAF] is actually up and running." One unnamed insider postulated that ABN-AMRO's defection "screwed the market [for art funds]."[145]

The opposite fates of FAF and Fernwood offer an indication of how the industry is unfolding. In its first year of operation, FAF I returned an average of 54 percent on sales, and through October 2009 it had achieved average annualized returns of 34 percent on assets sold since inception. Three additional funds are also in operation—the Fine Art Fund II, the China Fund, and the Middle East Fine Art Fund—with two further vehicles on the horizon: The Fine Art Fund III, a five-year, closed-end fund that will focus on acquiring art at distressed prices; and the Indian Fine Art Fund. In aggregate, FAF has generated returns of 30 percent on all of its realized assets to date.[146]

Fernwood, on the other hand, closed without notice in June 2006, only weeks before it was to have closed on what was reported to be an initial tranche of $25 million.[147] The firm's management never gave an exhaustive public explanation for this closure, but Michael Plummer, then chief financial officer, has offered thus: "We were concerned whether Taub had the financial stability and the wherewithal to manage the funds during

their life.... I studied the macro-economics of the art world for ten years. Art fairs have made changes and so have databases. But things are still run by a small group of insiders. And there is a lack of capital because of that."[148]

The reality appears to be far more dire. In February 2007 a consortium of investors who had purchased preferred shares in the parent company of Fernwood launched a lawsuit against Taub on grounds of embezzlement, fraud/intentional misrepresentation, negligent misrepresentation, and breach of fiduciary duty, among other claims. It claims that Fernwood

> was in fact little more than a vehicle for Taub to propel himself into the rarefied social circles of the art world by using other people's money. Taub's intention, borne out by his conduct, was to use his wife's and his social connections to gain access to wealthy individuals connected with the art world, obtain their funds through a sale of stock in Fernwood, insure that no one but he had control over the funds or access to information about their use and then use the funds to finance his own social aspirations and lifestyle.[149]

Furthermore, the $8 million alleged in the suit to have been raised by Taub was less than one-third of what had otherwise been reported and came nowhere near to the $150 million the fund initially sought.[150] Nor was this money even for the proposed funds, but simply to capitalize the parent company: Fernwood never actually raised any capital for its core investment activity. As arguably the single most high-profile art fund alongside FAF in the recent period, Fernwood's failure has gravely damaged the prospects of this industry as news of its collapse has ricocheted throughout the worlds of art and finance. This would only become worse were Taub to be found liable, his fall from grace underscoring the severe risks of investing in an industry with limited oversight and regulation, and almost endless smoke and mirrors.[151]

• • •

After the initial scramble for funding and innovation passes, the art investment universe may undergo a series of revisions—if it survives at all. One avenue is that of progressive specialization, or what Fine Art Wealth Management calls a "sector allocation" trend.[152] Here we see funds shifting from diversified art investment strategies, as embodied in Fernwood's proposed Sector Allocation Fund and FAF's two flagship diversified funds (FAF I and FAF II), to more focused sector-specific strategies limited to work of certain media or from particular geographic regions. The 2007 launch of WMG Photography Collection, a £10 million fund

based in London that sought to invest in several thousand photographic prints, followed in 2008 by the opening of the Merit Art Photography Fund, based in Vienna, are indicative of the former tendency, yet the latter is most prevalent.[153] This is reflected in FAF's Chinese and Middle Eastern investment vehicles, The China Fund and Aurora Fine Art Investments, which reportedly invested in circa $100 million of Russian art since its founding in 2005. New York-based Meridian Art Partners, set up by Andrew Littlejohn and Pamela Johnson in 2008, which sought to raise CHF 100 million for art investments from across the emerging markets spectrum, offers a further example.[154]

There is also a growing level of art fund activity in developing regions such as India. Some of the most noteworthy recent initiatives include the Osian's Art Fund, launched in 2006 by entrepreneur Neville Tuli as a further venture of the Osian's art conglomerate (which also owns the eponymous Indian auction house, as well as art advisory, film and publishing businesses); the Yatra Fund, launched in 2005 in partnership between Edelweiss Capital, a financial services company based in Mumbai, and Sakshi Art Gallery, Mumbai; and Crayon Capital Art Fund, launched in 2006 by asset management company Crayon Capital and Vadehra Art Gallery, both based in New Delhi.[155] These ventures are especially interesting because they signal the escalating relevance of the developing markets within the global art economy and reveal some key differences between art investing in these areas and in the West. The close strategic ties between these funds and leading Indian galleries and auctioneers is unheralded in the European and American context where, as we have seen, these parties have tended to erect far more rigid barriers between themselves and art funds. That this is less the case in India, or in other regions such as the Middle East and China, is telling and will be of utmost importance to the progression of the art market onto a truly global stage.

A second significant tendency is the shift toward opportunistic investing strategies. This has been prevalent from the outset, both in Fernwood's proposed Opportunity Fund and as one of the strategies deployed across FAF's various investment vehicles. However, due to significant price volatility within certain sectors of the market in recent years (especially for contemporary art), as well as the difficulty of actively managing a large, diversified portfolio of art investments (a hindrance also encountered by BRPF), a number of funds shifted more explicitly into this space beginning in 2008. In January 2009 FAF announced its intention to raise between $50 to $100 million for a new fund (FAF III) that would focus on distressed artworks whose prices have plummeted in the face of the economic crisis.[156] And a similar strategy also featured prominently with two funds founded the previous year: London-based Dean Art Investments, which sought $50 million and was to be advised by Jeremy Eckstein, for-

merly of Sotheby's and an advisor to BRPF; and ArtPlus, which sought up to $200 million and was to operated out of Luxembourg and Israel by brothers Serge and Micky Tiroche, the former an ex-Citigroup banker, the latter a cofounder of the Tiroche Auction House in Israel and director of a London gallery.[157]

Art investment syndicates run by market insiders seeking to escape administrative and regulatory constraints may also come to occupy a significant role. Investment banker-turned-dealer Robert Mnuchin, director of L&M Arts, New York, inaugurated such an initiative in 1993 and continues to run it as a small limited-partners fund with capital from ten principal investors (although details of its size, strategy, and returns have never been made public).[158] And Daniella Luxembourg's ArtVest has similarly discreet objectives (the majority of investors are long-time clients and friends). One witnesses it outside of the fine art trade as well: in 2005 New York map dealer Graham Arader solicited $200 million for the establishment of his own fund (though he ultimately abandoned the effort the following year).[159] Such ventures must be distinguished from funds that attempt to provide a structured investment solution for qualified HNW and institutional investors, but they are a notable presence in the market and are attractive precisely because they eradicate some of the major logistical hurdles and conflicts of interest that belabor vehicles like FAF. "Collectors/art investors are putting together small syndicates and they increase in number daily," explains New York art advisor Thea Westreich. "You see them at fairs; they're wearing baseball caps and sneakers; they act covertly but dealers are starting to recognise them.... All these new financial ventures will ultimately skew the marketplace."[160]

Precisely how they may do so remains unclear, but perhaps it is ultimately a matter of art funds converging on the business models of other art financial services firms. To the extent that they can be expected to continue, art investing as a formal practice may disintegrate into a more indistinct collection management and financing business. This would further reinforce comparisons with hedge funds, which at their peak were also in the process of shifting away from their key competencies toward more prominent undertakings in the insurance, private equity, and banking sectors—"making them rapidly becoming indistinguishable from the rest of the financial-services industry."[161]

In the art fund sector it is nevertheless unclear just by how much demand for such comprehensive services will increase even as HNW and institutional investors without extensive art market expertise—or the resources needed to independently manage their collections—enter the art trade. Unresolved as well is *who* will ultimately be best at supplying these provisions. On one hand, if demand for these services accelerates, auctioneers, banks, and dealers will presumably mount a stern challenge to

art funds; on the other, it may prove too laborious and costly for art funds to simultaneously meet their investment objectives and provide these faculties. Or these vehicles may be phased out altogether: "I think what we may be seeing is not less interest in diversifying one's portfolio to include art," Moses surmised in 2007, "but, rather, that individuals who decide to invest in art want to do it on their own. They don't need a manager for their art investments, and that causes an art fund to have a lot of headwinds to sail into."[162]

Despite even FAF's track record, it, too, bears this out. Most significantly, Hoffman and his team have raised less than $100 million across all of their funds, versus a projected target of $350 million at inception in 2003. Furthermore, the strong investment returns reported by FAF only tell part of the story. To begin, it is hardly surprising that the returns posted by FAF in its early stages have been impressive, as any such figures would tend to capture the performance of assets that had proved to be particularly "good" investments (with the drag of poor investments only being felt toward the end of a fund's life once all of its assets had been sold off). Second, because FAF is not under any legal obligation to disclose details of its investments (it is an unregulated business), there may be selection biases in the type of information it shares with the public, therefore lending an artificially rosy outlook to its prospects. Note, for example, that while the fund discloses its returns on assets already sold, it does not share the marked-to-market valuation of its overall investment portfolio, which may be weaker. Lastly, and related to both of these points, most of the assets it has sold up to 2009 benefited from an extremely prosperous period in the art market (not unlike BRPF's Impressionist sales of the late 1980s). However, it is not yet clear what effect the art market crash beginning in autumn 2008 will have on its overall investment portfolio. The fund has stressed that the majority of its assets are still valued above cost and that it has only sold one artwork at a loss (of $40,000), but its future prospects are far from certain—especially if the market's recovery is slow to take shape.[163] One need only recall that it took upwards of seventeen years for price levels to regain parity with their peak of the 1980s bubble (graph 1), a situation that, if replicated, could hold an ominous fate for funds like FAF with ten-year terms.

The broader art fund landscape reflects this more sober picture.[164] Due to fund-raising difficulties and other, more basic problems incurred in the setting up of such businesses and the marketing of them to investors, many of the funds discussed in this chapter have been put on hold or dissolved outright. The list of casualties, which has been steadily mounting in the wake of the market downturn, is extensive and includes the China Fund, the Osian's Art Fund, the Art Trading Fund, Meridian Art Partners, Dean Art Investments, ArtPlus, a variety of funds proposed by Société

Générale Asset Management, and the Art Dealers Fund, by MutualArt, among many others.[165] Littlejohn, of Meridian, gives his perspective:

> Right now, the major problem with art funds is liquidity and transparency. People are not willing to lock up their precious capital in this economic environment, and especially if they do not fully understand how the investment operation works—on all levels. We have endeavoured to respond to the latter with a fully transparent, institutional grade structure, that allows investors to know exactly how we operate and what is in the portfolio. We have a full custodial and administration structure so we have no access to investor money directly and all reporting comes from an auditor. But the main issue is client demand. There really is just not enough of it right now, and likely will not be for at least the next two quarters and maybe more. Then, there will be a sea change, and people will flock to invest in real asset vehicles.[166]

In January 2009 Sergey Skaterschikov, chairman of Skate's Art Industry Research & Ratings, was forced to delay the publication of an in-depth review of art funds "due to the failure of such funds to become a major force within the art market.... Most of these funds are struggling to raise capital."[167] Skaterschikov reckoned that upwards of fifty art funds have been announced, with just $250 million of capital between them— or only approximately $150 million spread across the field, excluding FAF. This is an extremely small pool of money by financial industry standards, and it helps to temper the considerable media spotlight that has been shined on this field in recent years. Indeed, by 2010 FAWM revealed that it tracks only twenty funds, down from fifty at its peak.[168] Art investing may yet mature into a vital part of the global art economy, but it has a number of major hurdles still to clear as funds first need to convince the marketplace of their relevance and then raise enough money to vindicate their worthiness in practice.

There are other unresolved questions as well. Can funds capture the risk-return profiles of art investing alluded to in theoretical market research? Will funds be able to resolve the conflicts of interest with dealers that they employ as advisors and buyers? And even if so, will they do this efficiently enough, and in absence of onerous fees, that they are able to generate the high turnover and aggressive investment margins they seek? FAF offers at least some hope that this may be possible; but Fernwood's failures, the weak historical track record of these funds, and the scaled-down aspirations and fundraising troubles of most vehicles in operation at the beginning of the new decade allude to the bleaker implications of such risks.

• • •

I conclude by taking three additional, and arguably even more funda-
mental, issues onboard. The first extends from the preceding chapters and
concerns what affects the shift to a more diffuse economy of artistic
goods, services, and experiences may have on the practice of art investing.
Might this handicap funds' reductive assumptions about the values of
art? In truth, the developments charted in the earlier case studies are un-
likely to have any great impact on funds' objectives and operations: they
remain overwhelmingly focused on the paintings trade, and this will al-
most certainly continue to be the case until practices like video and expe-
riential art establish a more robust commercial footing, especially in the
secondary market. Contemporary art in its broader sense nevertheless
remains a prominent focus of many funds established to date (comprising
upwards of a third or more of many "diversified" funds' portfolios), and
the sector's dramatically elevated footing in the international art market
over the past decade suggests that it will be firmly on the radar of funds
in the future irrespective of whether or not they are invested in it (its suc-
cesses and failures playing an ever more important role in determining
the health of the global trade). This is a significant point and means that
the contemporary sector cannot be ignored over the longer-term, even if
it is but one component of most funds' investment strategies. Of more
immediate concern is that a shift by dealers toward more protectionist
agendas in the face of the market downturn, characterized by strategic
underpricing and increased emphasis on carefully placing and sustaining
an artist's body of work, could be detrimental to funds currently in opera-
tion by taking liquidity out of the market.

The second issue, concerning the veracity of the supposed noncorrela-
tion between the art and the financial markets, has also been thrown into
the spotlight since the contemporary art bubble burst in autumn 2008.
This sudden reversal, irrespective of whatever benefits art may have in a
broad financial portfolio, demonstrated that the worlds of finance and art
are closely linked, and in particular that major shifts in global wealth
levels can have a profound impact on art prices. It also led to an immedi-
ate softening of investor demand for art funds and the sudden drying of
liquidity in the art market as a result of the crash raised questions about
the efficacy of their trading strategies. FAF's Hoffman has gone on record
saying that the fund stopped buying altogether during the first half of
2009—"to let the dust settle"—but most other funds that were still in the
capital-raising stage at this point did not have this luxury.[169] Many art
funds were abandoned as a result, and it is unclear what impact this will
ultimately have on this landscape in the coming years.

At an even greater level of abstraction, one final issue concerns whether
the very nature of art investing may erode art's symbolic value as the ulti-
mate mark of *distinction*, as conceptualized by Bourdieu. As art becomes

an ever more ubiquitous consumer good, its utility as a store of intrinsic economic value—a function predicated upon claims to prestige, exclusivity, and singularity—may subsequently deteriorate. Will art funds' explicit investment objectives—the reduction of art to finance—eventually lessen the symbolic, and ultimately economic, allure of acquiring art? Only time will tell. But should the art fund vision go on to flourish, we cannot ignore the possible ramifications that this could have on the trade as a whole: the reduction of art to a democratic and purely financial asset, serving to undermine the symbolic economy that has supported so much of the market's extraordinary prices in the first instance.

The instrumentalization of art—as an *asset class*, as an *investment*—is a work-in-progress. Yet we should remember that it is an experiment with historical precedent. In deliberating this frontier, we must therefore begin to focus less on the acclaimed singularity of these funds' business models and more on their ability to permeate within the actual culture of the art market and to achieve real returns in practice. These factors will prove critical in determining the fate of the art fund model, and the greater our awareness is of them, the more we will begin to appreciate the synergy between them and other contemporaneous developments in the art economy. And the better prepared we will be to evaluate their successes, failures, and implications, as well as their rightful place in the art market's ever evolving course.

Conclusion

This book opened with Damien Hirst's Beautiful auction at Sotheby's in September 2008 and it is only appropriate to come full circle with it here. For if it was exemplary of the extreme prices achieved by contemporary art during the first decade of the new millennium, it was also, with the benefit of hindsight, the final chapter in the market's latest boom. Paralleling the bleak financial environment at the time, prices plummeted in the immediate aftermath of the sale, the market's once confident buzz quieted to a murmur and liquidity drained from the system as new money exited the trade and smart money proceeded only with the greatest of caution.

In conclusion I would like to set this book's three case studies in greater context by widening the focus to some of the most pressing issues that surrounded this downturn. I begin with a brief account of the events preceding the Hirst sale in order to consider why the art market initially appeared resilient to the global meltdown. I then discuss the widespread belief in the noncorrelation between the art and financial markets and critically evaluate some of the "new era" stories about the role of the developing art markets.

While there was no shortage of writing about the global financial crisis and its impact on the art economy in the last years of the decade, early commentaries often adopted a rather impulsive outlook, readily interpreting new figures at hand but allowing little space for historical reflection. This was hardly surprising given the tumultuous and often contradictory events of the period. A score of galleries closed while others—sometimes against expectations—survived; many auction sales disappointed but a few were almost defiantly successful; and numerous art investment and business initiatives were abandoned yet some pressed ahead and others

were initiated in spite of it all. I cannot promise here to do justice to all the many and intricate facets of the burst contemporary art bubble, but I will try to put the most important issues into perspective and filter out the major myths and misconceptions that crept into the discourse. This is also the opportunity to speculate more broadly about forthcoming developments in the trade.

The Financial Crisis

We begin in August 2007 when Northern Rock, Britain's fifth largest mortgage provider and largest lender of subprime housing credit, alerted the Bank of England to the severity of problems it was facing. The root cause of these troubles, as is now well known, were the growing number of mainly lower- and middle-income homeowners who were beginning to default on their mortgages. These people tended to have poor credit history and had been enticed, on behalf of institutions like Northern Rock, by the prospects of owning their own homes. In fact they had purchased a fiction they could never actually repay and when they began to fall behind and default on their mortgage payments panic quickly spread.

The signs of this crisis had been several years in the making. Personal insolvencies in Britain rose fourfold from 1997 to 2007, with total consumer debt, amassed through mortgages, loans, and credit cards, exceeding British GDP in the latter year.[1] The picture was even more extreme on the other side of Atlantic where total debt in the U.S. economy rose from 255.3 percent of GDP in 1997 to 352.6 percent of GDP in 2007, with household debt among the strongest subcategories.[2] This swelling was harmonious with a consumer culture in which spending had begun to wildly outpace earnings potential and was particularly worrisome at the low end of the income spectrum where new subprime mortgages in the United States rose from $160 billion to $600 billion from 2001 to 2006, representing one-fifth of mortgage originations. The problem was that this acceleration in household debt was accruing at the same time as interest rates were on the rise (beginning in 2004) and as real estate prices were peaking. When housing prices began to fall at the end of 2006, borrowers started to lag on their payments and commercial lenders began freezing their loans.

Northern Rock's mortgage business was financed by borrowing from banks and money markets that would buy debt from Northern Rock in the form of bonds. Such a business is only as viable as these lines of credit allow, and when, in summer 2007, these financing streams came under pressure because investors had become wary of buying mortgage debt, Northern Rock braced for the worst. The realization of the depth of this

predicament prompted an unprecedented run on the institution's savings accounts, and many of its customers scrambled to withdraw their money en masse for fear that it would be irrecoverable if the bank imploded. More than £1 billion, 5 percent of total bank deposits, was withdrawn on Friday, 14 September, prompting the company's stock to tumble 32 percent. Northern Rock's stock fell a further 40 percent the following Monday, and fears were quelled only later that week when the Bank of England announced it would provide a crucial injection of short-term credit (promising £20 to £30 billion of financing).

The most damning feature of the now well-known Northern Rock calamity is that its origination did not stem from its own clients' defaults. Instead, it was the telltale victim of a systemwide contagion that had its origins in the United States and extended globally through a complex alchemy of liberal lending practices and the widespread repackaging and redistributing of mortgage-based products to the financial markets at large. This greatly magnified the scope of the subprime problem from a single, if substantial, corner of the economy (the jaded homeowners who had accrued this debt and the real estate brokers, insurers, and bankers who sold it to the greater economy). It quickly became apparent that huge numbers of financial institutions, governments, and investors were exposed to the subprime sector, often in ways that they did not understand.[3]

Most failed to grasp the severity of this fragile environment, or simply to understand the extent of their own exposure to it. The June 2007 closure of two real estate hedge funds managed by Bear Stearns shortly preceded Northern Rock's own failings, and that autumn, scores of the world's most prestigious financial institutions—Merrill Lynch, UBS, and Citibank, to name three—made enormous, multibillion-dollar balance sheet write-downs.

The crisis entered its next major phase in March 2008 in one of the most astonishing corporate failures of the past century: the collapse of investment bank Bear Stearns. One year earlier, Bear's stock traded as high as $172, and even as late as February 2008, despite the problems with its own real estate hedge funds the previous summer and the worsening financial climate, it was selling at $93. On Friday, 14 March, doomsday arrived, halving the already battered value of the firm's shares to $30 as investors pulled money from the bank for fear that it was significantly more exposed to subprime debt than it had acknowledged. Many argued that the company's book value did not merit such a decline—that real estate was only one of numerous sectors the firm had exposure to (true) and that it was being made a scapegoat for a wider market phenomenon (true, too, to an extent). But such arguments were moot insofar as the market's major players joined in an unspoken pact and effectively stopped

trading with Bear. This liquidity pressure devalued its asset base beyond repair.

On Sunday, 16 March, rival investment bank JP Morgan purchased Bear for $2 per share, or just $236 million, with the U.S. Federal Reserve promising to back this purchase to an additional $30 billion. Much was made of the fact that the estimated value of Bear's Fifth Avenue headquarters alone—$1.2 billion—was more than five times this price.[4] JP Morgan eventually raised its offer to $10 per share, but this adjustment paled in comparison to the cushion provided by the U.S. Federal Reserve Bank, a promise of last resort that had not been extended to the private sector since the advent of the Glass-Steagall Act in 1933. The moral hazard introduced by the Fed raised both a political and an economic uproar: should the government draw on public monies to avert the collapse of a private investment bank?

The zenith of the crisis came in September 2008 in a quick and extraordinary succession of further banking failures. This began on Monday, 7 September, with the U.S. government seizing control of Fannie Mae and Freddie Mac, the nation's two largest mortgage providers, for a combined $25 billion (plus additional commitments of up to $100 billion each to safeguard any shortfalls in capital) in an effort to stabilize the nation's then reeling property market.[5] The following week, coinciding with Hirst's Beautiful auction, Lehman Brothers declared bankruptcy, Bank of America bought Merrill Lynch at a fire sale price, and the Fed rescued insurance giant AIG in a stunning $85 billion deal.[6] Not even two weeks after this, federal regulators seized Washington Mutual, the largest savings and loan company in the United States, and brokered a $1.9 billion distressed sale of its main assets to JP Morgan.[7] And in England, Lloyds TSB purchased the largest U.K. mortgage provider, HBOS, on 19 September, ultimately culminating in mid-October with the U.K. Treasury promising to infuse £37 billion into the Royal Bank of Scotland Group, Lloyds TSB, and HBOS to avert a complete banking meltdown.[8]

The continued unraveling of the international financial and real estate markets, culminating at year's end with news that the United States had officially gone into recession, drew attention to the global magnitude of the crisis.[9] In fact, the total credit write-downs across Europe were actually greater than those in the Americas, at $202 billion and $178 billion, respectively, through mid-2008.[10] France's BNP Paribas and Swiss banking giant UBS were particularly hard hit, but their troubles paled in comparison to those of Iceland, which endured the collapse of its entire banking system. In less than a year, this small island nation, once an exemplary case study of free-market enterprise, saw its stock markets collapse by more than 90 percent and its three largest banks get nationalized, sparking fears that the country itself would declare bankruptcy.

During this same period, the financial infrastructure of resource-rich areas such as Russia and the Middle East had also come under extreme pressure as the price of oil nose-dived from a record high of over $140 per barrel in summer 2008 to just $40 per barrel six months later. The construction glut and precipitous declines in business investment and tourism only added to these troubles, especially in cities like Abu Dhabi and Dubai that not even a year before were the prototypical exemplars of a newly global model of urbanization and commerce. Elsewhere, countries such as China and India struggled to stave off double-digit levels of inflation that peaked at 9 and 11 percent, respectively, in 2008, more than twice the rate of inflation in the G7 area, while in Japan, firms reeled from multibillion-dollar subprime mortgage losses of their own.[11] "It is a truism that emerging markets hold up until they don't," one insider observed. "They are largely about momentum and as long as they are going up they are doing well. But when they fall, they fall the furthest."[12] Across much of the developing and developed international economy, a veil of false confidence was being lifted.

Bubble

A speculative bubble is defined as an unsustainable increase in prices brought on by investors' buying behavior rather than by genuine, fundamental information about value.[13] Bubbles are thus social in nature and driven by the irrationality of investors who push prices beyond a sustainable level. As long as prices are escalating, the boom mentality can continue, but a sudden, unexpected shock to the system can burst the bubble and reverse prices, sending investor confidence into a downward spiral.

Robert Shiller, professor of economics at Yale University, argues that the single most important element in understanding speculative bubbles is the social contagion of boom thinking, or what he calls the "'new era' stories that appear to justify the belief that the boom will continue."[14] Identifying this contagion is difficult precisely because we do not observe it directly—the zeitgeist becomes embedded in collective thinking—and because it is easy to neglect its underlying causes. The bubble then becomes manifest through a repetition of feedback loops, fueled by rising prices and ever more convincing "new era" stories: prices go up and a new dawn is heralded, so leading to even higher prices, more fanciful stories, and so on.[15] This feature, Shiller alleges in *The Subprime Solution*, his account of the global financial crisis, is what sent the real estate market out of control and caused it to come crashing back down to reality, dragging the health of the international economy with it.

Shiller does not address the art market in this book, but the onset of the financial crisis certainly raised questions about the art world's own new era stories and the potentially unsustainable, bubblelike features that permeated it in the first decade of the new millennium. Was the vertiginous escalation of contemporary art prices viable over the longer term or merely speculative? Could the multimillion-dollar prices for living artists' work that became customary since 2000 really be justified when many important Old Masters and antiquities were selling for a fraction of such prices? Would the newly rich hedge fund managers and developing market oligarchs be long-term fixtures of this economy, as we were led to believe, or just transient fashion-seekers? And just because demand surged and pushed prices upward, how much of this was actually attributable to the fundamental value of contemporary art (an admittedly vague yet crucial question)?

Suffice it to say, interest in these issues gathered apace with the tumbling of one sales record upon the next in the thick of the boom. Economic data, rumors—anything at all—were turned inside out as the market looked for telltale signs that the bubble would burst.[16] And while much of the art world continued to project a steely resolve of confidence as the financial landscape darkened in 2007, there was little doubt that in private many were secretly crossing their fingers, praying that their next show, their upcoming sale, their back office stock would not meet an unfortunate fate—the straw that broke the camel's back.

As it happened, these shifting tides did little to quell the art market's trajectory in 2007, which proved to be the record year for auction sales at $9.4 billion worldwide.[17] This was acutely apparent at the top of the market, with 1,200 works trading above $1 million at auction (equal to the combined total for 2005 and 2006), and in the hottest market sector—contemporary art.[18] Prices here rose by 85 percent, on average, from January 2002 to January 2008.[19] For the first time, contemporary art became Sotheby's largest category in 2007 with sales of $1.3 billion, an astonishing increase of 107 percent from 2006. And Christie's results were similarly impressive in 2007, with its sales of postwar and contemporary art netting $1.6 billion, against $822 million the previous year.

Yet some areas of the market began to show signs of weakness toward the end of the year. When Sotheby's Impressionist auction in New York on 7 November sold for a third less than its presale estimate, its stock plunged 28 percent overnight, the largest-ever one-day decline in the company's history; within a week it dipped 39 percent, from $52 to $32.[20] Its share price would recover to $41 by December, arguably correcting investors' overreaction to a single weak sale, but it soon relapsed into a steady, extensive decline for the next fifteen months.

An especially significant factor that contributed to this sliding share price was the risk the auction houses had been accruing during the boom years by extending large guarantees to consignors (money they will pay out irrespective of how much the art actually sells for) and favorable terms to buyers, and in particular that Sotheby's 2007 year-end report showed inflated accounts receivable (money owed to them by art buyers).[21] Guarantees were nothing new—their presence was also well documented during the 1980s bubble, and they have existed in varying shapes and forms since the early twentieth century—but their volume escalated significantly in the competitive standoff between Sotheby's and Christie's to gain market share in this most recent period.[22] Christie's, which is privately held, does not disclose such figures but the Sotheby's statistics speak for themselves: in 2007 the company issued $902 million in guarantees, double the amount of 2006 and up from $131 million in 2005. Sotheby's accounts receivable more than doubled on the previous year to $835 million by the end of 2007.[23]

These numbers underscore how the art market had been artificially propped up during the bubble by the generous financial arrangements orchestrated between the auctioneers and their marquee clients (consignments being induced by guarantees and the waving of commissions; purchases being encouraged through enticing loans and flexible payment schedules). In addition, to the extent that receivables were rising from late 2007, one would not be mistaken for drawing foreboding parallels to the ugly fate of the real estate market. Though there are clear differences between affluent art buyers and subprime borrowers, collectors, too, can default on payments while even the "best" art held as collateral introduces potentially dangerous balance sheet risks. Unlike stocks, the price of an artwork may never depreciate to zero, but the illiquid nature of the art market means that sudden, distressed sales can bring far lower prices than anticipated.

In the end, the market's worst fears about the auction houses' exposure to guarantees were not realized. Sotheby's lost $16 million on them in 2008, a reversal of $58 million in gains the previous year, but this was relatively minor when set against their wider business operations, and in 2009 the company, along with rival Christie's, essentially ground these offerings to a halt.[24] Some impressive figures were also churned out in 2008. While year-end global fine art auction sales were 15 percent off the highs of 2007, at $8.3 billion, this sum still compared attractively to the pre-2007 period (turnover in 2006 was just under $6.5 billion). Furthermore, nearly 1,100 works sold for more than $1 million during 2008, an indication of continued buoyancy at the top end of the market, and consignors were still bringing work to auction at a staggering rate: lots increased by 20 percent during the year. Indeed, the first six months of

2008 realized $5.5 billion in sales, a record for any half-year period.[25] At Christie's, this was reflected in a 10 percent rise in its worldwide sales from January to June and the setting of further price records, such as the firm's $33.6 million sale of Lucien Freud's *Benefits Supervisor Sleeping* (1995) in May, which made Freud the most expensive living artist at auction.[26] Sotheby's, meanwhile, realized $86.3 million for Francis Bacon's *Triptych* (1976) in May, a new price record for Bacon and the most expensive artwork ever sold in a contemporary art auction. Even by early autumn, the auctioneer was still able to whip collectors into a bidding frenzy at the Hirst sale.

Yet despite these landmarks, cracks also began to appear. Through the first six months of 2008, Christie's sales in the Americas dropped 1 percent from the same period the previous year (to $1.2 billion).[27] This was a modest decline, but against the double-digit growth Christie's had been experiencing it signaled the tapering of demand from its core U.S. clientele under pressure from the weak economy. In the New York contemporary art evening auctions of May 2008, more than half of the lots went below the presale estimate or did not sell, and bidders were noticeably sparse even for the record-breaking lots—a sign that demand was thinning. That the auctions were not a complete bust was "a great sign of relief," reflected Anders Petterson, founder of ArtTactic, just after the sale. "However the question, 'When will the art market fall?' [would not] go away."[28]

Hirst's mid-September auction proved to be the tipping point. The two-day sale generated $201 million, 30 percent above its midrange estimate, but even this remarkable figure failed to quell the market's worst fears. Sotheby's stock slid 11 percent in the week that followed, suggesting that investors discredited it as an anomaly, and it would tumble a further 63 percent from here by late October. While Sotheby's trumpeted the fact that a third of Beautiful's buyers were new to the auction house, thereby supporting claims that business was still awash with money and that new rungs of collectors, mainly from developing markets, would keep the trade buoyant, it was difficult not to see through this all the same: new money is often the most naïve, and it was equally probable that these buyers had simply overpaid at the crest of the market. Hirst's dealers were also active at the sale, fueling suspicion of protectionism and even outright manipulation.

November's contemporary art auctions were dire. Christie's generated $114 million, half a presale low estimate of $227 million, with 32 percent of lots failing to find buyers. Sotheby's sold $125 million against a low estimate of $200 million, with nearly a third unsold as well—and third-ranked Phillips fetched just under $10 million, versus a $23 million low estimate. In the end, 38 percent of the lots brought to auction in 2008

went unsold, peaking at 45 percent in December, and sales in the second half of the year were less than half of what they had been in the record period through June. And whereas 80 percent of lots with presale estimates above $1 million found buyers up to 16 September (the last day of the Beautiful sale), this number dropped to 55 percent from the next day to year's end, underscoring the sharp reversal made by the art market at the very moment the economy plummeted into the black.[29]

This downward trend continued into 2009. The auction houses began laying off significant numbers of staff at the beginning of the year and closed, or restructured, underperforming departments.[30] They also dramatically scaled back on the number of items on offer and presented a smaller selection of supposedly higher-quality works and strongly encouraged consignors to lower their reserve prices to limit the number of unsold lots.[31] On paper, at least, some of the results were encouraging; presale estimates were at times exceeded and buy-in rates significantly reduced. There were also some extraordinary bright spots. Christie's Yves Saint Laurent (YSL) sale in Paris in February 2009 generated $477 million, making it the most valuable single-owner auction in history. Yet however impressive this latter event may have been, it was difficult not to see it as an outlier, like Hirst's Beautiful auction six months earlier—vindication that demand exists for truly great art even in the worst of times, but hardly proof of an overall market recovery. Indeed, Standard & Poor's Rating Services placed a "BBB" corporate credit rating on Sotheby's the same month as the YSL sale. This is just one rating above junk status and triggered suspicion that the auctioneer would be bought out before year's end.[32] Adding insult to injury, Sotheby's first-ever auction in Qatar in March was a debacle, realizing just a fifth of its presale low estimate, at $3 million versus $15 million. Suspicion stirred that its recent extension into the region would be short-lived, and its stock bottomed out later that month at just under $6.50 a share, a twenty-year low that put it on par with the company's 1988 initial public offering price.

Year-end results reflected this weaker footing. In total, there were $4.8 billion of worldwide art sales at auction in 2009, down by nearly half from the record-breaking 2007 (at $9.4 billion), and $485 million in the contemporary sector, a drop of 64 percent from the annual peak reached in 2008. This changed landscape was particularly apparent in contractions at auction to the volume both of transactions, which declined by more than 70 percent from the height of the market, and of million-dollar sales, which were down 59 percent across the overall art market and 77 percent in the contemporary sector between 2007 and 2009.[33] Much of the market simply was not trading, especially not at the higher end, and values in turn were severely depressed.

The rapidity of this change in fortunes was reflected in the AMR Contemporary Art 100 Index, which measures the price level of one hundred leading contemporary artists (see graph 1). In just one year from its high of October 2008, the index plummeted by 42 percent. If this vertiginous drop-off was in line with the depreciation of the world's main stock markets in the wake of the financial crisis, it is worth considering that the bursting of the last art market bubble at the end of the 1980s saw the same index slide by a comparatively modest 10 percent in the first year of the market's downturn and that it would not fall to a similar level until nearly three years into the collapse, by late 1992. The index ultimately bottomed out at the end of 1996, 75 percent off its peak, and while we cannot predict how contemporary art prices will fare in the coming years—whether declines will be similarly drawn out, or whether the worst has already passed—there can be little doubting that the steep and sudden bursting of the latest bubble is evidence of a veritable crash.

Commercial gallery closures were not as immediate or widespread as many had initially predicted. Through 2009 approximately 10 percent of galleries had shut down in Manhattan's Chelsea district, the epicenter of the New York contemporary art market, but reasons were not necessarily uniform: some relocated, presumably to take advantage of cheaper rent elsewhere, while other closures in the city were not a direct by-product of the financial crisis.[34] Another contributing factor in Chelsea, versus the malaise that beset SoHo at the dawn of the 1990s, was that many blue-chip dealers owned their real estate and were therefore at least moderately insulated from the volatile economy.

Not all was well, though. Albion Gallery, headquartered in a posh Norman Foster–designed building in London, with a second branch on New York's Upper East Side, closed in June 2009, as Christie's-owned Haunch of Venison shut down its Zurich branch the following month. It was claimed that the latter was not due to the weak economy, but rather a strategic shift in the gallery's focus to its core operations in New York, London, and Berlin, however, it was difficult not to see both of these developments as by-products of difficult times all the same. Michael Hue-Williams Fine Art Ltd. went into administration at the same moment, and the days when the gallery famously employed a Michelin-starred chef for client entertaining had clearly passed: "This decision is really born out of knowing that [the boom] part of the art cycle is over," Hue-Williams admitted, noting that the gallery's turnover was down more than 50 percent through mid-2009. "Very large exhibitions and very large works of art are just not going to find buyers in this climate."[35]

This newly frugal trend was further reflected in the more conservative, postboom approach to public relations and art fairs that also took hold

during the year. Advertising pages in the September 2009 issue of *Artforum*, for example, were down 40 percent on the previous year, suggesting that if galleries were not shutting they were certainly curtailing their spending (during the boom years, the swelling of the magazine's thickness with glossy dealer-financed spreads drew almost as much attention as the writing, itself).[36] Notable absentees from the 2009 editions of New York's Armory Show and The European Fine Art Fair, in Maastricht, included Lehmann Maupin, Friedrich Petzel, and Matthew Marks, from the former, and Waddington and Acquavella, from the latter. Indeed, Marks's absence was especially poignant due to his instrumental role within the New York art world as a pioneering force in Chelsea's rise to prominence during the 1990s and because he was actually one of the cofounders of the Armory Show (then the Gramercy International Art Fair) in 1994. London's prestigious Grosvenor House Art & Antiques Fair held its final event in June 2009, and although confidence was gradually on the rise at the year's major contemporary art fairs from June to December, spanning Art Basel, Frieze, and Art Basel Miami Beach, the overall sentiment remained a far cry from that of the boom years.[37]

The immediate impact of the financial crisis outside of the commercial sector was somewhat more difficult to diagnose. A report on the subject issued by the Arts Council England in January 2009 indicated that it was simply "too early to tell" exactly what the recession's repercussions would be.[38] Nevertheless, the arts institutions it consulted for the report said that funding from trusts and foundations, in particular, was drying up, that commercial sponsorship had become harder to obtain, and that some institutions were having difficulty recruiting new donors while others were seeing donors downgrade their commitments. In a cruel twist of fate, less than a month after issuing this report, the council announced that it would be cutting its own workforce by a quarter.[39] The savings rendered in these layoffs were intended to make the council more efficient and yield even more grants money to English arts institutions, but it was clear to most that this likely signaled the beginning of further government cuts to arts funding to follow.

In summer 2009 a separate study revealed that more than half of respondents to a recent survey acknowledged declines in private investment, with the most acute drop-off in business investment where over a third of declines were greater than 50 percent.[40] The main difficulties in the not-for-profit sector, however, would not come in Britain but in the United States, where institutions were comparatively more reliant on nongovernmental funding. The headline debacle in the United States was arguably that of the Museum of Contemporary Art, Los Angeles, whose downfall echoed that of other speculative businesses. In 2008 it was

revealed that the museum had whittled its endowment down from $40 million to just a few million in under a decade through gross financial mismanagement. As the scale of this decline became dire that December —resulting from years of excessive spending on operations and the rapid depreciation of its assets due to the financial crisis—the museum was forced to the brink of merging with the larger Los Angeles County Museum of Art. It was ultimately bailed out in the last instant by billionaire art collector and philanthropist Eli Broad in a controversial $30 million deal (half of which would shore up the endowment, and half of which would go cover the institution's operations and exhibitions over five years). Other institutions, such as the Detroit Institute of Arts, the Newark Museum, and the Brooklyn Museum, were not so fortunate, however, and their struggles were widely remarked upon in the press.[41]

Myths

This narrative may be clear in hindsight, but it is important to appreciate that the bursting of the contemporary art bubble—as with most bubbles— was hardly deemed to be preordained at the time. Even right up until the turn, many still thought that prices would continue to swell, driven by influxes of new money, the globalization of collectors and arts institutions, and conflicting opinions about how the financial crisis, which seeped into the public consciousness in 2007 and climaxed with Lehman Brothers' collapse in September 2008, would affect the art market. A combination of these forces bred misunderstandings of far-reaching impact.

Two widely held assumptions about the art market were predominant during the boom years: first, that art prices were non-, or weakly, correlated to those of other financial assets; and second, that the art market's globalization was capable of supporting price levels irrespective of demand from core Western buyers, or at the very least that this phenomenon had created a buffer against a sudden, systemwide collapse. This latter rationale mirrored a similar logic that had gained popularity in the greater economy during this period, notably that the business cycles of emerging markets had become independent of, or "decoupled" from, those of the advanced economies of the United States and Europe.

The first assumption, about correlations, seemed reasonable enough on the surface. As we saw in the discussion of art investing in the last chapter, much of the recent research published by economists on the art market suggests that historical price movements of art and financial products like stocks and bonds are weakly, if not inversely, correlated and that art can play a valuable role in a wider portfolio of assets. This was

taken up by the art fund industry, not to mention legions of collection advisors, consultants, and auction house specialists as irrevocable proof of the benefits of art as an asset class.

Another widely held notion, often associated with the correlation argument, is that there tends to be a lag of anywhere from six months to two years between dramatic movements in the financial and art markets. One explanation for this is that the auction calendar is staggered with many months between the major sales, meaning that it can take some time before the softening of art prices is felt. In addition to this, the high net worth of art collectors means that they are more insulated from economic fluctuations than the general public. This does not necessarily imply that their spending habits are unaffected during recessions, just that contractions in their expenditures can be slower to take hold. Delays might be due to the fact that, because so much of collectors' money is held up in bonuses and stock options, it can take an additional year or more for economic slowdowns to materialize as a real drain on their savings accounts; spending adjustments might be made only after this point. And lastly, as became painfully evident in so many other areas of finance in the recent period, wealth financed through debt is put under pressure only once lines of credit dry up. This, too, can take time.

If one locates the first major manifestations of the subprime crisis to summer 2007, then it really was not so surprising, according to these related theories, that the art market remained intact through the early autumn of 2008. We should not have expected the market to come under pressure until this point at the earliest, and spring–summer 2009 more realistically—perhaps longer. This is consistent with the fact that the last major drop in the art market did not occur until 1990, over two years after Black Monday on Wall Street, in October 1987, crippled the exuberant 1980s economy.

But the problem with this line of thought is that it is also a matter of semantics—of one's reference point. For example, while we can identify a year-long lag in the most recent cycle if we locate the onset of the crisis to summer 2007, with the collapse of Northern Rock, it is important to consider that initial victims of the crisis—subprime borrowers—were hardly the high net worth art collectors whose prosperity remained largely intact during this early period, and that the major financial indices did not come under severe pressure until significantly later. Indeed, while the S&P 500, the index of the five hundred largest companies in the United States, had eased approximately 10 percent off its 2007 highs shortly after Bear Stearns's buyout of March 2008, it then rallied until May (making up about half of these losses) and did not plummet violently downward until that September, losing 40 percent in just three months. Setting aside the success of the Hirst sale, this plunge coincided precisely with the

downturn of the contemporary art market in autumn 2008: no lag here, let alone weak correlation.[42]

Similarly, if we return to the late 1980s, while it is true that the art bubble did not burst until more than two years after the air had been sucked out of the main U.S. and European stock markets, comparison with the Japanese economy tells a different story. The sudden halving of global art price levels between 1990 and 1992, for instance, parallels the descent of the Nikkei Index during these same years.[43] In other words, the health of the art market during this speculative bubble was firmly anchored to the financial prosperity of its most active constituent: as quickly as the Japanese rushed into the art market during the mid- to late 1980s, accounting for over half of the international auction market at its peak and motivated by attractive exchange rates and a surplus of invest-able riches, so they exited when this prosperity was on the wane.[44] Lags with the Western financial markets may therefore have occurred, but this metric is meaningless without also taking account of the underlying cause of the boom: Japan.[45]

These findings point to the ambiguity of the low correlation thesis that has been in the headlines so forcefully in the wake of recent studies by economists such as Mei and Moses. In fact, other researchers have found evidence to the contrary—that is, that the prices of artworks follow those of stocks very closely over the long term.[46] Divergences of opinion may be due to the different periods or markets under consideration, as illus-trated above in terms of which market—American, Japanese, global, etc.—we are referencing, or to the inherent limitations in how historical price indices are composed, rekindling critiques raised in the previous chapter. Perceived lags may also boil down to the fact that while financial indices are priced daily, most art indices are smoothed only on an annual or semi-annual basis, meaning that prices can appear to compound only after the fact.[47]

We should be prudent, despite these evident limitations, not to dismiss the correlation hypothesis altogether. Demonstrating correlations in asset prices, econometrically, is far more complex than a brief summation of major financial events, and it is beyond the scope of this study to give this issue the attention it merits. We also need to be careful not to conflate terms in the language we deploy. The presence of weak, or non-, corre-lation and the presence of lags are not one and the same: movements between two markets can be correlated yet still lag one another. What should nevertheless be clear is that art prices closely mirror wealth levels and that certainly in the two most recent bubbles, the deterioration in the wealth of the most active players had a crippling effect on their art con-sumption. The particular irony here is that while rises in global wealth were championed by the market during the post-2000 boom years as

irrevocable proof of the art economy's bountiful strength, the implications of a sudden reversal of fortune tended to either be downplayed, or avoided altogether.

The other major assumption to come into fashion during the boom was that the art world's globalization would be the market's saving grace in the face of crisis. A hot topic since the 1970s (coinciding with the inauguration of Sotheby's Hong Kong sales in 1973), championing of globalization gained pace after the fall of communism during the 1990s and became a veritable ideology in the new millennium as the art economy extended into rapidly developing regions.

Since 2000 Russian and Middle Eastern buyers, in particular, had established an unmistakable presence at auction, lending a new dimension to the competitive frenzy that these salesrooms thrive on. Extraordinarily brand conscious and competitive, these collectors frequently entered into public bidding wars that announced, in the most visceral of manners, that they meant business. This at times bemusing spectacle crystallized in 2007 with some of the most expensive modern and contemporary auction lots hammered down to the Al-Thani family of Qatar and to Ukraine's Victor Pinchuk. The former notably purchased the Rockefeller Rothko, *White Center (Yellow, Pink and Lavender on Rose)* (1950), for $72.8 million, Francis Bacon's *Study from Innocent X* (1962) for $52.7 million and Hirst's *Lullaby Spring* (2002) for $19.2 million; the latter bought Jeff Koons's *Hanging Heart (Magenta/Gold)* (1994–2006) for $23.6 million. Russian oligarch Roman Abramovich's spending spree at Christie's and Sotheby's in May 2008 saw him paying $33.6 million for Freud's *Benefits Supervisor Sleeping* and $86.3 million for Francis Bacon's *Triptych* (1976), a new price record for Bacon and the most expensive artwork ever sold in a contemporary art auction. We should also recall that a third of buyers at Hirst's Beautiful sale at Sotheby's later that September were reported to come from developing markets.[48]

These sales instilled an extraordinary level of confidence in much of the market. Remarks made by Tobias Meyer, worldwide head of contemporary art at Sotheby's, in 2006 were exemplary: "For the first time in history we are in a noncyclical market. But people don't get it. People make predictions from a market that once existed strictly in America and Europe. But there are new people entering this market all the time, coming here from Russia, from China, from Taipei, from anywhere."[49] The diffusion of the art market globally would enable the art economy, especially its darling contemporary sector, to continue its ascent despite the potentially unsustainable increase in prices and the onset of a global recession.

It was certainly easy to be swayed by this logic. For one, the sheer magnitude of statistics weighing in favor of the globalization thesis were diz-

zying. China emerged as the world's third largest auction market by 2007, and triple-digit contemporary art price inflation had become the norm across much of the developing market frontier during the bubble years.[50] Such factors, combined with the tremendous amount of money that had been accruing in regions beyond the United States and Europe and the transcendent popularity of contemporary art worldwide, appeared capable of endlessly sustaining the market's recent growth. There was also an alluring exoticism to the globalization of the art world. The rise of galleries in Mumbai and Moscow, and of art fairs and biennials in Dubai and Shanghai, presented fresh opportunities and inspired waves of curators, auction house specialists, dealers, and collectors from the West to set out on virgin territory. It was undeniably tempting to speculate that the bounty would be seismic and serve both to sustain the market boom and to fundamentally alter how we see, experience, and purchase art.

But the relationship between the art market's globalization and the recent price growth was far from straightforward. Too often the intense focus on the rise of high net worth developing-market collectors and the concomitant spike in the value of contemporary art from these regions led to major conclusions about the health of the international market at the expense of more judicious reflection. This fueled a dubious understanding of art economics and fundamentally inhibited attempts at reconciling some of the major issues at stake for the contemporary art market.

Globalization under the Microscope

Although the rise of developing markets certainly played an important role in the art trade during the boom, it was never clear how buyers would support the contemporary art boom during a crisis. Statements by players like Sotheby's Meyer must of course be judged guardedly: as the public face of the auction house, Meyer had many vested interests to promote the contemporary art economy's "noncyclicality" and to allege that new buyers are constantly entering the market.

In fact, despite the globalization rhetoric, buyers of contemporary art at auction remained overwhelmingly located in the United States and Western Europe for much of the boom. In 2006, for example, clients from these regions acquired fully 87 percent of contemporary art lots by value at Sotheby's (45 and 42 percent, respectively). Tax havens such as the Bahamas, British Virgin Islands, Cayman Islands, and Channel Islands are the next most well represented region (combining for 4.7 percent of sales), followed by Taiwan at 3.7 percent. Astoundingly, collectors from much-discussed emerging economies such as China, Russia, and India accounted for a mere 0.2 percent combined.[51]

Such figures, of course, do not tell the whole picture. The mobility of the world's elite suggests that a number of important collectors from emerging markets also maintain residences in Europe and the United States, and therefore that their buying may have been masked in the above statistic. Furthermore, it does not take many multimillion-dollar purchases to greatly affect such figures, and there were certainly more than a handful of individuals and institutions from these developing regions capable of doing so. Even so, these auction statistics offer a sobering perspective on the extent to which globalization had actually altered the fundamental structure of the contemporary art market in the recent period.[52]

Another major point to be made about the buying tendencies in these developing regions is that the lion's share of art purchases were domestically focused: Indian collectors predominantly bought the work of Indian artists, Chinese collectors accumulated pieces by Chinese artists, and so forth.[53] This is not surprising inasmuch as it reflects these collectors' cultural identities and was likely intertwined with a growing sense of nationalistic pride during their countries' robust economic development—the desire of a financial elite to contribute to the growth and prosperity of its internal art market. Pursuit of social distinction is another factor. Where prestige is concerned, it may have been more advantageous to be a major player in a moderate, if emerging, market than a small player in the wider international art world.

In addition, since infrastructures for exhibiting, selling, and supporting contemporary art in these regions were only just beginning to develop, collectors' buying habits were always apt to be unpredictable. Artists and styles would likely fall into and out of fashion as the market's tastes matured, and it was uncertain what would happen if and when prices of works by newly popular, up-and-coming artists suddenly dropped. Would these new collectors diversify into alternative, noncontemporary sectors of the art economy? Might they shift their expenditures to other luxury goods markets—jewelry, real estate, yachts? Could they really fill the void in major Western art market centers?

These questions could not be easily resolved. But because prestige and investment-driven buying had underpinned so much of these newcomers' art purchases, the descent of an artist from fashionability, or the bursting of any number of contemporary art bubbles (regionally or internationally), could have had major consequences. It was therefore misguided to assume that collectors in emerging markets would have unilaterally propelled the international contemporary market ahead in the face of a widening economic crisis.

Fundamental differences between the architectures of the Western and developing art markets should also be taken into consideration in such

speculative discussions. If the former is characterized by business models in which artists, galleries, and auction houses tend to serve distinct and mutually reinforcing roles, such institutional divisions are not nearly as entrenched in the latter. China may be exemplary in this respect, with its contemporary sector having become famous (or infamous, depending on one's perspective) for the entrepreneurial bravado of artists selling directly from their studios and consigning straight to auction, but similar practices persisted across this developing economy frontier.[54]

Let us look at a few key features of the art markets in these regions.[55] In the United Arab Emirates, the newly anointed hub of the Middle Eastern art trade, a market is literally being built from scratch. At the turn of the millennium, there were essentially no contemporary art institutions of international relevance, and even by the mid-2000s it possessed just a few. Yet as the boom gained momentum, a number of important galleries sprang up in and between Dubai and Abu Dhabi, two international art fairs were founded (Art Dubai and Art-Paris Abu Dhabi, both in 2007), and billions of dollars were earmarked for investment into new museums (most notably in Saadiyat Island). In response, Christie's began conducting modern and contemporary art auctions in Dubai in 2006, followed by Bonham's and Phillips de Pury & Company in 2008; and Sotheby's, as noted above, held its first sale in the region in Qatar in March 2009.[56] The region's tax regime also compares favorably to that in Europe and the United States for art transacting. Nevertheless, there is a significant level of censorship on the type of art that can be exhibited and sold (no nudity, for instance), and it is not clear how this will sit with the international art market over the medium and longer term.

In Russia, the contemporary art market has recently undergone a period of tremendous growth and restructuring, but it has a longer history. Its early twentieth-century avant-gardes were elemental to the development of Modernism, yet the country's domestic art market was long suffocated through political sanctioning under communism. With the tempering of the Cold War, the art trade in Russia, and much of the former Eastern Bloc, was resurrected during the 1990s through heightened international economic and political affiliations and because of the extraordinary wealth accumulated through its industrialization—the region's chief oil, mining, and energy magnates are also its foremost art collectors. The launch of the First Moscow Biennale in 2005, the opening of Christie's office in Moscow in 2007, and the rising profile of Russian art within the international market mark the continued opening of the country's art trade to the West.

China is different yet. Like Russia, it too has a noteworthy avant-garde legacy. Also like Russia, its contemporary art market was long stymied under communism and is now expanding as a result of tremendous foreign

investment and the brimming asset base of an upwardly mobile bourgeoisie. Scores of museums are under construction throughout the country, over six hundred galleries operate in Beijing and Shanghai—with the latter also possessing a major international art fair—and during the boom, prices for its most popular artists began rivaling the biggest Western names.[57] As we briefly considered in the preface with the example of the Estella Collection, contemporary Chinese art became an almost overnight success, with both Chinese and Western collectors and institutions snapping up works across a series of disciplines, including painting, installation, performance, photography, and video.

But China's contemporary art market, like some of its other business sectors, is mired in a web of contradiction. By withholding export tax on contemporary artworks, the government entices international art buyers to invest in its domestic market. However, the true flowering of this market is restricted by the government's continued policing of the cultural frontier and its barring, until 2005, of international auction houses from operating on the mainland.[58] Indeed, one significant, but often unmentioned, fact about China's art trade is that the bulk of its sales are actually realized in Hong Kong.[59] The latter may be a stubborn technicality, but it is difficult to imagine the Chinese art market achieving its full potential without also liberalizing some of these policies: trade might be driven underground, or simply abroad.

Readily apparent as these distinguishing features of the emerging art markets were, their actual relevance to the changing market climate with the onset of the financial crisis was poorly understood. Despite the surging of international auction figures widely reported in the press, comparatively little was known about the dealer market in these countries, meaning that the *real* size of these art economies was, and remains, difficult to pinpoint.[60] Furthermore, established institutionalized roles in the West build trust and confidence in the integrity of a market. Yet when these roles become blurred, as evidenced across the developing market frontier, it becomes more complex to infer how healthy a market truly is: provenance becomes more unreliable, as do inferences about supply and demand. And lastly, the rapid expansion of contemporary art in the developing markets also bore the risk of equally rapid obsolescence. It did not take many exhibitions and auctions of such art, for instance, before critiques of repetition, predictability, and outright copying of Western influences became widespread.

Discussions of the international contemporary art market are usually limited to data from the major auction houses, where economic data are most readily available. And by implication, they nearly always focus on paintings, its most valuable segment. The problem, as we have seen before, is that excessive focus on this particular segment of this sphere can

blind us to other dynamic changes that are occurring within the global market as a whole; it has the damning effect of solidifying an operation composed of many individual parts. When these factors are compounded atop the extreme price appreciation recently achieved, in addition to wide divergences in the taste of developing market collectors and variations in the maturity and politics of their art market infrastructures, forward-looking analysis becomes exceptionally slippery. These regions might have looked certain to continue their ascent, but bubbles also burst in unexpected ways.

On balance, the art markets of these countries have proven neither to be immune to the financial crisis nor to be capable of supporting global contemporary art prices as a whole. Contemporary art sales in Hong Kong, Singapore, and Dubai in October 2008 were among the first to experience the post–Lehman Brothers backlash (with buy-in rates averaging 35 percent, up from around 10 percent the previous year) and Sotheby's aforementioned inaugural auction of contemporary art in Qatar in March 2009 was a failure, with less than half the lots finding buyers. In fact, according to Artprice, China was the country most greatly affected by the initial setback in the contemporary market, with auction sales in this sector plummeting more than 60 percent between June 2007 and June 2008.[61] That the global art market crashed irrespective of growth in these regions exposed the frailty of the decoupling argument—regardless of what potential impact these new regions will ultimately come to play in tomorrow's art market.

Trust

Robin Blackburn, professor of historical studies at the New School for Social Research in New York, contends that the global financial crisis was triggered by more than the conflation of excessive consumer debt, volatile fuel and energy costs, and a soft housing market. It was instead a fundamental "crisis of financialization," stemming from the very culture of neoliberalism and deregulation that had come to characterize the global business environment since the 1990s.[62] The dizzying string of corporate failures that began mounting in 2007 and 2008 may have triggered our awareness of the "fantasy valuations" that permeated the housing market and accrued in unprecedented proportions and in unexpected ways on banks' balance sheets, but the actual roots of the calamity were embedded in the very tenets of the modern financial system itself.

Blackburn correctly points out that the finance industry can help allocate capital, facilitate investment, and smooth demand. These are some of its precepts, and it is worth recalling that they have been explicitly

drawn upon by art investment funds: rather than seeing themselves as parasitic speculators, these businesses pride themselves on bringing much-needed liquidity to the marketplace and on enabling a more efficient art distribution chain. The problem, however, is that when properly functioning and transparent regulatory systems are not in place, risk can also arise in unpredictable ways. This became acutely apparent in the financial crisis, one of the most sour subplots of which was the revelation that the credit ratings agencies charged with objectively analyzing debt obligations were plagued with conflicts of interest that led to biased ratings. This meant that the very basis of how some institutions' debt was being priced and traded in the marketplace was flawed to the core and led to an investor's nightmare in which key assets could not be valued. What metrics to use? Whom to trust?

The *Financial Times* flagged an iteration of this dilemma in the immediate aftermath of the Bear Stearns collapse. Credit, the newspaper reminds readers, has its origins in the Latin word *credere*—"to trust." And it is the systemwide erosion of this trust that sank institutions (like Bear Stearns) and an entire asset class (subprime mortgage bonds) and shattered the aura of omnipotence that had enveloped the world of finance until this crisis. "The credit world, in other words, now lacks *credit*—in the original meaning of 'he/she trusts.' "[63]

Such remarks are vital because they awaken us to the bigger picture. Trust is of the highest order in the art economy, by extension, precisely because reliable information is at such a premium and, even more fundamentally, because art has little intrinsic worth beyond its physical materials. Art, Pierre Bourdieu stresses, is a system of belief, and its market is where this belief is put to work. Prices can therefore inform one another and also act as a measure of value—socially, for sure, but also aesthetically, critically, and even art-historically. But without trust in the integrity of this system and belief in its overarching relevance—of what art says about us and why we hold it high—prices are meaningless. Lacking trust and belief, a Hirst shark is not worth $12 million, let alone $1.2 million or $120,000—it may be worth very little at all. Or, as dealer Leo Castelli famously said of selling an $800,000 Cézanne landscape, as quoted in this book's epigraph, so much of art's value lies in the myths that encircle it—and without belief in such myths, and a structure to support and perpetuate them, the extreme prices of art risk becoming obsolete.[64]

This returns us to the crisis of financialization identified by Blackburn. While there are clear differences in the workings of the financial and art markets, and the underlying causes of the latest crises in both (the prevalence of leverage and obscure derivatives products, to name only two of the main disparities, played a far larger role in instigating the former), so are there important correlations between the two. The "new era" story

about the impact of globalization on the art market, for example, offers a particularly apt point of comparison. Substituting "art" for "real estate" in the following passage from Shiller's aforementioned book underscores the haunting similarity between the recent art and subprime bubbles:

> Since the 1990s we have also come increasingly to think that the movers and the shakers of the world are smart investors too. We began to believe that nascent capitalism in China, India, Russia, Brazil and other less-advanced countries was producing a vast new class of the wealthy, who would bid up the price of real estate and others assets that were limited in supply. The mistake was in exaggerating the significance of these stories of emerging capitalism for the real estate market of today.[65]

A similarly sobering perspective can be gained if we return to the deflation of the 1980s bubble. In the conclusion to his 1992 book on the emergence of the modern art market, Peter Watson alerts readers to an investment bank's rosy report on the future of the art market, dated 1989. "The new breed of mega millionaires," it claimed, "are diversifying their wealth and using it to buy things like works of art.... Contrary to popular belief, this market rarely experiences cyclical downturns and we believe its past growth is sustainable over the next five-to-ten years."[66] Not even a year later the market collapsed, and while it would go on to recover and ultimately set the base for our most recent bubble, it is striking how naïve interpretations of escalations in global wealth and their concomitant impact on art prices get churned from one era to the next under the same headline of noncyclicality. Ever greater prosperity at the high end of the income spectrum will undoubtedly be critical to the development of the art market over the longer term, but projecting its immediate ramifications in bubble environments is a fool's game.

• • •

These are important points to bear in mind as the contemporary art market continues to globalize and envelope new trajectories. For while this bears novel opportunities—promises of an increasingly global cultural dialogue and an unprecedented level of interaction among the makers, buyers, sellers, and audiences of art—it invariably also brings forward major challenges and uncertainties. One unresolved issue is how the Western market will adjust to the realities of doing business in developing regions where the roles of the market's stakeholders are not as rigid and where values—economic, social, cultural, museological—are still in formation. Will this be a smooth process? What lessons and practices might the established markets come to incorporate from these formerly isolated

regions? Another related question is how the global extension of the trade and its increasingly competitive landscape might affect the market's conventional ecology. Will the auction houses' much remarked upon shift into the primary sector, which became acutely evident in 2007 with Christie's acquisition of Haunch of Venison, followed by Sotheby's Beautiful sale in 2008, have a long-term impact on how new works of art are sold, or were these just isolated responses to the then booming contemporary trade? Similarly, what of the rise of galleries with an international footprint, or of the power shift toward influential private collectors whose foundations and museums have come to rival the arts institutions of old?

While many of these questions served as a backdrop to this book, I have also presented a picture of how this new landscape has been unfolding. The commercialization of practices such as video and experiential art, previously marginalized in the market, and the acceleration of art investment activity offer evidence of how the art world's newly global infrastructure is being put to use. One thing is certain: the bursting of the contemporary art bubble sets these developments into further context.

Activity continues in the art fund space, for example, but the notable closures and funding struggles experienced since the collapse of Lehman Brothers et al. in 2008 have taken their toll on the industry. Vindicating the utility of art as an asset class was never going to be an easy sell, and investors' deteriorating appetite for untested products in lockstep with the financial crisis only added to these difficulties, casting further doubt over the prospects of these latest art investment initiatives. Art funds may well go on to thrive, of course, but in another decade or more, their nature and the very structure of the industry could be quite different. One potential outcome of the blurring of positions within the conventional art market is that such investment initiatives could become subsumed into wider art financial services platforms, stretching from auction houses to specialist businesses, dealers, and even investment banks. This would mark a major achievement for art as an asset class, yet it would also represent a considerable departure from such initiatives to date. Our discussion of art investing, then, would come to constitute but the first chapter within a longer unfolding history.

The main issues abutting the subjects of the two other case studies considered in this book are different yet. One particularly important point to keep apprized of, which applies to the market for both video and experiential art, is the extent to which the collector base of these practices can be broadened in the postbubble landscape. The good news is that despite their rising presence in the market and museum landscape, most of the artists under discussion tended to be insulated from the extreme speculative fervor of the boom years that centered more notably on highly branded figures like Hirst as well as producers of more discrete object-

based work. This means that artists from Barney, Viola, and Julien to Tiravanija, Seghal, and so on may actually benefit on a relative basis in the coming years: though prices of their work certainly escalated during the boom years, they never approached the multimillion-dollar heights of other contemporaries, and they may prove to be good "value" to collectors as a result (hence the evident discord between their high rankings in lists like the *Kunstkompass* and somewhat more moderate market prices).[67] On the other hand, one reason for their more limited scope in the commercial sector stems precisely from the type of work they produce (which can often be more challenging to exhibit, transport, and conserve) and from the protective measures taken by their dealers to support them (by strategically restricting supply and carefully placing much of their work with certain parties). Institutions, megacollectors, and, to a far lesser extent, niche collectors have been the main buyers of their work to date, and while this has certainly lent significant symbolic credibility to their reputations, it remains to be seen whether they will be able to secure a broader base of support in the coming years. The relative value argument suggests this may be possible, but the very nature of their work and other variables such as the role of the Internet (which, at least in the case of video art, threatens to usurp private collections as the natural habitat for presenting such content) make it difficult to tell what is to come.

As regards our discussion of experiential art, it is not yet clear what lies ahead for the generation of artists associated variously with the neo-conceptual, service-based, and relational aesthetics discourse. Many of these protagonists and their chief institutional supporters have reached the helm of the art world power triumvirate, and they may gain even further commercial strength in the coming years. If so, they might set the example of ever more innovative relationships with how art is made, presented, discussed, and sold. But it is worth recalling that many of these artists rose to prominence from the ashes of the deflated 1980s bubble, and it is certainly possible that a similar power shift in the wake of the most recent market crash could prove to be their undoing in the coming years. Add to this that the experience economy rhetoric already appears a somewhat dated, 1990s phenomenon and it is not difficult to foresee that the type of art that they have come to represent may fall by the wayside and crystallize into yet another art-historical footnote. Generalizations, of course, are never absolute, but prudence is sensible, moving forward.

The Internet, meanwhile, holds a wealth of novel, if as yet unclear, avenues for the development of the art economy at large. The evolution of online sales databases like Artnet and Artprice, for instance, has improved the transparency of art market information as well as the speed and scope with which these data are presented to the public. So far, these

sales figures only reflect the auction universe, with primary market prices remaining essentially as opaque as ever, but they may gradually set the example for greater transparency all around. Already, one outcome of the financial crisis has been an escalation of disclosure and compliance in the world of business, and the art market may be forced to follow a similar path, especially as it extends into new geographies and covers increasingly diverse types of artistic and financial practices about which collectors and investors alike will want greater assurances.

Despite the art world's notorious antitechnological leanings, it is not difficult to imagine that the fluid online sales and trading platforms flourishing in other economic sectors could eventually become successfully implemented in the trade. There are numerous and obvious differences between selling stocks and paintings on the Internet, and to date collectors have been understandably reluctant to allocate considerable money to online art purchases, site unseen; collectibles such as watches and wine, with lower price points and greater liquidity, have proven far more amenable. Many attempts at Internet-based sales platforms have also come and gone since the 1990s, most infamously Sotheby's failed partnerships first with Amazon in 2000 and then with eBay in 2002–03, each of which was abandoned after hardly a year.[68] But especially at a time when the art economy is at pains to demonstrate its global reach, comparable technology could be used to interconnect art businesses with a growing international collector base. And the bursting of the bubble could yet prove to be the catalyst to spark change as dealers and auction houses look for more cost-efficient ways to boost revenues.

Christie's LIVE, launched in July 2006, generated $157 million of sales in its first full year of operation, and by 2008 just over a fifth of its lots were sold online. The average price point is indeed on the lower end, at $6,000, but there have been some notable exceptions to the rule—such as the $1.3 million a previously unknown Russian online bidder paid for a Stradiavari violin in June 2008—and, crucially, a quarter of these buyers have been new to the auction house.[69] Sotheby's, meanwhile, has relaunched a proprietary online sales system, and in 2008 Artnet inaugurated a trading platform of its own, after an earlier failure, with auctions of items extending into the tens and hundreds of thousands. This latter development is particularly significant, for whereas the Internet presence of the major auctioneers is really just an extension of their core salesroom-based business, akin to the introduction of telephone bidding in the 1980s, the potential success of Artnet's online presence could herald far more wide-reaching developments to come. This might, for example, enable a more fluid art sales infrastructure to take shape (eradicating some of the time delays of consigning work to conventional auctions), and it could also enable the art market to tap new geographies and demographics.

Irrespective of how this unfolds, the art market is also at a decisive technological crossroads in other fundamental ways. Escalating numbers of artists deploy digital film, video, and photography in their work and make use of the Internet and alternative forms of computer programming for its presentation and distribution. The common denominator across most of this activity is that although such work can certainly be shown and sold in museums and galleries, its very ontology is often at odds with these contexts: such art forms can be copied and distributed in far more diverse ways than can traditional art objects. This has been a vexing challenge posed by reproducible media for well over a century now, but the matter is more urgent than before following the digital revolution. Will the art market and its conventional institutions continue to use artificial constraints like limited editioning to keep these types of practices within its bounds? Or will this type of content eventually seep beyond the art market's reach through viral, pirate, and user-led communities on the Internet?[70] The expansive social networks of the online gift economy (YouTube being an excellent example) certainly pose intriguing opportunities and challenges to the future development of the trade.

• • •

The cyclical nature of the art economy and the history of the avant-garde suggest that dynamic and unheralded developments are always on the horizon. The art market crash of 1990–92 left in its wake a more global, pluralistic, and diverse spectrum of practices than had ever previously existed. Going back further to the origins of the avant-garde in the mid- to late nineteenth century, we bear witness to an almost endless manipulation of inherited conventions, slowly, inevitably, and forever changing the landscape of art making. And with the benefit of hindsight, the artistic developments charted in this book that became institutionalized in the 1990s and increasingly central to the market in the new millennium may come to be exemplary of a particular moment in history, as the geography of art expands and new types of practices take flight in the future.

The ultimate success of the contemporary art economy's advancement over the long run requires that however these and other issues are addressed, they are resolved in a way such that trust in the precepts of art is maintained. The hope is that the answers to these challenges will lead to a more efficient and dynamic art trade. The risk is that if the market overstretches itself, we lose sight of the very thing at the heart of its tremendous expansion.

With this in mind, it is essential to look ahead. For of far greater significance than speculating further about the bursting of the latest contemporary art bubble is sharpening our focus on how the market will shape

up as a new equilibrium comes into being. And the sooner we take this on, the more capable we are of ensuring that the art market's recent growth has not come at the expense of its future prospects, or of belief in the fundamental value of art itself—of *trust* that art, after all, is more than just an empty stepping-stone to social, political, and economic enrichment.

Appendix A:
Record Prices for Video Art at Auction, December 2009

Table A1
Record Prices for Video Art at Auction, December 2009

Rank	Name	Title, Date	Price
1	Bill Viola	*Eternal Return* (2000)	$712,452
2	Nam June Paik	*Wright Brothers* (1995)	$646,423
3	Bill Viola	*Witness* (2001)	$601,000
4	Matthew Barney	*Cremaster 2* (1999)	$571,000
5	Matthew Barney	*Cremaster 4* (1994–95)	$387,500
6	Bill Viola	*Witness* (2001)	$374,400
7	Nam June Paik	*Baby Buddha* (2001)	$352,941
8	Nam June Paik	*Alexander the Great* (1993)	$344,803
9	Bill Viola	*The Return* (2007)	$308,000
10	Nam June Paik	*So Wol Kim* (1998)	$293,338
11	Nam June Paik	*Watch Dog II* (1997)	$288,000
12	Nam June Paik	*Miss Rheingold* (1993)	$283,860
13	Bill Viola	*Isolde's Ascension* (2005)	$275,539
14	Nam June Paik	*Enlightenment 78 RPMs* (1990)	$275,257
15	Bill Viola	*The Quintet of the Silent* (2000)	$274,816
16	Bill Viola	*The Last Angel* (2002)	$266,500
17	Bill Viola	*Four Hands* (2001)	$253,844
18	Bruce Nauman	*Good Boy Bad Boy* (1985)	$252,000
19	Bill Viola	*Mater* (2001)	$247,652
20	Nam June Paik	*Watching Buddha* (1995–99)	$234,814

Source: Artnet
*Prices include buyer's premium.

Sale Date	Auction House	Description
14-Oct-06	Phillips de Pury, New York	Color video triptych on LCD flat panels. Ed. 5
25-Nov-07	Christie's, Hong Kong	Mixed media and video.
15-Nov-07	Sotheby's, New York	Color video triptych on LCD flat panels. Ed. 4/5
14-Nov-07	Sotheby's, New York	Silkscreen, digital video disc, nylon, saddle leather, sterling silver, and other media.
19-May-99	Christie's, New York	Mixed media with disc. Ed. 3/10
8-Nov-05	Christie's, New York	Color video triptych on LCD flat panels.
27-May-07	Christie's, Hong Kong	Mixed media and video installation.
30-Nov-09	Christie's, Hong Kong	Mixed media, wooden sculpture with TV monitor and neon lights.
14-Feb-08	Sotheby's, New York	Colour high-definition video on plasma display. Ed. 2/5
13-Oct-07	Phillips de Pury, London	Radio boxes, televisions, electrical components.
11-Dec-07	Wright, Chicago	Color televisions, exterior circuitry panels, video disc consoles, video.
1-Jun-07	Lempertz, Cologne	Television monitors, wood, cameras, violin, cameras, beer cans.
16-Oct-09	Christie's, London	Video on plasma display, stereo sound. Ed. 3/12
28-May-06	Christie's, Hong Kong	Mixed media and video installation.
18-Oct-08	Phillips de Pury, London	Single-channel color video, plasma display. Ed. 5
12-May-09	Sotheby's, New York	DVD, plasma display and speakers. Ed. 1/5
21-Oct-08	Christie's, London	B/w video polytych, LCD panel displays. Ed. 1/12
17-May-07	Christie's, New York	Videotape installation. Ed. 35/40
8-Feb-06	Christie's, London	Color video diptych panel. Ed. 5/5
6-Apr-09	Sotheby's, Hong Kong	Mixed media, television set and video camera.

Appendix B:
The Film and Video Collections of Tate
and the Whitney Museum of American Art

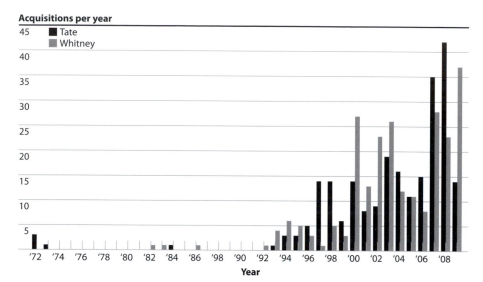

Graph B1. Tate and the Whitney Museum: Comparative Graph of Film and
Video Acquisitions, 1972–2009. Source: Tate, Whitney Museum Archives.

TABLE B1
Film and Video Collection of Tate, 1972–2009

No.	Year Acquired	Artist	Title (Date)	Description
1	1972	Gilbert & George	*A Portrait of the Artists as Young Men* (1970)	Video
2	1972	Gilbert & George	*Gordon's Makes Us Drunk* (1972)	Video
3	1972	Gilbert & George	*In the Bush* (1972)	Video
4	1973	Dan Graham	*Two Correlated Rotations* (1970–72)	Film and mixed media
5	1984	Susan Hiller	*Belshazzar's Feast, the Writing on Your Wall* (1983–84)	Video
6	1993	Bruce Nauman	*Violent Incident* (1986)	Video
7	1994	Matthew Barney	*Ottoshaft* (1992)	Video and mixed media
8	1994	Bruce Nauman	*Good Boy Bad Boy* (1985)	Color video and monitors
9	1994	Bill Viola	*Nantes Triptych* (1992)	Video and mixed media
10	1995	Gary Hill	*Between Cinema and a Hard Place* (1991)	Video
11	1995	Susan Hiller	*An Entertainment* (1990)	Video
12	1995	Tony Oursler	*The Most Beautiful Thing I've Never Seen* (1995)	Video, sofa, and mannequin
13	1996	Gary Hill	*Remarks on Color* (1994)	Video

continued

TABLE B1 cont.

No.	Year Acquired	Artist	Title (Date)	Description
14	1996	Steve McQueen	*Bear* (1993)	Video
15	1996	Tony Oursler	*Autochthonous AAAAHHHH* (1995)	Video and mixed media
16	1996	Steven Pippin	*The Continued Saga of an Amateur Photographer* (1993)	Photographs and video
17	1996	Andrea Zittel	*A-Z Comfort Unit with Special Comfort Features by Dave Stewart* (1994–95)	Mixed media
18	1997	Absalon	*Proposals for a Habitat* (1990)	Video
19	1997	Absalon	*Solutions* (1992)	Video
20	1997	Absalon	*Assassinations* (1993)	Video
21	1997	Absalon	*Battle* (1993)	Video
22	1997	Absalon	*Noises* (1993)	Video
23	1997	Mark Dickenson	*Untitled (Clothes)* (1995)	Video
24	1997	Tracey Emin	*Why I Never Became a Dancer* (1995)	Video
25	1997	Douglas Gordon	*10ms-1* (1994)	Video
26	1997	Lucy Gunning	*The Horse Impressionists* (1994)	Video
27	1997	Michael Landy	*Scrapheap Services* (1995)	Video and mixed media
28	1997	Sarah Lucas	*Sausage Film* (1990)	Video

29	1997	Mark Wallinger	*Angel* (1997)	Video
30	1997	Gillian Wearing	*Confess All on Video. Don't Worry You Will Be in Disguise. Intrigued? Call Gillian* (1994)	Video
31	1997	Gillian Wearing, Gerogina Starr, Carl Freedman, and Tracey Emin	*English Rose* (1996)	Video
32	1998	Mat Collishaw	*Hollow Oak* (1995)	Video
33	1998	Tacita Dean	*Disappearance at Sea* (1996)	16mm color film, audio
34	1998	Susan Hiller	*From the Freud Museum* (1991–96)	Mixed media
35	1998	William Kentridge	*Johannesburg the Second Greatest City after Paris* (1989)	Animation film
36	1998	William Kentridge	*Monument* (1990)	Animation film
37	1998	William Kentridge	*Mine* (1991)	Animation film
38	1998	William Kentridge	*Sobriety, Obesity, and Growing Old* (1991)	Animation film
39	1998	William Kentridge	*Felix in Exile* (1994)	Animation film
40	1998	William Kentridge	*History of the Main Complaint* (1996)	Animation film
41	1998	William Kentridge	*Ubu Tells the Truth* (1997)	Animation film
42	1998	Sean Landers	*Remissionem Peccatorum* (1994)	Video

continued

TABLE B1 cont.

No.	Year Acquired	Artist	Title (Date)	Description
43	1998	Gillian Wearing	Confess All on Video. Don't Worry You Will Be in Disguise. Intrigued? Call Gillian Version II (1994)	Video
44	1998	Gillian Wearing	Sacha and Mum (1996)	Video
45	1998	Gillian Wearing	10-16 (1997)	Video
46	1999	Matthew Barney	Cremaster 5 (1997)	35mm color film with mixed media (or) video on plasma screen installation with mixed media
47	1999	Willie Doherty	Tell Me What You Want (1996)	Video installation
48	1999	Mona Hatoum	So Much I Want to Say (1983)	Video
49	1999	Mona Hatoum	Changing Parts (1984)	Video
50	1999	Mona Hatoum	Measures of Distance (1988)	Video
51	1999	Sam Taylor-Wood	Brontosaurus (1995)	Video
52	2000	Roderick Buchanan	Sodastream (1997)	Video
53	2000	Paul McCarthy	Rocky (1976)	Video
54	2000	Jake and Dinos Chapman	Bring Me the Head of (1995)	Video
55	2000	Tracey Emin	Tracey Emin C.V. Cunt Vernacular (1997)	Video

56	2000	Rebecca Horn	*Performances I* (1972)	Video
57	2000	Rebecca Horn	*Performances II* (1973)	Video
58	2000	Rebecca Horn	*Berlin Exercises: Dreaming under Water* (1974–75)	Video
59	2000	Rebecca Horn	*The Gigolo* (1978)	Video
60	2000	Steve McQueen	*Drumroll* (1998)	Video
61	2000	Bruce Nauman	*Double No* (1988)	Video
62	2000	Bruce Nauman	*Work* (1994)	Video
63	2000	Charles Ray	*Fashions* (1996)	16mm film
64	2000	Stephanie Smith	*Mouth to Mouth* (1995)	Video
65	2000	Gillian Wearing	*My Favourite Track* (1994)	Video
66	2001	Eija-Liisa Ahtila	*Consolation Service* (1999)	Video installation
67	2001	Stan Douglas	*Win, Place or Show* (1998)	Video
68	2001	Mary Kelly, Margaret Harrison, and Kay Hunt	*Women and Work: A Document on the Division of Labour in Industry 1973–75* (1973–75)	Mixed media
69	2001	Paul McCarthy	*Rocky* (1976)	Video, pencil on paper
70	2001	Paul Neagu	*Going Tornado* (1974)	Video
71	2001	Mark Wallinger	*Hymn* (1997)	Video

continued

TABLE B1 *cont.*

No.	Year Acquired	Artist	Title (Date)	Description
72	2001	Mark Wallinger	*Prometheus* (1999)	Video
73	2001	Jane and Louise Wilson	*Gamma* (1999)	Video
74	2002	Tacita Dean	*Foley Artist* (1996)	Single-monitor installation, color video, with playback machine, 8 speakers, and dubbing chart in lightbox
75	2002	Tacita Dean	*Fernsehturm* (2001)	Single-screen projection, 16mm color anamorphic film with optical sound
76	2002	Peter Fischli and David Weiss	*Visible World* (1997)	Video
77	2002	Ori Gersht	*Neither Black Nor White* (2001)	Single monitor, color video, silent
78	2002	Liam Gillick	*Annlee You Proposes* (2001)	Metal, paint, plastic with lamps and multiformat color video, computer animation, audio
79	2002	Douglas Gordon	*Déjà-Vu* (2000)	Video
80	2002	Robert Morris	*Neo Classic* (1971)	16mm film, multiformat, b/w, transferred to video, silent
81	2002	Paul Neagu	*Neagu's Boxes* (1969)	Video

82	2002	Sam Taylor-Wood	*Killing Time* (1994)	4-screen projection, color video, audio
83	2003	Francis Alÿs	*The Last Clown* (1995–2000)	Mixed media
84	2003	Fikret Atay	*Rebels of the Dance* (2002)	Video
85	2003	Fikret Atay	*Fast and Best* (2003)	Mixed media
86	2003	Yael Bartana	*Kings of the Hill* (2003)	Single-screen projection, color video, audio
87	2003	Ian Breakwell	*The Other Side* (2002)	Video
88	2003	Willie Doherty	*Re-run* (2002)	Mixed media
89	2003	Pierre Huyghe	*The Housing Projects* (2001)	Single-screen projection, vistavision transferred to color video, audio, with ink on transparency in lightbox
90	2003	Christian Marclay	*Video Quartet* (2002)	4-screen projection, found Hollywood film clips transferred to color video, audio
91	2003	Sebastian Diaz Morales	*15,000,000 Parachutes* (2001)	Video
92	2003	Matthias Müller	*Vacancy* (1998)	Mixed media
93	2003	Shirin Neshat	*Soliloquy* (1999)	2 screen projection, color video, audio
94	2003	Lucia Nogueira	*Smoke* (1996)	Mixed media

continued

TABLE B1 cont.

No.	Year Acquired	Artist	Title (Date)	Description
95	2003	Oliver Payne and Nick Relph	The Essential Selection (2002)	Single-screen projection, color video, audio
96	2003	Oliver Payne and Nick Relph	Mixtape (2002)	Single-screen projection, color video, audio
97	2003	Oliver Payne and Nick Relph	Gentlemen (2003)	Single screen projection, color video, audio
98	2003	Pipilotti Rist	I'm Not the Girl Who Misses Much (1986)	Single monitor, color video, audio
99	2003	Anri Sala	Dammi i Colori (2003)	Video
100	2003	Paul Sietsema	Empire (2002)	Film
101	2003	Bill Viola	Five Angels for the Millennium (2001)	Video
102	2004	Zarina Bhimji	Out of Blue (2002)	16mm single screen projection, color film transferred to video, audio
103	2004	Phil Collins	they shoot horses (2004)	2-screen video projection, audio
104	2004	Tracey Emin	The Perfect Place to Grow (2001)	Mixed media
105	2004	Carlos Garaicoa	Letter to the Censors (2003)	Mixed media
106	2004	Paul Harrison and John Wood	Twenty-Six (Drawing and Falling Things) (2001)	Video

107	2004	Rebecca Horn	*Paradise Widow* (1975)	16mm film transferred to video, audio
108	2004	Rebecca Horn	*La Ferdinanda: Sonata for a Medici Villa* (1981)	35mm color film transferred to video, audio
109	2004	Rebecca Horn	*Buster's Bedroom* (1990)	35mm color film transferred to video, audio
110	2004	Christian Jankowski	*The Holy Artwork* (2001)	Video
111	2004	Isaac Julien	*Vagabondia* (2000)	2-screen video projection, audio
112	2004	Mark Leckey	*Fiorucci Made Me Hardcore* (1999)	Single-screen projection, color video, audio
113	2004	Jorge Macchi	*Musical Box* (2004)	Single-channel video, audio
114	2004	Bruce Nauman	*MAPPING THE STUDIO II with color shift, flip, flop, & flip/flop (Fat Chance John Cage)* (2001)	Video
115	2004	Markus Schinwald	*Dictio pii* (2001)	Single-screen projection with 5 35mm films transferred to DVD
116	2004	Santiago Sierra	*160 cm Line Tattooed on 4 People El Gallo Arte Contemporáneo. Salamanca, Spain. December 2000* (2000)	Single-channel video, audio
117	2004	Anton Vidokle	*New* (2003)	Single-screen projection, audio

continued

TABLE B1 cont.

No.	Year Acquired	Artist	Title (Date)	Description
118	2005	Jeremy Deller	The Battle of Orgreave Archive (An Injury to One Is an Injury to All) (2004)	Mixed media
119	2005	Rodney Graham	How I Became a Ramblin' Man (1999)	Film
120	2005	Rodney Graham	Aberdeen (2000)	Mixed media
121	2005	David Hammons	Phat Free (1997)	Video
122	2005	Jesper Just	Bliss and Heaven (2004)	16mm color film transferred to video, audio
123	2005	Mark Leckey	Made in 'Eaven (2004)	16mm film projection, silent
124	2005	Anthony McCall	Line Describing a Cone (1973)	Film
125	2005	Steve McQueen	Caribs' Leap/Western Deep (2002)	3-screen video projection, audio
126	2005	Jonathan Monk	A Cube Sol LeWitt photographed by Carol Huebner using nine different light sources and all their combinations front to back back to front forever (2001)	16mm film
127	2005	Fiona Tan	Saint Sebastian (2001)	2-screen video projection, audio
128	2005	Carey Young	Everything You've Heard Is Wrong (1999)	Single-channel video, audio
129	2006	Francis Alÿs	Drumming (2004)	3 single-channel video projections, audio, drawings and archival material

130	2006	Francis Alys	*Guards* (2004)	2-channel video projection, audio, related drawings and archival material
131	2006	Francis Alys	*The Nightwatch* (2004)	Computer hard drive and 20-monitor installation, silent, drawings and archival material
132	2006	Tacita Dean	*Palast* (2004)	Single-screen projection, 16mm film, audio
133	2006	Stan Douglas	*Inconsolable Memories* (2005)	16mm b/w film, audio
134	2006	Runa Islam	*First Day of Spring* (2005)	16mm film
135	2006	Christina Mackie	*Irrig* (2005)	Video, audio
136	2006	Daria Martin	*Closeup Gallery* (2003)	16mm film installation, audio
137	2006	Gustav Metzger	*Liquid Crystal Environment* (1965/2005)	Mixed media
138	2006	Deimantas Narkevicius	*The Role of a Lifetime* (2003)	Video
139	2006	Rosalind Nashashibi	*Hreash House* (2004)	Single-screen projection, 16mm color film transferred to DVD, audio
140	2006	Raymond Pettibon	*Repeater Pencil* (2004)	Single-screen animation, audio
141	2006	Rosangela Renno	*Experiencing Cinema* (1962)	Projection on intermittent steam curtain with 4 DVD-Rs
142	2006	Anri Sala	*Now I See* (2004)	35mm color film, audio

continued

Table B1 cont.

No.	Year Acquired	Artist	Title (Date)	Description
143	2006	Georgina Starr	*The Making of Junior (+ Entertaining Junior)* (1994)	Video
144	2007	Pawel Althamer	*Film* (2000)	Performance and archival material
145	2007	Alexander Apostol	*Documentary* (2005)	DVD
146	2007	Breda Beban	*The Most Beautiful Woman in Gucha* (2006)	DVD Video PAL
147	2007	John Bock	*Zero Hero* (2004–05)	Installation with DVD and mixed media
148	2007	Ulla von Brandenburg	*Around* (2005)	16mm film
149	2007	Tacita Dean	*A Bag of Air* (1995)	Film
150	2007	Tacita Dean	*Kodak* (2006)	16mm film
151	2007	Omer Fast	*CNN Concatenated* (2002)	DVD
152	2007	Iain Forsyth and Jane Pollard	*Anyone Else Isn't You* (2005)	Video
153	2007	Andrea Fraser	*Museum Highlights: A Gallery Talk* (1989)	Single-channel video, audio
154	2007	Andrea Fraser	*Little Frank and the Carp* (2001)	Video
155	2007	Andrea Fraser	*Official Welcome (Hamburg Version)* (2001/03)	Single-channel video, audio

156	2007	Ellen Gallagher and Edgar Cleijne	*Murmur* (2003–04)	16mm animated film projections (5 in total)
157	2007	Susan Hiller	*Psi Girls* (1999)	5-screen video projection
158	2007	Bethan Huws	*Singing for the Sea* (1993)	Film
159	2007	Pierre Huyghe	*A Journey That Wasn't* (2005)	Video, audio, and inkjet print on paper
160	2007	Jaki Irvine	*Star* (1994)	Film
161	2007	Jaki Irvine	*Sweet Tooth* (1994)	Film
162	2007	Igor Kopystiansky and Svetlana Kopystiansky	*Incidents* (1996–97)	Video
163	2007	Daria Martin	*In the Palace* (2000)	16mm film, audio
164	2007	Daria Martin	*Birds* (2001)	16mm film, audio
165	2007	Daria Martin	*Harpstrings and Lava* (2007)	16mm film
166	2007	Paul McCarthy	*Painter* (1995)	Video, audio
167	2007	Paul McCarthy	*Projection Room 1971-06* (2006)	Video, audio
168	2007	Jonas Mekas	*Diaries, Notes & Sketches a.k.a. Walden* (1964–69)	16mm color film, audio
169	2007	Aleksandra Mir	*First Woman on the Moon* (1999)	Video
170	2007	Valerie Mrejen	*Manufrance* (2005)	Video

continued

TABLE B1 cont.

No.	Year Acquired	Artist	Title (Date)	Description
171	2007	Dan Perjovschi	*Phantom Reportage (Charlotenburg) and Selected Drawings of the Phantom Reportage Notebooks (2006)*	Video and notebook
172	2007	Dan Perjovschi	*The Selected Drawings of the Istanbul Notebooks 2005 (2006)*	DVD projection
173	2007	Zineb Sedira	*Mother Tongue (2002)*	Video
174	2007	Bob and Roberta Smith	*Humiliate (1993)*	Video on monitor
175	2007	Catherine Sullivan	*The Chittendens: The Resuscitation of Uplifting (2005)*	16mm film transferred to single-channel video, audio
176	2007	Mark Titchner	*Artists Are Cowards (2002)*	Video
177	2007	Kara Walker	*8 Possible Beginnings or: The Creation of African-America, a Moving Picture by Kara E Walker (2005)*	Single-screen projection, 16mm film and video transferred to DVD, b/w, audio
178	2007	Xu Zhen	*8848–1.86 (2005)*	Mixed media
179	2008	Victor Alimpiev	*Sweet Nightingale (2005)*	Video, audio
180	2008	Alexander Apostol	*Libertador Avenue (2006)*	Video
181	2008	Black Audio Film Collective	*Expeditions One: Signs of Empire (1984)*	35mm Kodak tape slide, transferred to DVD

182	2008	Black Audio Film Collective	*Expeditions Two: Images of Nationality* (1984)	35mm Kodak tape slide, transferred to DVD
183	2008	Black Audio Film Collective	*Handsworth Songs* (1986)	16mm color film editioned on DVD
184	2008	Matthew Buckingham	*Situation Leading to a Story* (1999)	16mm film, audio
185	2008	Gerard Byrne	*1984 and Beyond* (2005–06)	3 single-channel DVDs on LCD screens, 20 b/w photographs
186	2008	Campbell	*Make it Fall, Bernadette* (2008)	16mm archival film
187	2008	Tacita Dean	*Michael Hamburger* (2007)	16mm film, optical sound
188	2008	Braco Dimitrijevic	*Resurrection of Alchemists* (2006)	Video
189	2008	Marcel Dzama	*The Lotus Eaters* (2001–07)	8mm, 16mm and Fisher Price Pixelvision transferred to video, with audio. Attaché case with mixed media interior
190	2008	Cao Fei	*Whose Utopia?* (2006)	Video, audio
191	2008	Yang Fudong	*East of Que Village* (2007)	6-screen film installation, b/w
192	2008	Johan Grimponprez	*Dial H-I-S-T-O-R-Y, Inflight* (1997–2001)	Video installation
193	2008	Sanja Ivekovic	*Instructions No. 1* (1976)	Video
194	2008	Sanja Ivekovic	*Make-up—Make-down* (1976)	Video
195	2008	David Lamelas	*Film Script (Manipulation of Meaning)* (1972)	16mm color film and triple-slide projection

continued

TABLE B1 cont.

No.	Year Acquired	Artist	Title (Date)	Description
196	2008	Mark Leckey	*Felix Gets Broadcasted* (2007)	Video on Digi-Beta
197	2008	Mark Leckey	*Flix* (2008)	16mm film animation
198	2008	Hilary Lloyd	*One Minute of Water* (1999)	Video, single monitor, and audio
199	2008	Hilary Lloyd	*Monika* (2000)	Video, single monitor, and audio
200	2008	Hilary Lloyd	*Car Wash* (2005)	Slide installation
201	2008	Simon Martin	*Wednesday Afternoon* (2005)	Video
202	2008	Simon Martin	*Carlton* (2006)	Video
203	2008	Ana Mendieta	*Untitled (Blood and Feathers)* (1974)	8mm color film transferred to DVD
204	2008	Antonio Muntadas	*Personal/Public* (1981)	Installation with CCTV, 2 monitors, and mixed media
205	2008	Lucia Nogueira	*Vai e Vem* (1993)	Video installation, mixed media
206	2008	Yoshua Okon	*Orillese a la Orilla* (1999–2000)	Video
207	2008	Ewa Partum	*Active Poetry* (1971–73)	8mm film transferred to DVD/mini DV
208	2008	Vong Phaophanit	*All That's Solid Melts into Air (Karl Marx)* (2006)	Video
209	2008	Florian Pumhosl	*Programm* (2006)	16mm film projection

210	2008	Anri Sala	*After Three Minutes* (2007)	Video
211	2008	Cindy Sherman	*Doll Clothes* (1975)	Super-8 b/w film transferred to video
212	2008	David Shrigley	*Light Switch* (2007)	Single-screen projection, audio
213	2008	Javier Tellez	*La Passion de Jeanne d'Arc (Rozelle Hospital, Sydney)* (2004)	2-screen projection
214	2008	Grazia Toderi	*Babel Red* (2006)	2-screen projection, video transferred to DVD, audio, loop
215	2008	Ruben Ortiz Torres	*Alien Toy* (1997)	Video, audio
216	2008	Ruben Ortiz Torres	*The Dream of Reason Still Produces Monsters* (2006)	Single-screen projection, computer animation, and audio
217	2008	Mark Wallinger	*Royal Ascot* (1993)	Video installation for 4 monitors, traveling cases, and speakers
218	2008	Mark Wallinger	*Threshold to the Kingdom* (2000)	Single-screen projection, soundtrack
219	2008	Clemens von Wedemeyer	*Occupation* (2001–02)	Digital video, audio
220	2008	Carey Young	*Product Recall* (2007)	Single-channel video, audio
221	2009	Juan Downey	*Video Trans Americas* (1976)	Video installation
222	2009	Andrea Fraser	*Projection* (2008)	2-channel high-definition video projection, audio
223	2009	Jack Goldstein	*A Glass of Milk* (1972)	16mm film

continued

TABLE B1 *cont.*

No.	Year Acquired	Artist	Title (Date)	Description
224	2009	Jack Goldstein	*A Spotlight* (1972)	16mm film
225	2009	Jack Goldstein	*Shane* (1975)	16mm film
226	2009	Jack Goldstein	*Under Water Sea Fantasy* (1983)	16mm film
227	2009	Jesse Aron Green	*Ärztliche Zimmergymnastik* (2008)	Video installation
228	2009	KwieKulik	*Shapes of Red and a Path of Edward Gierek* (1970–72)	2-screen slide installation trans-ferred to video
229	2009	Zbigniew Libera	*How to Train Little Girls* (1987)	Video
230	2009	David Maljkovic	*Images with the Own Shadows* (2008)	16mm film
231	2009	Guy Sherwin	*At the Academy* (1974)	16mm film, b/w, optical soundtrack
232	2009	Akram Zaatari	*This Day* (2003)	Video, audio
233	2009	Akram Zaatari	*Nature Morte* (2008)	Video projection, audio
234	2009	Artur Zmijewski	*Democracies* (2009)	Video installation

TABLE B2
Film and Video Collection of the Whitney Museum of American Art, 1982–2009

No.	Year Acquired	Artist	Title (Date)	Description
1	1982	Nam June Paik	*V-yramid* (1982)	40 televisions and videotape
2	1983	Mary Lucier	*Ohio at Giverny* (1983)	Video installation: 2 laserdiscs, color, sound. 7 monitors, progressing in size from left to right; 12″, 15″, 17″, 19″, 21″, 21″. Synchronous starter
3	1986	Nam June Paik	*Magnet TV* (1965)	17″ b/w television set with magnet
4	1992	Buky Schwartz	*Yellow Triangle* (1979)	Video installation: synthetic polymer on wall and floor
5	1993	Matthew Barney	*Drawing Restraint 7* (1993)	Video monitors, laserdisc players, silent color laserdiscs, steel, plastic, and fluorescent lighting fixture
6	1993	Pepón Osorio	*Angel: The Shoe Shiner* (1993)	Painted wood, rubber, fabric, glass, ceramic, shells, painted cast iron, 2 video monitors, 2 color videotapes, hand-tinted photographs, paper, and mirror
7	1993	Tony Oursler	*Crying Doll (Flowered)* (1993)	Sewn cloth, wood, video projector, laserdisc player, and laserdisc

continued

Table B2 cont.

No.	Year Acquired	Artist	Title (Date)	Description
8	1993	Nam June Paik	*Fin de Siecle II* (1989)	201 television sets with 4 laserdiscs
9	1994	Walter De Maria	*Hardcore* (1969)	16mm films with leather film case
10	1994	Dan Graham	*Three Linked Cubes/Interior Design for Space Showing Videos* (1986)	Wood-framed clear and 2-way mirrored glass panels
11	1994	Shigeko Kubota	*Meta-Marcel: Window* (1976)	Video monitor, glass and plywood
12	1994	Adrian Piper	*Out of the Corner* (1990)	Video installation, 17 monitors, 17 DVD players, 17 DVDs (originally shown on 3/4" videotape), color, sound; 64 gelatin silver prints, table, 16 chairs, pedestals, and specified lighting
13	1994	Earl Reiback	*Suspension* (1969)	Modified color television set
14	1994	Earl Reiback	*Thrust* (1969)	Modified color television set
15	1995	William Anastasi	*Transfer* (1968)	Video camera and monitor
16	1995	Doug Hall	*Machinery for the Re-education of a Delinquent Dictator* (1984)	Video installation
17	1995	Tony Oursler	*Getaway #2* (1994)	Mattress, cloth, video projector, laserdisc player, and laserdisc

18	1995	Diana Thater	*The Bad Infinite* (1993)	3 color laserdiscs, 3 laserdisc players, 1 sync box, 3 video projectors, and film gels
19	1995	Bill Viola	*The Greeting* (1995)	Video/sound installation
20	1996	Robert Frank	*Moving Pictures* (1994)	Silent, color and b/w videotape
21	1996	Dennis Oppenheim	*Gingerbread Man* (1970–71)	Videotape, 3 microprojectors, slides, and gingerbread-men cookies
22	1996	Raphael Montañez Ortiz	*Humpty Dumpty: Piano Destruction Concert* (1967)	Piano and video
23	1997	Tony Oursler	*Underwater Head* (1997)	Glass jar, glazed ceramic, water, laserdisc, laserdisc player, and video projector
24	1998	Richard Serra	*Hand Catching Lead* (1969)	16mm film, b/w, silent
25	1998	Richard Serra	*Hands Scraping* (1969)	16mm film, b/w, silent
26	1998	Richard Serra	*Hands Tied* (1969)	16mm film, b/w, silent
27	1998	Robert Smithson	*Spiral Jetty* (1970)	16mm film, color, sound
28	1998	Diana Thater	*Electric Mind* (1996)	6 3-lens video projector, 2 video monitors, 8 laserdisc players, 8 CAV laserdiscs, 1 Laserplay-6 synchronizer, and architecture
29	1999	Shirin Neshat	*Rapture* (1999)	Video installation, b/w, sound

continued

TABLE B2 cont.

No.	Year Acquired	Artist	Title (Date)	Description
30	1999	Liisa Roberts	Blind Side (1998)	1 16mm silent film loop in color (viewer activated); live outdoor sound (between film screenings); 16mm film projector adapted with film looper, motion detector and project/audio trigger device; 1 microphone, speaker and cables; glass screen sandblast
31	1999	Andy Warhol	Henry Geldzahler (1964)	Video transfer of b/w film, 16mm, silent
32	2000	Vito Acconci	Claim Excerpts (1971)	Videotape, b/w, sound
33	2000	Doug Aitken	Electric Earth (1999)	8 laserdisc installation and architectural environment
34	2000	John Baldessari	Inventory (1972)	Videotape, b/w, sound
35	2000	Stan Brakhage	Mothlight (1963)	16mm film, silent
36	2000	Jem Cohen	Lost Book Found (1996)	Videotape, color, sound
37	2000	Seungho Cho	Rev, n.d.	Videotape, b/w, sound
38	2000	Dara Friedman	Bim Bam (1999)	16mm film installation with 2 slot-loading projectors, metal armature, CD player, and speakers

No.	Year	Artist	Title	Medium
39	2000	Frank Gillette	*Hark! Hork!*, n.d.	Videotape, b/w, sound
40	2000	Dan Graham	*Performer/Audience/Mirror* (1975)	Videotape, b/w, sound
41	2000	Dan Graham	*Rock My Religion* (1983–86)	Videotape
42	2000	Gary Hill	*Site/Recite (a prologue)* (1989)	Videotape, color, sound
43	2000	Joan Jonas	*Organic Honey's Visual Telepathy* (1972)	Videotape, b/w, sound
44	2000	Joan Jonas	*SongDelay* (1973)	16mm film transferred to videotape, b/w, sound
45	2000	Joan Jonas	*Vertical Roll* (1972)	Video
46	2000	Silvia Kolbowski	*An Inadequate History of Conceptual Art* (1999)	Video and sound installation
47	2000	Iñigo Manglano-Ovalle	*Le Baiser/The Kiss* (1999)	Audio and video installation and mixed media
48	2000	Gordon Matta-Clark	*Bingo X Ninths* (1974)	Super-8mm film transferred to videotape, color, silent
49	2000	Gordon Matta-Clark	*Splitting* (1974)	Super-8mm film transferred to videotape, b/w and color, silent
50	2000	Gordon Matta-Clark	*Substrait (Underground Dailies)* (1976)	16mm film transferred to videotape, b/w and color, sound
51	2000	Bruce Nauman	*Revolving Upside Down* (1968)	Videotape, b/w, sound
52	2000	Bruce Nauman	*Gauze* (1969)	16mm film transferred to videotape, b/w, silent

continued

TABLE B2 cont.

No.	Year Acquired	Artist	Title (Date)	Description
53	2000	Tony Oursler	*The Darkest Color Infinitely Amplified* (2000)	Multimedia installation
54	2000	Paul Pfeiffer	*Pure Products Go Crazy* (1998)	Videotape, VHS player, projector and metal armature; image 3 × 4"
55	2000	Paul Pfeiffer	*Fragment of a Crucifixion* (After Francis Bacon) (1999)	Videotape, VHS player, projector and metal armature; image 3 × 4"
56	2000	Ira Schneider	*TV as a Creative Medium* (1969)	Videotape, b/w, sound
57	2000	Paul Sharits	*Shutter Interface* (1972)	Film installation, 2 16mm films, color, sound
58	2000	Diana Thater	*Six-Color Video Wall* (2000)	6 video monitors, 6 DVDs, 6 DVD players
59	2001	Trisha Brown	*Walking on the Wall* (1971)	16mm film, b/w, silent
60	2001	Peter Campus	*aen* (1977)	Video projection
61	2001	Peter Campus	*Head of a Man with Death on His Mind* (1978)	Video projection
62	2001	Arthur Jafa	*Corner* (2000)	DVD with sound
63	2001	Arthur Jafa	*Tree* (2001)	DVD with sound
64	2001	David Lamelas	*The Desert People* (1973–74)	16mm, color, sound
65	2001	Anthony McCall	*Line Describing a Cone* (1973)	16mm film, b/w, silent

66	2001	Robert Morris	*Slow Motion* (1969)	16mm film, b/w, silent
67	2001	Bruce Nauman	*Art Make-Up No. 1: White* (1967)	16mm, color, silent, transferred to videotape
68	2001	Bruce Nauman	*Art Make-Up No. 2: Pink* (1967–68)	16mm, color, silent, transferred to videotape
69	2001	Bruce Nauman	*Art Make-Up No. 3: Green* (1967–68)	16mm, color, silent, transferred to videotape
70	2001	Bruce Nauman	*Art Make-Up No. 4: Black* (1967–68)	16mm, color, silent, transferred to videotape
71	2001	Paul Pfeiffer	*Goethe's Message to the New Negroes* (2001)	Color LCD monitor, metal armature, DVD player, DVD
72	2002	Stephen Dean	*Pulse* (2001)	DVD projection, sound
73	2002	Omer Fast	*Glendive Foley* (2000)	Video installation; 2 DVDs, 2 monitors, 3 home entertainment units (entertainment center, TV cart, and utility cart)
74	2002	Robert Fenz	*Soledad: Meditations on Revolution III* (2001)	16mm film b/w, sound
75	2002	Glen Fogel	*Ascension* (2001)	16mm film, superimposed film and gelled light projection, color, sound
76	2002	Glen Fogel	*Control Sequences* (2001)	Video and 16mm film, superimposed projection, gelled b/w, sound
77	2002	Glen Fogel	*Endless Obsession* (2001)	16mm film, color, sound

continued

Table B2 cont.

No.	Year Acquired	Artist	Title (Date)	Description
78	2002	Glen Fogel	*Reflex* (1999)	16mm film, color, sound
79	2002	Hollis Frampton	*Nostalgia* (1971)	16mm film, b/w, sound
80	2002	Hollis Frampton	*Nostalgia (Hapax Legomena)* (1973)	16mm film, b/w, sound
81	2002	Brian Frye	*Oona's Veil* (2000)	16mm film, b/w, sound
82	2002	Peter Hutton	*Study of a River* (1996–97)	16mm film, b/w, silent
83	2002	Christian Jankowski	*The Holy Artwork* (2001)	Video projection, color, sound
84	2002	Joan Jonas	*Mirage* (1976/2001)	16mm film, b/w, silent; video projection, b/w, sound; 2 videotapes transferred to laserdisc shown on a monitor: *May Windows*, b/w, sound; *Good Night, Good Morning*, b/w, sound
85	2002	Mary Kelly	*Antepartum* (1973)	Super-8 film loop transferred to video, b/w, silent; presentation box signed by the artist
86	2002	Colleen Mulrenan	*daughter, sept. 13* (2001)	Video, color, sound
87	2002	Bruce Nauman	*Wall-Floor Positions* (1968)	Video, b/w, sound
88	2002	Dennis Oppenheim	*Aspen Projects* (1970)	Video, b/w and color

	Year	Artist	Title	Description
89	2002	Dennis Oppenheim	*Echo* (1973)	4 16mm film loops transferred to video, b/w, sound, projected simultaneously on 4 walls
90	2002	Luis Recoder	*Available Light: Yellow-Red* (1999)	16mm film at 18 fps, b/w and color, silent
91	2002	Liisa Roberts	*Trap Door* (1996)	4 16mm film projectors, 4 custom made lenses, 4 custom made screens, metal stands for projectors, 4 duplicate 16mm film negatives, 4 archive reference 16mm film prints, installation instructions
92	2002	Richard Serra	*Railroad Turnbridge* (1976)	16mm film, b/w, silent
93	2002	Stom Sogo	*Problem's You* (1997–2001)	Super-8 film at 18 fps, b/w and color, silent
94	2002	Jud Yalkut	*Destruct Film* (1967)	1 16mm film (color, silent), 35mm slides, 1 16mm film projector, 1 film looper, 2 35mm slide projectors, 2 motorized beam-splitter mirrors, and loose film stock
95	2003	Robert Beavers	*Sotiros* (1975–96)	35mm film, color, sound
96	2003	Jeremy Blake	*1906* (2003)	Sequence from DVD with sound for plasma or projection
97	2003	Beth Campbell	*Same as Me* (2002)	3-channel video

continued

TABLE B2 cont.

No.	Year Acquired	Artist	Title (Date)	Description
98	2003	Brian Fridge	*Sequence 2.3* (2003)	Video, b/w
99	2003	David Gatten	*Moxon's Mechanick Exercises, or, The Doctrine of Handy-Works Applied to the Art of Printing* (1999)	16mm film at 18 fps, b/w, silent
100	2003	Jack Goldstein	*The Portrait of Pere Tanguy* (1974)	16mm film, color, sound
101	2003	Jack Goldstein	*A Ballet Shoe* (1975)	16mm film, color, silent
102	2003	Jack Goldstein	*Metro-Goldwyn-Mayer* (1975)	16mm film, color, sound
103	2003	Jack Goldstein	*Shane* (1975)	16mm film, color, sound
104	2003	Jack Goldstein	*Some Butterflies* (1975)	16mm film, color, silent
105	2003	Jack Goldstein	*The Chair* (1975)	16mm film, color, silent
106	2003	Jack Goldstein	*The Knife* (1975)	16mm film, color, silent
107	2003	Jack Goldstein	*White Dove* (1975)	16mm film, color, sound
108	2003	Jack Goldstein	*Bone China* (1976)	16mm film, color, sound
109	2003	Jack Goldstein	*The Jump* (1977)	16mm film, color, silent
110	2003	Ellen Harvey	*Twins* (2001)	Video installation; 2 video projections onto matte plexiglass panels clipped to metal poles, color, sound

111	2003	Ken Jacobs	*Flo Rounds a Corner* (1999)	Digital video, color, sound
112	2003	Robert Morris	*Gas Station* (1969)	16mm film, double-screen projection, color, silent
113	2003	Robert Morris	*Mirror* (1969)	16mm film, b/w, silent
114	2003	Jun Nguyen-Hatsushiba	*Memorial Project Nha Trang, Vietnam, Towards the Complex—For the Courageous, the Curious and the Cow* (2001)	Video projection
115	2003	Paul Pfeiffer	*Live Evil* (2002)	Digital video, LCD monitor (1 1/2 × 2″), DVD player, cast plastic armature
116	2003	Peter Sarkisian	*Hover* (1999)	Video installation with mixed media
117	2003	Paul Sietsema	*Empire* (2002)	Super 16mm film, b/w, color, silent
118	2003	Steina	*Mynd* (2000)	Video installation with 6 projections
119	2003	Diana Thater	*Nature Black Square #3 (broken glass with four pink flowers)* (1990)	Video, color, sound
120	2003	Robert Morris	*Wisconsin* (1970)	16mm film, b/w, silent
121	2004	Burt Barr	*A Fan* (2004)	Video, b/w, chrome fan, wood, and pedestal
122	2004	Slater Bradley	*Theory and Observation* (2002)	Single-channel video installation, sound
123	2004	Sue DeBeer	*Hans und Grete* (2002)	2 channel video installation

continued

Table B2 cont.

No.	Year Acquired	Artist	Title (Date)	Description
124	2004	Morgan Fisher	() (2003)	16mm film, color, silent
125	2004	Harrell Fletcher	Blot Out the Sun (2002)	Digital video, color, sound
126	2004	Harrell Fletcher	The Problem of Possible Redemption (2003)	Digital video, color, sound
127	2004	Sandra Gibson	NYC Flower Film (2003)	Super-8 film, color, silent
128	2004	Howard Lester	One Week in Vietnam (1970)	16mm film, color, sound
129	2004	Julie Murray	Untitled (light) (2002)	16mm film, color, sound
130	2004	Lucas Samaras	Self (1969)	16mm color film. Produced, written, and directed by Lucas Samaras. Edited and photographed by Kim Levin
131	2004	Catherine Sullivan	Ice Floes of Franz Joseph Land (2003)	5-channel video installation, 16mm film transferred to video then DVD, b/w, sound
132	2004	Bill Viola	Five Angels for the Millennium (2001)	5 video projections, color, sound. Co-owned by Whitney Museum of American Art, New York; Tate, London; and Centre Pompidou, Paris
133	2005	Stan Brakhage	Chinese Series (2003)	16mm film, color, silent

134	2005	Stan Brakhage	*Persian Series 13-18* (2001)	16mm film, color, silent
135	2005	Ellen Gallagher	*Murmur: Watery Ecstatic, Kabuki Death Dance, Blizzard of White, Monster, Super Boo* (2003)	5 16mm films, b/w, color, silent and sound
136	2005	Jack Goldstein	*Under Water Sea Fantasy* (1983–2003)	16mm film, color, sound
137	2005	Craigie Horsfield	*El Hierro Conversation* (2002)	Video installation
138	2005	Sharon Lockhart	*NŌ* (2003)	16mm film, color, sound
139	2005	Christian Marclay	*Video Quartet* (2002)	4 screen video projection, color, sound
140	2005	Jim O'Rourke	*Not Yet* (2003)	Digital video, color, sound
141	2005	Luis Recoder	*Linea* (2002)	16mm film double projection, b/w, silent
142	2005	Edward Ruscha	*Miracle* (1975)	16mm film, color, sound
143	2005	Eve Sussman	*89 Seconds at Alcazar* (2004)	Digital video, color, sound
144	2006	Kenneth Anger	*Mouse Heaven* (2005)	Video, color, sound
145	2006	Slater Bradley	*The Animals* (2004)	Single-channel video and 7 gelatin silver prints
146	2006	Trisha Donnelly	*Untitled* (2005)	Audio loop (CD)
147	2006	Luis Gisperr/Jeff Reed	*Stereomongrel* (2005)	DVD; Super 35mm transferred to HD, color, sound

continued

TABLE B2 *cont.*

No.	Year Acquired	Artist	Title (Date)	Description
148	2006	Matthew Higgs	*Video of a Book* ("*VIDEO ART*") (1999–2000)	Video, color, silent
149	2006	Pierre Huyghe	*A Journey That Wasn't* (2005)	Super 16mm film and high-definition video transferred to high-definition video, color, sound. Co-owned with Walker Art Center, Minneapolis
150	2006	Rirkrit Tiravanija	(*a film title for an unrealized film*) (2004)	16mm film, b/w, silent, projected on panel
151	2006	Ryan Trecartin	*A Family Finds Entertainment* (2004)	Video, color, sound
152	2007	Vito Acconci	*Three Frame Studies* (1969)	Super 8mm film transferred to video, color, sound
153	2007	Vito Acconci	*Three Relationship Studies* (1969–70)	Super 8mm film transferred to video, b/w, sound
154	2007	Vito Acconci	*The Red Tapes* (1977)	Video, b/w, sound
155	2007	Paul Chan	*1st Light* (2005)	Digital animated projection onto floor
156	2007	Marcel Duchamp	*Anemic Cinema* (1926)	16mm film, b/w, silent
157	2007	Nancy Holt	*Points of View: Clocktower* (1977)	Video, b/w, sound

158	2007	Nancy Holt	*Sun Tunnels* (1978)	16mm film, color, silent
159	2007	Joan Jonas	*Left Side Right Side* (1972)	Video, b/w, sound
160	2007	T. Kelly Mason	*JUMP* (2004)	16mm film, color, sound
161	2007	Gordon Matta-Clark	*Tree Dance* (1971)	Super 8 film transferred to 16mm film, b/w, silent
162	2007	Bruce Nauman	*Green Horses* (1988)	2 color video monitors, 2 DVD players, 1 video projector, 2 DVDs, and 1 chair
163	2007	Claes Oldenburg	*Injun I* (1962/75)	16mm film, b/w, silent
164	2007	Claes Oldenburg	*Injun II* (1962/75)	16mm film, b/w, silent
165	2007	Claes Oldenburg	*Nekropolis I* (1962/75)	16mm film, b/w, silent
166	2007	Claes Oldenburg	*Nekropolis II* (1962/75)	16mm film, b/w, silent
167	2007	Claes Oldenburg	*Store Days I* (1962/75)	16mm film, b/w, silent
168	2007	Claes Oldenburg	*Store Days II* (1962/75)	16mm film, b/w, silent
169	2007	Claes Oldenburg	*Voyages I* (1962/75)	16mm film, b/w, silent
170	2007	Claes Oldenburg	*Voyages II* (1962/75)	16mm film, b/w, silent
171	2007	Claes Oldenburg	*World's Fair I* (1962/75)	16mm film, b/w, silent
172	2007	Claes Oldenburg	*World's Fair II* (1962/75)	16mm film, b/w, silent
173	2007	Mathias Poledna	*Version* (2004)	16mm film, b/w, silent

continued

Table B2 cont.

No.	Year Acquired	Artist	Title (Date)	Description
174	2007	Lotte Reiniger	*The Adventures of Prince Achmed* (1926)	16mm film, b/w with tinting and toning, sound
175	2007	Liisa Roberts	*What's the Time in Vyborg?* (2003–04)	Video, color, sound
176	2007	Richard Serra	*Frame* (1969)	16mm film, b/w, silent
177	2007	Richard Serra	*Television Delivers People* (1973)	Video, color, sound
178	2007	Kerry Tribe	*Here & Elsewhere* (2002)	2 video projections, color, sound
179	2007	Jordan Wolfson	*I'm sorry but I don't want to be an Emperor . . .* (2005)	16mm film, b/w, silent
180	2008	Burt Barr	*Jodi* (2008)	2-screen video installation, b/w, silent
181	2008	Tamy Ben-Tor	*Alejandra* (2008)	Video, color, sound
182	2008	Tamy Ben-Tor	*The Artist in Residence* (2005)	Video, color, sound
183	2008	Tamy Ben-Tor	*The Contractor* (2005)	Video, color, sound
184	2008	Morgan Fisher	*Color Balance* (1980/2002)	3-projector film installation, 3 16mm loops, color, silent
185	2008	Amy Granat	*T.S.O.Y.W.* (2007)	2-channel projection, 16mm film transfered to digital video, color, sound

186	2008	Mike Kelley	*Fresh Acconci* (1995)	Video, color, sound
187	2008	Mike Kelley and Paul McCarthy	*Heidi* (1992)	Video, color, sound
188	2008	Svetlana and Igor Kopystiansky	*The Day Before Tomorrow* (1999)	2-screen slide projection with 216 slides in 4 carousels
189	2008	Andrew Lampert	*Varieties of Slow* (2008)	3-channel film and performance
190	2008	Elad Lassry	*Untitled* (2008)	16mm film, color, silent
191	2008	Standish Lawder	*Color Film* (1972)	16mm film, color, sound
192	2008	Bruce Nauman	*Thighing (Blue)* (1967)	16mm film transferred to video, color, sound
193	2008	Bruce Nauman	*Dance or Exercise around the Perimeter of a Square (Square Dance)* (1967–68)	16mm film transferred to video, b/w, sound
194	2008	Bruce Nauman	*Elke Allowing the Floor to Rise Up over Her, Face Up* (1973)	Video, color, sound
195	2008	Bruce Nauman	*Tony Sinking into the Floor, Face Up, and Face Down* (1973)	Video, color, sound
196	2008	Raymond Saroff	*Claes Oldenburg "Happenings": Ray Gun Theater* (1962)	16mm film, b/w, silent
197	2008	Raymond Saroff	*The Real Thing* (1964)	16mm film, b/w, sound
198	2008	Richard Serra	*Color Aid* (1970–71)	16mm film, color, sound
199	2008	Richard Serra	*Tina Turning* (1972)	Video, b/w, sound

continued

TABLE B2 cont.

No.	Year Acquired	Artist	Title (Date)	Description
200	2008	Richard Serra	*Boomerang* (1974)	Video, color, sound
201	2008	Kara Walker	*". . . calling to me from the angry surface of some grey and threatening sea. I was transported."* (2007)	Video installation, color, sound
202	2008	Robert Wilson	*Renée Fleming (dyptich)* (2007)	2-channel HD, video with 65" HD plasma screen, custom speakers, and HD media player
203	2009	Sadie Benning	*Play Pause* (2006)	2-channel video installation, b/w and color, sound
204	2009	Ingibjorg Birgisdottir	*Seven Sisters* (2006)	Video, color, sound
205	2009	Dara Birnbaum	*Technology/Transformation: Wonder Woman* (1978–79)	Video, color, sound
206	2009	Mel Bochner, Robert Moskowitz	*New York Windows* (1966)	16mm film, b/w, silent
207	2009	Chris Burden	*Documentation of Selected Works (1971–75)*	16mm and Super-8 transferred to video, color and b/w, sound
208	2009	Lucinda Childs	*Dance* (1979/2001)	Video, color, sound
209	2009	Bruce Conner	*A MOVIE* (1958)	16mm film, b/w, sound
210	2009	Bruce Conner	*EVE-RAY-FOREVER* (1965/2006)	3-screen video projection transferred from Super-8 film, b/w, silent

211	2009	Bruce Conner	THE WHITE ROSE (1967)	16mm film, b/w, sound
212	2009	Bruce Conner	HIS EYE IS ON THE SPARROW (2006)	Video, b/w and color, sound
213	2009	Maya Deren	Meditation on Violence (1948)	16mm film, b/w, sound
214	2009	Morgan Fisher	North Light (1979)	16mm film installation, color, silent
215	2009	Robert Frank	Pull My Daisy (1955)	16mm film, b/w, sound
216	2009	Dan Graham	Past Future Split Attention (1972)	Video, b/w, sound
217	2009	Dan Graham	Pavilions (1999)	Video, color, sound
218	2009	Mike Kelley	Day Is Done (2005–06)	Video, color, sound
219	2009	Kalup Linzy	Conversations Wit de Churen V: As da Art World Might Turn (2006)	Video, color, sound
220	2009	Gordon Matta-Clark	Food (1972)	16mm film transferred to video, b/w, sound
221	2009	Paul McCarthy	cisuM fo dnuoS ehT (1965/2008)	35mm film transferred to video, color, sound
222	2009	Paul McCarthy	The Black and White Tapes (1970–75)	Video, b/w, sound
223	2009	Pat O'Neil	Screen (1969)	16mm film, color, silent
224	2009	Carolee Schneemann	Meat Joy (1964)	16mm film transferred to video, color, sound
225	2009	Carolee Schneemann	Body Collage (1967)	16mm film transferred to video, b/w, silent

continued

Table B2 cont.

No.	Year Acquired	Artist	Title (Date)	Description
226	2009	Robert Smithson,	*Swamp* (1969) Nancy Holt	16mm film, color, sound
227	2009	Claes Oldenburg	*Fotodeath* (1961)	16mm film, b/w, silent
228	2009	Claes Oldenburg	*Injun* (1962/71)	16mm film, b/w, sound
229	2009	Claes Oldenburg	*Autobodys* (1963)	16mm film, b/w, silent
230	2009	Claes Oldenburg	*Birth of the Flag, Part I and II* (1965/74)	16mm film transferred to video, b/w, silent
231	2009	Claes Oldenburg	*Hole* (1967)	Super 8mm transferred to 16mm film, color, silent
232	2009	Stan Vanderbeek, Claes Oldenburg	*Snapshots from the City* (1961)	16mm film transferred to video, b/w, sound
233	2009	Francesco Vezzoli	*Greed* (2009)	Video, color, sound
234	2009	Lawrence Weiner	*Deep Blue Sky* (2002)	Video, color, silent
235	2009	Lawrence Weiner	*Light Blue Sky* (2002)	Video, color, silent
236	2009	Lawrence Weiner	*Inherent in the Rhumb Line* (2005)	Video, color, silent
237	2009	Lawrence Weiner	*Turning Some Pages* (2007)	Video, color, silent
238	2009	WINTERFILM	*Winter Soldier* (1972)	16mm film transferred to video, b/w, sound
239	2009	Vernon Zimmerman, Claes Oldenburg	*Scarface and Aphrodite* (1963)	16mm film, b/w, sound

Appendix C:
Art Investment Fund Universe

..

Table C1 presents the universe of art investment funds as of December 2009. The information has been gathered both from publicly available sources and from my own correspondence with the management of the funds themselves. I present who is behind the funds, when they were established, how they are structured, as well as their investment targets, strategy, and status. The table reflects, to the best of my knowledge, the most accurate snapshot of these investment vehicles at the time of writing.

Readers should note, however, that as the majority of these funds are unregulated and highly discreet—even biased—about the information they reveal, any summary overview is bound to at least a moderate degree of imprecision. Moreover, the effects of the global financial crisis, which were felt acutely in this industry beginning in the second half of 2008, caused many funds to close, restructure, or disappear from the radar. Some information is consequently missing or "undetermined"—a reflection of the art investment fund universe as, above all, a work in progress.

TABLE C1
Art Investment Fund Universe, December 2009

Management	Name of Fund	Investment Details	Fund Overview
ABN-AMRO with Seymour Management. Ariel Salama. London	ABN-AMRO Art Investment Advisory Service	Target: $75m–150m	Launched September 2004
Société Générale Asset Management Alternative Investments (SGAM AI). Olivier Maman. Luxembourg	Alternative Investment Art Fund	Target: €50m Minimum: €125,000 Term: 8 years	Launch announced June 2007. Modern and contemporary art
The Collectors Fund, LLC. Alexander Kemper. Kansas City	American Masters Collection I, LLC	Target: $20m–$30m Minimum: $132,000 Term: 10 years + 2 optional 1-year extensions	Launched May 2007. 20th–21st century American art

Fund Description, Fees	Website	Status
Art investment 'fund of funds.'		Abandoned 2005. Available art funds not sufficient to set up fund of funds.
Private equity model. Target IRR: 15%–20%. Avg holding period of 2–4 years. Seek approx 100 works (avg value €500,000). Expected to raise $150m in its second year, with 15% annual returns.		Abandoned 2009 after several attempts by SGAM to restructure and market it.
Most investments between $50,000–$500,000. To buy $10m–$15m of art each year. Investors may borrow works from Fund. Active mangement. 2% annual management fee and 20% performance fee. One time initial fee: 6% on commitments up to $132,000; 4% on additional commitments up to $500,000; retroactive fee adjustment at $500,000 and above.	www.thecollectors fund.com	Valued at $13m in August 2009. Expected to close to new members at end of 2009, and have approximately 130 investor entities.

continued

Management	Name of Fund	Investment Details	Fund Overview
Anthea Art Investments AG. Massimiliano Subba, Nicolai Frahm. Zug	Anthea 1 Contemporary Art Investment Fund	Target: €30m–€40m Minimum: €250,000 Term: 8 years	Launch planned for May 2010. Postwar and contemporary art
MutualArt Inc. New York	Art Dealer Fund	Target: $50–$100m Term: 10 years	Announced 2004/05. Contemporary art by emerging and midcareer artists
Artemundi Management. Javier Lumbreras. Cayman Islands	Artemundi Global Fund	Target: $150m (expandable to $225m) Minimum: $500,000 (individuals) $1m (institutions) Term: 5 years	Launched August 2009. Old Masters to contemporary art

Fund Description, Fees	Website	Status
Closed-end fund. Target IRR: 15% p.a. First art fund to be regulated by the Irish Financial Services Regulatory Authority. Diversified investment strategy aimed at a mixture of iconic works by leading post-war/contemp artists alongside work by emerging artists, artists from developing economies and distressed sales opportunities. 2% p.a. management fee; 20% performance fee.	www.anthea-art.com	In startup phase.
Closed-end private equity fund model. Participating dealers to be paid for the works, 50% in cash plus 50% in participation notes in the fund. Proceeds allocated to investors, dealers and management according to tranched structure. 2.5% annual management fees.		Abandoned shortly after announcement.
Closed-end fund. Target annual IRR: 18% net of fees and expenses. Most art investments above $250,000. Members may display fund's artworks in their homes.	www.artemundi globalfund.com	Undetermined.

continued

Management	Name of Fund	Investment Details	Fund Overview
Art Estates GMBH. Taris Ersin Yoleri/ Johannes Heinzmann. Hamburg	Art Estate Kunstfonds 01	Target: €7.4m Minimum: €2,500 Term: 15 years	Launched fall 2006. Postwar and contempo-rary art
Rik Reinking, Martin Bouchon. Hamburg	Artfonds 21 AG	Target: €3m Minimum: €3,000 Maximum: €30,000 No Term	Launched April 2007. Modern and contem-porary art

Fund Description, Fees	Website	Status
25 artworks by 10 established contemporary artists (incl. Richter, Baselitz, Warhol, Rauschenberg, Wesselmann, Stella, Rosenquist). Annual return target: 10%.	www.artestate.com	Undetermined—website no longer in operation.
Structured as a German stock corporation, without limited duration, that collects and trades modern and contemporary art. Gallery owners and art producers acquire shares in the company in lieu of payment, or can become a partner in the partnership Artfonds 21 Kunstler GbR and receive 10% of annual profits. Running costs are covered by leasing of the art and by sales of editions. Minimum holding period of approx 5 years. Funds received through sales will either be reinvested in new works or paid out as a dividend to shareholders.	www.artfonds-21.com	Raised €303,750 from 25 investors and invested €270,000 thereof into approx. 50 artworks. First sales projected in 2011–12.

continued

Management	Name of Fund	Investment Details	Fund Overview
CAIAC Fund Management AG. René Bollhander. Lichtenstein	TheArtFund (FineArt AG)	Target: €50m Minimum: €25,000	Launched May 2007. Modern painting, with limited photography and contemporary art
Art Fund Management Ltd. Gil Brandes. Israel	Art Partners		Postwar and contemporary art, primarily midcareer artists frequently traded at auction
Merit Alternative Investments GmBH. Friedrich Kiradi. Vienna (Cayman Islands SPC)	Art Photography Fund	Minimum: €70,000 Target: €70m	Launched March 2008. 19th century to 1970s art (up to 90%) and contemporary art (up to 25%)
Serge and Micky Tiroche. Israel/ Luxembourg	ArtPlus	Target: $100m–$200m	Launched fall 2008. Modern and contemporary art

Fund Description, Fees	Website	Status
Open-ended (quarterly redemptions). Open trading (arbitrage) art fund. Works are retained for a maximum of 3 years. Art investments above €25,000. Additional income from exhibitions, merchandising, art leasing and traditional loans. Maximum of 10% to 20% invested in fixed interest securities. Annual return between 12%–15%. All-in-fee: 4% per annum	www.theartfund.li	Undetermined—website no longer in operation; no response to email requesting further information.
Investment Committee also includes Amalia Dayan, Mark Fletcher, Chemi Peres and Isaac Hillel.	www.artfunds.com	Undetermined.
Open-ended (quarterly redemptions). Expected 10%–15% returns annually. Minimum 3 years. 2% management fee, 20% performance fee.	www.artphotography fund.com	17.7%: Cumulative returns since inception. Composed of over 1,100 works by 130 artists. (Figures as of September 2009)
To raise money in the form of shares. Will hold "blue-chip" works and engage in short-term trading. Aim to issue shares within 3–5 years.		Abandoned.

continued

Management	Name of Fund	Investment Details	Fund Overview
Artistic Investment Advisors. Justin Williams/Chris Carlson. Guernsey	Art Trading Fund 1	Target: £25m Minimum: £100,000 Term: 3 years	Launched summer 2007. Impressionist, modern, and contemporary art
ARTvest/ UBU Gallery. Glasgow	ARTvest	Target: £112,500 Minimum: £1,500 p.a. Term: 3 years	Launched June 2006. Contemporary art
Aurora Fine Art Investments. Viktor Vekselberg. New York	Aurora Fine Art Investment Fund	Target: $100m+	Launched April 2005. 19th–20th century Russian art and crafts; since 2008 also Impressionist and Post-Impressionist art
Cannonball Funds. Federico Moccia. Singapore	Cannonball Art Fund	Target: $10m Minimum: €100,000	Launched 2007. Warhol prints

Fund Description, Fees	Website	Status
Closed-end fund. Target IRR: 30% p.a. Art hedge fund aiming to exploit the ineffiiences of the market and aggregate primary and secondary markets; buying art directly from 10 living artists, plus derivatives from art market-related companies. Challenges conventional "buy and hold" art fund model. Lists Charles Saatchi as art advisor. 2% flat fee, 20% performance fee on returns over Libor.	www.thearttrading fund.com	Abandoned December 2009. Investment performance of The Art Trading Fund I unclear; plans to launch The Art Trading Fund II in 2008 and a 5-year Vulture Fund in 2009 never materialized. Email to management requesting further information not responded to.
Art buying syndicate. Pools of max 25 members; every member gets 2 artworks or the equivalent in cash at the end; most purchases directly from artists. 20% management fee.	www.artvest.co.uk	Undetermined—website still in operation but does not appear not to have been updated since 2006.
More than 1,000 artworks.	www.aurorafund.com	Still in existence but never seems to have been established as a "fund" in the conventional sense— principally an investment vehicle for Vekselberg's own collection. Cumulative value supposedly peaked at over $200m but reportedly in the process of being sold off since 2008.
30% performance fee (no management fee).		Undetermined— believed to have been wound down.

continued

Management	Name of Fund	Investment Details	Fund Overview
Castle Trust Group. Gibraltar	Castle Apollo Fund (Castle Fund Administrators Ltd)	Minimum: €100,000	Launched August 2008. Fund of funds
Julian Thompson and Jason Tse. London and Shanghai	The China Fund	Target: $100m Minimum: $250,000 Term: 5–7 years	Chinese arts and crafts (low painting allocation)
Christie's Art Asset Management. London and New York	Christie's Opportunity Fund I	Target: $250m–$350m Term: 5 years (plus up to 3 1-year extensions)	Fund planning initiated 2008. Old Masters, Impressionist, modern and contemporary art
Castlestone Management. Angus Murray. London/ British Virgin Islands	Collection of Modern Art	Target: $100m Minimum: $10,000 (individuals) $1m (institutions) Term: 8 years	Inaugurated November 2007; opened to investors March 2008; commenced trading spring 2009. Postwar art from non-producing or deceased artists

Fund Description, Fees	Website	Status
Seeks to invest in 15–20 international art funds. Targeted at medium to long term investment periods of 18–36 months.	www.castlefund administrators.com	Abandoned in 2009.
Closed-end fund. Target IRR: 12%–15%. Annual purchasing allocation: 40% to core collection purchases; 40% to "master-pieces"; 20% to short-term investment opportunities. Fees: 2% AUM; 20% performance (after 6% hurdle)		Generated some press in the 2004-05 period, around the same time that the Fine Art Fund launched its first art investment vehicle, but it never got off the ground and has subsequently been abandoned.
Closed-end fund. Target IRR: 20%. Focus primarily on works below $10m and majority between $1–$4m.		Abandoned spring 2009.
Open-ended mutual fund. Target IRR: approx 9% (or 4%–6% above inflation). Aim to create portfolio that mirrors AMR Post-War 50 Art Index: 80–120 works in total from 40–60 artists. Fees: 20% performance fee charged to all investors; 1% management fee charged to institutions; 1.25% management fee charged to invididuals (retained by Independent Financial Advisor who places investor with Castlestone).	www.collectionof modernart.com	$28m total commitments and $12m allocated to art as of December 2009; majority of commitments to date in art from fund founder.

continued

Management	Name of Fund	Investment Details	Fund Overview
Advanced Capital Group. Simon de Pury/ Robert J. Tomei. Luxembourg	Contemporary Art Fund	Target: €150m	Announced summer 2008. Established and emerging contemporary artists, some photography and design
Crayon Capital/ Vadehra Art Gallery. New Delhi	Crayon Capital Art Fund	Target: Rs 40 crore (approx $8m) Minimum: Rs 10 lakh (approx $20,000)	Launched November 2006. Indian contemporary art
Daman Invest-ments PSC. Shehab Gargash. Dubai	The Daman Middle East Art Fund	Target: AED 50m (approx $14m) Term: 5 years (with up to 2-year extension)	Launched May 2008. Contem-porary Middle Eastern art

Fund Description, Fees	Website	Status
Target IRR: 20%.	www.contemporary artfund.lu	Fund placed on hold in 2009.
Closed-end fund. Target returns of 30%–40%. "By invitation only." Lock-in period of 3 years. Leading artists only.	www.crayoncapital .com	Returns of 10.10% as of September 2009, according to the fund's website. Invitation-only structure suggests that Crayon Capital is closer to a private investment syndicate than an actual art fund.
	www.daman.ae	Undetermined.

continued

Management	Name of Fund	Investment Details	Fund Overview
Dean Art Investments Ltd. Gerard Moxon, David Thomas. London, supported by Harbor Capital Partners Ltd. Dean Art Fund IC established as a Jersey-based Incorporated Cell Company	Dean Art Fund IC	Target: $50m–$200m	Launched October 2008. Old Masters to contemporary art
Emotional Assets Management & Research LLP. Bernard Duffy. London/Guernsey	The Emotional Assets Fund I	Minimum: £100,000 Term: 5 years	Launched November 2009. "Emotional Assets" across 15 collectables sectors, from fine art and stamps to vintage jewelry and rare manuscripts

Fund Description, Fees	Website	Status
Open-ended fund with minimum 3-year lock-up. Diversified portfolio with co-investment opportunities and borrowing/leasing art to shareholders; avg. price between $500k–$5m. Unique feature is full FSA regulation of the Manager, via Harbour Capital platform. Fees: 2.5% management fee, payable monthly; 10% incentive fee, based on semi-annual valuations; 1% performance fee, on realised sales. Investment Art Advisor: Jeremy Eckstein.	www.deanart investments.com	Abandoned summer 2009.
Closed-end fund. Target IRR: 15% p.a. Hybrid structure: The Fund aims to invest 60% of its gross assets in funds invested in Emotional Assets and 40% in direct Emotional Assets holdings. Distributions to investors made as assets are sold. Advisor is authorised and regulated by the FSA.	www.emotionalassets .com	Raising funds.

continued

Management	Name of Fund	Investment Details	Fund Overview
Fernwood Art Investments, LLC. Bruce Taub. New York and Boston.	2 funds proposed: Fernwood Sector Allocation Fund, Fernwood Opportunity Fund	Target: $150m Minimum: $250,000 Term: 8–10 years	Company founded October 2003. Old Masters to contemporary art.
Fine Art Management Services. Philip Hoffman. London	4 funds in operation: The Fine Art Fund I, The Fine Art Fund II, The Chinese Fine Art Fund, The Middle East Fine Art Fund	Target: $100m–$350m Minimum: $250,000 (for FAF I and FAF II); $100,000 (for Chinese and Middle East FAF)	Company founded in 2002, FAF I opened in April 2004. Old Masters to contemporary art for FAF I and FAF II; 2 other funds are region-specific

Fund Description, Fees	Website	Status
Closed-end funds available for sophisticated and qualified investors. FSAF structured as a diversified fund, with investments across eight genre categories from Old Masters to Emerging Masters. FOF focused on opportunisitc short-term gains.		Dissolved June 2006. Suit outstanding against Taub by investors who had purchased preferred shares in the parent company, Fernwood Art Investments, LLC. Claims include embezzlement, fraud/intentional misrepresentation, negligent misrepresentation, and breach of fiduciary duty.
Annual return target: 10%–15%. All funds are closed-end. The Middle East FAF is managed in partnership with Bahrain-based Addax Bank; all others are managed exclusively by FAMS. FAMS charges a 2% annual management charge on the funds and takes a 20% performance fee over a 6% return rate. Two additional vehicles are also on the horizon, both with a projected launch in late 2009 and an initial close in early 2010: The Fine Art Fund III, a five-year closed-end fund which will focus on acquiring art at distressed prices; and The Indian Fine Art Fund.	www.thefineartfund .com	Results (as of October 2009): $89.27m: total commitments 30.15%: Annualised return on *all* assets sold 34%: FAF I avg annualized return on assets sold 29%: FAF II avg annualized return on assets sold 13%: Chinese FAF returns based on Directors' valuation of assets 6%: Middle East FAF returns based on Directors' valuation of assets 18 months: Avg. holding period on assets sold.

continued

Management	Name of Fund	Investment Details	Fund Overview
Neville Tuli, advised by Osians. Cayman Islands registered fund with a Jersey Feeder	The Indian Asian Arab Art Fund	Target: $200m	Launch planned for beginning of 2008. Indian, Asian, and Arab art
Meridian Art Partners LLC. Andrew Littlejohn, Pamela Johnson, Delaware. Managed by Meridian Art Management LLC, New York. Distribution Partner, Calamander Capital Pte Ltd, Singapore (Fund jurisdiction: Delaware/ BVI Master-Feeder Structure)	The Meridian Emerging Art Markets Fund	Target: CHF 100m Minimum: CHF 250,000 Term: 5 years with up to two 1 year extensions	Launched February 2008. Established contemporary art, mainly from emerging markets
Osian's–Connoisseurs of Art Pvt. Ltd. Neville Tuli. Mumbai	The Osian's Art Fund (Scheme Contemporary 1)	Target: Rs 100 crore (approx $20m) Minimum: Rs 10 lakh and thereafter in multiples of Rs 5 lakh ($20,000 and $10,000, respectively)	Launched July 2006. Modern and contemporary Indian art

Fund Description, Fees	Website	Status
Closed-end fund with 4-year lock-in period. Target IRR: 16%–24% p.a. Looking to hold assets for 18–30 months.		Fund placed on hold in November 2008.
Closed-end. Target IRR: 30% p.a. Trading executed through global network of consultants and art advisors. Investment strategy focuses on absolute returns and diversified risk across geographic market sectors. 85% of portfolio allocated to established contemporary art from emerging markets; 15% allocation to Western contemporary art.	www.meridianart partners.com	Fund placed on hold in May 2009.
Closed-end fund with 3-year lock-in period. Target IRR: 20%+ after tax.	www.osians.com/ wms/funds.php	Dissolved July 2009. The closure has attracted considerable press, notably focusing on delays in redeeming the fund's investors and other outstanding legal claims against Tuli and Osians. Prior to closure, the fund reportedly had Rs 102.40 crore under management, with returns of 5% since inception.

continued

Management	Name of Fund	Investment Details	Fund Overview
Prime Art Management Ltd. Manuel Gerber	Prime Art Funds	Term: 6–8 years	Launched fall 2008. Emerging artists with little or no track record
Phillips, de Pury & Company and Savigny Partners LLF	The Savigny Art Fund	Target: $300m–400m, with $250m being raised in a first closing. Term: 10 years	Announced November 2007. Contemporary art (80% established artists, 20% emerging artists), design, and photography
Sharpe Investments Ltd. Thomas Scharitzer. Gibraltar/Cayman Islands	Sharpe Art Fund	Minimum: €100,000	Launched August 2006. European, U.S., Asian, and African art
Corepoint Capital AG. Zurich	The Stella Fund	Term: 4 years, with up to 2 1-year extensions	
Zelda Cheatle, London	WMG Photography Collection	Target: £10m	Launched September 2007. Photographs
Edelweiss Capital/ Sakshi Art Gallery. Geetha Mehra. Mumbai.	The Yatra Fund	Target: $3.7m Minimum: $60,000 (in 2 tranches) Term: 5 years	Launched September 2005. Indian art

Fund Description, Fees	Website	Status
Proprietary econometric system enables forecasting future price in absence of past market records. Gallery-friendly (not at auctions), exclusive focus on the primary market.	www.primeartfunds .com	Dissolved in 2009.
Target IRR: 20%+, 80%–90% with medium term appreciation; 10–20% shorter-term investments (9 months–2 years).		Abandoned in 2008. Unable to attract sufficient investor interest.
Open-ended fund with quarterly redemptions. 2% management fee, 20% performance fee.	www.sharpeartfund .com	€22m under management (as of December 2009) NAV: 152.65 (year-end 2009) Performance in 2009: 6.87%.
Quarterly redemptions, with 90-day notice.	www.corepointcapital .com	Undetermined.
20 investors; allocation to approx 4,000 photographic prints.		Intial backing by WMG, a London-based hedge fund, fell through and the initiative was restructured in 2009 as the Tosca Fund Collection. Details on AUM and returns not available.
Target IRR: 10%+ p.a.	www.edelcap.com	Undetermined.

Notes

..

PREFACE

1. See "Hirst Dealers Bolster Prices at Record Sale," *Sunday Times*, 21 September 2008.

2. Sotheby's, *2008 Annual Report*, p. 27.

3. Carol Vogel, "Contemporary Chinese on Sale in Hong Kong," *New York Times*, 28 March 2008.

4. The second half of the Estella Collection auction, originally slated for October 2008, never occurred. Sotheby's press office has not given a definitive explanation for this, but the cancellation of this sale was presumably a result of the deteriorating market climate by this time and the negative press stemming from the Hong Kong auction. A number of the works from the Estella Collection were nevertheless quietly offered for sale in Sotheby's Contemporary Art Asia auction in New York on September 17, 2008. Some of the works, such as Yu Hong's acrylic, *She-Beautiful Writer Zhao Bo* (2004), were bought-in, but others did extremely well: Zhang Huan's *Family Tree* (2000), a series of chromogenic prints, sold for more than double the high estimate at $386,500.

INTRODUCTION

1. Justin Williams, cofounder of the Art Trading Fund, in Kit Roane, "The Art of Investing in Art," 27 June 2007, available at http://www.portfolio.com/news-markets/international-news/portfolio/2007/06/26/Hedge-Funds-Turn-to-Art-as-an-Asset/. The fund, which launched in 2007, was shut down in December 2009.

2. Pierre Bourdieu, *The Field of Cultural Production: Essays on Art and Literature*, ed. Randal Johnson (Cambridge: Polity Press, 1993), p. 74.

3. Signposts include the German quarterly *Art Investor*, which debuted in 2001 and produced its first English international edition in 2007; *Art + Auction*'s launching of its inaugural annual "Art Investment" issue in 2004; the founding of numerous consultancies and businesses furnishing analytical market expertise and services (e.g., Fine Art Wealth Management, artnet.com, artprice.com, artasanasset .com, and artfacts.net); and even *Vanity Fair*'s flagship "Art Special" in December 2006 that highlighted some key art market players and trends.

4. For an excellent discussion of this shift in arts education, see Howard Singerman, *Art Subjects: Making Artists in the American University* (Berkeley and Los Angeles: University of California Press, 1999). For a good general overview, see

Julian Stallabrass, *Art Incorporated: The Story of Contemporary Art* (Oxford: Oxford University Press, 2004).

5. For instance, Olav Velthuis's *Talking Prices* offers one of the best recent accounts of how contemporary art prices are established, but it is predominantly theoretical, drawing upon economics and sociology to rationalize the art trade, and does not touch upon the main case studies of the present book. Nor does Raymonde Moulin in her now classic text, *The French Art Market*. See Olav Velthuis, *Talking Prices: Symbolic Meanings of Prices on the Market for Contemporary Art* (Princeton: Princeton University Press, 2005); and Raymonde Moulin, *The French Art Market: A Sociological View*, trans. Arthur Goldhammer (New Brunswick: Rutgers University Press, 1987). On the branding of contemporary art, see Don Thompson, *The $12 Million Stuffed Shark* (London: Aurum Press, 2008).

6. William Baumol's famous analysis of 1986 is central to the upsurge in art investment literature ever since: William Baumol, "Unnatural Value: Or Art Investment as Floating Crap Game," *American Economic Review*, vol. 76, no. 2 (May 1986): 10–14. An even earlier quantitative analysis of art investing that is also positioned against the backdrop of popular interest in the attractiveness of art as a financial asset is provided by Robert Anderson, "Paintings as an Investment," *Economic Inquiry*, vol. 12 (1974): 13–26. For a cogent overview of the Japanese art scandals, see Peter Watson, *From Manet to Manhattan: The Rise of the Modern Art Market* (London: Hutchinson, 1992), pp. 456–66 (chap. 41, "Anticlimax: The Art of *Zaiteku*").

7. Giorgio Vasari, *Lives of the Artists* [1568], trans. George Bull (New York: Penguin, 1965).

8. The inaugural auction in England of 1676 was used to sell the library of Lazarus Seeman; the first picture auction did not take place in London until 1682. Iain Pears, *The Discovery of Painting: The Growth of the Interest in the Arts in England 1680–1768* (New Haven: Yale University Press, 1988), p. 57. For art historian David Solkin, these changes in the market meant that "the eighteenth century witnessed nothing less than the invention of culture per se, as a commodity to be consumed ostensibly for its own sake, through the medium of rational discussion." David Solkin, *Painting for Money: The Visual Arts and the Public Sphere in Eighteenth-Century England* (New Haven: Yale University Press, 1993), p. 2.

9. See especially Richard Goldthwaite, *Wealth and Demand for Art in Italy: 1300–1600* (Baltimore: Johns Hopkins University Press, 1993); Francis Haskell, *Patrons and Painters: Art and Society in Baroque Italy* (New Haven: Yale University Press, 1980); and John Michael Montias, *Vermeer and His Milieu: A Web of Social History* (Princeton: Princeton University Press, 1989).

10. Jonathan K. Nelson and Richard J. Zeckhauser, *The Patron's Payoff: Conspicuous Commissions in Italian Renaissance Art* (Princeton: Princeton University Press, 2009).

11. Richard Rush, *Art as an Investment* (New York: Bonanza Books, 1961).

12. Ibid., p. vii. Emphasis added.

13. Gerald Reitlinger, *The Economics of Taste*. Vol. 1: *The Rise and Fall of the Picture Market: 1760–1960*; Vol. 2: *The Rise and Fall of Objets d'Art Prices since*

1750; Vol. 3: *The Art Market in the 1960s* (London: Barrie & Rockliff, 1961, 1963, 1970).

14. The most expensive, at $137.4 million in 2010 dollars, is Van Gogh's *Portrait of Dr. Gachet* (1890) which sold at Christie's, New York, in 1990 for $82.5 million. Second, at $130.0 million in 2010 dollars, is Renoir's *Au Moulin de la Galette* (1876) which sold at Sotheby's, New York, in 1990 for $78.1 million. Third, at $120.0 million in 2010 dollars, is Picasso's *Garçon à la pipe* (1905) which sold at Sotheby's, New York, in 2004 for $104.2 million. Fourth, and the record holder in nominal terms, as this book went to press, is Alberto Giacometti's *Walking Man I* (1960) which sold for $104.3 million in February 2010. And fifth, at $103.2 million in 2010 dollars, is Van Gogh's *Irises* (1889) which sold at Christie's, New York, in 1987 for $53.9 million. Original prices have been adjusted for inflation using the U.S. consumer price index, available at http://www.minneapolisfed.org/index.cfm.

15. A useful overview of these features is provided in *Artforum*'s special issue on "Art and Its Markets" from April 2008, in particular the roundtable discussion on pp. 292–303. A colorful alternative account is presented in Sarah Thornton, *Seven Days in the Art World* (London: Granta, 2008).

16. http://business.timesonline.co.uk/tol/business/specials/rich_list/.

17. See Thompson, *The $12 Million Stuffed Shark*, p. 67.

18. Hirst was ranked number 1 in *Art Review*'s annual "Power 100," November 2008. The following year, November 2009, he dropped to number 48.

19. Data from Artprice. Recall that these figures are actually an underestimation as they reflect the hammer price only and do not include the buyer's premium. Artprice defines contemporary art as work made by artists born after 1945. My discussion of contemporary art in this book is somewhat different and refers to art made after 1960, with emphasis on art produced by living artists in the past two decades.

20. In 2007 contemporary art became the highest-grossing sales category at both Sotheby's and Christie's for the first time ever. Sotheby's sold $1.34 billion in its Contemporary Art category during the year, against Impressionist and Modern Art sales of $1.16 billion, while Christie's sold even more at $1.56 billion in its Post-War and Contemporary Art category, against $1.44 billion in its Impressionist and Modern Art category. Differences in the contemporary art figures cited by Christie's and Sotheby's (at $2.9 billion, cumulatively) versus the aforementioned figure of Artprice (at $1.2 billion) are due to the fact that the auction houses include the buyer's premium in their data and also adhere to a more general definition of contemporary art—as art produced in the post-1945 period (and not the more restrictive view, taken by Artprice, of art produced by artists born after 1945). Statistics on artworks selling above $100,000 are from Artprice, *Contemporary Art Market 2008/2009: The Artprice Annual Report* (St-Romain-au-Mont-d'Or: Artprice.com, 2009), p. 86.

21. On MPT, see Harry Markowitz, "Portfolio Selection," *Journal of Finance*, vol. 7, no. 1 (March 1952): 77–921. William Sharpe is typically credited with having created CAPM, though papers published by Lintner and Mossin concurrent to Sharpe's were also important in the model's articulation and development. See William F. Sharpe, "Capital Asset Prices: A Theory of Market Equilibrium

under Conditions of Risk," *Journal of Finance*, vol. 19, no. 3 (September 1964): 425–42; John Lintner, "The Valuation of Risk Assets and the Selection of Risky Investments in Stock Portfolios and Capital Budgets," *Review of Economics and Statistics*, vol. 47, no. 1 (February 1965): 13–37; and Jan Mossin, "Equilibrium in a Capital Asset Market," *Econometrica*, vol. 34 (January 1966): 768–83.

22. Baumol, "Unnatural Value," is one of the most important studies based on the Reitlinger dataset.

23. It has been observed that although the auctioning of contemporary art was not unique to this moment, it *was* in the Anglo-Saxon countries: Watson, *From Manet to Manhattan*, p. 417.

24. Robert Rauschenberg's public ridiculing of the Sculls after his *Thaw* (1958) and *Double Feature* (1959) were hammered down for $85,000 and $90,000, against purchase prices of $900 and $2,500 in 1958 and 1959, also underscored the contentiousness of auctioning living artists' work. A good account of the Scull sale and its significance within the evolution of the contemporary art market is given in Anthony Haden-Guest, *True Colors: The Real Life of the Art World* (New York: Atlantic Monthly Press, 1996), pp. 1–20. On the rise of the New York art market, see A. Deidre Robson, *Prestige, Profit, and Pleasure: The Market for Modern Art in New York in the 1940s and 1950s* (New York: Garland, 1995).

25. The origins of contemporary art sales at auction are discussed in Terry Smith, *What Is Contemporary Art?* (Chicago: University of Chicago Press, 2009), pp. 123–27.

26. All quotations in this paragraph from Velthuis, *Talking Prices*, pp. 142–45.

27. For an excellent overview, see David Harvey, *The Condition of Postmodernity: An Enquiry into the Origins of Cultural Change* (Oxford: Blackwell, 1990); and Robert Brenner, *The Boom and the Bubble: The U.S. in the World Economy* (London: Verso, 2002).

28. Such issues are specifically and adeptly addressed by Chin-tao Wu, who illustrates how the art world embraced enterprise capitalism in the 1980s in the wake of President Reagan's and Prime Minister Thatcher's respective models of privatization. Chin-tao Wu, *Privatising Culture: Corporate Art Intervention since the 1980s* (London: Verso, 2003). See also Mark Rectanus, *Culture Incorporated: Museums, Artists and Corporate Sponsorships* (Minneapolis: University of Minnesota Press, 2002). Mark Wallinger and Mary Warnock offer an additional excellent prognosis of the rationales and risks of these changes within the cultural sector, in Mark Wallinger and Mary Warnock, eds., *Art for All? Their Policies and Our Culture* (London: Peer, 2000).

29. Lucy Lippard's *Six Years: The Dematerialization of the Art Object from 1966 to 1972* [1973] (Berkeley: University of California Press, 1997), remains the quintessential volume of art writing on this subject. Fredric Jameson's theorizations of postmodern culture are also extremely important. See Fredric Jameson, *Postmodernism, or, the Cultural Logic of Late Capitalism* (London: Verso, 1991); and Jameson, *The Postmodern Turn: Selected Writings on the Postmodern, 1983–1998* (London: Verso, 1998).

30. See Jean-François Lyotard, *The Postmodern Condition: A Report on Knowledge* [1979], trans. Geoff Bennington and Brian Massumi (Manchester: Manches-

ter University Press, 1984); and *Les Immatériaux: Epreuves d'écriture*, exh. cat. (Paris: Centre Georges Pompidou, 1985).

31. Of course trade regulations governing immaterial properties such as image rights have existed for centuries and have been elemental to the development of economic systems for print-making and publishing, and to generating royalties from the circulation of fine art imagery. For an excellent account of the dawn of intellectual property rights in the printing press of fifteenth-century Venice, see Jaime Stapleton, "Art, Intellectual Property and the Knowledge Economy," Ph.D. diss., Goldsmiths College, 2002, pp. 30–81.

32. For a synopsis of these dynamics in performance art, see *Out of Actions: Between Performance and the Object, 1949–1979*, exh. cat. (Los Angeles: Museum of Contemporary Art, 1998).

33. An informative analysis of the rise of American and German Neoexpressionism and the Italian Transavantguardia during this period is provided in Irving Sandler, *Art of the Postmodern Era: From the Late 1960s to the Early 1990s* (Boulder: Westview Press, 1996), pp. 222–318. On the market for conceptual art, see especially Alexander Alberro, *Conceptual Art and the Politics of Publicity* (Cambridge: MIT Press, 2003).

34. Nicolas Bourriaud, *Relational Aesthetics* [1998], trans. Mathieu Copeland, Simon Pleasance, and Fronza Woods (Dijon: Les presses du réel, 2002).

35. Michael Denning observes that the *Oxford English Dictionary* locates the first use of the word "globalization" in 1961, while the first book to include it in its title was published in 1988. See Michael Denning, *Culture in the Age of Three Worlds* (London: Verso, 2004), p. 17.

36. Wallerstein's famous *World-System Analysis* was originally published in three volumes from 1974 to 1988 by the Academic Press, New York. For a helpful overview, see Immanuel Wallerstein, *World-Systems Analysis: An Introduction* (Durham: Duke University Press, 2004). Wallerstein is hardly the lone adherent to this perspective. Giovanni Arrighi's equally formidable writing on the subject fleshes out the long-term cycles of capitalist accumulation, and Robert Brenner has played a valuable role in furthering our understanding of globalization's deeper economic trajectory. See Giovanni Arrighi, *The Long Twentieth Century: Money, Power and the Origins of Our Times* (London: Verso, 1994); Robert Brenner, *The Boom and the Bubble*; and Robert Brenner, *The Economics of Global Turbulence* (London: Verso, 2006). For an important alternative accounts of globalization's geopolitical implications, see Michael Hardt and Antonio Negri, *Empire* (Cambridge: Harvard University Press, 2000); and Gopal Balakrishnan, ed., *Debating Empire* (London: Verso, 2003).

37. See especially Immanuel Wallerstein, *The Decline of American Power: The U.S. in a Chaotic World* (New York: New Press, 2003).

38. Explanatory overviews are provided in Hans Belting and Andrea Buddensieg, eds., *The Global Art World: Audiences, Markets and Museums* (Ostfildern: Hatje Cantz Verlag, 2009); Charlotte Bydler, *The Global Artworld, Inc.: On the Globalization of Contemporary Art* (Stockholm: Uppsala University, 2004); Stallabrass, *Art Incorporated*, pp. 29–72; and *Artforum*'s "globalism" issue, vol. 42, no. 3 (November 2003).

39. All figures in this paragraph from Clare McAndrew, *The International Art Market: A Survey of Europe in a Global Context* (Helvoirt: European Fine Art Foundation, 2007), pp. 10, 33, 64; and McAndrew, *Globalisation and the Art Market: Emerging Economies in the Art Trade in 2008* (Helvoirt: European Fine Art Foundation, 2009), p. 10.

40. McAndrew, *Globalisation and the Art Market*, p. 21.

41. Whereas the total number of people with high net worth worldwide grew at 6 percent from 2006 to 2007 (reaching 10.1 million people), by far the largest gains were posted in the BRIC nations (Brazil, Russia, India, and China), at 19.4 percent, and the Middle East, at 15.6 percent, versus Europe and North America at a comparatively modest 3.7 and 4.2 percent, respectively. See CapGemini and Merrill Lynch, *World Wealth Report: 2008*.

42. Sarah Thornton and Cristina Ruiz, "Revealed: Royal Family of Qatar Is Buyer of World's Most Expensive Hirst," *Art Newspaper*, no. 191 (May 2008): 1.

43. For a critique of this, see Paul Werner, *Museum, Inc.: Inside the Global Art World* (Chicago: Prickly Paradigm Press, 2005).

44. For an analysis of the Guggenheim Bilbao's economic impact, see Beatriz Plaza, "The Return on Investment of the Guggenheim Museum Bilbao," *International Journal of Urban and Regional Research*, vol. 30, no. 2 (June 2006): 452–67.

45. Not all of these ventures, however, have succeeded: the 2001 closure of the Guggenheim SoHo (which opened in 1992) and the 2003 closure of the Las Vegas branch only fifteen months after its launch, in addition to the abandoning of expansion proposals in downtown Manhattan, Taiwan, Rio de Janeiro, and Hong Kong, underscore their speculative nature.

46. Tate Modern attracted 5.2 million visitors in 2007, eclipsed only by the Louvre (at 8.3 million) and the Centre Pompidou (at 5.5 million). On attendance figures, see "Exhibition Attendance Figures," *Art Newspaper*, no. 189 (March 2008): 24. On MoMA's and Tate's renovations and expansions, see http://moma.org/about_moma/history/index.html; http://tate.org.uk/modern/transformingtm/; and Jonathan Glancey, "Tate Modern 2: The Epic Sequel," *Guardian*, 26 July 2006.

47. Figures in Alan Riding, "Abu Dhabi Is to Gain a Louvre of Its Own," *New York Times*, 13 January 2007.

48. In addition to the Louvre Abu Dhabi and the Guggenheim Abu Dhabi Museum, the other cultural institutions include the Sheikh Zayed National Museum, which will be built by Norman Foster; the Abu Dhabi Performing Arts Centre, by Zaha Hadid (supported by the Solomon R. Guggenheim Foundation); and the Maritime Museum Abu Dhabi, by Tadao Ando.

49. The gallery also maintains offices in La Jolla and Hong Kong as well as a stand-alone shop on New York's Madison Avenue.

50. Hauser & Wirth has its flagship operation in Zurich and two galleries in London (one in partnership with Old Masters dealer Colnaghi); a fourth venue, Zwirner & Wirth, operated in New York since 2000 with dealer David Zwirner, closed in 2009. PaceWildenstein operates three galleries in New York and in August 2008 opened a satellite branch in Beijing.

51. Haunch of Venison closed its Zurich branch in 2009.

52. This arguably reached its apex in Okwui Enwezor's *Documenta XI*, which was organized as a series of five international "Platforms" in 2001 and 2002, ultimately culminating in an exhibition in Kassel, Germany. For a good introduction to the exhibition's positioning in relation to globalization discourse, see Okwui Enwezor, "The Black Box," in *Documenta XI, Platform 5: The Exhibition*, exh. cat. (Kassel: Documenta und Museum Fridericianum, 2002), pp. 42–55.

53. Important precedents include the Venice Biennale, established in 1893; Documenta, in Kassel, Germany (which occurs once every five years), established in 1955; and even earlier variants such as the Great Exhibition at Crystal Palace, London, 1851, the World Fairs held in Paris between 1867 and 1889, and the World Exposition, Vienna, 1873.

54. Owing to the great number of small-scale and regional biennials, and to those on the periphery of the "artistic" field, authoritative statistics on these developments are sparse and may be imprecise. Even so, they now span Europe, the Americas, Asia, Australia, and Africa, with the following source noting the existence of at least seventy-two such undertakings in 2001: Bettina Funcke, ed., *6th Caribbean Biennial* (Dijon: Les presses du reel/Janvier, 2001), n.p. For a good discussion of their expansion into emerging and formerly Communist states, see Stallabrass, *Art Incorporated*, pp. 33–34; and on their development within Europe, see Barbara Vanderlinden and Elena Filipovic, *The Manifesta Decade: Debates on Contemporary Art Exhibitions and Biennials in Post-Wall Europe* (Cambridge: MIT Press, 2005).

55. Thirteen such fairs coincided with the 2006 edition of Art Basel Miami Beach, including Aqua, Art Miami, Bridge Art Fair, Design Miami, Digital and Video Art Fair (DIVA), Flow, Fountain Miami, Ink Art Fair, New Art Dealers Alliance Fair (NADA), Photo Miami, Pool Art Fair, Pulse, and Scope Miami.

56. Sales in the United States and Britain combined for 71 percent of the international fine art auction market at the peak of the bubble in 2007. McAndrew, *Globalisation and the Art Market*, p. 10.

57. For a good discussion of this, see ibid., pp. 29–30.

58. See Alain Quemin, "The Illusion of the Elimination of Borders in the Contemporary Art World," in *Artwork through the Market: The Past and the Present*, ed. Ján Bakos (Bratislava: Foundation—Center for Contemporary Arts, 2004), pp. 275–300.

59. Two of the most prominent online sales databases are Artnet (https://www.artnet.com/) and Artprice (http://www.artprice.com/).

60. McAndrew is not alone in being confounded by the size of the artist labor market: a 2004 Arts Council England report did no better than estimate that there were anywhere between 34,000 and 110,000 professional artists living in England. The 2000 U.S. Census presents a figure of 1,931,000 artists, or 1.4 percent of the American labor force. Figures in McAndrew, *The International Art Market*, 2007, pp. 22–23; Louisa Buck, *Market Matters: The Dynamics of the Contemporary Art Market* (London: Arts Council England, 2004), p. 21; and Neil Alper and Gregory Wassall, "Artists' Careers and Their Labor Markets," in *Handbook of the Economics of Art and Culture*, ed. Victor Ginsburgh and David Throsby (Amsterdam: Elsevier, 2006), p. 831.

61. McAndrew, *The International Art Market*, p. 18.

62. Market share calculations in Artprice, *Art Market Trends 2008* (St-Romain-au-Mont-d'Or: Artprice.com, 2009), pp. 10–11. For perspective, it has recently been estimated that there are 750 auction houses, alongside 9,600 dealers, in Britain alone. See Iain Robertson, "The International Art Market,'" in *Understanding International Art Markets and Management*, ed. Iain Robertson (London: Routledge, 2005), p. 31.

63. McAndrew, *The International Art Market*, pp. 74–75.

64. Martha Rosler, "Money, Power, Contemporary Art," *Art Bulletin*, vol. 79, no. 1 (March 1997): 21. All quotations in this paragraph are from this page.

65. A modified version of this model is proposed in Robertson, "The International Art Market," p. 17.

66. René Gimpel, "Art as Commodity, Art as Economic Power," *Third Text*, no. 51 (Summer 2000): 51.

67. Rosler, "Money, Power, Contemporary Art," p. 21.

68. For an introduction to "monopoly rent," see David Harvey, *The Limits to Capital, New Edition* [1982] (London: Verso, 1999), p. 350; and David Harvey, "The Art of Rent: Globalization, Monopoly and the Commodification of Culture," *Socialist Register* (2002), available at http://socialistregister.com/recent/2002/harvey2002. Harvey's discussion is actually based on Karl Marx's earlier writing on the subject in *Capital*, vol. 3 (New York: International Publishers, 1967), pp. 774–75.

69. This may sound like a trivial observation but it has important implications. All things being equal, prices typically increase relative to size (up to a certain point); unique works are more valuable than editions (and the smaller the edition, the better); signed works command a premium; and sexiness sells (pretty pictures, from female nudes to fashion photographs and colorful landscapes, are often preferred to more "difficult" work).

70. See William Grampp, *Pricing the Priceless: Art, Artists, and Economics* (New York: Basic Books, 1989).

71. For Velthuis's discussion of Grampp, see Velthuis, *Talking Prices*, p. 26.

72. Bourdieu, *The Field of Cultural Production*, p. 75. David Throsby highlights James Coleman's contributions on social and cultural capital as well in *Economics and Culture* (Cambridge: Cambridge University Press, 2001), p. 49. See also James Coleman, "Social Capital in the Creation of Human Capital," *American Journal of Sociology*, vol. 94 (Supplement) (1988): S95–S120.

73. This term is borrowed from Velthuis, who uses it to explain how symbolic, or cultural, capital can be transferred in the long run into economic capital. See Velthuis, *Talking Prices*, p. 26.

74. For further reading on this, see Paul DiMaggio, "Classification in Art," *American Sociological Review*, vol. 52 (August 1987): 440–55; and Herbert Gans, *Popular Culture and High Culture: An Analysis and Evaluation of Taste* [1974] (New York: Basic Books, 1999).

75. For Velthuis, the "Hostile Worlds" perspective is best encapsulated in the writings of Marxist art historian Arnold Hauser. See Velthuis, *Talking Prices*, pp. 23–26; and Arnold Hauser, *The Social History of Art*, vols. 1 and 2, trans. Stanley Godman (London: Routledge & Kegan Paul, 1951).

76. This is nicely encapsulated in the following quote by a collector who is a hedge fund manager: "Look, you have people who'd rather spend $1.5 million for a work at auction than $1 million privately. That way their friends can see them bidding, they have fun, and they get offered more work." Quotation in Greg Allen, "Rule No.1: Don't Yell, 'My Kid Could Do That,' " *New York Times*, 5 November 2006.

77. Velthuis, *Talking Prices*, pp. 36–37.

78. Stapleton, "Art, Intellectual Property and the Knowledge Economy," pp. 89–90.

79. Ibid., p. 88.

80. Ibid., pp. 84–85.

81. Ibid., p. 28.

82. For an introduction to this, see Andrea Fraser, "What's Intangible, Transitory, Mediating, Participatory, and Rendered in the Public Sphere?" *October*, no. 80 (Spring 1997): 111–16; and Bourriaud, *Relational Aesthetics*.

83. B. Joseph Pine and James Gilmore, *The Experience Economy: Work Is Theatre and Every Business a Stage* (Boston: Harvard Business School Press, 1999).

CHAPTER 1: VIDEO ART

1. See Jonathan Romney, "Unnatural Wonders," *Modern Painters*, vol. 15, no. 5 (Winter 2002): 29. Although neither Michael Kimmelman nor Nancy Spector uses the word "*gesamtkunstwerk*," Kimmelman underscores the *Cremaster Cycle*'s Wagnerian rhetoric while Spector discusses the piece as "a total work of art," the word's English translation. See Michael Kimmelman, "The Importance of Matthew Barney," *New York Times Magazine*, 10 October 1999, p. 66; Nancy Spector, "Acknowledgements," in *Matthew Barney: The Cremaster Cycle*, exh. cat. (New York: Guggenheim Museum, 2002), p. xiv (henceforth "Guggenheim, 2002").

2. Kimmelman, "Importance of Matthew Barney," p. 69.

3. Guggenheim, 2002.

4. Source: Artnet.

5. See http://www.smecc.org/sony_cv_series_video.htm.

6. See David Antin, "Television: Video's Frightful Parent," *Artforum*, vol. 14, no. 4 (December 1975): 43; and David Ross, "A Provisional Overview of Artist's Television in the U.S.," *Studio International*, vol. 191, no. 981 (May/June 1976): 266.

7. For an excellent description of this, see Robert Hutchins, *The Learning Society* (New York: Praeger, 1968), p. 127.

8. George Brecht had also schematized an unrealized installation with television sets, inspired by John Cage's work with radio receivers, as early as 1959. See Dieter Daniels, "Television—Art or Anti-Art? Conflict and Cooperation between the Avant-Garde and the Mass Media in the 1960s and 1970s," n. 28, available at http://www.medienkunstnetz.de/themes/overview_of_media_art/massmedia/print/.

9. In Martha Rosler, *Decoys and Disruptions: Selected Writings, 1975–2001* (Cambridge: MIT Press, 2004), p. 67. This essay was originally delivered as a lecture in 1984. Rosler's discussion of video's "museumization" is also taken up in this chapter, and her use of the term forms an important reference point for the present analysis of the practice's "marketization." For an alternative account that looks at artists' responses to television in the 1960s and 1970s, see David Joselit, *Feedback: Television against Democracy* (Cambridge: MIT Press, 2007).

10. Discussion of these latter tendencies is provided in Deirdre Boyle, "A Brief History of American Documentary Video," in *Illuminating Video: An Essential Guide to Video Art*, ed. Doug Hall and Sally Jo Fifer (New York: Aperture, 1990), pp. 51–69.

11. Marita Sturken, "Paradox in the Evolution of an Art Form: Great Expectations and the Making of a History," in *Illuminating Video*, ed. Hall and Fifer, pp. 108–9 and n. 16.

12. See, for example, John Hanhardt's discussion of Paik's "early TV sculptures" in John Hanhardt, "Dé-collage/Collage: Notes toward a Reexamination of the Origins of Video Art," in *Illuminating Video*, ed. Hall and Fifer, pp. 71–79.

13. Ibid., p. 108.

14. For a chronology of artists' film and video broadcast schemes in England, see John Walker, *Arts TV: A History of Arts Television in Britain* (London: John Libbey, 1993), pp. 123–35; and Michael Maziere, "Institutional Support for Artists' Film and Video in the England: 1966–2003," available at http://www.study collection.co.uk/maziere/paper.html.

15. Figure referenced in, "Institutional Support."

16. On NEA's video funding, see Barbara London, "Video: A Selected Chronology, 1963–1983," *Art Journal*, vol. 45, no. 3 (Autumn 1985): 252.

17. For further discussion, see Kathy Rae Huffman, "Video Art: What's TV Got to Do with It?" in *Illuminating Video*, ed. Hall and Fifer, pp. 81–88.

18. The Paik sale is noted in Marita Sturken, "TV as a Creative Medium: Howard Wise and Video Art," *Afterimage*, vol. 11, no. 10 (May 1984): 6. My reference to the Wilder sales is cited in Ross, "Provisional Overview," p. 266. The latter transaction is especially interesting and indicative of the poor documentation of these early sales records. In his article, Ross claims that Wilder sold *Video Pieces (a–n)* (1968). Curiously, however, no such work exists in Nauman's official *catalogue raisonné*, and in actuality *Video Pieces (a–n)* was probably a compilation of several early video recordings by Nauman onto a single tape. Thanks to Jennifer Burbank of Sperone Westwater Gallery, which represents Nauman, for bringing this to my attention.

19. Sturken, "TV As a Creative Medium," p. 6, observes that *Participation TV* "was the only piece Paik sold for some time thereafter."

20. For Wise's discussion of this decision, see ibid., p. 8.

21. http://www.eai.org/eai/.

22. *Castelli-Sonnabend Videotapes and Films* (New York: Castelli-Sonnabend Tapes and Films, 1974), vol. 1, no. 1.

23. The majority of its works were absorbed into Chicago's not-for-profit Video Data Bank, established in 1976. In 2009 Video Data Bank charged a standard rental fee of $50 for VHS tapes and $75 for DVDs. See http://www.vdb.org/.

24. See *Ready to Shoot: Fernsehgalerie Gerry Schum/videogalerie schum*, exh. cat. (Düsseldorf: Kunsthalle Düsseldorf, 2003), p. 109.

25. Figures in Rudolf Frieling, "Form Follows Format: Tensions, Museums, Media Technology and Media Art," available at http://www.medienkunstnetz.de/themes/overview_of_media_art/museum/7/. A sample of Schum's 1971 price list is provided in Daniels, "Television—Art or Anti-Art?," p. 49.

26. In a letter dated 29 November 1972, Schum argues that the decision to close the gallery was a factor of the industry's inability to bring affordable videocassette players onto the market, therefore greatly limiting his potential customer base. At the same time, he had commenced negotiations with the Museum Folkwang, Essen, for the production and dissemination of video content, thus representing a reversion to public programming. See Schum, *Ready to Shoot*, p. 42.

27. Wulf Herzogenrath, "Video Art and Institutions: The First Fifteen Years," in *40yearsvideoart.de—Part 1: Digital Heritage: Video Art in Germany from 1963 until the Present*, ed. Rudolf Frieling and Wulf Herzogenrath (Ostfildern: Hatje Cantz Verlag, 2006), p. 27.

28. On Art/Tapes/22, see David Hall, "Artists Video at the Galleries," *Studio International*, vol. 193, no. 985 (January 1977): 22; and www.mariagloriabicocchi .it/. On Oppenheim and the eventual acquisition of her collection by the Kunstmuseum Bonn in 1990, see http://kunstmuseum.bonn.de/sammlungen/videos/videos_e.htm.

29. Some of these issues are addressed retrospectively in Christine Van Assche, "Aesthetic and Museological Approach to the New Media," in Réunion des musees nationaux, *3eme biennale de Lyon d'art contemporaine: installation, cinema, video, informatique*, exh. cat. (Paris, 1995), pp. 450–53.

30. Rosler, *Decoys and Disruptions*, p. 55. A related argument is advanced in Catherine Elwes, *Video Art: A Guided Tour* (London: I. B. Tauris, 2005), p. 143.

31. Ross, "Provisional Overview," p. 268.

32. London, "Video," p. 256. Everson curator Deborah Ryan confirmed via email on 20 August 2007 that the museum began collecting video art during Ross's tenure but could not specify what works had been acquired nor precisely when. She estimates that of the nearly 500 videotapes in the museum's collection, only approximately half are actual video artworks (the remainder comprising interviews, television broadcasts, and related documentation). For an excellent discussion of LBMA's early involvement with video art, see "Recollections: A Brief History of the Video Programs at the Long Beach Museum of Art," in *California Video*, exh. cat. (Los Angeles: J. Paul Getty Museum, 2008), pp. 252–68.

33. See London, "Video," pp. 249–62.

34. All references in this paragraph from Antin, "Television," p. 43. For an informative firsthand account of these editing difficulties, see Raymond Bellour, "Interview with Bill Viola," *October*, no. 34 (Autumn 1985): 102.

35. Subsequent improvements in digital imaging technology have alleviated some of these concerns through the introduction of alternative archival formats, which, when properly stored, enhance the work's longevity. But even newer exhibition formats such as laser discs (LDs) and digital videodiscs (DVDs) remain susceptible to degradation (scratching of the surface, especially) and possess a wide

quality spectrum (due to compression and encoding), while the lifespan of storage devices such as computer hard drives remains unclear. Digital Betacams (released in 1993) are currently the preferred choice for preservation masters. These are typically kept in storage and may be used to generate exhibition copies. For an excellent overview of these issues, see http://resourceguide.eai.org/collection/singlechannel/equiptech.hrml. On VHS shelf life, see also Rudolf Frieling, "The Conservator's Struggle with the Vanishing Medium of Video," in *How Durable Is Video Art?* (Wolfsburg: Kunstmuseum Wolfsburg, 1997), p. 23.

36. It has been estimated that over sixty-five analog and digital playback formats have been introduced since the inception of consumer video technology. See http://www.imappreserve.org/pres_101/index.html.

37. Some of these issues are raised in Frieling, "The Conservator's Struggle," p. 21.

38. This was not uniformly applauded, however. For some, MTV's advent signaled video's cooptation by commerce—the much-maligned pulling of work by once alternative videographers and filmmakers into the mainstream, as exemplified by Benjamin Buchloh's "From Gadget Video to Agit Video: Some Notes on Four Recent Video Works," *Art Journal*, vol. 45, no. 3 (Autumn 1985): 217–27.

39. For example, the Fridge in Brixton, London, and New York's Area and Danceteria. Dara Birnbaum gives a good account of this in "Do It 2," *Artforum*, vol. 47, no. 7 (March 2009): 191–92. For further reading, see also http://www.3ammagazine.com/musicarchives/2003/jan/interview_andy_czezowski.html.

40. See Cecilia Andersson, ed., *X Factor* (Liverpool: FACT, 2003).

41. Some notable media centers established in the United States at this time include Image Film/Video Center (Atlanta, 1977); Chicago Editing Center (1978), the MIT Media Lab (Cambridge, 1980), and the Media Project (Portland, OR, 1982), in addition to the founding of organizations like the Bay Area Video Coalition (San Francisco, 1976).

42. For an excellent discussion of this that draws on C. P. Snow's "two cultures" argument in the context of then emergent computer-based arts, see Louise Sørensen, "Discrete Analogies: The Use of Digital Imaging Technology in Contemporary Art Photography," Ph.D. diss., Courtauld Institute of Art, London, 2006, pp. 244–59.

43. Paul Messier, "Dara Birnbaum's 'Tiananmen Square: Break-In Transmission:' A Case-Study in the Examination, Documentation and Preservation of a Video-Based Installation,"*Journal of the American Institute for Conservation*, vol. 40, no. 3 (Autumn–Winter 2001): 194.

44. These commercial difficulties are discussed in: Buchloh, "From Gadget Video to Agit Video," pp. 217–18.

45. See also Frieling, "Form Follows Format."

46. These purchases comprised three of Nauman's camera and monitor installations of 1969–70 and twelve of Davis's single-channel videos dated 1973–81. Figures from Giuseppe Panza and Christopher Knight, *Art of the Fifties, Sixties and Seventies: The Panza Collection* (Milan: Jaca Books, 1999), pp. 299–313.

47. Quoted in D. C. Dennison, "Video Art's Guru," *New York Times*, 25 April 1982.

48. Video installations, for example, featured in successive Whitney Biennials in 1981 and 1983, with works by Frank Gillette and Buky Schwartz in the former, followed by those of Shigeko Kubota and Mary Lucier in the latter.

49. Francesc Torres, "The Art of Possible," in *Illuminating Video*, ed. Hall and Fifer, pp. 207–8. For an overview of this, see Claire Bishop, *Installation Art: A Critical History* (New York: Routledge, 2005). On the emergence of installations in exhibition display, see Bruce Altshuler, *The Avant-Garde in Exhibition: New Art in the 20th Century* (New York: Harry N. Abrams, 1994); and Mary Anne Staniszewski, *The Power of Display: A History of Exhibition Installations at the Museum of Modern Art* (Cambridge: MIT Press, 1998).

50. See Margaret Morse, "Video Installation Art: The Body, the Image, and the Space-in-Between," in *Illuminating Video*, ed. Hall and Fifer, pp. 154–56.

51. Sturken, "Paradox in the Evolution of an Art Form," in *Illuminating Video*, ed. Hall and Fifer, p. 112.

52. Rosler, *Decoys and Disruptions*, p. 82.

53. Huffman, "Video Art," in *Illuminating Video*, ed. Hall and Fifer, p. 86.

54. Acconci's remarks originally appeared in *The Luminous Image*, exh. cat. (Amsterdam: Stedelijk Museum, 1984); they are quoted here in Vito Acconci, "Television, Furniture, and Sculpture: The Room with the American View," in *Illuminating Video*, ed. Hall and Fifer, p. 132.

55. Daniels, "Television—Art or Anti-Art?," p. 42.

56. For a discussion of this at the time, see Roberta Smith "The Art Market," *New York Times*, 4 September 1992; and James Servin, "SoHo Stares at Hard Times," *New York Times*, 20 January 1991.

57. Quoted "Multi-Multi-Media: An Interview with Barbara London," *CRUMB (Curatorial Resource for Upstart Media Bliss)*, 22 March 2001, available at www.newmedia.sunderland.ac.uk/crumb; see also Steven Henry Madoff, "After the Roaring 80s in Art, a Decade of Quieter Voices," *New York Times*, 7 November 1997.

58. This occurred in 1991 for Birnbaum, with exhibitions at New York's Josh Baer Gallery, San Francisco's Rena Bransten Gallery, and Chicago's Rhona Hoffman Gallery; in 1992 for Viola, with shows at London's Anthony d'Offay Gallery and Chicago's Donald Young Gallery; and in 1993 for Hill, also at Donald Young.

59. Evocatively, McCarthy's first solo exhibition in New York also occurred in 1993, at Luhring Augustine, in which he presented his own videos and films.

60. Zwirner quoted in "Buying Time/Collecting Video: Roundtable Discussion," Paula Cooper Gallery, New York, 26 January 1999, available at http://www.imappreserve.org/pdfs/Educate_Train_pdfs/ArtTable.pdf.

61. MoMA is the most prominent exception: it began collecting photography in 1930 and established a photography department in 1941. This and related issues are raised in Gerry Badger, *Collecting Photography* (London: Mitchell Beazley, 2003), pp. 7–19.

62. Badger argues that William Eggleston's 1976 exhibition at MoMA "effectively sanction[ed] colour photography as a serious medium for art photographers." Ibid., p. 130.

63. Sotheby's first stand-alone photography auction, which also included cameras and memorabilia, occurred in 1971; Christie's commenced similar sales under the heading "Photography and Photographica" in 1972. By 1976 both auction houses began regularly holding photography-only sales. Investment return figures in Jeffrey Pompe, "An Investment Flash: The Rate of Return for Photographs," *Southern Economic Journal*, vol. 63, no. 2 (October 1996): 488–95. For a good account of how these factors precipitated the rise of Tate's photography acquisitions of the mid-1990s, see Alexandra Moschovi, "Photo-phobia and Photophilia: The Neglect and Accommodation of Photography in British Art Institutions in the Postmodern Era," Ph.D. diss., Courtauld Institute of Art, 2004, p. 139.

64. All figures in this paragraph from Artnet as of December 2009.

65. Chrissie Iles, "The Mutability of Vision," in *Scream and Scream Again: Film in Art*, exh. cat. (Oxford: Museum of Modern Art, 1996), n.p. See also Elwes, *Video Art*, pp. 168–72; Elwes, "The Big Screen," *Art Monthly*, no. 199 (September 1996): 11–16; *Being and Time: The Emergence of Video Projection*, exh. cat. (Buffalo: Albright-Knox Art Gallery, 1996); and Jeffrey Shaw and Peter Weibel, eds., *Future Cinema: The Cinematic Imaginary after Film*, exh. cat. (Karlsruhe: ZKM Center for Art and Media, 2003).

66. Author's interview with Isaac Julien, 9 March 2006.

67. The first DVD players and discs went on sale in December 1996 in Japan and March 1997 in the United States. By 2002 major manufacturers of LD players had terminated their production runs of the equipment.

68. This transition is part and parcel of the availability of digital recording and editing technologies in the consumer marketplace. Sony's 1997 release of the digital camcorder in the United States is seen to have "forever altered" this landscape, diminishing the relevance of the singular qualities video possesses as a formal medium, and encouraging a whatever-fits-best approach to shooting that diminishes boundaries between video, digital video, and film. See Michael Rush, *Video Art* (London: Thames & Hudson, 2007), pp. 167–69.

69. Viola emphasizes this point in Edward Lewine, "Art That Has to Sleep in the Garage," *New York Times*, 26 June 2005.

70. "How Durable Is Video Art?, Contributions to Preservation and Restoration of the Audiovisual Works of Art," was held at the Kunstmuseum Wolfsburg, November 1995; "Playback 1996" was organized by the Bay Area Video Coalition, San Francisco, March 1996. Transcripts from "Playback 1996" are available at http://palimpsest.stanford.edu/byorg/bavc/pb96/. "TechArchaelogy: A Symposium on Installation Art Preservation," held at the San Francisco Museum of Modern Art, January 2000, is also key to this chronology; papers from this meeting were published in the *Journal of the American Institute for Conservation*, vol. 40, no. 3 (Autumn–Winter 2001). For an alternative perspective, see Alain Depocas, Jon Ippolito, and Caitlin Jones, eds., *The Variable Media Approach: Permanence through Change* (New York and Montréal: Guggenheim Museum Publications and The Daniel Langlois Foundation for Art, Science and Technology, 2003).

71. David Ross, "Video: The Success of its Failure," in Réunion des musees nationaux, *3eme biennale de Lyon d'art contemporaine: installation, cinema, video, informatique*, exh. cat. (Paris, 1995), p. 441.

72. Video art, for example, was featured in sequential Documentas in 1987 and 1992, and exhibitions like Pioneers of Electronic Art (Linz, Austria, 1992), installation, cinéma, video, informatique (the title of the Third Lyon Biennial, 1995–96), and Video Spaces: Eight Installations (MoMA, 1995). In 1995 Viola represented the United States at the Venice Biennale.

73. Figures presented in this section have been provided by Tate and the Whitney; for a complete record of their film and video collections, see appendix B.

74. Chrissie Iles and Henriette Huldisch, "Keeping Time: On Collecting Film and Video Art in the Museum," in *Collecting the New: Museums and Contemporary Art*, ed. Bruce Altschuler (Princeton: Princeton University Press, 2005), p. 69.

75. Information in this paragraph from author's interview with Pip Laurenson, 6 March 2006.

76. Ibid.

77. Author's interview with Stuart Comer, 26 September 2007. Comer highlights the following four areas as lacking in Tate's Time-Based Media Collection: film installation from the 1960s and 1970s; single-channel video; work from Eastern Europe and other areas where there has been a limited commercial market; and artists' film through the mid-1990s.

78. For perspective on the Whitney's early involvement with video art, see Marita Sturken, "The Whitney Museum and the Shaping of Video Art: An Interview with John Hanhardt," *Afterimage*, no. 10 (May 1983): 4–8.

79. Author's interview with Henriette Huldisch, 22 September 2006.

80. Author's email correspondence with Chrissie Iles, 20 November 2007.

81. Iles and Huldisch, "Keeping Time," p. 69.

82. Ibid., p. 70.

83. Ibid.

84. This and other quotations in the paragraph from Jameson, *Postmodernism*, pp. 76–78.

85. For a critique of Jameson's video art analysis, see Nicholas Zurbrugg, *Critical Vices: The Myths of Postmodern Theory* (Amsterdam: G+B Arts, 2000), pp. 85–103.

86. Thompson's rationale is indicative of the tepid interest in the economics of video art to date: "Such works [by which he also means performance, film, and photography] are excluded because I don't understand them, and because with the exception of the photography of Cindy Sherman and a couple others major auction houses do not sell them under the heading of contemporary art." Thompson, *The $12 Million Stuffed Shark*, p. 10.

87. A good example of this is David Zwirner's 2008 program, which opened and closed the year at his flagship New York gallery (in Chelsea) with exhibitions by Diana Thater and Stan Douglas that were heavily populated with video art (Thater's in its entirety, Douglas's comprising one main video projection and five photographs). Of the sixteen other exhibitions and projects presented throughout the year, only Michael Riedel's solo show from September to October had a substantial emphasis on video art; six were devoted exclusively to painting, with other solo and group exhibitions focusing on painting, photography, installation, sculpture, watercolor, and drawing (or some combination thereof). Zwirner + Wirth, the uptown gallery David Zwirner operated in collaboration with influential Zurich

and London dealer Iwan Wirth from 2000 to 2009, included five secondary-market exhibitions highlighting painting, sculpture, and works on paper. The gallery also presented two separate secondary-market exhibitions from the collection of Helga and Walther Lauffs—one downtown highlighting major works of Conceptual and Minimal art and a smaller one uptown of works on paper. More "challenging" primary-market exhibitions of video art are thus strategically counterbalanced with both primary- and secondary-market shows in more conventional—and fundamentally easier to sell—media. For further reference, see http://www.davidzwirner.com/.

88. To put this in perspective, as the contemporary art market neared its peak in 2007, the three largest auction houses—Christie's, Sotheby's, and Phillips—sold just $4.6 million of video art at their primary venues in New York, London, and Hong Kong, versus worldwide contemporary art sales at auction of $1.2 billion during the year. Even accounting for additional sales at other international venues of these houses as well as those at smaller regional auctioneers, this represents an admittedly marginal percentage of contemporary art turnover. These figures are based on the combined value of advanced searches on Artnet for sales including at least one of the following keywords: "video," "DVD," "VHS," "laserdisc," "television," "projector," and "projection." This is not a perfect science, but since neither Artnet nor any other online auction sales database singles out video art as a distinct category, it offers at least a rough approximation of this sales universe.

89. Hirst figure cited in Artprice, *Art Market Trends 2008*, p. 4.

90. Quoted in Josh Sims, "Alternative Investments: Moving Pictures," March 2006, available at: http://cnbceb.com/2006/03/01/w_alternative/.

91. Ross, "Video."

92. Figures from http://www.capital.de/guide/kunstmarkt-kompass.

93. Overviews of these industries are provided in Arthur de Vany, "The Movies," and Marie Connolly and Alan Kreuger, "Rockonomics: The Economics of Popular Music," in *Handbook of the Economics of Art and Culture*, ed. Ginsburgh and Throsby, pp. 615–65, 667–719.

94. See, for example, Stallabrass, *Art Incorporated*, p. 25.

95. For an alternative application of this argument in the market for 1960s-era "land art," see Victor Ginsburgh and Anne-Françoise Penders, "Land Artists and Art Markets," *Journal of Cultural Economics*, vol. 21, no. 3 (1997): 219–28.

96. A more recent example involves Jankowski's *16mm Mystery* (2004), sold in an edition of five as either a film or DVD projection (priced between €50,000 and €80,000) and as a resin cast film reel (ed. 10, €10,000). Figures from the Lisson Gallery, London, and Klosterfelde, Berlin.

97. James Lingwood and Hans Ulrich Obrist, "Matthew Barney: Artist Project," *Tate: International Arts and Culture*, no. 2 (November–December 2002): 60.

98. Barney does not, however, sell the storyboards (or "notational sketches") that he produced in the early stages of each successive film. Author's interview with Matthew Barney, 17 August 2006.

99. To be exact, the *Cremaster Cycle* consists of 163 artworks, or 953 individual items when editioned, of which 721 are photographs. These calculations do not account for "Artist Proofs" (of which there are usually one or two per edition) that Barney also has the option of selling. It is therefore possible that they

underestimate the actual number of works in circulation. Figures referenced in Guggenheim, 2002, pp. 510–53. All subsequent data on the *Cremaster Cycle*'s editioning are from these pages unless noted otherwise.

100. This reinforces confusion as to whether Barney is a filmmaker or an artist working in video.

101. The Gladstone Gallery did not respond to questions about how Barney's work is editioned and sold, maintaining that such information is confidential.

102. Author's interview with James Lingwood, 16 February 2006.

103. Ibid.

104. Figures in Shari Roman, "The Genius of the System," *Filmmaker: The Magazine of Independent Film*, vol. 10, no. 3 (Spring 2002): 48.

105. Author's interview with Matthew Barney, 17 August 2006.

106. See, for example, Wolfgang Schmid, "Dürer's Enterprise: Market Area, Market Potential, Product Range," in *Economic History and the Arts*, ed. Michael North (Cologne: Böhlau Verlag, 1996), pp. 27–37.

107. Artnet.

108. Figure cited in Mark Spiegler, "The Road to Basel: How One Isaac Julien Video Became 10 Triptychs," *Independent on Sunday Review*, 21 June 2002.

109. My thanks to James Lindon of the Victoria Miro Gallery for providing these figures.

110. Until this juncture, Julien's smaller photogravures and video stills had been offered more modestly between £1,000–£5,000, and he had never previously produced a photographic triptych. See: Spiegler, 2002.

111. Julien has elsewhere estimated the *True North* production budget at $600,000. Assuming that filming occurred in 2003, this corresponds to £336,000 (at a year-end exchange rate of £0.56/$1.00). Julien is quoted in Ludlow Bailey and Joy-Ann Reid, "An Absence of Color: Blacks and Art Basel," 19 January 2006, available at http://www.miamiartexchange.com/miami_art_articles/miami_art_articles_2006/an_absence_of_color_blacks_and_art_basel.html. Exchange-rate figures from http://www.xe.com.

112. Distribution figures courtesy of Victoria Miro Gallery.

113. All quotations in this paragraph from author's interview with Isaac Julien, 9 March 2006.

114. Ibid.

115. Since October 2000, the Lisson Gallery and Book Works have produced collector's boxes for the following: Jennifer Allora and Guillermo Calzadilla, Francis Alÿs, Pierre Bismuth, Christine Borland, Roderick Buchanan, Mat Collishaw, Atom Egoyan and Julião Sarmento, Ceal Foyer, Douglas Gordon, Dan Graham, Rodney Graham, Igor and Svetlana Kopystiansky, Paul McCarthy, Jonathan Monk, Tony Oursler, Simon Patterson, and Jane and Louise Wilson. Figures provided by Lisson Gallery and Book Works.

116. "Bill Viola: *Five Angels for the Millennium*," Tate Modern press release, 19 May 2003, available at http://www.tate.org.uk/about/pressoffice/pressreleases/billviola_19-05-03.htm.

117. "SFMoMA and Walker Art Center Acquire Matthew Barney's *Cremaster 2*," SFMoMA press release, 5 May 2000, available at http://www.sfmoma.org/press/pressroom.asp?arch=y&id=73.

118. Carol Vogel, "'Sleepwalkers' Video Is Tailored for Miami," *New York Times*, 26 October 2007.

119. It is also noteworthy that Aitken, like Julien, is represented by Victoria Miro. This demonstrates the strategic role that versioning serves for the gallery's artists and suggests that, far from being isolated cases, these undertakings possess significant resonance for the marketing of video art content at large. *Electric Earth* example referenced in Lewine, "Art That Has to Sleep in the Garage."

120. Dwight Eschliman, "The Exhibitionists," *New York Times Style Magazine* (Fall 2007): 160–67.

121. *Seeing Time: Selections from the Pamela and Richard Kramlich Collection of Media Art*, exh. cat. (San Francisco: San Francisco Museum of Modern Art, 1999), p. 10. Video Acts: Single Channel Works from the Collections of Pamela and Richard Kramlich and the New Art Trust, was later exhibited at PS1 Contemporary Art Center, New York, and the Institute of Contemporary Art, London, November 2002–October 2003.

122. Ibid.

123. Lori Zippay, "Interview with Christopher Eamon," September 2005, available at http://resourceguide.eai.org/exhibition/installation/interview_eamon .html.

124. Their close support of Tate also led to Muir's appointment as Kramlich curator in 2001.

125. For a discussion of this, see Christine van Assche, "Conversation with Jean-Conrad and Isabelle Lemaître," in *Une vision due monde, la collection video de Jean-Conrad et Isabelle Lemaître*, exh. cat. (Paris: La maison rouge, 2006), pp. 125–26.

126. Author's interview with Jean-Conrad Lemaître, 23 March 2006.

127. The Wilsons' *Monument Apollo Pavillion, Peter Lee* (2003, ed. 3) is exhibited as a four-screen DVD installation on wall-mounted flat-screen televisions; Opie's computer-generated images such as *Sarah undressing* (2004, ed. 41) are typically presented on large-scale LCD monitors; and Bell-Smith's *Sparkler Set* (2006, ed. 3), a sequence of five 26–28-second loops, consists of five video files and five custom video players.

128. For a critique of these aspects of Viola's reception, see Bishop, *Installation Art*, pp. 96–97.

129. Bob Colacello, "The Subject as Star," *Vanity Fair* (December 2006): 206–12.

130. http://www.sketch.uk.com. All references to, and quotations about, Sketch are from this website unless otherwise noted.

131. Author's interview with Marisa Futernick, 18 March 2004.

132. http://www.ocma.net/orangelounge/about/.

133. "Orange County Museum of Art's Orange Lounge, South Coast Plaza," *Los Angeles Times Online*, available at http://www.calendarlive.com/visitor/ 78641,0,7840410.venue.

134. See http://www.loop-barcelona.com/ and http://www.divafair.com. All references in the analysis of video art fairs are from these websites unless otherwise noted.

135. For instance, see http://www.divafair.com/paris_07/VIP.html.

136. This set, *Point of View: An Anthology of the Moving Image* (2004), was produced in an edition of 1,500, originally listed at $1,000. The price has since been discounted to $399, illustrating the continued difficulty of marketing video editions with high print runs: http://www.newmuseumstore.org/viewItem .asp?ItemID=10014383&UnitCde=1.

137. Author's interview with Isaac Julien, 9 March 2006.

138. ARC is the museum department within this institution responsible for organizing contemporary art exhibitions; purchases are ultimately made by MAMVP.

139. The museum also acquired five video stills for promotional purposes. This is important because it underscores that *Intervista* would only exist as an *artwork* in video form. In contradistinction to other examples presented in this chapter, Sala therefore did not deem these stills to be unique artworks, and he did not market them as such.

140. Author's interview with Anri Sala, 21 March 2006.

141. François Michaud, "Video and Publishing Economics: From the Videogalerie Schum to the Cremaster Cycle," in *New Media Collection. Installations. La collection du Centre Pompidou/Musée national d'art moderne*, exh. cat. (Paris: Editions du Centre Pompidou, 2006), pp. 67–68.

142. Author's interview with Hans Ulrich Obrist, 14 December 2005.

143. The "lack of a single standard" for video art acquisition and preservation is also raised in Iles and Huldisch, "Keeping Time," p. 75.

144. See, for example, Lewine, "Art That Has to Sleep in the Garage."

145. A search for "video art" on YouTube in December 2009 generated more than 25,000 clips; UbuWeb, a free curated site of artists' video, presents thousands of works by nearly four hundred artists and artist groups. See http://www .ubu.com/ and http://www.youtube.com.

146. Hughes quoted in Greg Allen, "When Fans of Pricey Video Art Can Get It Free," *New York Times*, 17 August 2003. Hughes's online archive of video art is available at http://www.freehomepages.com/crhughes. For an alternative example of video art's availability on P2P networks, see http://www.irational.org/ video/2.html.

147. Dave Beech, "Video after Diderot," *Art Monthly*, no. 225 (1999): 7–10.

148. Stallabrass, *Art Incorporated*, pp. 25–26.

149. Sims, "Alternative Investments: Moving Pictures."

150. Marc Spiegler, "Money for Old Soap," *Independent on Sunday Review*, 21 July 2002.

151. For a good recent perspective on this, see Jerry Saltz, "Has Money Ruined Art?" *New York Magazine*, 15 October 2007, pp. 36–42.

152. Frieling, "Form Follows Format."

153. Quoted in Lewine, "Art That Has to Sleep in the Garage."

154. Cynthia Chris, "Video Art: Stayin' Alive," *Afterimage*, vol. 27, no. 5 (March/April 2000): 10.

155. Julian Stallabrass, *Internet Art: The Online Clash of Culture and Commerce* (London: Tate Publishing, 2003). See also http://www.nettime.org/; Josephine Bosma, ed., *Readme! Filtered by Nettime: ASCII Culture and the Revenge of Knowledge* (Brooklyn: Autonomedia, 1999); and Geert Lovink, *Dark Fiber: Tracking Critical Internet Culture* (Cambridge: MIT Press, 2002).

156. Martha Rosler, "Out of the Vox," *Artforum*, vol. 43, no. 1 (September 2004): 218.

157. Author's interview with Martha Rosler, 1 June 2005. On the repatriation of video sales proceeds, see "Buying Time/Collecting Video," p. 85.

158. Artist and writer Gregory Sholette's theorization of "dark matter" constitutes one of the most important recent extensions of this discussion. See Gregory Sholette, "Heart of Darkness: a Journey into the Dark Matter of the Art World," 2002; and "Dark Matter: Activist Art and the Counter-Public Sphere," 2003. Both essays are available at: http://gregorysholette.com/.

159. Chris Anderson, *The Long Tail* (London: Random House, 2006), p. 175. For a good analysis of the causality between the growth of online file sharing and the reduction of CD sales, see Felix Oberholzer-Gee and Koleman Strumpf, "The Effect of File Sharing on Record Sales: An Empirical Analysis," *Journal of Political Economy*, vol. 115, no. 1 (2007): 1–42.

160. Between 1999 and 2003, the average price of DVDs dropped by 20 percent versus CD prices, which actually increased by 10 percent. Figures from p. 35 of an earlier version of Oberholzer and Strumpf, "Effect of File Sharing," available at http://www.unc.edu/~cigar/papers/FileSharing_June2005_final.pdf.

161. Radiohead's release of its album *In Rainbows* in 2007 is arguably the most famous example to date of this practice.

162. Yochai Benkler, *The Wealth of Networks: How Social Production Transforms Markets and Freedom* (New Haven: Yale University Press, 2006), pp. 427–28.

163. Author's interview with Philippe Parreno, 2 February 2006.

164. See Michael Fried, "Absorbed in the Action," and Tim Griffin, "The Job Changes You," *Artforum*, vol. 45, no. 1 (September 2006): 332–39, 398.

165. Another good example of this is Barney's *Drawing Restraint 9*, which premiered at the 2005 Venice Film Festival and has since been presented in cinemas and, alongside related objects and installations, in art exhibitions.

166. http://www.artnet.com/magazineus/reviews/robinson/robinson7-18-06.asp.

167. A similar argument is advanced in relation to digitized reproductions of theater performances, in Andrew Taylor, "Pandora's Bottle: Cultural Content in a Digital World," in *The Arts in a New Millennium: Research and the Arts Sector*, ed. Valerie B. Morris and David B. Pankratz (Westport, CT: Praeger, 2003), p. 116.

168. Author's interview with Matthew Barney, 17 August 2006.

169. Barney states that he and Palm Pictures, the company that distributed the *Cremaster Cycle* in the United States and Britain, actually sought to release all five videos in their entirety on DVD. However, upon facing "violent opposition" from owners of the limited editioned works who were consulted on this, the idea was abandoned: "A large discussion took place around this possibility and the definition of what the thing was that [the collectors] owned. It was quite interesting. In the end we felt that the argument was strong enough that we couldn't do it. Legally I could probably have figured out a way to do it, but morally it felt wrong to me." The interactive DVD was a practical resolution to this problem. Quotation from ibid. This point is also raised in Daniels, "Television—Art or Anti-Art?" p. 46, n. 20.

170. Rush, *Video Art*, p. 251.

CHAPTER 2: EXPERIENTIAL ART

1. Well-known comparisons include Alison Knowles's *Identical Lunch* (1969) and Gordon Matta-Clark's *Food* restaurant in New York (1971–74).

2. Bourriaud, *Relational Aesthetics*, p. 32; Jerry Saltz, "A Short History of Rirkrit Tiravanija," *Art in America*, vol. 84 (February 1996): 84. Gavin Brown quoted in *Supermarket*, exh. cat. (Zürich: Migros Museum für Gegenwartskunst, 1998), p. 72.

3. Bourriaud, citing Duchamp, also adheres to this conception of *art-as-game*. See Bourriaud, *Relational Aesthetics*, p. 19.

4. Alice Yang, "Letting Go: The Work of Rirkrit Tiravanija," *Art Asia Pacific*, vol. 3, no. 2 (1996): 62.

5. http://www.thelandfoundation.org/?About_the_land.

6. Ibid.

7. I am thinking in particular of Höller's *Double Club*, a temporary art installation-cum-bar, restaurant, and nightclub funded by the Fondazione Prada and based in London in 2008–09; the public marches organized by Deller such his *Social Parade* during the opening of Manifesta 5, 2004, and *Procession* during the Manchester International Festival, 2009; and Jacir's varied, neoconceptual projects that often involve her documenting interactions and experiences with others, such as *Where We Come From* (2001–03).

8. Bourriaud, *Relational Aesthetics*.

9. *Oxford English Dictionary*, 2nd ed., vol. 5 (Oxford: Clarendon Press, 1989), p. 564.

10. See Liam Gillick, "Ill Tempo: The Corruption of Time in Recent Art," *Flash Art*, no. 188 (May/June 1996): 69–70.

11. Alexander Alberro, "Deprivileging Art: Seth Siegelaub and the Politics of Conceptual Art," Ph.D. diss., Northwestern University, 1996.

12. See, for example, Alexander Alberro, "Reconsidering Conceptual Art, 1966–1977," in Alexander Alberro and Blake Stimson, eds., *Conceptual Art: A Critical Anthology* (Cambridge: MIT Press, 2000), p. xvii.

13. Lucy Lippard and John Chandler, "The Dematerialization of Art," *Art International*, vol. 12, no. 2 (February 1968): 31–36.

14. Lippard, *Six Years*, pp. 263–64.

15. Notable precedents can be found in Dada poetry and Surrealist automatism, which challenged these conventions and helped to expand the scope of collaboratively authored work. László Moholy-Nagy's *Telephone Paintings* (1922), in which specifications for enamel paintings were conveyed over the phone to a sign factory simply by using graph paper and the factory's color chart, offers an excellent alternative example of how earlier artists confronted the "genius" model in favor of a detached, systems-based mode of production—an approach that would be revitalized under Conceptualism.

16. First published in *January 5–31, 1969*, exh. cat. (New York: Seth Siegelaub, 1969), n.p.

17. The titles themselves described actions such as *An Amount of Bleach Poured on a Rug and Allowed to Bleach*, which Weiner "performed" the day before

the exhibition's opening. For further discussion, see Alberro, *Conceptual Art and the Politics of Publicity*, p. 98.

18. For a useful discussion on the rise of the curator in the wake of conceptualism, see Jan Verwoert, "This Is Not an Exhibition,' in *Art and Its Institutions: Current Conflicts, Critique and Collaborations*, ed. Nina Möntmann (London: Black Dog Publishing, 2006), pp. 132–40; for a critique of the rise of curating, see Alex Farquharson, "I Curate, You Curate, We Curate," *Art Monthly*, no. 269 (September 2003): 7–10.

19. Benjamin Buchloh, "Into the Blue: Klein and Poses," *Artforum*, vol. 33, no. 10 (Summer 1995): 93.

20. Alberro, *Conceptual Art and the Politics of Publicity*, p. 118.

21. All quotations in this paragraph are from Mark Godfrey, "A Sense of Huebler," in *Douglas Huebler*, exh. cat. (London: Camden Arts Centre, 2002), p. 7.

22. I am thinking here of the contracts accompanying Manzoni's *Living Sculptures* and his cans of "Artist's Shit" (*Merda d'artista*) (both 1961), and Morris's legally notarized *Statement of Aesthetic Withdrawal* (1963).

23. Benjamin Buchloh, "Conceptual Art 1962–1969: From the Aesthetic of Administration to the Critique of Institutions," *October*, no. 55 (Winter 1990): 105–43.

24. Ibid., p.141. Original reference in Lucy Lippard, "Introduction," in *955.000*, exh. cat. (Vancouver: Vancouver Art Gallery, 1970), n.p.

25. See also John Henry Merryman, "The Wrath of Robert Rauschenberg," *American Journal of Comparative Law*, vol. 41, no. 1 (Winter 1993): 103–27, for a good discussion of this.

26. "A Conversation between Seth Siegelaub and Hans Ulrich Obrist," *TRANS*, no. 6 (1999): 51–63, available at http://www.e-flux.com/projects/do_it/notes/interview/i001_text.html. For a good recent overview of this topic, see Maria Eichhorn, *The Artist's Contract*, ed. Gerti Feitzek (Cologne: Walther Konig, 2008).

27. Many of these arguments have resurfaced in relation to present-day Artists' Resale Right (ARR) legislation, which came into force in Britain in 2006 as a scaled royalty on the resale of living artists' work. Recipients must be citizens of the European Union or approximately one dozen other participating countries, and only sales occurring in these regions are ARR compliant; at present this royalty is not applicable in the United States.

28. Alberro, *Conceptual Art and the Politics of Publicity*, p. 169.

29. Joseph Kosuth, "Art after Philosophy, part 1," *Studio International*, no. 915 (October 1969): 137.

30. This is similar to the preservation of video art practices and to technologically based arts generally.

31. Huebler quoted in Andrea Fraser, "What's Intangible, Transitory, Mediating, Participatory, and Rendered in the Public Sphere? Part 2,' in Andrea Fraser, *Museum Highlights: The Writings of Andrea Fraser*, ed. Alexander Alberro (Cambridge: MIT Press, 2005), pp. 63–64. Originally reference in Douglas Huebler, *Prospect '69*, exh. cat. (Düsseldorf: Kunsthalle Düsseldorf, 1969), p. 26.

32. Fraser, *Museum Highlights*, p. 64.

33. Author's interview with Liam Gillick, 9 August 2004.

34. Nicolas Bourriaud, *Postproduction*, trans. Jeanine Herman (New York: Lukas & Sternberg, 2002). His latest book offers a critical rethinking of modernity in the twenty-first century: Nicolas Bourriaud, *The Radicant*, trans. James Gussen and Lili Porten (New York: Lukas & Sternberg, 2009).

35. Dave Beech, "The Art of the Encounter," *Art Monthly*, no. 278 (July–August 2004): 46.

36. Bourriaud, *Relational Aesthetics*, p. 15.

37. Ibid., p. 16.

38. Ibid., p. 22.

39. Ibid., p. 14. See also Bourriaud's analysis of Tiravanija on p.14 and in *Postproduction*, pp. 41–43.

40. For an important survey of these critiques, see Claire Bishop, "Antagonism and Relational Aesthetics," *October*, no. 110 (Fall 2004): 51–79; Beech, "Art of the Encounter," p. 46; and Hal Foster, "Art Party," *London Review of Books*, 4 December 2003, pp. 21–22. Readers should also reference Gillick's heated response to Bishop's essay for an alternative discussion of Bourriaud's writing from the perspective of one of the artists central to his theories: Liam Gillick, "Contingent Factors: A Response to Claire Bishop's 'Antagonism and Relational Aesthetics,'" *October*, no. 115 (Winter 2006): 95–106.

41. Bourriaud, *Relational Aesthetics*, p. 30. See also Bourriaud's reference to Lippard on p. 31, n. 2.

42. See Fraser, *Museum Highlights*, in particular pp. 47–54 and 153–61; and Miwon Kwon, *One Place after Another: Site-Specific Art and Locational Identity* (Cambridge: MIT Press, 2002). For good alternative discussions of these tendencies in contemporary art, see also Grant Kester, *Conversation Pieces: Community and Communication in Modern Art* (Berkeley and Los Angeles: University of California Press, 2004).

43. References in this paragraph from Kwon, *One Place after Another*, pp. 47, 50.

44. Some formative texts include Michel Callon, John Law, and Arie Rips, eds., *Mapping the Dynamics of Science and Technology* (London: Macmillan, 1986); Bruno Latour, *Science in Action: How to Follow Scientists and Engineers through Society* (Milton Keynes: Open University Press, 1987); Latour, *Reassembling the Social: An Introduction to Actor-Network-Theory* (Oxford: Oxford University Press, 2005); John Law, "Notes on the Theory of the Actor Network: Ordering, Strategy, and Heterogeneity," 1992, available at http://www.lancs.ac .uk/fss/sociology/papers/law-notes-on-ant.pdf; and John Law and John Hassard, eds., *Actor Network Theory and After* (Oxford and Keele: Blackwell and the Sociological Review, 1999).

45. Law, "Notes on the Theory of the Actor Network," p. 2.

46. See John Law, "After ANT: Complexity, Naming and Topology," in *Actor Network Theory and After*, ed. Law and Hassard, pp. 1–14; Arturo Escobar, "Welcome to Cyberia: Notes on the Anthropology of Cyberculture," *Current Anthropology*, vol. 35, no. 3 (June 1994): 211–31; and Nilmini Wickramasinghe, Rajeev Bali, and Arthur Tatnall, "Using Actor Network Theory to Understand Network Centric Healthcare Operations," *International Journal of Electronic Healthcare*, vol. 3, no. 3 (2007): 317–28.

47. Stapleton, "Art, Intellectual Property and the Knowledge Economy," pp. 117, 118.

48. Morris quoted in ibid., p. 123.

49. Ibid., pp. 130–31.

50. Ibid., p. 117, nn. 68, 69.

51. Stapleton's analysis draws extensively upon the contributions of Boyle and Leadbeater to the management of intellectual property rights within the "knowledge economy." The reason this periodization comes approximately one decade after the dawn of the postmodern economy is that Stapleton defines it as being linked to the application of copyright law to the writing of computer software at this time. For further reading, see James Boyle, *Shamans, Software and Spleens: Law and the Construction of the Information Society* (Cambridge: Harvard University Press, 1996); and Charles Leadbeater, *Living on Thin Air: The New Economy* (London: Viking, 1999). See also Manuel Castells, *The Information Age: Economy Society and Culture*, Volume 1: *The Rise of Network Society*, 2nd ed. (Oxford: Blackwell, 2000).

52. The fee paid by Cohen to Hirst has never been revealed, but the collector has dubbed the expense "inconsequential." It was estimated that the injection of formaldehyde into the tank alone was approximately $100,000, including labor and materials. For a discussion of this, see Carol Vogel, "Swimming with Famous Dead Sharks," *New York Times*, 1 October 2006.

53. The Cohen–Hirst transaction also alludes to a controversial aspect of ANT, notably that such legalistic rights may then be utilized to strategically enhance the economic value of the artwork one owns, as exemplified in Cohen's subsequent three-year loan of Hirst's newly renovated shark to New York's Metropolitan Museum of Art, beginning in October 2007.

54. See Vivian van Saaze, "Doing Artworks: An Ethnographic Study into a Case Study of the *Inside Installations'* Project," paper presented at the conference "Shifting Practice, Shifting Roles? Artists' Installations and the Museum," Tate Modern, London, 22 March 2007.

55. In March 2007 Carlos and Rosa de la Cruz subsequently donated their own collection of seventeen works associated with *No Ghost* to Tate Modern and the Museum of Contemporary Art, North Miami, to be jointly owned by both institutions. See http://www.mocanomi.org/moca-tate.htm.

56. For a useful overview of these processes, see Pierre Huyghe and Philippe Parreno, *No Ghost Just a Shell* (Cologne: Verlag der Buchhandlung Walther König, 2002). For a critical analysis of this project, see Tom McDonough, "No Ghost," *October*, no. 110 (Fall 2004): 107–30.

57. This distinction is made in van Saaze, "Doing Artworks," p. 6. A final matter associated with the Van Abbemuseum presentation was the artists' collaboration with lawyer Luc Saucier to compose a contract dictating how ownership of Annlee's copyright would ultimately belong to *her*, not to the artists who had purchased her image. This is important because it brings the project to a synchronous conclusion: upon "freeing" Annlee from her utility within the commercial animation industry, the project is terminated when this character becomes the exclusive owner of its own rights. This decision also situates the project at the opposite end of the spectrum from the GNU or Creative Commons licenses, which

would have enabled the continued legal manipulation of the image had it been relegated to the public domain. Although this contract restricts the commercial values ordinarily derived of such animations, it also enhances its art market value by limiting the number of applications this character may take; Huyghe, Parreno, and other artists who produced art for *No Ghost* thus strengthen their ability to charge a premium for these works. This strikes an accord with Parreno's limited-life *Boy from Mars* DVD, discussed in chapter 1, and it also recalls similar tendencies in the photography market such as Richard Avedon's destruction of the unused negatives from his book, *In the American West*, 1985. See Laura Wilson, *Avedon at Work in the American West* (Austin: University of Texas Press, 2003), p. 125.

58. Author's interview with Pierre Huyghe, 17 August 2005.

59. Bourriaud, *Relational Aesthetics*, p. 48.

60. Author's interview with Anton Kern, 15 April 2004.

61. I am referring here to *Untitled–Flaming morning glory no.103*, 2005 (edition of four), consisting of mirrors, birch plywood, stove, wok, and a gas canister, which sold at Phillips de Pury & Company New York in 2007 for $34,600. Source: Artnet.

62. Janet Kraynak, "Tiravanija's Liability," *Documents*, no. 13 (Fall 1998): 40.

63. "Andrea Fraser in Conversation with Praxis," *Brooklyn Rail*, October 2004, available at http://www.thebrooklynrail.org/arts/oct04/fraser.html.

64. Guy Trebay, "Encounter; Sex, Art and Videotape," *New York Times*, 13 June 2004.

65. Andrea Fraser and Andrew Hunt, "Is This a Site Specific Interview?" *Untitled*, no. 32 (Summer 2004): 8.

66. For a description, see Jens Hoffman, "Tino Sehgal," *Flash Art*, vol. 34, no. 224 (May–June 2002): 131.

67. Sehgal quoted in ibid., p. 131.

68. Michel Chevalier, "'I'm dreaming of a white Christmas ...' Tino Sehgal at the Kunstverein in Hamburg," available at http://www.thing-hamburg.de/index.php?id=123.

69. The heroics of Rhoades's gallery's description of these events is worth quoting at length:

> *Black Pussy* is foremost a sculpture; however it is not merely the result of material objects chosen by the artist, but also the activities of participants in the ten *Black Pussy* soirées held in his Los Angeles studio. For a period of six months, the artist invited a small group of selected guests to attend a series of events officially known as *Black Pussy Soirée Cabaret Macramé*. Though seemingly improvised, these evenings were highly structured hybrids of performance, Happening, dinner party, and art opening. Rhoades hired performers, but also expected a high level of guest participation with the intention that these soirées would add to the constantly evolving *Black Pussy* installation. Each guest not only contributed a new personal *pussy word* to his encyclopaedic list, but also a bit of themselves in the form of charisma—their intangible and individual spiritual power. The events were heavily documented in the form of photographs which were both physically incorporated into the installation and used to compile a coffee table book, and also in the form of a

soundtrack, which became part of the work itself. Only after the addition of sound—the auditory remains of the cycle of soirées—did Rhoades consider the sculpture complete.

See "Jason Rhoades: Black Pussy," press release, David Zwirner Gallery, 24 October 2007, available at http://www.davidzwirner.com/exhibitions/140/.

70. See http://www.ghw.ch/exhibitions/pressrelease.php?exhibition_id=261.

71. Author's interview with Hajoe Moderegger, 2 March 2007.

72. Quoted in Michael Wang, "Project Runaway," 22 September 2006, available at http://www.artforum.com/diary/archive=200609.

73. Author's email correspondence with Franzy Lamprecht, 2 March 2007.

74. Bourriaud, *Relational Aesthetics*, p. 47.

75. Stallabrass, *Art Incorporated*, p. 152.

76. Ibid.

77. *Untitled 1991 (tom ka soup)* was presented in Touch: Relational Art from the 1990s to Now, curated by Bourriaud at SFAI, October—December 2002. Attendance at the opening night dinner with Tiravanija involved buying a $50 ticket; this was the first time the piece had been activated since the 1995 dinner in Kern's apartment. *Musselslessum* was presented in Sitings: Installation Art, 1969–2002, at MOCA, October 2003–January 2004.

78. Author's interview with Brian Butler, 28 April 2004; all quotations by Butler in this paragraph are from this conversation.

79. Tiravanija quoted in Richard Flood and Rochelle Steiner, "En Route," *Parkett*, no. 44 (1995): 116. See also Calvin Tomkins, "Shall We Dance? The Spectator as Artist," *New Yorker*, 17 October 2005, p. 82.

80. Kraynak, "Tiravanija's Liability," p. 36.

81. Tiravanija's polished chrome *Cooking Corner* pieces from 2003 to 2005, which are sold in an edition of four and consist of a chromed pot, burner, gas tank, and three stainless steel plates, achieve a similar function. One edition of this workwas on offer for $44,000 at 1301PE's stand at the 2005 Frieze Art Fair.

82. Spector's comments were made in a panel entitled "Where is Adventure? What Is Culture?" 17 October 2004. An audio recording is available at http://www.friezeartfair.com/talks/2004/.

83. Adam Lindemann, *Collecting Contemporary* (Cologne: Taschen, 2006).

84. Ibid., p. 17.

85. http://www.fineartwealthmgt.com/art-wealth-management/events-lifestyle-services.

86. Ibid. This chart is no longer available on the FAWM website.

87. For a critical discussion of this, see J. J. Charlesworth, "Bonfire of the Vanities," *Art Monthly*, no. 305 (April 2007): 5–8. Charlesworth's argument draws extensively on Phil Mullan, "It's Capitalism, but Not as We Know It," 7 January 2005, available at http://www.spiked-online.com/Articles/0000000CA864.htm.

88. Pine and Gilmore, *The Experience Economy*, pp. 2, 11–12, 22.

89. Ibid., p. 3.

90. Ibid., p. 58.

91. Ibid., pp. 13–14.

92. Which is also to say that it is not always possible to differentiate between services and experiences.

93. Paul Nunes and Brian Johnson, *Mass Affluence: Seven Rules of Marketing to Today's Consumers* (Boston: Harvard Business School Press, 2004), pp. 6–7.

94. Jeremy Rifkin, *The Age of Access: How the Shift from Ownership to Access Is Transforming Modern Life* (London: Penguin Books, 2000), pp. 30–55.

95. Ibid., p. 50. Emphasis added. For an alternative account of cooperation in the present-day economy, see Hardt and Negri, *Empire*, pp. 393–413.

96. Rifkin relates this to Pine and Gilmore's experience economy. Rifkin, *Age of Access*, pp. 145–46.

97. C. K. Prahalad and Venkat Ramaswamy, *The Future of Competition: Co-Creating Unique Value with Customers* (Boston: Harvard Business School Publishing, 2004), p. 10.

98. Albert Boswijk, Thomas Thijssen, and Ed Peelen, "A New Perspective on the Experience Economy," 2005, available at http://www.experience-economy.com/wp-content/UserFiles/File/Article%20Lapland5.pdf.

99. Rifkin, *Age of Access*, pp. 168–85.

100. Luc Boltanski and Eve Chiapello, *The New Spirit of Capitalism* [1999], trans. Gregory Elliott (London: Verso, 2005), pp. 17, 70–74. The authors' use of the "big bang" derives from Peter Drucker, *Managing in the Next Society* (New York: St. Martin's Press, 2002).

101. Sebastian Budgen, "A New 'Spirit of Capitalism,' " *New Left Review*, no. 1 (January–February 2000): 153.

102. See Adorno, *Culture Industry*, pp. 187–97; and Jameson, *Postmodernism*, and *Postmodern Turn*.

103. Tim Griffin, "Editor's Letter," *Artforum*, vol. 42, no. 2 (October 2003): 18.

104. Matthew Jesse Jackson, "Managing the Avant-Garde," *New Left Review*, no. 32 (March–April 2005): 114; Spencer Johnson, *Who Moved My Cheese?* (London: Vermilion, 1998). For an alternative account of how arts institutions deploy lessons of the experience economy, see Ed Petkus Jr., "Enhancing the Application of Experiential Marketing in the Arts," *International Journal of Nonprofit and Voluntary Sector Marketing*, vol. 9, no. 1 (2004): 49–56.

105. See also *Let's Entertain: Life's Guilty Pleasures*, exh. cat. (Minneapolis: Walker Art Center, 1999), for an excellent overview of the relationship between contemporary art making and the experience economy.

106. Bourriaud, *Postproduction*, p. 65.

107. Jérôme Sans and Marc Sanchez, eds., *What Do You Expect from an Art Institution in the 21st Century?* (Paris: Palais de Tokyo, 2001), p. 5.

108. It is erroneous to conflate these undertakings: the collaborative process-based emphasis of the Kunstverein Munich under Lind invokes different opportunities and problems from the fetishisation of artistic labor on view at BALTIC. I discuss them together here simply to highlight a broad trend in gallery/exhibition management.

109. See especially Katharina Schlieben, "Sputniks: Whichever Way the Journey Goes," 2002, available at http://www.kunstverein-muenchen.de (which also

provides extensive documentation of the Sputnik program). See also Liam Gillick and Maria Lind, eds., *Curating with Light Luggage: A Symposium* (Frankfurt: Revolver, 2004).

110. Sarah Martin and Emma Thomas, eds., *BALTIC: The Art Factory* (Gateshead: BALTIC, 2002).

111. The placement of Bruce Mau's *Bookmachine* at the center of Laboratorium, 1999, offers another excellent example of this whereby the making of the exhibition's catalogue is placed on public view. Laboratorium is also a salient case in point of the workshop-based approach to art marking and presentation generally. See Hans Ulrich Obrist and Barbara Vanderlinden, eds., *Laboratorium*, exh. cat. (Antwerp: Dumont, Antwerpen Open, Roomade, 1999).

112. Krens quoted in Andrea Fraser, "Isn't This a Wonderful Place?" in Fraser, *Museum Highlights,* p. 255.

113. Ibid., p. 255. See also Hal Foster, *Design and Crime (and Other Diatribes)* (London: Verso, 2002), pp. 27–42.

114. See Francis Haskell, *The Ephemeral Museum: Old Master Paintings and the Rise of the Art Exhibition* (New Haven: Yale University Press, 2000).

115. Bettina Funcke, ed., *6th Caribbean Biennial* (Paris: Les Presses du Réel/ Janvier, 2001).

116. All quotations in this paragraph from ibid., n.p.

117. Katy Siegel and Paul Mattick, eds., *Art Works: Money* (London: Thames & Hudson, 2004).

118. For an excellent history of contemporary art fairs, beginning with Kunstmarkt 67 in Cologne in September 1967, see Christine Mehring, "Emerging Market," *Artforum*, vol. 46, no. 8 (April 2008): 322–29, 390.

119. http://www.artbasel.com.

120. This figure is composed of 136 galleries in the main part of the fair and 19 in the Frame section. See http://www.friezeartfair.com/yearbook_2009/.

121. Maria Lind makes a similar point in a book released and freely distributed at the 2005 Frieze Art Fair. See "Introduction," in *European Cultural Policies 2015: A Report with Scenarios on the Future of Public Funding for Contemporary Art in Europe*, ed. Maria Lind and Raimund Minichbauer (London, Stockholm, Vienna: eipcp/IASPIS, 2005), p. 6.

122. By contrast, The European Fine Art Fair (TEFAF), in Maastricht, uses an authentication board to ensure that artworks' provenance is accurate. This vetting process is executed prior to the fair's official opening. See http://www.tefaf .com.

123. Quoted in Marc Spiegler, "The Trouble with Art Fairs," *Art Newspaper*, no. 175 (December 2006): 36.

124. Quoted in Brian Sholis, "Peaches and Beaches," 7 December 2006, available at http://artforum.com/diary/archive=200612.

125. In 2006 members of the Society of London Art Dealers reported that they achieved an average of 28 percent of their net annual sales at fairs (up from 24 percent in 2004), and that 85 percent of them participated in at least one art fair (up from 76 percent in 2004): Society of London Art Dealers, *Biennial Members Survey 2007*, June 2007. Another recent survey of dealers exhibiting at The Euro-

pean Fine Art Fair in Maastricht indicates far bolder figures: those polled allege that, on average, 40 percent of their annual turnover now derives from art fairs, while this may rise to upwards of 90 percent for dealers outside of the major art centers. See Jeremy Eckstein Associates, *The Art Fair as Economic Force* (Helvoirt: European Fine Art Foundation, 2006).

126. Peter Schjeldahl, "Temptations of the Fair: Miami Virtue and Vice," *New Yorker*, 25 December 2006, p. 148.

127. This defense was aired in conversation with Hans Ulrich Obrist and Rem Koolhaas at the Post-Marathon event at the Serpentine Gallery, London, 14 October 2006.

128. Jack Bankowsky, "Tent Community: On Art Fair Art," *Artforum*, vol. 44, no. 2 (October 2005): 228–32.

129. Ibid., p. 229.

130. Statistics from http://artbaselmiamibeach-online.com/.

131. See Elisa Turner, "Art Basel Miami: 'Even Better' The Second Time Around," *ARTnewsletter*, vol. 29, no. 9 (December 23, 2003): 3. Attendance statistics from Adrian Dannatt, "Art Basel Miami Beach: Secrets of Success amidst the Gloom," *Art Newspaper*, no.132 (January 2002): 33; and Guy Trebay, "Miami Basel: An Art Costco for Billionaires," *New York Times*, 10 December 2006. Net-Jets statistics in Trebay and Peter Aspden, "Art's Most Glittering Event," *Financial Times*, 15 December 2006.

132. Trebay, "Miami Basel."

133. Trebay and Aspden, "Art's Most Glittering Event."

134. Thomas Crow begins his 2008 survey article on the state of the art economy with discussion of the *Grand Luxe* and its possible signaling of the "telltale peak of excess in the recent art market." See Thomas Crow, "Historical Returns," *Artforum*, vol. 46, no. 8 (April 2008): 286. The megayacht's website is at http://www.expoships.com/.

135. Alexandra Wolfe, "Voyage of the Art Barge," 13 August 2007, available at http://www.portfolio.com/culture-lifestyle/culture-inc/arts/2007/08/13/Grand-Luxe-Art-Barge/.

136. In fact, although six Scene and Herd entries were written in November 2004, this section of the website actually premiered at the 2004 edition of ABMB the following month. One of its first posts, for example, covered the party hosted at the house of influential collector Rosa de la Cruz: http://www.artforum.com/diary/archive=200412.

137. Author's interview with Brian Sholis, 16 April 2007.

138. David Velasco, "Another 48 Hours," 12 December 2006, available at http://www.artforum.com/diary/archive=200612.

139. "The Art Universe," *Vanity Fair* (December 2006): 230–31.

140. Moshe Adler, "Stardom and Talent," *American Economic Review*, vol. 75, no. 1 (March 1985): 208–12.

141. See Lind, "Introduction," p. 4.

142. Dave Hickey, "A Fair to Remember," *Vanity Fair* (November 2008), available at http://www.vanityfair.com/culture/features/2008/11/art-fair200811.

143. Quoted in Tomkins, "Shall We Dance?" p. 95.

CHAPTER 3: ART INVESTMENT FUNDS

1. Leo Steinberg, *Other Criteria: Confrontations with Twentieth Century Art* [1972] (Chicago: University of Chicago Press, 2007), p. 56.

2. Quotations in this paragraph from: www.fernwood.com. All references to this website were accessed between October 2005 and April 2006. The website was terminated in June 2006 and remains nonoperational. All quotations from Fernwood in this chapter are from this website unless noted otherwise.

3. My reference to Steinberg here is lifted from the epithet to Julian Stalla-brass's chapter, "Uses and Prices of Art," in his *Art Incorporated*, p. 100, where they were used by to embark upon a discussion of some key features of the contemporary art market.

4. Some representative articles on the subject include "Art as Investment: Betting on Genius," *The Economist*, 23 August 2003, pp. 55–56; Deborah Brewster, "Dollar's Slide Helps Lift US Art Market," *Financial Times*, 26 January 2004; Toddi Gutner, "Funds to Please the Eye," *BusinessWeek*, 14 February 2005, pp. 88–90.

5. Lita Solis-Cohen, "New Art Investment Firm to Launch," *Maine Antiques Digest* (September 2004), available at http://www.maineantiquedigest.com/articles/sep04/fernwood0904.htm.

6. Craig Hallum quoted in Nina Siegal, "Profit Motives," *Art + Auction*, vol. 26, no. 14 (August 2004): 18. See also: Georgina Adam, "ABN-AMRO Launch New Service to Advise Private Banks," *Art Newspaper*, no. 152 (November 2004): 47; and *ABN-AMRO Bank N.V. Art Funds Initiative*, 2005 Global Road Show.

7. A hallmark example of this was Christie's abandonment of its own art fund initiative, which aimed to raise between $250 and $350 million. See Lindsay Pollack, "Christie's Scraps Plans for Art-Investment Fund, Loan Division," *Bloomberg News*, 20 August 2009, available at http://www.bloomberg.com/apps/news?pid=20601088&sid=a.c_YSlc6BhY.

8. Figures current as of October 2009. FAF manages the following four art investment vehicles: the Fine Art Fund I, the Fine Art Fund II, the China Fund, and the Middle East Fine Art Fund. The latter, launched in November 2008, is managed in partnership with Bahrain-based Addax Bank; the other funds are operated entirely by Fine Art Management Services Ltd (FAMS), the art investment fund business of the management company the Fine Art Fund Group. Two additional vehicles are also on the horizon, both with initial closes in 2010: the Fine Art Fund III, a five-year, closed-end fund that will focus on acquiring art at distressed prices; and the Indian Fine Art Fund. Source: The Fine Art Fund Group. Unless otherwise noted, all references to FAF are from this source.

9. Louisa Buck and Judith Greer, *Owning Art: The Contemporary Art Collector's Handbook* (London: Cultureshock Media, 2006), p. 31.

10. Thompson, *The $12 Million Stuffed Shark*, is a good case in point. Philip Hook, *The Ultimate Trophy: How the Impressionist Painting Conquered the World* (Munich: Prestel Verlag, 2009), meanwhile, presents an insider account of prestige buying in the market for Impressionist paintings up to the 1990s, as Nelson and Zeckhauser, *The Patron's Payoff*, offer insight into such motivations during the Italian Renaissance.

11. The veracity of this assumption is another matter, and certainly the simultaneous decline in the financial and art markets beginning in fall 2008 suggests that they are highly correlated. In actuality, the most salient point is how movements in the financial market affect the movement of art prices—and how art investors can profit from these interrelationships.

12. Britain's FTSE 100 Index fell by 48 percent from its peak in October 2007 to its trough in March 2009; during the same period, the S&P 500 Index in the United States dropped by 56 percent. Source: Yahoo! Finance.

13. Hoffman quoted in Alix Stuart, "Investing in Oils," *CFO Magazine*, 1 April 2007, available at http://www.cfo.com/article.cfm/8885618/c_2984339/?f=archives. For a discussion of the benefits of investing in real assets such as art and gold during periods of high inflation, see Rachel Campbell, "Is Art an Investable Asset Class?," April 2009, available at http://www.collectionofmodernart.co.uk/#/research/.

14. This contrasts, for instance, with the tendency of dealers to adopt a model of horizontal differentiation aimed at promoting a particular genre or style in an effort to gain a critical mass advantage in securing the interest of art market actors to the gallery. For an explanation of this, see Richard Caves, *Creative Industries: Contracts between Art and Commerce* (Cambridge: Harvard University Press, 2000), p. 46.

15. Hoffman raised this in a presentation at the "Art Markets Symposium," Chateau St. Gerlach, Maastricht, 8 March 2007.

16. Accredited investors are defined as persons whose individual net worth, or combined net worth with their spouse, is in excess of $1 million; persons who have earned $200,000 for each of the last two years with a reasonable expectation of earning the same amount in the current year; or a charitable organization, corporation, or partnership with assets exceeding $5 million. See http://www.sec.gov/answers/accred.htm.

17. One notable exception to this is Castlestone Management's Collection of Modern Art, launched in 2009, which is an open-ended fund. The collection is set up as a BVI-regulated mutual fund, accepting investments through accredited financial advisors beginning at $10,000. It extends from Castlestone's expertise in real and alternative assets such as gold bullion, precious metals, and commodities. See http://www.collectionofmodernart.co.uk/.

18. This hurdle rate is quite common among art funds, as well as many hedge funds. It is predicated on the London Interbank Offered Rate (LIBOR, the interest rate at which banks can borrow unsecured funds from other banks in the London interbank market) plus a spread of two or three basis points with the notion that an investor could earn this amount if he or she had deposited cash in an interest-bearing money market account. If an art fund returns 16 percent with a 6 percent hurdle, performance fees will only be charged on the 10 percent above the hurdle rate.

19. FAF actually aims for 10 to 20 percent.

20. Investors with FAF, for example, can borrow works owned by the fund at a cost of 1.25 percent of their appraised value. But in actuality, and much to the chagrin of investors themselves, this is seldom implemented due to tax and insurance complications.

21. Buyers include Charles Beddington and Johnny van Haeften, in Old Master Paintings; James Roundell, in Impressionist and Modern Art; Ivor Braka, in Contemporary and Modern Art; and Thomas Dane, in Contemporary Art.

22. One notable exception to the art investment models evaluated here is the Artist Pension Trust (APT), which does not actually brand itself as a fund at all. APT was founded in 2004 by Israeli entrepreneur Moti Shniberg and economist Dan Galai as the first long-term financial security net, or pension scheme, for artists. The business model works as follows: 250 artists are selected in consultation with a management board and curatorial committees to participate in the trust; each of these artists give twenty works to the trust over a twenty-year period (two per year for the first five years; one per year for the next five; and one every other year for the remaining ten); as items are sold, individual artists retain 40 percent of net proceeds from their own artwork sales, while 32 percent of these proceeds accrue to the collective benefit of all participants, with the remaining 28 percent being directed to management and operational costs. As of November 2009, there are eight trusts (in New York, London, Berlin, Los Angeles, Mexico City, Mumbai, Dubai, and Beijing), comprising a total of 1,019 artists and 3,874 artworks. APT has generated a considerable amount of critical interest in the art and financial communities, but while most of this attention has focused on perceived benefits to artists themselves, APT's similarity to the art fund model is of greater concern to us. For example, its unique model of working directly with living artists offers a robust pipeline into the contemporary market that other existing funds do not tend to have. Over time, this can be scaled to bring thousands of artists, and tens of thousands of works, into its investment portfolio. Furthermore, although APT does not charge the usual 2 percent asset management fee, its 28 percent performance fee is well above that of other current art funds. Operational costs of running such a large business may therefore exceed those of more conventional funds, but the earnings potential of its management and investors is significant nevertheless. At the very least, it is critical to view APT not merely as an altruistic financial opportunity for artists, but as a shrewd approach to monetizing the value of an ever-expanding collection of contemporary art over the long term. See http://www.aptglobal.org.

23. Solkin, *Painting for Money*, p. 2; Watson, *From Manet to Manhattan*, p. 157.

24. See Watson, *From Manet to Manhattan*, p. 157.

25. A good account of this situation over the course of the nineteenth century is provided in Guido Guerzoni, "The British Painting Market 1789–1914," in *Economic History and the Arts*, ed. North, pp. 97–132.

26. See John Richardson, *A Life of Picasso*, Volume 2: *1907–1917* (London: Jonathan Cape, 1996), pp. 48, 297–99. All quotations in this paragraph are from this book.

27. The Peau de l'Ours auction shares some telling characteristics with the 1973 Scull sale, discussed in the introduction. Both represented the first time, in France and then the United States, a major group of artworks by living artists had come up at auction; both received extensive press coverage and were attended by many of the leading players of their times; both achieved extraordinary results; and both raised the issue of living artists' reserved rights to sales proceeds—after the sale, Level took the then groundbreaking measure of returning 20 percent of

the revenues to artists (which preceded the imposition of the *droit de suite* in French law by six years), while Rauschenberg's outcry helped catalyze discussion of artists' resale rights in the United States. Indeed, it is notable that arguably the first-ever art investment fund returned such a large percentage of its proceeds to the artists themselves. For an excellent analysis of the Scull sale and of the *droit de suite*, see Merryman, "The Wrath of Robert Rauschenberg."

28. The following articles are exemplary of this earlier period: W. G. Menzies, "Collecting as an Investment," *Apollo*, vol. 22 (August 1935): 87–90; and, George Savage, "Art for Investment," *The Studio*, vol. 162 (July 1961): 31, 36–37.

29. Figures based on an advanced search under "art" and "investment" executed on the Art Index Retrospective database of the Wilson Web Art Index. The Art Index Retrospective presents citations to Art Index volumes 1–32 of the printed index published between 1929 and 1984 and incorporates 871 journals. The advanced search I executed in May 2005 returned thirty-six articles in the following distribution: eleven from 1930–44; zero from 1945–61; five from 1962–69; eight from 1970–79; and twelve from 1980–84. Although strict search parameters and English-only publications limit the applicability of these findings, they nevertheless seem instructive approximations of how art investing literature has evolved in response to moments of economic instability.

30. The *Kunstkompass* artist ranking system, published annually by *Capital* since its founding in 1970, was created by German economist Willi Bongard as a model for calculating an artist's reputation in the art world. Rankings were established by giving a numeric weighting to variables such as what collections an artist's work was represented in and the exhibitions, articles, or books artists had been included in. Acquisition by a blue-chip museum counts more than one by a regional gallery; a solo show corresponds to a greater value than a group exhibition. Bongard passed away in 1985, but the enterprise is ongoing. For further information, see http://www.capital.de/guide/kunstmarkt-kompass.

31. A similar line of thought may help explain the upsurge of art investing after the collapse of the dot-com bubble and in the wake of 9/11. For a discussion of this, see András Szántó's comments on the post-9/11 correlation between art collecting and the "pursuit of meaning," in a blog entry of 28 May 2007 available at http://www.artworldsalon.com/blog/2007/05/27/contemporary-what-real-value/. Martha Rosler has also commented on more general aspects of this in her "Theses on Funding," originally a contribution to a panel discussion at the Mid-America Art Association (Houston, 1980), reprinted in Rosler, *Decoys and Disruptions*, pp. 323–24.

32. Reitlinger, *The Economics of Taste* (1961, 1963, 1970).

33. Ibid. (1963), p. 282.

34. Reference in Artemis Fine Arts, "The Report of the Board of Directors," *Annual Report 1970–1971*, n.p. For further discussions, see Leonard Sloane, "A Portfolio of Art Investments: Ephraim Ilin and the Modarco Fund," *ARTnews*, vol. 72 (December 1973): 63–65; Grace Glueck, "These Investors Are Bullish on the Art Market," *New York Times*, 12 January 1975; Michael Goedhuis, "Investment in Art," *Studio International*, vol. 189, no. 974 (January 1975): 19–20; and Nicholas Faith, *Sold: The Rise and Fall of the House of Sotheby* (New York: Macmillan, 1985), p. 218.

35. Artemis's consolidated audited annual reports (1970–2006) are archived in the British Library. The firm's website, active as recently as April 2007, is no longer in operation. On the Modarco-Knoedler merger, see Grace Glueck, "Art People," *New York Times*, 1 July 1977.

36. These ventures are discussed in Sloane, "Portfolio of Art Investments"; and H. J. Maidenberg, "A Risky Way to Buy Collectibles," *New York Times*, 3 June 1979.

37. Marylyn Bender, "High Finance Makes Bid for Art," *New York Times*, 3 February 1985.

38. Jeremy Eckstein, an independent art market expert and former advisor to BRPF, notes that the annual inflation figure in Britain at the end of 1974 was just short of 30 percent, while U.S. inflation peaked at over 12 percent during the same period. In Britain the FT-Actuaries Index (the main indicator of stock market performance at the time) fell by over 70 percent between the beginning of 1973 and the end of 1974 (when the fund began to buy works of art), during which time the Dow Jones Index in the United States fell by more than 40 percent. Reference in Jeremy Eckstein, "The Experience of the British Rail Pension Fund," ms, n.p.. See also Jeremy Eckstein, Randall Willette, and Clare McAndrew, "Art Funds," in *Fine Art and High Finance: Expert Advice on the Economics of Ownership*, ed. Clare McAndrew (New York: Bloomberg Press, 2010), pp. 135–59.

39. Lewin quoted in Faith, *Sold*, p. 209.

40. In actuality, the fund stayed under its £3 million cap only during its first year of art purchases, peaking in excess of £7 million per annum between 1976 and 1979. See Eckstein, "British Rail Pension Fund."

41. Eckstein emphasizes the former point in ibid.. Nicholas Faith argues that the termination of BRPF's art acquisitions also had to do with rising controversy in the pension fund industry about the fund's undertakings. See Faith, *Sold*, p. 212.

42. These factors are discussed in Eckstein, "British Rail Pension Fund."

43. "Art Funds II … British Rail Out," *Art in America*, vol. 77 (April 1989): 29.

44. Figures cited in Eckstein, "British Rail Pension Fund." Reference to these sales is also made in ABN-AMRO Bank N.V. Art Funds Initiative, 2005 Global Road Show, p. 6; Peter Cannon-Brookes, "Art Investment and the British Rail Pension Fund," *Museum Management and Curatorship*, vol. 15 (December 1996): 407; and, Laura Suffield, "British Rail: Art on the Right Tracks?" *Art Newspaper*, no. 37 (April 1994): 31.

45. Cannon-Brookes, "Art Investment," p. 407.

46. Eckstein, "British Rail Pension Fund."

47. Eckstein emphasizes this point in his retrospective account of the fund, but he points out that it is hardly unsurprising given the extraordinary growth of the equity markets during this period: "The fact that the Fund's art holdings yielded less than comparable stock market investments in most other instances was not an indication that the other categories of art had necessarily performed poorly; it was more a result of the unprecedented bull market in the UK over the period. In the circumstances, it would have been unrealistic to expect that an alternative asset-backed class of investment, offering comparable levels of security to fine art,

should have consistently matched the returns which could have been achieved by an index spread of stock market securities over the same period." Eckstein does not provide comparative stock market returns over the period, but a press statement delivered on 10 July 1996 by Susan Adeane, BRPF's company secretary, provides for sobering reflection: "[Our results were] far less than equities across the period but on a par with British government gilts; the same funds placed in the S&P 500, BRPF disclosed, would have earned 18%." My own calculations indicate that the FTSE All Stock Index returned 15.7 percent per annum between 1974 and 2000. See ibid.; Adeane quoted in Godfrey Barker, "Off-Track Bets," *Art + Auction*, vol. 26, no. 14 (August 2004): 47; FTSE statistics from: http://www.finfacts.com/Private/curency/ftseperformance.htm.

48. Quotation from Faith, *Sold*, p. 211.

49. Throughout the 1980s, approximately 60–70 percent of the collection was held in storage. See Eckstein, "British Rail Pension Fund."

50. See Anise Wallace, "Chase Fund to Invest in Artworks," *New York Times*, 20 February 1989.

51. See Souren Melikian, "Let the Art Investor Beware," *Art + Auction*, vol. 21, no. 12 (March 1999): 18–22; and Siegal, "Profit Motives," p. 18.

52. See Georgina Adam, "Art Fund Goes Bust," *Art Newspaper*, no. 136 (May 2003): 39.

53. These are enumerated on the fund's website at http://www.thefineartfund.com.

54. Jianping Mei and Michael Moses, "Art as an Investment and the Underperformance of Masterpieces," *American Economic Review*, vol. 92, no. 5 (December 2002): 1656–68.

55. Ibid., p. 1666.

56. Rachel Campbell, "Art as an Alternative Asset Class," working paper, Maastricht University, 2005, p. 18. See also Campbell, "Art as a Financial Investment," *Journal of Alternative Investments* (Spring 2008): 64–81; and A. C. Worthington and H. Higgs, "Art as an Investment: Risk. Return and Portfolio Diversification in Major Painting Markets," *Accounting and Finance*, vol. 44 (2004): 257–71.

57. Variance and standard deviation both measure the same thing—the statistical dispersion of values around a mean. Variance is defined as the squared difference between an asset's actual and expected (or mean) return; standard deviation, the more common term, is the square root of variance.

58. Mei and Moses, "Art as an Investment," p. 1662.

59. I stress approximations here because it is highly unlikely that art returns will be perfectly distributed in a bell curve, as per the random coin-tossing game.

60. Modern finance theory rests upon two principal assumptions: all things being equal, investors prefer higher mean returns to lower mean returns; and investors are "risk averse" and thus prefer less return variance to more return variance. A key shortcoming of this assumption is that it marginalizes the influence of speculators, or risk-seekers—i.e., those who may have different, non-risk averse utility functions.

61. Markowitz, "Portfolio Selection."

62. Covariance explains the relationship between two variables: if assets X and Y move together, covariance is a positive number; if they are inversely related, covariance is negative; and if they are unrelated, covariance is zero.

63. Efficient frontiers are a keystone of modern finance theory and refer to the highest expected return for a given level of risk, or conversely, the least possible risk for a given level of return. For Taub's argument about the benefits of portfolio diversification into art, see Bruce Taub, "New Choices for Sophisticated Investors," April 2004.

64. For an overview of this coverage, see http://artasanasset.com/media/.

65. On the launch of Citibank Art Advisory and the firm's strategic partnership with Sotheby's, see Rita Reif, "Sotheby, Citibank Explain Pact; Clients' Art Holdings Assessed," *New York Times*, 22 September 1979; and Reif, "For $1 Million, Citibank Will Buy You Some Pictures," *New York Times*, 30 September 1979.

66. On the rise of art advisory services in the banking industry, see Georgina Adam, "Artful Investment?," *Art Newspaper*, no. 109 (December 2000): 69.

67. Adam, "Artful Investment?," p. 69.

68. Ibid.

69. FAWM's art investment services are at http://www.fineartwealthmgt.com/investor-services. In November 2008 the firm launched *Art Fund Tracker*, the first industry newsletter to provide regular analysis of key developments in the art fund space: http://www.fineartwealthmgt.com/resource-library/art-fund-tracker.

70. Taub, "New Choices for Sophisticated Investors," p. 2.

71. For a discussion of this in the art market, see Clare McAndrew, *The Art Economy: An Investor's Guide to the Art Market* (Dublin: Liffey Press, 2007), pp. 79–80; and CapGemini and Merrill Lynch, *World Wealth Report: 2007*, pp. 11–12.

72. The term "passion investments" is borrowed from CapGemini and Merrill Lynch, *World Wealth Report, 2007*, pp. 11–12.

73. See, for example, Fernwood Art Investments, "North American Wealth Advisor Survey Report on Art Investing," 1st annual ed., October 2004 (henceforth "Fernwood Wealth Survey").

74. CapGemini and Merrill Lynch, *World Wealth Report: 2008*, p. 2.

75. In 2007 luxury collectibles accounted for 16.2 percent of HNW's investments of passion, followed by art at 15.9 percent. And in Europe and Latin America (at 22 percent and 21 percent, respectively), art was actually the single most popular passion investment. See ibid. p. 21.

76. For evidence of this, see "Fernwood Wealth Survey," p. 3; and CapGemini and Merrill Lynch, *World Wealth Report: 2004*, p. 11.

77. CapGemini and Merrill Lynch, *World Wealth Report: 2006*, p. 2.

78. Hedging entails buying a financial position in one market to offset the risk of holding an equal but opposite position in another. The fundamental goal is to reduce potential losses in the case of an unexpected event—essentially like buying insurance. In finance, investors commonly use derivatives such as futures and options to hedge positions held in stocks. For a good introduction to hedge funds, see William Goetzmann and Stephen M. Ross, "Hedge Funds: Theory and Performance," ms. 1 October 2000, available at http://viking.som.yale.edu/will/hedge/Goetzmann-Ross.pdf; and Ted Caldwell, "Introduction: The Model for Superior

Performance," in *Hedge Funds: Investment and Portfolio Strategies for Institutional Investors*, ed. Jess Lederman and Robert A. Klein (New York: McGraw-Hill, 1995), pp. 1–17.

79. Short selling refers to the practice of selling a financial asset that one does not actually own at the time of sale. Whereas investors typically buy assets in the hope that their prices rise (going long), shorting is a way to make money by betting that the price of an asset falls. Short selling is done by renting an asset from a broker, selling it in the market, and later repurchasing and returning the same asset to the broker. This is a risky gambit: if the price drops, the investor can buy the asset back for less than he or she originally sold it for and net the difference in price; if the price rises, however, the investor has to repurchase it at a higher price and loses money (and whereas prices can only drop to zero, they can rise indefinitely—hence the high level of risk). On the differences between hedge fund and mutual fund regulation see Goetzmann and Ross, "Hedge Funds," p. 2.

80. Arbitrage refers to the simultaneous purchase and sale of identical, or highly congruent, financial assets with the objective of creating an instantaneous and risk-free profit. Ibid., pp. 1–2.

81. These AUM figures exclude leverage, thus actually underestimating the real buying power of hedge funds. In 2004 investment bank J. P. Morgan estimated the industry's average leverage at 5–1, meaning that if hedge fund AUM constitutes $1 trillion, at any given moment, these funds may actually be invested in $5 trillion worth of assets. Data presented in this paragraph from Report of the President's Working Group on Financial Markets, "Hedge Funds, Leverage and the Lessons of Long Term Capital Management," April 1999, p. 1; Sanford C. Bernstein & Co., "Hedge Fund Myths and Realities," October 2002, p. 3; J. P. Morgan Securities, Ltd., "Have Hedge Funds Eroded Market Opportunities?" 1 October 2004, pp. 2–3 (henceforth JPM, 2004); and Lynnley Browning, "A Hamptons for Hedge Funds," *New York Times*, 1 July 2007.

82. Boris Groysberg, Tim Keller, and Joel Podolny, "Fernwood Art Investments: Leading in an Imperfect Marketplace." Harvard Business School Case Study, 9-405-032, 12 December 2004, p. 11.

83. Figures from the National Association of Real Estate Investment Trusts, at http://www.reit.com/AllAboutREITs/tabid/54/Default.aspx.

84. Groysberg, Keller, and Podolny, "Fernwood Art Investments," p. 9.

85. Financial leverage refers to the practice of borrowing to enhance investment returns. The premise is that by taking a loan, an investor can increase his or her exposure to an asset and therefore stand to benefit disproportionately if that asset's value rises more than the rate of interest on the debt. But it is a double-edged sword: if the asset's value depreciates, the investor not only absorbs the loss but is also liable to pay both the loan principal and accrued interest. This high-risk approach became synonymous with hedge fund investing since the 1990s and helped to propel the industry's exorbitant returns and also cripple it in the fallout from the economic crisis beginning in 2007. Figures in JPM, 2004, p. 3.

86. Figure cited in Fiammetta Rocco and Sarah Thornton, "Suspended Animation," *Economist*, 28 November 2009, p. 3 (of special report on the art market). Data provided by Clare McAndrew, who notes that by 2009 the market had decreased from a high of approximately $65 billion in 2007.

87. A similar point is made in JPM, 2004, p. 3. See also Roger Lowenstein, *When Genius Failed: The Rise and Fall of Long-Term Capital Management* (New York: Random House, 2000).

88. Backfill bias is related to survivorship bias and refers to the tendency of indexes to gather data on hedge funds ex-post. Because funds may choose to publish their performance results only once they are favorable, this has the adverse effect of "backfilling" biased data into an index when a new fund is added to it. See Goetzmann and Ross, "Hedge Funds," pp. 26–28.

89. For instance, in a survey of ninety-four "long/short" funds in 2000, Sanford Bernstein calculates a mean annual return on investment of 17 percent. Excluding the best fund, this figure drops to 12.4 percent, and excluding the top three diminishes the average even further to 10.3 percent; 455 percent was the best reported fund in the survey, while –39.3 percent was the worst. See Bernstein, "Hedge Fund Myths," p. 7.

90. The two considered in the report are index entry/exit anomalies (measured in the FTSE); and convertible arbitrage. See JPM, 2004, pp. 16–17.

91. Goetzmann and Ross, "Hedge Funds,"p. 42.

92. Ibid., p. 27; and Bernstein, "Hedge Fund Myths," p. 8. See also Stephen Brown, William Goetzmann, and Stephen Ross, "Survival," *Journal of Finance*, vol. 50, no. 3 (1995): 853–73.

93. See Deborah Brewster, "$150 Billion Taken Out of Hedge Funds," *Financial Times*, 14 January 2009; and James Mackintosh, "Cut Down to Size?," *Financial Times*, 12 January 2009.

94. Nor do all recent studies endorse the practice. For a good discussion of these issues, and more critical conclusions on the *real* benefits of art investing, see Benjamin Mandel, "Art as an Investment and Conspicuous Consumption Good," *American Economic Review*, vol. 99, no. 4 (September 2009): 1653–63; and Luc Renneboog and Christophe Spaenjers, "Buying Beauty: Prices and Returns in the Art Market," working paper (February 2009) (JEL Classification: G1, Z11). Another helpful overview is Orley Ashenfelter and Kathryn Graddy, "Art Auctions," in *Handbook of the Economics of Art and Culture*, ed. Ginsburgh and Throsby, pp. 921–23.

95. See Anderson, "Paintings as an Investment"; John Picard Stein, The Appreciation of Paintings, Ph.D. diss., University of Chicago, 1973; and Stein, "The Monetary Appreciation of Paintings," *Journal of Political Economy*, vol. 85, no. 5 (1977): 1021–35.

96. Emphasis added. Baumol, "Unnatural Value," p. 14. On the random walk theory, see Eugene Fama, "Random Walks in Stock Market Prices," *Financial Analysts Journal*, vol. 21, no. 5 (1965): 55–59; and Burton Malkiel, *A Random Walk Down Wall Street* (New York: Norton, 1973). These concepts are ultimately related to the Efficient Market Hypothesis: Eugene Fama, "Efficient Capital Markets: A Review of Theory and Empirical Work," *Journal of Finance*, vol. 25, no. 2 (May 1970): 383–417.

97. Goetzmann does, however, find that other periods were more robust: from 1900 to 1986, art generated real returns of 13.3 percent. William Goetzmann, "Accounting for Taste: Art and the Financial Markets over Three Centuries," *American Economic Review*, vol. 83, no. 5 (December 1993): 1370–76.

98. Ibid., 1374–75.

99. For a good overview of these arguments, see Victor Ginsburgh, Jianping Mei, and Michael Moses, "The Computation of Prices Indices," in *Handbook of the Economics of Art and Culture*, ed. Ginsburgh and Throsby, pp. 947–79; and William Goetzmann and Liang Peng, "The Bias of the RSR Estimator and the Accuracy of Some Alternatives," *Real Estate Economics*, vol. 30, no. 1 (Spring 2002): 13–39.

100. The hedonic method draws on H. S. Houthakker's early contribution to the problem of quality variation and the theory of consumer behavior in 1952. It was first put to broad use in 1971 by Zvi Griliches and was modified by Sherwin Rosen in 1974. See H. S. Houthakker, "Compensated Changes in Quantities, and Qualities Consumed," *Review of Economic Studies*, vol. 19, no. 3 (1952–53): 155–64; Zvi Griliches, *Price Indexes and Quality Change: Studies in New Methods of Measurement* (Cambridge: Harvard University Press, 1971); and Sherwin Rosen, "Hedonic Prices and Implicit Markets: Product Differentiation in Pure Competition," *Journal of Political Economy*, vol. 82, no. 1 (January–February 1974): 34–55.

101. A combined RSR-hedonic model has also recently been proposed: Marilena Locatelli-Biey and Roberto Zanola, "The Market for Picasso Prints: A Hybrid Model Approach," *Journal of Cultural Economics*, vol. 29, no. 2 (May 2005): 127–36.

102. Kusin quoted in Bruce Wolmer, "Conversation: Crunching the Numbers," *Art + Auction*, vol. 27, no. 12 (August 2005): 50.

103. In a study of Impressionist and Modern painting sales from 1980 to 1991, Ashenfelter and Graddy find that a RSR of 474 price pairs generated a return of 9 percent, versus a 4 percent return in a hedonic regression of 8,792 artworks from the same data set. See Ashenfelter and Graddy, "Art Auctions," in *Handbook of the Economics of Art and Culture*, ed. Ginsburgh and Throsby, p. 916.

104. Alan Beggs and Kathryn Graddy offer one notable exception. See Alan Beggs, and Kathryn Graddy, "Failure to Meet the Reserve Price: The Impact on Returns to Art," working paper, JEL Classification Numbers: D44, L82, July 2006.

105. For an alternative approach, reference Velthuis's study of gallery sales in the contemporary Dutch art market in Velthuis, *Talking Prices*, pp. 97–11. This weakness of the literature is reinforced by Guerzoni, who notes that thirty of the thirty-two investment return studies he analyzed for an article on the subject were based exclusively on auction house data: Guido Guerzoni, "Analysing the Price of Art: What the Indices Do Not Tell You," *Art Newspaper*, no. 157 (April 2005): 54.

106. Guerzoni (ibid.) has estimated that paintings constitute just 30 percent of the entire art trade. For research into alternative collectables, see Olivier Chanel, Louis-André Gérard-Varet, and Stéphanie Vincent, "Auction Theory and Practice: Evidence from the Market for Jewellery," in *Economics of the Arts: Selected Essays*, ed. Victor Ginsburgh and Pierre-Michel Menger (Amsterdam: Elsevier, 1996), pp. 135–49; James Pesando, "Art as an Investment: The Market for Modern Prints," *American Economic Review*, vol. 83, no. 5 (December 1993): 1075–89; and James Pesando and Pauline Shum, "The Return to Picasso's Prints and to

Traditional Financial Assets, 1977 to 1996," *Journal of Cultural Economics*, vol. 23, no. 3 (1999): 183–92.

107. There are additional upward biases within the sample set too. If a painting sold at Christie's or Sotheby's, New York, is known to have a past auction sale, Mei and Moses include this prior record in their dataset to calculate the relevant investment return. By the same token, however, if a painting has its first sale at Christie's or Sotheby's, New York, and is later resold elsewhere—even at a rival New York auctioneer, or at another international venue of Christie's or Sotheby's, let alone smaller auctioneers elsewhere—the painting is not included. Assuming that these two New York auction houses represent the apex of the art market, Mei and Moses therefore capture the price movements of paintings on their upward trajectory but subsequently fail to account for the universe of paintings that never reach this part of the market or only sell once at one of these houses and later fall from fashion. For a good discussion of this, see Luc Renneboog and Christophe Spaenjers, "The Upward Bias in Repeat Sales Art Indices," ms., Tilburg University, 2009.

108. http://www.artasanasset.com/main/.

109. The Art Trading Fund, a U.K. art investment fund launched in 2007, tried to resolve this limitation through a trading strategy in which long positions in art were hedged by shorting stocks like Sotheby's and the luxury goods group Richemont, which they believed have a high correlation to the art market. The idea was that unlike ordinary buy-and-hold art investors, ATF would be able to make money on art price declines through offsetting put options on stocks whose performance is closely linked to the health of the art economy. Critics, however, were vocal in challenging the actual extent of such correlations and the efficacy of this strategy as a *real* hedge. Though ATF counted megacollector Charles Saatchi as one of its advisors, its flagship fund managed to raise only $10 million and a second fund was delayed in 2009. As late as November 2009 its website claimed that cofounders Justin Williams and Chris Carlsson had reoriented their focus toward Artistic Investment Advisors, a more general art advisory business, and were also raising capital for a new five-year distressed Vulture Fund. The website, however, has since been disbanded and in December 2009 the fund officially shut down. For an overview of ATF, see Steve Johnson, "Hedge Fund Sees Art as Exotic Asset Class," *Financial Times*, 15 June 2007. For a good critique, see Felix Salmon's string of blogs on ATF posted between 14 May 2007 and 23 May 2008, available at http://www.portfolio.com/views/blogs/market-movers. On ATF's troubles, see Melanie Gerlis, "Downturn Hits Art Investment Funds," *Art Newspaper*, no. 201 (April 2009).

110. For a useful summary of these points, see Groysberg, Keller, and Podolny, "Fernwood Art Investments," pp. 4–5.

111. Private treaty sales conducted by auction houses offer one exception to this, whereby the house brokers a transaction between buyer and seller behind closed doors without the auction bidding process. Sales conducted in this way compete directly with the private dealer market. It has been widely noted that this facet of auction houses' business has increased in recent years in their attempt to offer a broader range of artworks and services to clients. Sotheby's 2006 acquisi-

tion of Noortman Fine Art, the preeminent Old Master and Impressionist dealer in Holland, followed by Christie's purchase of the contemporary art gallery Haunch of Venison in 2007, offer two significant recent steps taken by the auction houses to achieve a presence in this area. This emphasis has been especially notable since the sharp downturn of auction consignments in the wake of the credit crunch, with the firms relying ever more on such sales, which can be advantageous to clients who do not want to risk their art being bought-in at auction, to drive bottom-line revenues: private treaty sales grew by 27 percent in 2009, to a value of $472.6 million, from the previous year.

112. Ibid., p. 5. Economists Frey and Eichenberger suggest that this constant removing of works from the marketplace is one reason why "particular [price] anomalies are even larger and more widespread with respect to art than in the financial markets." See Bruno Frey and Reiner Eichenberger, "On the Return of Art Investment: Return Analyses," *Journal of Cultural Economics*, vol. 19, no. 3 (1995): 212–13.

113. See Groysberg, Keller, and Podolny, "Fernwood Art Investments," p. 4.

114. Economists account for this disparity by underscoring the "aesthetic" dividends enjoyed by collectors of art.

115. The Barclays study is based upon the Mei and Moses RSR data set. See Barclays Capital, "Equity Guilt Study," February 2005, p. 67; and Georgina Adam, "You Can Make Money on Art, But Only after 35 Years," *Art Newspaper*, no. 157 (April 2005): 54.

116. Mei and Moses, "Art as an Investment," p. 1666. Emphasis added.

117. The rise in buyer's premiums during this period has been counterbalanced by a steady decline in seller's commissions. Indeed, charges to blue-chip sellers were often eliminated altogether and substituted with lucrative up-front guarantees and other financial incentives in an attempt to win business at the peak of the post-2000 bubble. As a new equilibrium comes into order, following significant declines in the volume and value of art sales in 2009, seller's commissions may once again come back into vogue and possibly even increase in order to offset the tapering of revenues from buyer's premiums.

118. Indeed, of the thirty-two art investment return studies analyzed by Guerzoni, only four accounted for transaction costs, which, he estimates, represent approximately 25 percent of the artwork's value. Guerzoni, "Analysing the Price of Art."

119. Though, as we have seen with Saatchi, this hardly means that aggressive trading, especially in the primary market, is unprofitable; it is just risky and subject to potentially onerous externalities. Quoted in Frey and Eichenberger, "On the Return of Art Investment," p. 213.

120. For further reading, see Andrei Shleifer and Robert Vishny, "The Limits of Arbitrage," *Journal of Finance*, vol. 52, no. 1 (March 1997): 35–55; Andrei Shleifer, *Inefficient Markets: An Introduction to Behavioral Finance* (Oxford: Oxford University Press, 2000); and Nicholas Barberis and Richard Thaler, "A Survey of Behavioral Finance," in *Corporate Finance: Handbook of the Economics of Finance*, ed. George Constantinides, Milton Harris, and René Stulz (Amsterdam: Elsevier, 2003), pp. 1053–1123.

121. For an argument about why anomalies are likely to be larger and more widespread in art than in financial markets, see Bruno Frey and Reiner Eichenberger, "On the Rate of Return in the Art Market: Survey and Evaluation," *European Economic Review*, vol. 39 (1995): 531–33. We will also see, in the next section, how divergent socioeconomic utility maximization functions of art market actors may further complicate arbitrage efficiency.

122. See especially Taub, "New Choices for Sophisticated Investors," pp. 3–4.

123. Richard Coffman, "Art Investment and Asymmetrical Information," *Journal of Cultural Economics*, vol. 15, no. 2 (1991): 93. Emphasis added.

124. Akerlof's paper on "lemons" in the used car market is the most influential study of informational asymmetries: George Akerlof, "The Market for 'Lemons:' Quality Uncertainty and the Market Mechanism," *Quarterly Journal of Economics*, vol. 84, no. 3 (August 1970): 488–500. For an informative application in the art trade, see also William Goetzmann, "The Informational Efficiency of the Art Market," *Managerial Finance*, vol. 21, no. 6 (1993): 25–34.

125. Quoted in Groysberg, Keller, and Podolny, "Fernwood Art Investments," p. 1.

126. Coffman, "Art Investment and Asymmetrical Information," p. 92.

127. For an introduction to this school of thought, see Mark Granovetter and Richard Swedberg, eds., *The Sociology of Economic Life* (Boulder: Westview Press, 1992); and Richard Swedberg, *Principles of Economic Sociology* (Princeton: Princeton University Press, 2003). On embeddedness, see Mark Granovetter, "Economic Action and Social Structure: The Problem of Embeddedness," *American Journal of Sociology*, vol. 91, no. 3 (November 1985): 481–510.

128. For an alternative revisionist account of financial markets, see especially Mitchel Abolafia, *Making Markets: Opportunism and Restraint on Wall Street* (Cambridge: Harvard University Press, 1996).

129. Velthuis, *Talking Prices*, p. 6. See also Viviana Zelizer, "How and Why Do We Care about Circuits," *Accounts. Newsletter of the Economic Sociology Section of the American Sociological Section*, vol. 1 (2000): 3–5.

130. On "family" rhetoric in the dealer market, see Velthuis, *Talking Prices*, pp. 53–76.

131. Ibid., pp. 77–79.

132. Addressing the French art market setback of the early 1960s, Moulin actually observes the inverse—that collectors at "public auctions ... have been able to buy paintings for one-tenth the amount that paintings by the same painter cost in a gallery (5,000 as against 50,000 Francs)." See Moulin, *French Art Market*, p. 170.

133. Velthuis, *Talking Prices*, p. 90. This point is also developed in James Sproule, "When a Deep Wallet Isn't Enough," *Art Newspaper*, no. 171 (July–August 2006): 27.

134. Thus the higher prices Velthuis discovers at auction may reflect "premiums" to transact quickly and outside of dealers' direct influence. Or conversely, existence of gallery markups constitutes insurance premiums: collectors are privy to a greater inventory of works in their specific area of interest, while the collector's personal relationship with a dealer (trust) and the latter's expertise represent "quality" guarantees. Reference in Velthuis, *Talking Prices*, pp. 79–80. For further evidence of price dispersion and antagonistic dealer-auction relationships,

see Federico Ruberti, "Too Much to Do with Investment," *Art Newspaper*, no. 83 (July–August 1998): 37

135. On the dealer/auction schism, see Velthuis, *Talking Prices*, pp. 80–96.

136. Ibid., pp. 95–96. For another example of this antagonism, see Lauren Schuker, "Painted into a Corner," *Wall Street Journal*, 27 October 2007.

137. Although true in principle, such protectionist policies also have a tendency to dissipate in weak economic climates: few dealers, in the face of recession, turn away prospective buyers. For further anecdotal evidence of such protectionism, see Roger Bevan, "The Changed Contemporary Art Market: Breaking the Mold," *Art Newspaper*, no. 121 (January 2002): 34.

138. Velthuis draws extensively on Bourdieu to explain this "denial of economic interests." For further reference, see Velthuis, *Talking Prices*, pp. 26–28. Abbing gives an informative account of these circumstances as well, in Hans Abbing, *Why Are Artists Poor? The Exceptional Economy of the Arts* (Amsterdam: Amsterdam University Press, 2002).

139. Velthuis, *Talking Prices*, p. 76.

140. Viviana Zelizer, *The Social Meaning of Money: Pin Money, Paychecks, Poor Relief, and Other Currencies* (New York: Basic Books, 1994), p. 77.

141. Quoted in ibid., p. 91.

142. Fee structures provided by FAF.

143. An exception to this is the Collection of Modern Art, run by Castlestone Management, which employs an in-house team to execute all sales and trading.

144. One solution may be to employ traders on the funds' full-time payroll; however, to date this has not been widely adopted.

145. Quotations in this paragraph from Georgina Adam and Brook Mason, "Art Funds Struggling," *Forbes* (September 2005), available at http://www.forbes.com/home/collecting/2005/09/19/abn-amro-artfunds-cx_0920hot_ls.html.

146. All figures provided by FAF and current as of October 2009.

147. Anthony Haden-Guest, "Promises of Perfection," *Financial Times*, 17 June 2006.

148. Plummer quoted in ibid.

149. *Whitmore Brey LLC, The Hinchliffe Living Trust, Louise and Tom Jones Subscription LLC, Andrea Van de Kamp, William Pearlstein, John Scharffenberger and Ashton Hawkins v. Bruce D. Taub, Fernwood Art Investments LLC IMA, LLC, and Fernwood Management Services, LLC*, United States District Court Southern District of New York, 27 February 2007, p. 2.

150. The bulk of the $25 million reported to have been invested with Fernwood seems to have been little more than an unsubstantiated claim by Taub that Merrill Lynch, his former employer, had agreed to invest upwards of $20 million in the fund and to market it to its clients. This money, however, was never actually invested.

151. In July 2007 it was reported that both law firms representing Taub—Jager Smith PC and Pachulski Stang Ziehl Young Jones & Weintraub LLP—withdrew from the case. See Lauren Gentile, "Taub's Lawyers Leave Him," 11 July 2007, available at http://specullector.com/category/bruce-taub/.

152. Fine Art Wealth Management, "*Art Fund Tracker*," Issue 1 (November 2008): 1.

153. On WMG Photography Collection, see Colin Cameron, "Altered Images," *Financial Times*, 15–16 September 2007; and Julia Werdigier, "Building a Portfolio with Things, Not Paper," *New York Times*, 13 July 2007. On the Merit Art Photography Fund, see Fine Art Wealth Management, *Art Fund Tracker*, Issue 2 (April 2009): 4–5.

154. Aurora appears to exist solely to the benefit of Vekselberg himself, who is the majority shareholder and only known investor in the fund. For further information, see John Varoli, "Ukrainian Billionaire Sets Up New Fund for Russian Art," *Art Newspaper*, no. 160 (July/August 2005): 1; Varoli, "New Fund Will Spend $100 Million on Russian Art," *Art Newspaper*, no. 163 (November 2005): 52; Varoli, "A Fund's New Dawn," *Art + Auction* (August 2008): 51–54; and http://www.aurorafund.com. On Meridian, see "Meridian Art Partners Announces Launch of New Emerging Markets Art Fund," 1 September 2008, available at http://meridianartpartners.com/press/.

155. For further information about these funds, see Deepti Bhaskaran, "Have Money, Should Buy," 23 July 2007, available at http://www.expressindia.com/news/fullstory.php?newsid=89889; Abhay Rao, "Art Funds Trying to Paint a Brighter Picture," 23 November 2008, available at http://www.financialexpress.com/news/art-funds-trying-to-paint-a-brighter-picture/389318/0#; "Interview with Neville Tuli," in *Art Fund Tracker*, issue 1, pp. 2–3,14; http://osians.com/wms/funds.php; and www.crayoncapital.com.

156. Dominic O'Connell, "Fine Art Fund Group Will Cash in on Falling Art Prices," *Sunday Times*, 11 January 2009.

157. See Melanie Gerlis, "Can You Trade Your Way through a Recession?," *Art Newspaper*, no. 190 (April 2008); and http://www.deanartinvestments.com/.

158. See Roger Bevan, "C&M Aims High," *Art Newspaper*, no. 26 (March 1993): 22; and Sarah Douglas, "The Wise Men: Robert Mnuchin," *Art + Auction*, annual investment issue (August 2008): 22–23.

159. On ArtVest, the Art Collectors Fund, and Graham Arader, see Adam and Mason, "Art Funds Struggling." It has also been reported that the Art Collectors Fund's has revised its capital target from $200 million to $50 million. See http://www.caslon.com.au/artfundsnote2.htm.

160. Westreich quoted in Adam and Mason, "Art Funds Struggling," 2005.

161. "Buttonwood: Identity Crisis," *Economist*, 30 June 2007, p. 73.

162. Moses quoted in Donn Zaretsky, "Fernwood Suit," 17 April 2007, at http://theartlawblog.blogspot.com/2007/04/fernwood-suit.html.

163. The Fine Art Fund Group, "Art Market Update: Impact of the Financial Crisis," March 2009.

164. For an analysis of this, see Melanie Gerlis, "Downturn Hits Art Investment Funds," *Art Newspaper*, no. 201 (April 2009): 1.

165. An overview of this is provided in appendix C. See also Ute Krepler, "Art Fund Adventures," *Artinvestor*, no. 1 (2007): 83. On the Art Trading Fund, see also n. 110 above.

166. Author's email correspondence with Littlejohn, 24 January 2009.

167. Sergey Skaterschikov, "Art Industry Investment Report," 23 January 2009, available at http://www.skatepress.com/index.php. See also Sergey Skaterschikov, *Skate's Art Investment Handbook* (Vienna: Kunst AM, 2006).

168. Katya Kazakina, "Banker Waits Out Global Crisis, Auction Slump to Test Art Fund," *Bloomberg News*, 17 February 2010.

169. Hoffman quoted at the Art Fund and Art Advisory panel session in London on 13 October 2009.

Conclusion

1. Insolvencies in Britain increased from an average of 24,000 annually in 1997 to over 100,000 by 2007, at which point British consumer debt stood at £1,345 billion versus £1,330 billion in GDP. Figures from successive annual reports issued in 2007 and 2008 by chartered accountants Grant Thornton. See "Amount of UK Consumer Debt Exceeds UK GDP as Country Struggles to Pay Off Personal Debt," available at http://www.grant-thornton.co.uk/press_room/amount_of_uk_consumer_debt_exc.aspx and "UK Personal Debt Exceeds UK GDP for Second Year Running," available at http://www.grant-thornton.co.uk/press_room/uk_personal_debt_exceeds_uk_gd.aspx.

2. Household debt grew from 66.1 percent of GDP in 1997 to 99.9 percent in 2007. Figures in this paragraph from Robin Blackburn, "The Subprime Crisis," *New Left Review*, no. 50 (March/April 2008): 66.

3. Two instructive accounts on the underpinnings of the crisis are Paul Mason, *Meltdown: The End of the Age of Greed* (London: Verso, 2009); and Gillian Tett, *Fool's Gold: How Unrestrained Greed Corrupted a Dream, Shattered Global Markets and Unleashed a Catastrophe* (London: Little, Brown, 2009).

4. Elizabeth Hester, "JPMorgan Seals Bear Stearns Purchase, Ending Era," *Bloomberg News*, 29 May 2008, available at http://www.bloomberg.com.

5. Stephen Labaton and Edmund L. Andrews, "In Rescue to Stabilize Lending, U.S. Takes over Mortgage Finance Titans," *New York Times*, 8 September 2008.

6. Two months later, the U.S. Treasury restructured its deal with AIG, increasing its total financing to $150 billion. This was raised once again in March 2009 with the government agreeing to provide an additional $30 billion. See Andrew Ross Sorkin and Mary Williams Walsh, "U.S. Is Said to Offer Another $30 Billion in Funds to A.I.G.," *New York Times*, 1 March 2009.

7. Eric Dash and Andrew Ross Sorkin, "Government Seizes WaMu and Sells Some Assets," *New York Times*, 25 September 2008.

8. Andrew Porter, James Kirkup, Gordon Rayner, and Jon Swaine, "Financial Crisis: Banks Nationalised by Government," *Telegraph*, 13 October 2008.

9. The recession in the United States, which was estimated to have commenced in December 2007, was officially announced by the National Bureau of Economic Research in December 2008. See http://www.nber.org/dec2008.pdf.

10. Peter Graham, "Bernanke Comment Helps Dollar Recover," *Financial Times*, 9 July 2008.

11. See Bill Emmott, "Can China and India Save the US?," *Guardian*, 11 April 2008; and John Authers, "The Short View: Time for Chindia?," *Financial Times*, 2 July 2008.

12. Quotation in David Teather, "How the Bubble Burst—and Why 10 Bourses Have Bucked the Downturn," *Guardian*, 5 August 2008.

13. Definition in Robert Shiller, *Irrational Exuberance* (New York: Broadway Books, 2000), p. 5.

14. Robert Shiller, *The Subprime Solution* (Princeton: Princeton University Press, 2008), p. 41. For a further extension of some of the ideas raised in this book, see also George Akerlof and Robert Shiller, *Animal Spirits: How Human Psychology Drives the Economy and Why It Matters for Global Capitalism* (Princeton: Princeton University Press, 2009).

15. Shiller, *Subprime Solution*, pp. 45–46.

16. For an especially good article, written at the time, see Mark Spiegler, "Five Theories on Why the Art Market Can't Crash and Why it Will Anyway," *New York Magazine*, 3 April 2006, available at http://nymag.com/arts/art/features/16542/.

17. Annual sales data provided by Artprice (see graph 2 for annual worldwide auction sales from 1998–2009).

18. Artprice, *Art Market Trends 2008*, p. 4.

19. Artprice, *Contemporary Art Market 2008/2009*, p. 86.

20. Linda Sandler and Philip Boroff, "Sotheby's Stock Drops 28% Following N.Y. Evening Sale," *Bloomberg*, 8 November 2007.

21. For perspective on this, see Robert Frank, "Is Street Turmoil Coloring Art Market?," *Wall Street Journal*, 14 April 2008; Marion Maneker, "Going, Going, Not Gone," 28 April 2008, available at http://www.slate.com/id/2190114/pagenum/all/#p2; and Ian Charles Stewart, "Of Stocks & Markets," 30 April 2008, available at http://www.artworldsalon.com/blog/2008/04/of-stocks-markets/#comments. Sotheby's financial statements are available at http://investor.shareholder.com/bid/index.cfm.

22. The presence of guarantees in the 1920s is discussed in Watson, *From Manet to Manhattan*, pp. 215–18. A more recent illustration of the riskiness of guarantees was provided in Bernard Arnault's short-lived reign as owner of rival auctioneer Phillips, de Pury & Luxembourg from 1999 to 2002, which drew to an infamously premature end as the firm incurred guarantee-related losses into the hundreds of millions in its effort to gain a foothold at the top end of the market. In November 2001 alone, the firm reportedly lost approximately $80 million in its sale of the Smooke Collection, which it had guaranteed at an estimated $185 million. By February 2002 LVMH, the parent company controlled by Arnault, trimmed its ownership in Phillips, de Pury & Luxembourg to 27.5 percent from 75 percent. See Andrew Ross Sorkin and Carol Vogel, "LVMH Luxury Conglomerate Sells Its Art Auction House," *New York Times*, 20 February 2002.

23. Sotheby's guarantee and accounts receivable figures referenced in Sotheby's, *2008 Annual Report*, pp. 25, 55. In the face of the weakening financial climate, these guarantees were reduced to $626 million, with receivables down to $544 million, in 2008.

24. Ibid., p. 25.

25. This figure, and those referenced in the three previous sentences, from Artprice, *Art Market Trends 2008*, pp. 4–5.

26. Christie's, "Christie's International Announces Worldwide Sales of £1.8 billion ($3.5 billion) for First Half 2008," 17 July 2008, available at http://www.christies.com/about/press-center/.

27. Ibid.

28. Quoted in Lauren Tara LeCapra, "A Look at How the Art Market Is Faring," 18 May 2008, available at www.thestreet.com.

29. Figures from the last two sentences of this paragraph from Artprice, *Contemporary Art Market 2008/2009*, pp. 4, 6.

30. Sotheby's and Christie's both shed approximately 20 percent of their staff during these cutbacks. Sotheby's reported that these and other cost-saving measures helped reduce operating costs by 29 percent during 2009. Source: Sotheby's Investor Briefing, March 2010, available at http://investor.shareholder.com/bid/eventdetail.cfm?EventID=79272; Artprice, *Art Market Trends 2009*, 5.

31. The reserve is a price equal to, or less than, the auction house's published presale low estimate, below which the artwork will not sell if bidding fails to reach this level.

32. "S&P Puts Sotheby's Rating on Negative Watch," *Associated Press*, 9 February 2009.

33. Philip Boroff, "Sotheby's Sees Art Market Bottom: Profit Declined 87%," *Bloomberg News*, 5 August 2009; ArtTactic, "US and European Contemporary Art Market Confidence Report," June 2009, 1; and Artprice, *Art Market Trends 2009*, 6.

34. Figure cited in Lindsay Pollock, "The Big Chill Seeps through Chelsea," *Art Newspaper*, no. 205 (September 2009): 53. Rivington Arms, on the Lower East Side, was one gallery that reportedly closed (in the beginning of 2009) due to a dispute between its founders, not because of the financial crisis. For further reference, see also Katya Kazakina, "Rivington Arms to Close as Partners Differ on Gallery's Future," *Bloomberg News*, 5 November 2008; and Roberta Smith, "The Mood of the Market, as Measured in the Galleries," *New York Times*, 4 September 2009.

35. Quoted in Judd Tully, "Changing Hue," *Art + Auction*, 1 July 2009, available at http://www.artinfo.com/news/story/31750/changing-hue/.

36. Smith, "Mood of the Market."

37. This was widely remarked upon in ArtTactic's Confidence Indicator, based upon a questionnaire survey of leading art world figures, of June 2009 which increased nearly threefold from its low in December 2008 (up to a level of 28 from 11). But despite rising confidence, more than 50 percent of respondents still held a negative view of the market at this point, and the index remained more than 60 percent off its 2007 peak. See ArtTactic, "US and European Contemporary Art Market Confidence Report," p. 1.

38. Arts Council England, "Research on the Impact of the Economic Downturn on a Range of Arts Organisations: Summary of Findings," January 2009.

39. Charlotte Higgins, "Arts Council England to Slash Jobs by a Quarter," *Guardian*, 25 February 2009.

40. Arts & Business, "Market Trends 2009" (Summer/Autumn), pp. 14–15, available at http://www.artsandbusiness.org.uk/central/research.aspx.

41. See, for example, Holland Cotter, "Museums Look Inward for Their Own Bailouts," *New York Times*, 11 January 2009.

42. For a good discussion of this, see Franklin Boyd, "The Flawed Thinking Behind Buying Art as an Investment," 17 November 2008, available at http://www.artreview.com/profiles/blog/show?id=1474022%3ABlogPost%3A573501.

43. The AMR 100 Index, which gauges price levels across the general art market, fell 63 percent from 1990 to 1992. The AMR Contemporary Art 100 Index dropped by 47 percent during the same period, while the Nikkei 225 Index fell by 54 percent.

44. By 1988, 53 percent of worldwide auction sales were to Japan. See James Goodwin, "Introduction," in *The International Art Markets*, ed. Goodwin, p. 11.

45. An important recent contribution to the literature on this is provided in Takato Hiraki, Akitoshi Ito, Darius A. Spieth, and Naoya Takezawa, "How Did Japanese Investments Influence International Art Prices?," *Journal of Financial and Quantitative Analysis*, vol. 44, no. 6 (2009): 1489–1514.

46. See, for example, Goetzmann, "Accounting for Taste."

47. An instructive discussion of these issues is provided in the following paper, which is also one of the first to systematically analyze the impact of wealth creation on art prices over the long term: William Goetzmann, Luc Renneboog, and Christoph Spaenjers, "Art and Money," Yale ICF Working Paper no. 09-26, available at http://ssrn.com/abstract=1501171.

48. All prices in this paragraph are from Christie's and Sotheby's press releases. For the identify of the buyers, see Thornton and Ruiz, "Revealed," p. 1; and Stephen Adams, "Roman Abramovich 'Revealed as Freud and Bacon Buyer,'" *Telegraph*, 18 May 2008.

49. Ingrid Sischy, "Money on the Wall," *Vanity Fair*, 1 December 2006, pp. 199, 202.

50. McAndrew, *Globalisation and the Art Market*, p. 10.

51. Data provided by Sotheby's.

52. For a good critique of the extent of the art market's globalization, see Quemin, "The Illusion of the Elimination of Borders."

53. McAndrew, *Globalisation and the Art Market*, pp. 21–22.

54. For a good discussion of this, see Antonia Carver, "The Art Market Forum: Are Auction Houses Moving onto Gallery Turf?," *Bidoun*, no. 13 (Winter 2008), available at http://www.bidoun.com/13_artmarket.php.

55. Goodwin, ed., *The International Art Markets*, provides introductions to these, and other, international art markets.

56. For an overview of these developments, see Susan Moore, "An Imprint of the Soul of Dubai," *Financial Times*, 7 March 2009.

57. This trajectory has been extraordinary: "Only one Chinese artist—Zao Wouki, a traditional painter who lives in France—ranked among the Top Ten best-selling living artists in 2004, according to Artprice.com, which tracks auction sales. (He ranked ninth.) But by 2007, five of the ten best-selling living artists at auction were Chinese-born, led by Zhang Xiaogang, who trailed only Gerhard Richter and Damien Hirst. That year, Mr. Zhang's auction sales totalled $56 million, according to Artprice.com." From David Barboza, "China's Art Market: Cold or Maybe Hibernating?," *New York Times*, 11 March 2009.

58. Christie's 2005 alliance with Forever, a Beijing auction house, was among the first and most notable instances of mainland China opening its art market to foreign competition (an obligation the country was required to fulfil after joining the World Trade Organization in 2001). The inaugural sale under the cobranded

Christie's/Forever partnership was conducted in Beijing in November 2005. See McAndrew, *Globalisation and the Art Market*, p. 38.

59. The increase in the value of sales in Hong Kong is especially striking, growing at Christie's Hong Kong branch from just $1.8 million in 1986 to $473 million in 2007. See Carol Vogel, "Amid Asian Art Boom, Manhattan Gallery to Open Branch in Beijing," *New York Times*, 29 April 2008.

60. For a good discussion of this, see McAndrew, *Globalisation and the Art Market*.

61. Artprice, *Contemporary Art Market 2008/2009*, p. 91.

62. Blackburn, "The Subprime Crisis," p. 67.

63. Gillian Tett, "A Lack of Trust Spells Crisis in Every Financial Language," *Financial Times*, 18 March 2008.

64. Greenfeld, "Sort of the Svengali of Pop," p. 45.

65. Shiller, *Subprime Solution*, p. 58.

66. Watson, *From Manet to Manhattan*, pp. 479–80.

67. For example, none of the artists at the core of chapters 1 and 2 featured in the 2008 list of Top 50 artists by value at auction (Bill Viola is highest at number 62), whereas upwards of half of the Top 20 places in the most recent *Kunstkompass* annual rankings have comprised artists who work actively in film, video, and installation. See, for example, Artprice, *Contemporary Art Market 2008/2009*, p. 70; and *Kunstkomkpass*, 2009.

68. The termination of Sotheby's partnership with eBay bore a one-time restructuring charge of approximately $2 million, and it was reported that between 1999 and 2003 the auction house had absorbed losses of up to $100 million from its online auctions. Indeed, Sotheby's earlier partnership with Amazon (sothebys. amazon.com) drew to a close in October 2000 after launching in January that year; for its Internet-related sales of $31 million in the first half of the 2000, it reported losses of $28 million. See Georgina Adam, "Sothebys.amazon.com Closes," *Art Newspaper*, no. 108 (November 2000); Sotheby's, "Sotheby's Holdings, Inc. Announces Full Year and Fourth Quarter Results," 17 March 2003, available at http://investor.shareholder.com/bid/; "Industry News—Sotheby's Logs Out of Ebay Deal," 11 February 2003, available at http://www.timezone.com/library/news/news631805827943125000. Another notable art e-retailing failure was that of Eyestorm Media, which launched amid great fanfare in 1999 and sought to sell editions and commissioned works by artists such as Hirst and Koons. The venture was ultimately shut down in 2002, however, with debts estimated at $30 million.

69. Figures in "The World's Biggest Saleroom: Auctions Are Moving Online," *Economist*, 28 November 2009, p. 4 (of special report on the art market).

70. For an example of cultural and economic debate on Web 2.0, see *Mute: Culture and Politics after the Net*, vol.2, no. 4 (January 2007). On the potentiality of, and challenges facing, online cultural practices, see Stallabrass, *Internet Art*.

Selected Bibliography

Abbing, Hans. *Why Are Artists Poor? The Exceptional Economy of the Arts*. Amsterdam: Amsterdam University Press, 2002.

Abolafia, Mitchel Y. *Making Markets: Opportunism and Restraint on Wall Street*. Cambridge: Harvard University Press, 1996.

Adam, Georgina, and James Sproule. "Crystal-ball Gazing: Four Reasons Why the Market Could Be Heading for a Bust … and Five Why It Is Not," *Art Newspaper*, no. 128 (September 2002).

Adler, Moshe. "Stardom and Talent." *American Economic Review*, vol. 75, no. 1 (March 1985): 208–12.

Adorno, Theodor. *The Culture Industry: Selected Essays on Mass Culture*, ed. J. M. Bernstein. London: Routledge, 1991.

Alberro, Alexander. "Deprivileging Art: Seth Siegelaub and the Politics of Conceptual Art." Ph.D. diss., Northwestern University, 1996.

———. *Conceptual Art and the Politics of Publicity*. Cambridge: MIT Press, 2003.

Alberro, Alexander, and Sabeth Buchmann, eds. *Art after Conceptual Art*. Cambridge and Vienna: MIT Press and Generali Foundation, 2006.

Alberro, Alexander, and Blake Stimson, eds. *Conceptual Art: A Critical Anthology*. Cambridge: MIT Press, 2000.

Albright-Knox Art Gallery. *Being and Time: The Emergence of Video Projection*, exh. cat. Buffalo, 1996.

Allen, Greg. "When Fans of Pricey Video Art Can Get It Free." *New York Times*, 17 August 2003.

Altshuler, Bruce. *The Avant-Garde in Exhibition: New Art in the 20th Century*. New York: Harry N. Abrams, 1994.

———, ed. *Collecting the New: Museums and Contemporary Art*. Princeton: Princeton University Press, 2005.

Anderson, Chris. *The Long Tail*. London: Random House, 2006.

Anderson, Robert C. "Paintings as an Investment." *Economic Inquiry*, vol. 12 (1974): 13–26.

Andersson, Cecilia, ed. *X Factor* Liverpool: FACT, 2003.

Andre, Carl, and Jeremy Gilbert-Rolfe. "Commodity and Contradiction, or Contradiction as Commodity." *October*, vol. 2 (Summer 1976): 100–104.

Anon. "Art as Investment: Betting on Genius." *Economist*, 23 August 2003, pp. 55–56.

Antin, David. "Television: Video's Frightful Parent." *Artforum*, vol. 14, no. 4 (December 1975): 36–45.

Arrighi, Giovanni. *The Long Twentieth Century: Money, Power and the Origins of Our Times*. London: Verso, 1994.

Artprice. *Art Market Trends 2008*. St-Romain-au-Mont-d'Or: Artprice.com, 2009.

———. *Contemporary Art Market 2008/2009: The Artprice Annual Report*. St-Romain-au-Mont-d'Or: Artprice.com, 2009.

———. *Art Market Trends 2009*. St-Romain-au-Mont-d'Or: Artprice.com, 2010.

Ashenfelter, Orley, and Kathryn Graddy. "Auctions and the Price of Art." *Journal of Economic Literature*, vol. 41 (2003): 763–87.

Badger, Gerry. *Collecting Photography*. London: Mitchell Beazley, 2003.

Bakos, Ján, ed. *Artwork Through the Market: The Past and the Present*. Bratislava: Foundation-Center for Contemporary Arts, 2004.

Balakrishnan, Gopal, ed. *Debating Empire*. London: Verso, 2003.

Bankowsky, Jack. "Tent Community: On Art Fair Art." *Artforum*, vol. 44, no. 2 (October 2005): 228–32.

Baumol, William. "Unnatural Value: Or Art Investment as Floating Crap Game." *American Economic Review*, vol. 76, no. 2 (May 1986): 10–14.

Baxandall, Michael. *Painting and Experience in Fifteenth-Century Italy: A Primer in the Social History of Pictorial Style*. 2nd ed. Oxford: Oxford University Press, 1988.

Becker, Howard. *Art Worlds*. Berkeley and Los Angeles: University of California Press, 1982.

Beech, Dave. "Video after Diderot." *Art Monthly*, no. 225 (1999): 7–10.

———. "The Art of the Encounter." *Art Monthly*, no. 278 (July–August 2004): 46.

Beggs, Alan, and Kathryn Graddy. "Failure to Meet the Reserve Price: The Impact on Returns to Art." Working paper, JEL Classification Numbers: D44, L82, July 2006.

Bell, Daniel. *The Coming of Post-Industrial Society: A Venture in Social Forecasting*. London: Heinemann Educational Books, 1974.

Bellour, Raymond. "Interview with Bill Viola." *October*, no. 34 (Autumn 1985): 91–119.

Belting, Hans, and Andrea Buddensieg, eds. *The Global Art World: Audiences, Markets and Museums*. Ostfildern: Hatje Cantz Verlag, 2009.

Benkler, Yochai. *The Wealth of Networks: How Social Production Transforms Markets and Freedom*. New Haven: Yale University Press, 2006.

Bhabha, Homi. *The Location of Culture*. London: Routledge, 1994.

Bishop, Claire. "Antagonism and Relational Aesthetics." *October*, no. 110 (Fall 2004): 51–79.

———. *Installation Art: A Critical History*. New York: Routledge, 2005.

———. "The Social Turn: Collaboration and Its Discontents." *Artforum*, vol. 44, no. 6 (February 2006): 178–83.

Boltanski, Luc, and Eve Chiapello. *The New Spirit of Capitalism* [1999], trans. Gregory Elliott. London: Verso, 2005.

Bonus, Holger, and Dieter Ronte. "Credibility and Economic Value in the Visual Arts." *Journal of Cultural Economics*, vol. 21 (1997): 203–18.

Boomgaard, Jeroen, and Bart Rutten. *The Magnetic Era: Video Art in the Netherlands, 1970-1985*. Rotterdam: NAi Publishers, 2003.

Bosma, Josephine, ed. *Readme! ASCII Culture and the Revenge of Knowledge.* Brooklyn: Autonomedia, 1999.

Boswijk, Albert, Thomas Thijssen, and Ed Peelen. "A New Perspective on the Experience Economy," 2005, available at http://www.experience-economy.com/wp-content/UserFiles/File/Article%20Lapland5.pdf.

Bourdieu, Pierre. *The Field of Cultural Production: Essays on Art and Literature,* ed. Randal Johnson. Cambridge: Polity Press, 1993.

———. *The Rules of Art: Genesis and Structure of the Literary Field.* Cambridge: Polity Press, 1996.

———. *Distinction: A Social Critique of the Judgment of Taste* [1979], trans. Richard Nice. New York: Routledge, 2003.

Bourriaud, Nicolas. *Relational Aesthetics* [1998], trans. Mathieu Copeland, Simon Pleasance, and Fronza Woods. Dijon: Les presses du réel, 2002.

———. *Postproduction,* trans. Jeanine Herman. New York: Lukas & Sternberg, 2002.

———. *The Radicant,* trans. James Gussen and Lili Porten. New York: Lukas & Sternberg, 2009.

Boyd, Franklin. "The Flawed Thinking Behind Buying Art as an Investment," 17 November 2008, available at http://www.artreview.com/profiles/blog/show?id=1474022%3ABlogPost%3A573501.

Boyle, James. *Shamans, Software and Spleens: Law and the Construction of the Information Society.* Cambridge: Harvard University Press, 1996.

Brenner, Robert. *The Boom and the Bubble: The U.S. in the World Economy.* London: Verso, 2002.

Brown, Stephen J., William Goetzmann, and Stephen A. Ross. "Survival." *Journal of Finance,* vol. 50, no. 3 (1995): 853–73.

Buchloh, Benjamin. "From Gadget Video to Agit Video: Some Notes on Four Recent Video Works." *Art Journal,* vol. 45, no. 3 (Autumn 1985): 217–27.

———. "Conceptual Art 1962–1969: From the Aesthetic of Administration to the Critique of Institutions." *October,* no. 55 (Winter 1990): 105–43.

———. "Into the Blue: Klein and Poses." *Artforum,* vol. 33, no. 10 (Summer 1995): 92–97, 130, 136.

———. *Neo-Avantgarde and Culture Industry: Essays on European and American Art from 1955 to 1975.* Cambridge: MIT Press, 2003.

Buck, Louisa. *Market Matters: The Dynamics of the Contemporary Art Market.* London: Arts Council England, 2004.

Buck, Louisa, and Judith Greer. *Owning Art: The Contemporary Art Collector's Handbook.* London: Cultureshock Media, 2006.

Buelens, Natalie, and Victor A. Ginsburgh. "Revisiting Baumol's Art as a Floating Crap Game." *European Economic Review,* vol. 37, no. 7 (1993): 1351–71.

Bürger, Peter. *Theory of the Avant-Garde,* trans. Michael Shaw. Minneapolis: University of Minnesota Press, 1984.

Bydler, Charlotte. *The Global Artworld, Inc.: On the Globalization of Contemporary Art.* Stockholm: Uppsala University, 2004.

Campbell, Rachel. "Art as an Alternative Asset Class." Working paper, Maastricht University, 2005.

———. "Art as a Financial Investment." *Journal of Alternative Investments* (Spring 2008): 64–81.

———. "Is Art an Investable Asset Class?," April 2009, available at http://www.collectionofmodernart.co.uk/#/research/.

Carver, Antonia. "The Art Market Forum: Are Auction Houses Moving onto Gallery Turf?" *Bidoun*, no. 13 (Winter 2008), available at http://www.bidoun.com/13_artmarket.php.

Castells, Manuel. *The Information Age: Economy Society and Culture*, Volume 1: *The Rise of the Network Society.* 2nd ed. Oxford: Blackwell, 2000.

———. *The Internet Galaxy: Reflections on the Internet, Business and Society.* Oxford: Oxford University Press, 2001.

Caves, Richard E. *Creative Industries: Contracts between Art and Commerce.* Cambridge: Harvard University Press, 2000.

Centre Georges Pompidou, *Les Immatériaux: Epreuves d'écriture*, exh. cat., Paris, 1985.

———. *New Media Collection. Installations. La collection du Centre Pompidou/ Musée national d'art moderne*, exh. cat. Paris, 2007.

Chanel, Olivier, Louis-André Gérard-Varet, and Victor A. Ginsburgh. "The Relevance of Hedonic Price Indexes." *Journal of Cultural Economics*, vol. 20, no. 1 (1996): 1–24.

Charlesworth, J. J. "Bonfire of the Vanities." *Art Monthly*, no. 305 (April 2007): 5–8.

Coffman, Richard B. "Art Investment and Asymmetrical Information." *Journal of Cultural Economics*, vol. 15, no. 2 (1991): 83–94.

Coleman, James. "Social Capital in the Creation of Human Capital." *American Journal of Sociology*, vol. 94 (Supplement) (1988): S95–120.

Collins, Randall. "Situational Stratification: A Micro-Macro Theory of Inequality." *Sociological Theory*, vol. 18, no. 1 (2000): 17–43.

Comer, Stuart, ed. *Film and Video Art.* London: Tate Publishing, 2009.

Crane, Diana. *The Transformation of the Avant-Garde: The New York Art World, 1940–1985.* Chicago: Chicago University Press, 1989.

Crimp, Douglas. *On the Museum's Ruins.* Cambridge: MIT Press, 1993.

Crow, Thomas. "Historical Returns." *Artforum*, vol. 46, no. 8 (April 2008): 286–91, 390.

Cubitt, Sean. *Timeshift: On Video Culture.* London: Routledge, 1991.

Cuno, James, ed. *Whose Muse? Art Museums and the Public Trust.* Princeton: Princeton University Press, 2004.

Czujak, Corinna. "Picasso Paintings at Auction, 1963–1994." *Journal of Cultural Economics*, vol. 21, no. 3 (1997): 229–47.

Daniels, Dieter. "Television—Art or Anti-Art? Conflict and Cooperation between the Avant-Garde and the Mass Media in the 1960s and 1970s," no. 28. Available at http://www.medienkunstnetz.de/themes/overview_of_media_art/massmedia/print.

Danto, Arthur. "The Art World." *Journal of Philosophy*, vol. 61, no. 19 (1964): 571–84.

———. *Beyond the Brillo Box: The Visual Arts in post-Historical Perspective.* New York: Farrar, Straus and Giroux, 1992.

———. *After the End of Art: Contemporary Art and the Pale of History*. Princeton: Princeton University Press, 1995.

Davis, Douglas, and Allison Simmons, eds. *The New Television: A Public/Private Art*. Cambridge: MIT Press, 1977.

de la Barre, Madeleine, Sophie Docclo, and Victor A. Ginsburgh. "Return of Impressionist, Modern and Contemporary European Paintings, 1962–2001." *Annales d'économie et de Statistique*, vol. 35 (1996): 143–81.

De Marchi, Neil, and Crawford D. W. Goodwin, eds. *Economic Engagements with Art*. Durham: Duke University Press, 1999.

Denning, Michael. *Culture in the Age of Three Worlds*. London: Verso, 2004.

Depocas, Alain, Jon Ippolito, and Caitlin Jones, eds. *The Variable Media Approach: Permanence through Change*. New York and Montréal: Guggenheim Museum Publications and The Daniel Langlois Foundation for Art, Science and Technology, 2003.

DiMaggio, Paul. "Classification in Art." *American Sociological Review*, vol. 52 (August 1987): 440–55.

DiMaggio, Paul, and Hugh Louch. "Socially Embedded Consumer Transactions: For What Kinds of Purchases Do People Use Networks Most?' *American Sociological Review*, vol. 63, no. 5 (October 1998): 619–37.

Drucker, Peter. *Managing in the Next Society*. New York: St. Martin's Press, 2002.

Eco, Umberto. *The Open Work*, trans. Anna Cancogni. Cambridge: Harvard University Press, 1989.

Eichhorn, Maria. *The Artist's Contract*, ed. Gerti Feitzek. Cologne: Walther Konig, 2008.

Elwes, Catherine. "The Big Screen." *Art Monthly*, no. 199 (September 1996): 11–16.

———. *Video Art: A Guided Tour*. London: I. B. Tauris, 2005.

Faith, Nicholas. *Sold: The Rise and Fall of the House of Sotheby's*. New York: Macmillan, 1985.

Fama, Eugene. "Random Walks in Stock Market Prices." *Financial Analysts Journal*, vol. 21, no. 5 (1965): 55–59.

———. "Efficient Capital Markets: A Review of Theory and Empirical Work." *Journal of Finance*, vol. 25, no. 2 (May 1970): 383–417.

Farquharson, Alex. "I Curate, You Curate, We Curate." *Art Monthly*, no. 269 (September 2003): 7–10.

Felix, Zdenek, Beate Hentschel, and Dirk Luckow, eds. *Art & Economy*, exh. cat. Hamburg: Deichtorhallen, 2002.

Flood, Richard, and Rochelle Steiner. "En Route." *Parkett*, no. 44 (1995): 114–29.

Foster, Hal. *The Return of the Real: The Avant-Garde at the End of the Century*. Cambridge: MIT Press, 1996.

———. *Design and Crime (and Other Diatribes)*. London: Verso, 2002.

———. "Art Party." *London Review of Books*, 4 December 2003, pp. 21–22.

Frank, Robert. "Painting by Numbers: Hedge-Fund Experts Put Art in the Deal." *Wall Street Journal*, 18 May 2005.

Fraser, Andrea. "From the Critique of Institutions to the Institution of Critique." *Artforum*, vol. 44, no. 1 (September 2005): 278–83, 332.

———. *Museum Highlights: The Writings of Andrea Fraser*, ed. Alexander Alberro. Cambridge: MIT Press, 2005.

———. "What's Intangible, Transitory, Mediating, Participatory, and Rendered in the Public Sphere?" *October*, no. 80 (Spring 1997): 111–16.

Fraser, Andrea, and Andrew Hunt. "Is This a Site Specific Interview?" *Untitled*, no. 32 (Summer 2004): 4–9.

Frey, Bruno, and Reiner Eichenberger. "On the Rate of Return in the Art Market: Survey and Evaluation." *European Economic Review*, vol. 39 (1995): 528–37.

Frey, Bruno, and Werner Pommerehne. "Is Art Such a Good Investment?" *Public Interest*, vol. 91 (Spring 1988): 79–86.

———. "Art Investment: An Empirical Inquiry." *Southern Economic Journal*, vol. 56, no. 2 (October 1989): 396–409.

———. *Muses and Markets: Explorations in the Economics of the Arts*. Oxford: Basil Blackwell, 1989.

———. "On the Return of Art Investment: Return Analyses." *Journal of Cultural Economics*, vol. 19, no. 3 (1995): 207–20.

Frieling, Rudolf, and Wulf Herzogenrath, eds. *40yearsvideoart.de—Part 1: Digital Heritage: Video Art in Germany from 1963 until the Present*. Ostfildern: Hatje Cantz Verlag, 2006.

Gaensheimer, Susanne, and Nicolaus Schafhausen, eds. *Liam Gillick*. New York: Lukas & Sternberg, 2000.

Galenson, David W. *Painting Outside the Lines: Patterns of Creativity in Modern Art*. Cambridge: Harvard University Press, 2001.

Gans, Herbert J. *Popular Culture and High Culture: An Analysis and Evaluation of Taste* [1974]. New York: Basic Books, 1999.

J. Paul Getty Museum. *California Video*, exh. cat., Los Angeles, 2008.

Gilbert, Chris, Carlos Basualdo, T. J. Demos, and Gregory Sholette. "'Dark Matter into Light": A Round-Table Discussion," *Art Journal*, vol. 64, no. 3 (Fall 2005): 84–101.

Gillick, Liam. "Ill Tempo: The Corruption of Time in Recent Art." *Flash Art*, no. 188 (May/June 1996): 69–70.

———. *Discussion Island/Big Conference Center*. Ludwigsburg and Derry: Kunstverein Ludwigsburg and Orchard Gallery, 1997.

———. "Contingent Factors: A Response to Claire Bishop's "Antagonism and Relational Aesthetics." *October*, no. 115 (Winter 2006): 3–14.

Gillick, Liam, and Maria Lind, eds. *Curating with Light Luggage: A Symposium*. Frankfurt: Revolver, 2004.

Gimpel, René. "Art as Commodity, Art as Economic Power." *Third Text*, no. 51 (Summer 2000): 51–55.

Ginsburgh, Victor A., and Philippe Jeanfils. "Long-Term Comovements in International Markets for Paintings." *European Economic Review*, vol. 38 (1995): 538–48.

Ginsburgh, Victor A., and Pierre-Michel Menger. *Economics of the Arts: Selected Essays*. Amsterdam: Elsevier, 1996.

Ginsburgh, Victor A., and Anne-Françoise Penders. "Land Artists and Art Markets." *Journal of Cultural Economics*, vol. 21, no. 3 (1997): 219–28.

Ginsburgh, Victor A., and David Throsby, eds. *Handbook of the Economics of Art and Culture*. Amsterdam: Elsevier, 2006.

Goedhuis, Michael. "Investment in Art." *Studio International*, vol. 189, no. 974 (January 1975): 19–20.

Goetzmann, William. "Accounting for Taste: Art and the Financial Markets over Three Centuries." *American Economic Review*, vol. 83, no. 5 (December 1993): 1370–76.

———. "The Informational Efficiency of the Art Market." *Managerial Finance*, vol. 21, no. 6 (1993): 25–34.

Goetzmann, William, and Liang Peng. "The Bias of the RSR Estimator and the Accuracy of Some Alternatives." *Real Estate Economics*, vol. 30, no. 1 (Spring 2002): 13–39.

Goetzmann, William, Luc Renneboog, and Christophe Spaenjers. "Art and Money." Yale ICF Working paper no. 09-26. Available at SSRN:http://ssrn.com/abstract=1501171.

Goetzmann, William, and Stephen M. Ross. "Hedge Funds: Theory and Performance." Ms., 1 October 2000, available at http://viking.som.yale.edu/will/hedge/Goetzmann-Ross.pdf.

Goetzmann, William, and Matthew Spiegel. "Art Market Repeat Sales Indices Based upon Gabrius S.P.A. Data." Gabrius White Paper, 2003.

Goldthwaite, Richard A. *Wealth and Demand for Art in Italy: 1300–1600*. Baltimore: Johns Hopkins University Press, 1993.

Goodwin, James, ed. *The International Art Markets: The Essential Guide for Collectors and Investors*. London: Kogan Page, 2008.

Gopinath, Deepak. "The Deal of the Art." *Bloomberg Markets* (March 2006): 85–90.

Graeser, Paul. "Rate of Return to Investment in American Antique Furniture." *Southern Economic Journal*, vol. 59, no. 4 (1993): 817–21.

Grampp, William. *Pricing the Priceless: Art, Artists, and Economics*. New York: Basic Books, 1989.

Granovetter, Mark. "Economic Action and Social Structure: The Problem of Embeddedness." *American Journal of Sociology*, vol. 91, no. 3 (November 1985): 481–510.

Granovetter, Mark, and Richard Swedberg, eds. *The Sociology of Economic Life*. Boulder: Westview Press, 1992.

Greenfeld, Josh. "Sort of the Svengali of Pop." *New York Times Magazine*, 8 May 1966, pp. 34–35, 38, 40, 42, 45–46, 48, 50, 52, 55, 58.

Greenfeld, Liah. *Different Worlds: A Sociological Study of Taste, Choice and Success in Art*. Cambridge: Cambridge University Press, 1989.

Groysberg, Boris, Tim Keller, and Joel Podolny. "Fernwood Art Investments: Leading in an Imperfect Marketplace." *Harvard Business School Case Study*, 9-405-032, 12 December 2004.

Grunenberg, Christoph, and Max Hollein, eds. *Shopping: A Century of Art and Consumer Culture*, exh. cat., Schirn Kunsthalle Frankfurt and Tate Liverpool. Ostfildern-Ruit: Hatje Cantz Publishers, 2002.

Guerzoni, Guido. "Analysing the Price of Art: What the Indices Do Not Tell You." *Art Newspaper*, no. 157 (April 2005): 54.

Guggenheim Museum. *The Worlds of Nam June Paik*, exh. cat. New York, 2000.

Habermas, Jürgen. *The Structural Transformation of the Public Sphere: An Inquiry into a Category of Bourgeois Society* [1962], trans. Thomas Burger with the assistance of Frederick Lawrence. Cambridge: MIT Press, 1989.

Haden-Guest, Anthony. *True Colors: The Real Life of the Art World*. New York: Atlantic Monthly Press, 1996.

Hall, David. "Artists Video at the Galleries." *Studio International*, vol. 193, no. 985 (January 1977): 19–22.

Hall, Doug, and Sally Jo Fifer, eds. *Illuminating Video: An Essential Guide to Video Art*. New York: Aperture, 1990.

Hamburger Bahnhof. *Beyond Cinema: The Art of Projection. Films, Videos and Installations from 1963 to 2005*, exh. cat. Berlin, 2006.

Hardt, Michael, and Antonio Negri. *Empire*. Cambridge: Harvard University Press, 2000.

Harvey, David. *The Limits to Capital, New Edition* [1982]. London: Verso, 1999.

———. *The Condition of Postmodernity: An Enquiry into the Origins of Cultural Change*. Oxford: Blackwell, 1990.

———. "The Art of Rent: Globalization, Monopoly and the Commodification of Culture." *Socialist Register* (2002). Available at http://socialistregister.com/recent/2002/harvey2002.

———. *A Brief History of Neoliberalism*. Oxford: Oxford University Press, 2005.

Haskell, Francis. *Patrons and Painters: Art and Society in Baroque Italy*. New Haven: Yale University Press, 1980.

———. *The Ephemeral Museum: Old Master Paintings and the Rise of the Art Exhibition*. New Haven: Yale University Press, 2000.

Hatton, Rita, and John A. Walker. *Supercollector: A Critique of Charles Saatchi*. London: Ellipsis, 2000.

Hauser, Arnold. *The Social History of Art*, trans. Stanley Godman. Volumes 1 and 2. London: Routledge & Kegan Paul, 1951.

Heilbrun, James, and Charles M. Gray. *The Economics of Art and Culture*. 2nd ed. Cambridge: Cambridge University Press, 2001.

Hiraki, Takato, Akitoshi Ito, Darius A. Spieth, and Naoya Takezawa. "How Did Japanese Investments Influence International Art Prices?" *Journal of Financial and Quantitative Analysis*, vol. 44, no. 6 (2009): 1489–1514.

Hirsch, Paul M. "Processing Fads and Fashions: An Organization-Set of Cultural Industry Systems." *American Journal of Sociology*, vol. 77, no. 4 (1972): 639–59.

Hoffmann, Jens, ed. *The Next Documenta Should be Curated by an Artist*. Frankfurt am Main: Revolver, 2004.

Hook, Philip. *The Ultimate Trophy: How the Impressionist Painting Conquered the World*. Munich: Prestel Verlag, 2009.

Horowitz, Noah. "Collecting with Light Luggage: A Conversation with Hans Ulrich Obrist." *immediations, The Research Journal of the Courtauld Institute of Art*, vol. 1, no. 3 (2006): 78–99.

Hudson, Richard L., and Benoit B. Mandelbrot. *The (Mis)behaviour of Markets: A Fractal View of Risk, Ruin and Reward*. London: Profile Books, 2004.

Huyghe, Pierre, and Philippe Parreno. *No Ghost Just a Shell*. Cologne: Verlag der Buchhandlung Walther König, 2002.

Iles, Chrissie, ed. *Into the Light: The Projected Image in American Art 1964–1977*, exh. cat. New York: Whitney Museum of American Art, 2001.

Institute for the Arts. *Yves Klein, 1928–1962: A Retrospective*, exh. cat. Houston: Rice University, 1982.

Irwin, ed. *East Art Map: Contemporary Art and Eastern Europe*, London: Afterall, 2006.

Jackson, Matthew Jesse. "Managing the Avant-Garde." *New Left Review*, no. 32 (March–April 2005): 105–16.

Jameson, Fredric. *Postmodernism, or, the Cultural Logic of Late Capitalism*. London: Verso, 1991.

———. *The Postmodern Turn: Selected Writings on the Postmodern, 1983–1998*. London: Verso, 1998.

Jeremy Eckstein Associates. *The Art Fair as Economic Force*. Helvoirt: European Fine Art Foundation, 2006.

Jones, Amelia. "'Presence' in Absentia: Experiencing Performance as Documentation." *Art Journal*, vol. 56, no. 4 (Winter 1997): 11–18.

Joselit, David. *Feedback: Television against Democracy*. Cambridge: MIT Press, 2007.

Kahnweiler, Daniel-Henry, with Francis Crémieux. *My Galleries and Painters*, trans. Helen Weaver. New York: Viking, 1971.

Kester, Grant. *Conversation Pieces: Community and Communication in Modern Art*. Berkeley and Los Angeles: University of California Press, 2004.

Kimmelman, Michael. "The Importance of Matthew Barney." *New York Times Magazine*, 10 October 1999, pp. 62–69.

Kosuth, Joseph. "Art after Philosophy, part 1." *Studio International*, no. 915 (October 1969): 134–37.

Krauss, Rosalind. "Video: The Aesthetics of Narcissism." *October*, no. 1 (Spring 1976): 50–64.

———. *The Originality of the Avant-Garde and Other Modernist Myths*. Cambridge: MIT Press, 1986.

———. *Passages in Modern Sculpture*. Cambridge: MIT Press, 1993.

Kraynak, Janet. "Tiravanija's Liability." *Documents*, no. 13 (Fall 1998): 26–40.

Krepler, Ute. "Art Fund Adventures." *Artinvestor*, no. 1 (2007): 82–85.

Kunsthalle Düsseldorf, *Prospect '69*, exh. cat. Düsseldorf, 1969.

———. *Ready to Shoot: Fernsehgalerie Gerry Schum/videogalerie schum*, exh. cat. Düsseldorf, 2003.

Kunstmuseum Wolfsburg. *How Durable is Video Art?* Wolfsburg, 1997.

Kusin & Company. *The European Art Market in 2002: A Survey*. Helvoirt: European Fine Art Foundation, 2002.

Kwon, Miwon. *One Place after Another: Site-Specific Art and Locational Identity*. Cambridge: MIT Press, 2002.

La maison rouge. *Une vision due monde, la collection video de Jean-Conrad et Isabelle Lemaître*, exh. cat. Paris, 2006.

Latour, Bruno. *Science in Action: How to Follow Scientists and Engineers through Society*. Milton Keynes: Open University Press, 1987.

————. *Reassembling the Social: An Introduction to Actor-Network-Theory*. Oxford: Oxford University Press, 2005.

Law, John. "Notes on the Theory of the Actor Network: Ordering, Strategy, and Heterogeneity," 1992. Available at http://www.lancs.ac.uk/fss/sociology/papers/law-notes-on-ant.pdf.

Law, John, and John Hassard, eds. *Actor Network Theory and After*. Oxford and Keele: Blackwell and the Sociological Review, 1999.

Leadbeater, Charles. *Living on Thin Air: The New Economy*. London: Viking, 1999.

Lee, Pamela M. "Boundary Issues: The Art World Under the Sign of Globalism." *Artforum*, vol. 42, no. 3 (November 2003): 164–67.

Leighton, Tanya, ed. *Art and the Moving Image: A Critical Reader*. London: Tate Publishing in association with *Afterall*, 2008.

Lewine, Edward. "Art That Has to Sleep in the Garage." *New York Times*, 26 June 2005.

Lind, Maria, and Raimund Minichbauer, eds. *European Cultural Policies 2015: A Report with Scenarios on the Future of Public Funding for Contemporary Art in Europe*. London, Stockholm, Vienna: eipcp/IASPIS, 2005.

Lindemann, Adam. *Collecting Contemporary*. Cologne: Taschen, 2006.

Lingwood, James, and Hans Ulrich Obrist. "Matthew Barney: Artist Project." *Tate: International Arts and Culture*, no. 2 (November–December 2002): 58–68.

Lippard, Lucy, ed. *Six Years: The Dematerialization of the Art Object from 1966 to 1972* [1973]. Berkeley: University of California Press, 1997.

Lippard, Lucy R., and John Chandler. 'The Dematerialization of Art." *Art International*, vol. 12, no. 2 (February 1968): 31–36.

Locatelli-Biey, Marilena, and Roberto Zanola. "The Market for Picasso Prints: A Hybrid Model Approach." *Journal of Cultural Economics*, vol. 29, no. 2 (May 2005): 127–36.

London, Barbara. "Video: A Selected Chronology, 1963–1983." *Art Journal*, vol. 45, no. 3 (Autumn 1985): 249–62.

Lovink, Geert. *Dark Fiber: Tracking Critical Internet Culture*. Cambridge: MIT Press, 2002.

Luhmann, Niklas. *Art as a Social System*, trans. Eva M. Knodt. Stanford: Stanford University Press, 2000.

Lyotard, Jean-François. *The Postmodern Condition: A Report on Knowledge* [1979], trans. Geoff Bennington and Brian Massumi. Manchester: Manchester University Press, 1984.

Madoff, Steven Henry. "After the Roaring 80s in Art, A Decade of Quieter Voices." *New York Times*, 7 November 1997.

Malkiel, Burton. *A Random Walk Down Wall Street*. New York: Norton, 1973.

Mandel, Benjamin. "Art as an Investment and Conspicuous Consumption Good." *American Economic Review*, vol. 99, no. 4 (September 2009): 1653–63.

Manovich, Lev. "The Death of Computer Art." (1996; revised 2001). Available at http://absoluteone.ljudmila.org/lev_manovich.php.

Manovich, Lev. *The Language of New Media*. Cambridge: MIT Press, 2001.

Maraniello, Gianfranco, Sergio Risaliti, and Antonio Somaini, eds. *The Gift: Generous Offerings, Threatening Hospitality*. Milan: Charta, 2001.

Mason, Paul. *Meltdown: The End of the Age of Greed*. London: Verso, 2009.

Mauss, Marcel. *The Gift: The Form and Reason for Exchange in Archaic Societies* [1950], trans. W. D. Halls. London: Routledge, 2002.

Maziere, Michael. "Institutional Support for Artists' Film and Video in the England: 1966–2003." Available at http://www.studycollection.co.uk/maziere/paper.html.

McAndrew, Clare. *The Art Economy: An Investor's Guide to the Art Market*. Dublin: Liffey Press, 2007.

———. *The International Art Market: A Survey of Europe in a Global Context*. Helvoirt: European Fine Art Foundation, 2007.

———. *Globalisation and the Art Market: Emerging Economies in the Art Trade in 2008*. Helvoirt: European Fine Art Foundation, 2009.

———, ed. *Fine Art and High Finance: Expert Advice on the Economics of Ownership*. New York: Bloomberg Press, 2010.

McLean, Daniel, and Karsten Schubert. *Dear Images: Art, Copyright and Culture*. London: ICA and Ridinghouse, 2002.

McMillan, John. *Reinventing the Bazaar: A Natural History of Markets*. New York: Norton, 2002.

McNeill, Donald. "McGuggenisation? National Identity and Globalisation in the Basque Country." *Political Geography*, vol. 19, no. 4 (2000): 473–94.

Mehring, Christine. "Emerging Market." *Artforum*, vol. 46, no. 8 (April 2008): 322–29, 390.

Mei, Jianping, and Michael Moses. "Art as an Investment and the Underperformance of Masterpieces." *American Economic Review*, vol. 92, no. 5 (December 2002): 1656–68.

Meigh-Andrews, Chris. *A History of Video Art: The Development of Form and Function*. Oxford: Berg, 2006.

Melikian, Souren. "Let the Art Investor Beware." *Art + Auction*, vol. 21, no. 12 (March 1999): 18–22.

Menzies, W. G. "Collecting as an Investment." *Apollo*, vol. 22 (August 1935): 87–90.

Merryman, John Henry. "The Wrath of Robert Rauschenberg." *American Journal of Comparative Law*, vol. 41, no. 1 (Winter 1993): 103–27.

Merryman, John Henry, and Albert E. Elsen. *Law, Ethics and the Visual Arts*. 4th ed. London: Kluwer Law International, 2002.

Meyers, John Bernard. *Tracking the Miraculous: A Life in the New York Art World*. New York: Random House, 1983.

Migros Museum für Gegenwartskunst, *Supermarket*, exh. cat. Zürich, 1998.

Mitropoulos, Angela. "The Social Software." *Mute: Culture and Politics after the Net*, vol. 2, no. 4 (January 2007): 20–31.

Modern Art Oxford. *Scream and Scream Again: Film in Art*, exh. cat. Oxford, 1996.

Moderna Museet. *What If: Art on the Verge of Architecture and Design*, exh. cat. Stockholm, 2000.

Montias, John Michael. *Vermeer and His Milieu: A Web of Social History.* Princeton: Princeton University Press, 1989.

———. *Art at Auction in 17th Century Amsterdam.* Amsterdam: Amsterdam University Press, 2000.

Möntmann, Nina, ed. *Art and Its Institutions: Current Conflicts, Critique and Collaborations.* London: Black Dog Publishing, 2006.

Morris, Valerie B., and David B. Pankratz, eds. *The Arts in a New Millennium: Research and the Arts Sector.* Westport, CT: Praeger, 2003.

Moulin, Raymonde. *The French Art Market: A Sociological View*, trans. Arthur Goldhammer. New Brunswick: Rutgers University Press, 1987.

———. *L'artiste, l'institution et le marché.* Paris: Flammarion, 1992.

———. "The Construction of Art Values." *International Sociology*, vol. 9, no. 1 (March 1994): 5–12.

Museum of Contemporary Art. *Out of Actions: Between Performance and the Object, 1949–1979*, exh. cat. Los Angeles, 1998.

———. *Public Offerings*, exh. cat. Los Angeles, 2001.

Museum of Modern Art. *Video Spaces: Eight Installations*, exh. cat. New York, 1995.

Nelson, Jonathan K., and Richard J. Zeckhauser. *The Patron's Payoff: Conspicuous Commissions in Italian Renaissance Art.* Princeton: Princeton University Press, 2009.

Nelson, Robert S., and Richard Shiff, eds. *Critical Terms for Art History.* Chicago: University of Chicago Press, 1996.

North, Douglass C. *Institutions, Institutional Change and Economic Performance.* Cambridge: Cambridge University Press, 1990.

North, Michael, ed. *Economic History and the Arts.* Cologne: Böhlau Verlag, 1996.

Nunes, Paul, and Brian Johnson. *Mass Affluence: Seven Rules of Marketing to Today's Consumers.* Boston: Harvard Business School Press, 2004.

Oberholzer-Gee, Felix, and Koleman Strumpf. "The Effect of File Sharing on Record Sales: An Empirical Analysis." *Journal of Political Economy*, vol. 115, no. 1 (2007): 1–42.

Obrist, Hans Ulrich, ed. *Gerhard Richter: The Daily Practice of Painting: Writings and Interviews 1962–1993*, trans. David Britt. London: Thames & Hudson, 1995.

Obrist, Hans Ulrich, and Barbara Vanderlinden, eds. *Laboratorium*, exh. cat. Antwerp: Dumont, Antwerpen Open, Roomade, 1999.

O'Doherty, Brian. *Inside the White Cube: The Ideology of the Gallery Space* [1976]. Berkeley and Los Angeles: University of California Press, 1999.

Panza, Giuseppe, and Christopher Knight. *Art of the Fifties, Sixties and Seventies: The Panza Collection.* Milan: Jaca Books, 1999.

Pears, Iain. *The Discovery of Painting: The Growth of the Interest in the Arts in England 1680–1768.* New Haven: Yale University Press, 1988.

Pesando, James. "Art as an Investment: The Market for Modern Prints." *American Economic Review*, vol. 83, no. 5 (December 1993): 1075–89.

Pesando, James, and Pauline Shum. "The Return to Picasso's Prints and to Traditional Financial Assets, 1977 to 1996." *Journal of Cultural Economics*, vol. 23, no. 3 (1999): 183–92.

Petkus, Ed, Jr. "Enhancing the Application of Experiential Marketing in the Arts," *International Journal of Nonprofit and Voluntary Sector Marketing*, vol. 9, no. 1 (2004): 49–56.

Pine, B. Joseph, and James Gilmore. *The Experience Economy: Work Is Theatre and Every Business a Stage*. Boston: Harvard Business School Press, 1999.

Plaza, Beatriz. "The Return on Investment of the Guggenheim Museum Bilbao." *International Journal of Urban and Regional Research*, vol. 30, no. 2 (June 2006): 452–67.

Polsky, Richard. *Art Market Guide: Contemporary American Art, 1995–1996 Season*. New York: Distributed Art Publishers, 1995.

Pompe, Jeffrey. "An Investment Flash: The Rate of Return for Photographs." *Southern Economic Journal*, vol. 63, no. 2 (October 1996): 488–95.

Prahalad, C. K., and Venkat Ramaswamy. *The Future of Competition: Co-Creating Unique Value with Customers*. Boston: Harvard Business School Publishing, 2004.

P.S.1 Contemporary Art Center. *Video Acts: Single Channel Works from the Collections of Pamela and Richard Kramlich and the New Art Trust*, exh. cat. New York, 2002.

Rectanus, Mark. *Culture Incorporated: Museums, Artists and Corporate Sponsorships*. Minneapolis: University of Minnesota Press, 2002.

Reitlinger, Gerald. *The Economics of Taste*. Volume 1: *The Rise and Fall of the Picture Market: 1760–1960*; Volume 2: *The Rise and Fall of Objets d'Art Prices since 1750*; Volume 3: *The Art Market in the 1960s*. London: Barrie & Rockliff, 1961, 1963, 1970.

Renneboog, Luc, and Christophe Spaenjers. "Buying Beauty: Prices and Returns in the Art Market." Working paper (February 2009) (JEL Classification: G1, Z11).

———. "The Upward Bias in Repeat Sales Art Indices." Ms., Tilburg University, 2009.

Réunion des musees nationaux. *3eme biennale de Lyon d'art contemporaine: installation, cinema, video, informatique*, exh. cat. Paris, 1995.

Rifkin, Jeremy. *The Age of Access: How the Shift from Ownership to Access Is Transforming Modern Life*. London: Penguin Books, 2000.

Robertson, Iain ed. *Understanding International Art Markets and Management*. London: Routledge, 2005.

Robertson, Iain, and Derrick Chong, eds. *The Art Business*. London: Routledge, 2008.

Robson, A. Deidre. *Prestige, Profit, and Pleasure: The Market for Modern Art in New York in the 1940s and 1950s*. New York: Garland, 1995.

Rosler, Martha. "Money, Power, Contemporary Art." *Art Bulletin*, vol. 79, no. 1 (March 1997): 20–24.

———. *Decoys and Disruptions: Selected Writings, 1975–2001*. Cambridge: MIT Press, 2004.

———. "Out of the Vox." *Artforum*, vol. 43, no. 1 (September 2004): 218–19.

Ross, David. "A Provisional Overview of Artist's Television in the U.S." *Studio International*, vol. 191, no. 981 (May/June 1976): 265–72.

Ross, Myron, and Scott Zondervan. "Capital Gains and the Rate of Return on a Stradivarius." *Economic Inquiry*, vol. 27 (1989): 529–40.

Ruberti, Federico. "Too Much to Do with Investment." *Art Newspaper*, no. 83 (July–August 1998): 37.

Rush, Michael. *Video Art*. London: Thames & Hudson, 2007.

Rush, Richard. *Art as an Investment*. New York: Bonanza Books, 1961.

Saltz, Jerry. "A Short History of Rirkrit Tiravanija." *Art in America*, vol. 84 (February 1996): 82–85, 106–7.

———. "Has Money Ruined Art?" *New York Magazine*, 15 October 2007, pp. 36–42.

San Francisco Museum of Modern Art. *Seeing Time: Selections from the Pamela and Richard Kramlich Collection of Media Art*, exh. cat. San Francisco, 1999.

Sandler, Irving. *Art of the Postmodern Era: From the Late 1960s to the Early 1990s*. Boulder: Westview Press, 1996.

Sans, Jérôme, and Marc Sanchez, eds. *What Do You Expect from an Art Institution in the 21st Century?* Paris: Palais de Tokyo, 2001.

Savage, George. "Art for Investment." *The Studio*, vol. 162 (July 1961): 31, 36–37.

Schneider, Ira, and Beryl Korot, eds. *Video Art: An Anthology*. New York and London: Harcourt Brace Jovanovich, 1976.

Seth Siegelaub Gallery. *January 5–31, 1969*, exh. cat. New York, 1969.

Shaw, Jeffrey, and Peter Weibel, eds. *Future Cinema: The Cinematic Imaginary after Film*, exh. cat. Karlsruhe: ZKM Center for Art and Media, 2003.

Shiller, Robert. *The Subprime Solution*. Princeton: Princeton University Press, 2008.

Shiller, Robert, and George Akerlof. *Animal Spirits: How Human Psychology Drives the Economy and Why It Matters for Global Capitalism*. Princeton: Princeton University Press, 2009.

Shleifer, Andrei. *Inefficient Markets: An Introduction to Behavioral Finance*. Oxford: Oxford University Press, 2000.

Shleifer, Andrei, and Robert W. Vishny. "The Limits of Arbitrage." *Journal of Finance*, vol. 52, no. 1 (March 1997): 35–55.

Sholette, Gregory. "Heart of Darkness: a Journey into the Dark Matter of the Art World" (2002). Available at http://gregorysholette.com.

———. "Dark Matter: Activist Art and the Counter-Public Sphere" (2003). Available at http://gregorysholette.com/.

Siegel, Katy, and Paul Mattick, eds. *Art Works: Money*. London: Thames & Hudson, 2004.

Siegelaub, Seth, and Hans Ulrich Obrist. "A Conversation between Seth Siegelaub and Hans Ulrich Obrist." *TRANS>*, no. 6 (1999): 51–63.

Singer, Leslie. "Phenomenology and Economics of Art Markets: An Art Historical Perspective." *Journal of Cultural Economics*, vol. 12, no. 1 (1988): 27–40.

———. "The Utility of Art Versus Fair Bets in the Investment Market." *Journal of Cultural Economics*, vol. 14, no. 2 (1990): 1–13.

Skaterschikov, Sergey. *Skate's Art Investment Handbook*. Vienna: Kunst AM, 2006.

Smith, Terry. *What Is Contemporary Art?* Chicago: University of Chicago Press, 2009.

Society of London Art Dealers. *Annual Members Survey for 2002*, June 2003.
———. *Survey of Members 2005*, June 2005.
———. *Biennial Members Survey 2007*, June 2007.
Solkin, David. *Painting for Money: The Visual Arts and the Public Sphere in Eighteenth-Century England*. New Haven: Yale University Press, 1993.
Sørensen, Louise. "Discrete Analogies: The Use of Digital Imaging Technology in Contemporary Art Photography." Ph.D. diss., Courtauld Institute of Art, 2006.
Spiegler, Mark. "Money for Old Soap." *Independent on Sunday Review*, 21 June 2002.
———. "The Road to Basel: How One Isaac Julien Video Became 10 Triptychs." *Independent on Sunday Review*, 21 June 2002.
———. "Five Theories on Why the Art Market Can't Crash and Why It Will Anyway." *New York Magazine*, 3 April 2006. Available at http://nymag.com/arts/art/features/16542/.
———. "The Trouble with Art Fairs." *Art Newspaper*, no. 175 (December 2006): 36.
Sproule, James. "Why Use an Art Fund? Just Do It Yourself." *Art Newspaper*, no.153 (December 2004): 26.
———. "When a Deep Wallet Isn't Enough." *Art Newspaper*, no. 171 (July 2006): 27.
Stallabrass, Julian. *High Art Lite: British Art in the 1990s*. London: Verso, 1999.
———. *Internet Art: The Online Clash of Culture and Commerce*. London: Tate Publishing, 2003.
———. *Art Incorporated: The Story of Contemporary Art*. Oxford: Oxford University Press, 2004.
Staniszewski, Mary Anne. *The Power of Display: A History of Exhibition Installations at the Museum of Modern Art*. Cambridge: MIT Press, 1998.
Stapleton, Jaime. "Art, Intellectual Property and the Knowledge Economy." Ph.D. diss., Goldsmiths College, 2002.
Stedelijk Museum. *Det Lumineuze Beeld* [*The Luminous Image*], exh. cat. Amsterdam, 1984.
Stein, John P. "The Appreciation of Paintings." Ph.D. diss., University of Chicago, 1973.
———. "The Monetary Appreciation of Paintings."' *Journal of Political Economy*, vol. 85, no. 5 (1977): 1021–35.
Steinberg, Leo. *Other Criteria: Confrontations with Twentieth Century Art* [1972]. Chicago: University of Chicago Press, 2007.
Stiglitz, Joseph. *Globalization and Its Discontents*. London: Penguin Books, 2002.
Sturken, Marita. "The Whitney Museum and the Shaping of Video Art: An Interview with John Hanhardt." *Afterimage*, no. 10 (May 1983): 4–8.
———. "TV as a Creative Medium: Howard Wise and Video Art." *Afterimage*, vol. 11, no. 10 (May 1984): 5–9.
Swedberg, Richard. *Principles of Economic Sociology*. Princeton: Princeton University Press, 2003.
Tate Gallery. *The Tate Gallery 1972–74: Biennial Report and Illustrated Catalogue of Acquisitions*. London, 1975.

Tate Modern. *Time Zones: Recent Film and Video*, exh. cat. London, 2004.

Tett, Gillian. *Fool's Gold: How Unrestrained Greed Corrupted a Dream, Shattered Global Markets and Unleashed a Catastrophe*. London: Little, Brown, 2009.

Thompson, Don. *The $12 Million Stuffed Shark*. London: Aurum Press, 2008.

Thompson, Nato, and Gregory Sholette, eds. *The Interventionists: Users Manual for the Creative Destruction of Everyday Life*. Cambridge: MIT Press, 2004.

Thornton, Sarah. *Seven Days in the Art World*. London: Granta, 2008.

Throsby, David. *Economics and Culture*. Cambridge: Cambridge University Press, 2001.

Tomkins, Calvin. "Shall We Dance? The Spectator as Artist." *New Yorker*, 17 October 2005, pp. 82–95.

Towse, Ruth, ed. *A Handbook of Cultural Economics*. Cheltenham: Edward Elgar, 2003.

Trebay, Guy. "Encounter—Sex, Art and Videotape." *New York Times*, 13 June 2004.

———. "Miami Basel: An Art Costco for Billionaires." *New York Times*, 10 December 2006.

Vanderlinden, Barbara, and Elena Filipovic. *The Manifesta Decade: Debates on Contemporary Art Exhibitions and Biennials in Post-Wall Europe*. Cambridge: MIT Press, 2005.

Veblen, Thorsten. *Theory of the Leisure Class* [1899]. New York: Penguin Classics, 1994.

Velthuis, Olav. *Imaginary Economics: Contemporary Artists and the World of Big Money*. Rotterdam: NAi Publishers, 2005.

———. *Talking Prices: Symbolic Meanings of Prices on the Market for Contemporary Art*. Princeton: Princeton University Press, 2005.

———. "Accounting for Taste: Olav Velthuis on the Economics of Art." *Artforum*, vol. 46, no. 8 (April 2008): 304–6.

Walker Art Center. *Let's Entertain: Life's Guilty Pleasures*, exh. cat. Minneapolis, 1999.

Walker, John A. *Arts TV: A History of Arts Television in Britain*. London: John Libbey, 1993.

Wallerstein, Immanuel. *The Decline of American Power: The U.S. in a Chaotic World*. New York: New Press, 2003.

Wallinger, Mark, and Mary Warnock, eds. *Art for All? Their Policies and Our Culture*. London: Peer, 2000.

Watson, Peter. "Japan's Art of Deception." *Observer*, 14 July 1991.

———. *From Manet to Manhattan: The Rise of the Modern Art Market*. London: Hutchinson, 1992.

Werner, Paul. *Museum, Inc.: Inside the Global Art World*. Chicago: Prickly Paradigm Press, 2005.

Worthington, A. C., and H. Higgs. "Art as an Investment: Risk, Return and Portfolio Diversification in Major Painting Markets." *Accounting and Finance*, vol. 44 (2004): 257–71.

Wu, Chin-tao. *Privatising Culture: Corporate Art Intervention Since the 1980s*. London: Verso, 2003.

Wynants, Marleen, and Jan Cornelis, eds. *How Open is the Future? Economic, Social and Cultural Scenarios Inspired by Free and Open-Source Software.* Brussels: VUB Brussels University Press, 2005.

Youngblood, Gene. *Expanded Cinema.* London: Studio Vista, 1970.

Zelizer, Viviana. *The Social Meaning of Money: Pin Money, Paychecks, Poor Relief, and Other Currencies.* New York: Basic Books, 1994.

———. "Payments and Social Ties." *Sociological Forum,* vol. 11, no. 3 (September 1996): 481–95.

———. "How and Why do We Care about Circuits." *Accounts. Newsletter of the Economic Sociology Section of the American Sociological Section,* vol. 1 (2000): 3–5.

Zurbrugg, Nicholas. *Critical Vices: The Myths of Postmodern Theory.* Amsterdam: G+B Arts, 2000.

Index

..

ABN-AMRO, 144, 159, 180, 205
Acconci, Vito, 31, 35, 43, 77
Acquavella, William, xvi, xvii, 198
Actor-Network-Theory (ANT), 24, 102;
 examples of in the sales of artists' work,
 105–10; theory and implications of for
 the art market, 103–5. *See also* intellec-
 tual property law
Adam, Georgina, 160
Adorno, Theodor, 127
Aitken, Doug, 46, 67–69 (*ill.*), 298n119
Al-Thani family, 202
Alberro, Alexander, 93, 96, 117
Albion Gallery, London, 197
Alpert, Jon, 31
American International Group (AIG), xiii,
 116–17, 191
ancillary goods: criticism of, 63, 78;
 economic role of, 24, 29, 54, 57–58
Anderson, Robert, 166
Andre, Carl, 87, 94, 99
Anna Sanders Films, 82
Arader, Graham, 183
arbitrage: hedge funds and, 161–62, 165;
 limits to (in the art market), 170–71,
 173–77
ARCO, 16
Armory Show, 16, 198
Ars Electronica, Linz, 41
art advisory services, 9, 122, 182; Fine Art
 Fund and, 150; rise of, 159–60; role of
 in banks, 160, 180
Art Basel, 16, 83, 121, 131, 135–36, 198
Art Basel Miami Beach, 16, 66, 134, 136,
 169, 287n55
Art Capital Group, 160
art collectors: art fairs and, 17, 74, 132,
 138; art market structure and, 18; black-
 lists and, 176; conceptual art and, 12,
 94, 99–100; dealers' strategic targeting
 of, 58, 60, 64, 66, 68, 76, 176; experien-

tial art and, 91–92, 102, 141; fashion
 seekers and, 7, 193; financial crises and,
 200–203 globalization of, 14, 136, 195,
 199, 202–7; lifestyle and, 121–23; "new"
 collecting class and, 7, 13, 122–23, 139,
 146; ownership rights of, 102–5, 107,
 113; prestige buying and, 146, 204; pri-
 vate museums and, 15–16, 210; resale
 royalties and, 98; shifting focus of, 9;
 social dynamics of, 123, 175, 177; socio-
 economic motivations of 22; versus in-
 vestors, 143, 183; video art and, 29,
 39–40, 42, 53, 69, 72, 77. *See also* col-
 lector's box; hedge fund collectors;
 limited editioning; private museums
Art Cologne, 16
art dealers, xiii–xvii; art fairs and, 134–36,
 308n125; art funds and, 25, 144–45,
 148, 150, 153, 169, 171, 178–80, 185,
 210; art market indexes and, 167, 170;
 art market structure and, 18–19, 138–
 98; classifications of, 22; distinction be-
 tween "commercial" and "genuine," 22;
 economic strategies and, 23, 54, 64, 78,
 175–77, 179, 212, 322n134; economic
 versus social objectives of, 175–77;
 encroachment of auction houses upon,
 321n111; front- versus backroom dis-
 tinctions of, 22–23, 54; globalization
 and, 203, 206; history of the contempo-
 rary art market and, 10; protectionist
 strategies of, 175–77 186, 195, 211; re-
 sale royalties and, 98; satellite branches
 of galleries, 15; video art pricing and,
 67–68; video art sales and, 40, 54, 78
Art Dealers Fund, 185
art fairs: "Art Fair Art" and, 136; art funds
 and, 169, 183; art market transparency
 and, 181; as a challenge to gallery exhi-
 bitions, 134; attendance figures of, 136;
 criticism of, 139–40; diminishing quality